The VES Handbook
of Virtual Production

The VES Handbook of Virtual Production is a comprehensive guide to everything about virtual production available today – from pre-production to digital character creation, building a stage, choosing LED panels, setting up Brain Bars, in-camera compositing of live action and CG elements, Virtual Art Departments, Virtual Previs and scouting, best practices, and much more.

Current and forward-looking, this book covers everything one may need to know to execute a successful virtual production project – including when it is best to use virtual production and when it is not. More than 80 industry leaders in all fields of virtual production share their knowledge, experiences, techniques, and best practices. The text also features charts, technical drawings, color images, and an extensive glossary of virtual production terms.

The VES Handbook of Virtual Production is a vital resource for anyone wishing to gain essential knowledge in all aspects of virtual production. This is a must-have book for both aspiring and veteran professionals. It has been carefully compiled by the editors of *The VES Handbook of Visual Effects*.

Susan Zwerman, ves, is an experienced Visual Effects Producer with a passion for cutting-edge film production. She is highly respected for her expertise in visual effects and virtual production budgeting and scheduling. As chair of the DGA UPM/AD VFX Digital Technology Committee, Susan organizes virtual production seminars to introduce members to this exciting and evolving new technology. Susan received the Frank Capra Achievement Award in recognition of career achievement and service to the industry and the Directors Guild of America in 2013. She is a member of the Academy of Motion Picture Arts and Sciences, the Producers Guild of America, the Directors Guild of America, and a member and Fellow of the VES.

Jeffrey A. Okun, ves, is an award-winning Visual Effects Supervisor who is more than conversant with virtual production. He is a member and Fellow of the VES and a member of The Academy of Motion Pictures, Arts and Sciences, the American Society of Cinematographers (asc), the Television Academy, and the Editor's Guild. Okun created visual effects tracking and bidding software in 1992 that is still in wide use within the industry today, as well as the revolutionary visual effects techniques dubbed the "PeriWinkle Effect" and the "Pencil Effect" – a predictive budgeting tool. He is also a noted 60s, 70s, and 80s rock and roll photographer.

The VES Handbook of Virtual Production

Edited by
Susan Zwerman, VES
Jeffrey A. Okun, VES

Co-Editor
Susan Thurmond O'Neal

Routledge
Taylor & Francis Group

NEW YORK AND LONDON

Cover Design: Daniel Flannery, Graphic Designer

First published 2024
by Routledge
605 Third Avenue, New York, NY 10158

and by Routledge
4 Park Square, Milton Park, Abingdon, Oxon, OX14 4RN

Routledge is an imprint of the Taylor & Francis Group, an informa business

Library of Congress Cataloging-in-Publication Data
Names: Zwerman, Susan, editor. I Okun, Jeffrey A., editor. I
 Visual Effects Society, issuing body.
Title: The VES handbook of virtual production / Susan Zwerman,
 Jeffrey A. Okun.
Description: New York, NY : Routledge, 2024. I Includes
 bibliographical references.
Identifiers: LCCN 2023016368 (print) I LCCN 2023016369 (ebook) I
 ISBN 9781032432663 (hardback) I ISBN 9781032432649 (paperback) I
 ISBN 9781003366515 (ebook)
Subjects: LCSH: Digital cinematography—Handbooks, manuals, etc. I
 Cinematography—Special effects—Handbooks, manuals, etc.
Classification: LCC TR860 .V47 2024 (print) I LCC TR860 (ebook) I
 DDC 777—dc23/eng/20230510
LC record available at https://lccn.loc.gov/2023016368
LC ebook record available at https://lccn.loc.gov/2023016369

ISBN: 978-1-032-43266-3 (hbk)
ISBN: 978-1-032-43264-9 (pbk)
ISBN: 978-1-003-36651-5 (ebk)

DOI: 10.4324/9781003366515

Typeset in Helvetica
by Apex CoVantage, LLC

Contents

v

Contents

Contents

Contents

Contents

Contents

Contents

Contents

Contents

Contents

Contents

Contents

Contents

Contents

Contents

Contents

About the VES

The Visual Effects Society (VES) is a nonprofit professional, honorary society dedicated to advancing and promoting the art and science of visual effects and to fostering and striving for excellence and knowledge in all matters pertaining to visual effects. Further, the VES strives to actively cultivate talented individuals in this discipline; to educate and develop public awareness and understanding; to support and encourage technological advancements in the field of visual effects; and to establish a collective organization that recognizes, advances, and honors visual effects as an art form, in order to promote the interests of its membership.

Mission Statement

The VES, a professional, honorary society, is dedicated to advancing the arts, sciences, and applications of visual effects and to improving the welfare of its members by providing professional enrichment and education, fostering community, and promoting industry recognition.

Foreword

Kim Libreri, CTO at Epic Games

Visual effects have constantly evolved since their inception. Early effects pioneers like Georges Méliès and Oscar Rejlander invented methods to leverage motion picture technology and create visual illusions that could not exist in real life. Visual effects consistently wowed audiences in ways that would otherwise be impossible to achieve, and we still have not yet discovered their ultimate limits.

Many innovations throughout the history of visual effects altered the trajectory and perception of what is possible. Stop-motion, optical compositing, motion control, CG animation, digital compositing, physically based ray-tracing, and performance capture are all techniques invented and refined to achieve ever more impressive spectacles. This process of discovery and reinvention continues to this day with the latest advances in virtual production, in-camera visual effects, and real-time game engine animation.

Digital visual effects over the past three decades revolutionized what we can create. At the same time, the democratization of digital content creation tools shifted the workflow and economic paradigm. Decreasing margins, more demanding audiences and clients, and the ubiquity of post-production tools and facilities led to a status quo within the industry.

The ubiquity of spectacle also threatens to erode the genuine awe and wonder that brought most of us into this business in the first place. We must constantly innovate to counter this ubiquity. Pioneers like Douglas Trumbull and his associates inspired us to strive to create something new by taking the first steps into virtual production.

As an inventor constantly seeking new ways to develop hyperrealistic scenery to captivate the imaginations of moviegoing audiences and elevate the theatrical experience, Trumbull saw the

immense promise of real-time tools. "If it's not real-time, then it's got to be near real-time, so we can make aesthetic and editorial judgments and rapidly proceed with production," Trumbull *said back in 2012*.[1] His goal was to generate spectacular content that demanded viewing on the largest screen possible.

The dream of real-time, closed feedback loop visual effects completely live and in-camera, as envisioned by many pioneers, is here today, but we are only scratching the surface. To succeed, a visual effects artist must master the technical workflows and comprehend the underlying aesthetic and business processes. **Today, the opportunity has never been more significant for visual effects artists because virtual production with real-time animation changes the game.**

An Evolving World for Visual Effects Artists

An appreciation for the state of visual effects today benefits highly from some observations about how real-time animation and virtual production may impact visual effects artists going forward. Artists will become more present and crucial throughout the production process, whether during pre-production or production, rather than relegated to post-production. This heralds a return to the creative inclusion of visual effects artists in pre-production and production phases because the tools' rendering speed will not hold them back. We will no longer wait for overnight renders or modeling changes because everything can be manipulated and rendered in real-time.

The speed that creative work can be delivered also heralds new configurations for working relationships. Creatives will expect the immediate feedback loop of real-time and no longer await the delays of traditional long-form post-render pipelines. Visual effects artists may feel more pressure to deliver their best work within tighter timeframes while collaborating more directly with creatives. These changes can also lead to a firmer commitment to significant decisions earlier in the process, meaning fewer redundancies and less busy work for artists.

Visual effects artists should master lighting and cinematography as they exist in the real world because the engines rapidly evolve to match reality. Prior animation tools often lacked realistic lighting simulations and leaned on the artists to mimic realism. Because game engines offer physical based lighting and realistic camera simulations, they can better approximate real-world cinematography. The onus is on the artists to understand lighting ratios and real-world materials as they interact with the cinematographer directly instead of following up on their work while siloed off in post-production.

Visual effects will become less abstract and more tactile for the artists and the creatives they collaborate with. Real-time engines enable highly realistic visuals out of the box, meaning proxy imagery and provisional visualization will be far more accessible to all stakeholders. Less technical filmmakers will engage more with visual effects, leading to new voices and a greater diversity

of ideas. The speed of iteration and interactivity will also increase, demanding greater precision and attention to detail.

Although we strive to follow in the theatrically motivated footsteps of Douglas Trumbull, our audience's consumption habits continue to evolve. The convergence of video games and filmed entertainment will increase as the metaverse takes shape. No one can predict this interactive new media platform's final form. Still, we can expect it will require the same or better visual effects quality to succeed. As media boundaries blur, visual effects artists will find opportunities across various industries driven by real-time animation skill sets.

Conclusion

Virtual production with in-camera visual effects and real-time engines offers a creative renaissance for visual effects artists who fully embrace its strengths. We need a new creative revolution to deliver fresh ideas and new possibilities. Real-time tools, specifically game engines, are the catalysts that will touch every aspect of the production process and open up new opportunities for visual effects artists and their craft.

As with any pioneering technology, artists should embrace the future and not be overly precious about preserving the past. Significant innovations often come from a level of naivete or at least pushing through the downside of existing paradigms. Visual effects artists should strive to embrace change and avoid analysis paralysis as much as possible.

In other words, do not be afraid to leap into the unknown and take risks as perfection is often the enemy of evolution. The willingness of filmmakers to bring the power of real-time engines onto their sets and in front of their cameras will help us all push through exceptional barriers and deliver the next level in the rich tradition of visual effects pioneers.

Note

1 https://www.btlnews.com/crafts/post-production/douglas-trumbull-fuels-new-filmmaking-paradigm-with-nvidia-quadro-gpus/.

Introduction

Miles Perkins, Industry Manager, Film and Television at Epic Games

A Visual Effects Paradigm Shift

Imagine a recording session with jazz great Duke Ellington and his orchestra. Members play off of one another through the subtle collaborative interchange of rhythm, dynamics, and improvisational phrasings – except for one band member. That member can only contribute their part after the recording is complete, note-by-note, and without the context of the collaborative exchange that comes from creating alongside peers.

Due to the limitations of available hardware, this is how traditional CG visual effects have operated for the past three decades, where many critical creative decisions are made outside the primary iterative process. With CG workflows only being as fast as the slowest part of the pipeline, many bottlenecks have centered around rendering and simulation, where iteration times are often measured in minutes, if not hours. But with advancements in graphics hardware, this paradigm is rapidly shifting where high-quality photorealistic imagery is being generated in real-time. Driven mainly by the talents of software developers, inspired by these advancements, game engine technology has powered a real-time revolution appropriately dubbed Virtual Production.

Virtual production is any filmmaking process or workflow that removes the barrier between virtual and physical. A filmmaker can engage with a virtual environment no differently from a physical set. Enabling this new wave of virtual production are technologies that strip away the byproducts that have kept CGI primarily a post process.

For shows that leveraged computer graphics, navigating through visual effects workflows, and communicating in a very different language than traditional filmmaking, caused an artificial impediment between post-production and the other heads of production departments (HODs). Until recently, physical production craftspeople had limited input or visibility into the final product – often only seeing it once it premiered to an audience. But through real-time workflows, production

DOI: 10.4324/9781003366515-1

dynamics are rapidly changing, empowering departments teams to bring the best of their crafts to the project more fluidly and collaboratively, whether in the physical or virtual world.

As this evolution continues and other film departments increasingly adopt virtual production workflows, CG artists will find more opportunities to participate earlier in the creative process. Virtual production empowers visual effects to be part of the creative process before, during, and beyond the moment of live-action creation.

How Real-Time Enhances Traditional Visualization

Along with a survey of existing virtual production tools within a game engine, it is also valuable to enumerate how virtual production in real-time can enhance traditional visual effects workflows.

Because the quality of previs imagery generated in real-time tools is much higher and more realistic, shots generated during this visualization process can carry forward into production and post-production. Critical creative decisions can be made much earlier, avoiding the need to recreate work or rebuild assets multiple times across the life cycle of a project. It also allows filmmakers and department HODs to make and own decisions much earlier in the process, which, if managed well, can lead to a more efficient and collaborative approach.

Cinematic Simulation Possibilities

An obvious benefit of real-time technology is the ability to render photoreal images in a fraction of a second. Another feature of game engines that is often overlooked: Cinematic design through simulation. Without simulation, a visualization will only show what the artist animates explicitly via keyframe animation or performance capture. Simulation, machine learning, and artificial intelligence open new ways to achieve shots and experiment just as a live-action director would on an actual set.

In the same way, any "cause-and-effect" action can be set up to provide a more organic performance between the characters and their environments, like flocking, destruction, growth, and environmental effects – just like the real world, but with more creative control.

Simulation can lead to serendipity and happy accidents that a more rigid visual effects workflow might overlook. An excellent example is *The Matrix Awakens* (2021), a unique project that coincided with the release of *The Matrix Resurrections* (2021). Viewers can interact with a massive procedural/AI-simulated environment representing the San Francisco–like city of the movie. The amount of detail within the simulation is enormous, with many buildings, pedestrians, traffic patterns, etc. And while it is a persistent world, none of it is baked; the engine can render everything

photorealistically on the fly to react to the viewer's input. The same methods can create highly interactive visualizations, iterate on final visual effects shots, or populate LED volume environments with virtual elements like extras and traffic.

Visual Effects Roles in Virtual Production

Virtual production encapsulates many different roles and enables artists with a real-time skill set to transition fluidly through many other areas, including but not limited to production design and art department, cinematography, pre-production and production visualization, and more broadly, game design, automotive and manufacturing, architecture, AI, and more. This means more significant opportunities for professional development, more jobs, and stimulating new challenges.

For studios working in this paradigm, it allows them to repurpose intellectual property and digital assets for many forms of distribution, including movies, streaming, games, location-based entertainment, and ultimately, future transmedia opportunities and whatever form the Metaverse takes. For artists this means less redoing of work and a longer life cycle for their creations.

Because virtual production with in-camera visual effects demands camera-ready assets before production can commence, CG artists also support the production's art department. Increasingly, visual effects artists are on set with in-camera visual effects, working in a live-action environment. Artists collaborate in real-time with the cinematographer, director, production designer, and the like. This elevates visual effects to play a role in the entire production process. The shift means additional opportunities and new modes of contribution for visual effects artists.

Creative Iteration in Real-Time

For visual effects professionals, iteration can be a double-edged sword. There is a desire to offer plenty of creative options, but doing and redoing work can often feel repetitive and is time-consuming. Because there is much less time penalty associated with real-time rendering and the image quality is much higher without a proxy mode, iteration can be much more satisfying to deliver. The iterative feedback loop with the filmmaker can be more immediate and effective, allowing decisions to be made in the moment.

Shot-to-shot continuity is also easier to achieve when each shot can be adjusted in relation to surrounding shots without layout or rendering penalties. Visual effects teams are accustomed to seeing individual shots out of context because the surrounding media is incomplete. Critical creative assessments are challenging because the entire picture needs to be clarified. Real-time rendering at high-quality can be completed much earlier in the pre-production process, so artists see everything in context and can quickly support the editorial cut.

Workflow Evolution

Technological changes ultimately impact the workflow and offer new methods of working more effectively and collaboratively. Visual effects move from an assembly line analogy to a creative feedback loop where less effort is lost on the broad strokes. Artists should expect a cycle of big and small loops, where iteration is constant until the desired outcome is achieved organically vs. out of end-of-schedule necessity.

To make this process work, it is critical that visual effects and other departments share an intuitive and familiar filmmaking vocabulary. Unreal Engine has been developed over different releases to bring filmmaking terminology into virtual production so that ways of referring to lights, color values, and other important properties use cinematic terms. Epic Games, along with the ASC, Netflix, and the VES, supported the creation of the Virtual Production Glossary as a standard reference for professionals arriving at the world of virtual production. These different aspects of the engine are conscious attempts to bridge the gap between the virtual and physical worlds.

Conclusion

Virtual production delivers cinematic visual effects with the spontaneity and collaborative nature of live-action production. This benefits the completed projects and the creative individuals working hard to deliver on schedule and within budget. An ideal solution is a hybrid approach that leverages the power of real-time creation while preserving all the advantages of post-rendered effects.

Advanced real-time workflows are designed to fit into a non-siloed production pipeline. The spirit of collaboration and spontaneity is often the spark that separates a good movie from a great one. Real-time virtual production tools can assist this effort and empower craftspeople to deliver their best work, supported by best-in-class workflows and state-of-the-art technology.

1

What Is Virtual Production

Definition of Virtual Production / Types of Virtual Production

Sally Slade – Voltaku Studios

Definition of Virtual Production

Virtual production is the augmentation or replacement of traditional visual effects or animation workflows by the use of real-time, digital technology.

There are a range of existing implementations of the above definition, spanning from live green screen replacement to full digital replacement of actors, environments, and even cameras. What follows are practical examples to impart further clarity.

Live green screen replacement is perhaps the most widely publicized manifestation of virtual production today. In this practice, rather than a traditional green screen, an LED wall is used to substitute for a material environment. Virtual production operators can transmit final-frame 3D imagery to the wall in real-time, allowing the cast and crew to become immersed in the space, both story-wise as well as physically.

The imagery on the wall is more than just a static background: The render is presented from the perspective of the in-world shot camera, which means that as the shot camera moves, the digital environment rendered to the LED wall updates its perspective. This enables a level of parallax and realism unrivaled by traditional matte paintings.

DOI: 10.4324/9781003366515-2

Figure 1.1 A motorcycle is lit by LED walls and ceilings on the set of Imagination's *Into the Volume* (2021)
Source: (Image courtesy of Imagination, Global Experience Design Company)

This practice offers a few advantages. In terms of story, an LED wall enables cinematographers, directors, and actors to have a shared sense of diegetic[1] space. This enhances the team's ability to make coherent, dynamic decisions on set, often leading to a more nuanced performance or camera movement that might not otherwise take place if the environments were added in post-production.

In physical terms, an LED wall offers realistic light-bounce. This ensures the talent, props, and set are responsive to environment lighting. It also eliminates the dangers of visual artifacts left behind from legacy green screen spill or challenging rotoscope work.

LED walls are not the only approach to set-replacement or extension: Real-time in-camera green screen replacement is a chronological predecessor to LED walls, and it is a workflow that has continued to evolve.

First publicized by Disney's *The Jungle Book* (2016), the in-camera green screen replacement technique involves the digitization and real-time transmission of the shot camera's position and lens information from the set directly into a game engine. From there, a virtual scene is instantly rendered and sent to monitors on set, allowing the cast and crew to see what might be considered a pre-visualization, or even the final frame content of a sequence or shot.

At the time of this writing, final frame is not often captured directly from a real-time renderer when it comes to live-action film productions. The quality bar is elusive in an only partially raytraced

environment with asset production pipelines tuned to the needs of AAA video games rather than Hollywood productions.

However, virtual production extends beyond Hollywood productions. There are live performances from actors and musicians participating in virtual production workflows across the entertainment industry. By leveraging a high level of stylization, these creators can easily get away with rendering final pixels in-camera in real-time.

A historic example of this process would be musician Katy Perry's performance of her song "Daisies" during the finale of *American Idol* (2020). In the first known large-scale broadcast of this technique, Perry delivered vocals while navigating through and interacting with a complex virtual environment, consisting of shifting horizon lines, and moving objects at different depths and scales in time with her music.

This production used an LED wall and a single prop chair to complete the physical set in combination with real-time in-camera composites to achieve a full, omnidirectional set extension, complete with moving abstract elements and several visually unique virtual rooms.

As technology evolves from desktop monitor displays to mobile device displays to head mounted displays, terminology evolves as well. It is important to note that in-camera composites may also currently be referred to as "augmented reality."

The definition of augmented reality is the real-time digital augmentation of the user's perception of reality. It is not relevant if the user's perception of reality is through a device screen or their own eyeballs. Nor is it relevant if the augmentation is photoreal, tracks with the camera, or has light sources that match its real-world environment. Examples of augmented reality range from informational displays on car windshields to Snapchat lens filters to the science fiction brain-implant technologies seen on television shows like *Black Mirror* (2016).

However, as the limits of creative expression continue to be removed by technical innovation, expertly integrated augmented reality assets have begun to distinguish themselves from more primitive forms of augmented reality (AR).

Augmented reality which takes integration a step further via tracking with the camera and enabling occlusion of the virtual asset via real-world objects can be referred to as mixed reality (MR). However, given the rate at which mixed reality technologies are developing, many creators do not bother to distinguish MR from AR and leave it up to context.

One could easily describe Katy Perry's performance of *Daisies* (2020) as either an AR or MR experience – both of which fall under, but are not limited to, the umbrella of technologies that make up virtual production workflows.

Virtual production is more than just the replacement, or augmentation, of environments: Virtual production workflows are already sophisticated enough to be integral to character performance as well.

By using full-body tracking and facial motion capture, on-set operators can capture a character's performance. The captured data can be stored or immediately transmitted to a character rig, allowing the virtual character to be puppeteered in real-time.

A practical example of this can be found in the production of Netflix's *Super Giant Robot Brothers* (2022), created by ReelFX. This production involved a motion capture stage where multiple actors performed simultaneously while a cinematographer captured everything using a virtual camera with a portable monitor display that rendered the view from within the game engine in real-time.

The cinematographer was not constrained by the real-world motion of the camera and was able to augment camera movements using thumbstick controllers mounted to the camera rig. In this way, the DP was able to overcome the physical limitations faced by non-virtual camera operators to travel large distances instantly, shoot from drone heights, or isolate the camera motion to a single vector.

The ability to watch an actor's performance mapped onto a digital character is also not limited to strictly in-camera compositing for on-screen display. Creators around the world have begun filming and broadcasting from directly within the digital world of virtual reality (VR). Virtual reality is distinct from augmented reality in that it entirely replaces one's reality with a fully virtual landscape and cast of characters.

Over the last few years, creators such as PHIA, of *The Virtual Reality Show* (2020–present), have been fabricating environments, props, and characters and filming final frames directly within game engines via handheld, and statically placed, virtual cameras. In 2022, a feature-length documentary called *We Met in Virtual Reality* (2022), was filmed entirely within *VRChat* – a fully immersive social VR platform.

Figure 1.2 Pioneering independent virtual productions such as *The Virtual Reality Show* (2020) are filmed entirely within VR, using virtual cameras, virtual sets, and avatars driven by motion capture
Source: (Image courtesy of PHIA)

The seeds of these techniques date back to the turn of the century when independent filmmakers created an 18-episode season of a television show called *Red vs. Blue* (2003), filmed entirely within the virtual world of the *Halo* video game franchise. The technique at that time was colloquially referred to as "Machinema."

Meanwhile in Hollywood, the crew on Disney's *The Lion King* (2019) often immersed themselves in virtual reality for virtual location scouting, animation blocking, and final camera movements. This full immersion technique gives the cast and crew a sense of presence that transcends both in-camera compositing and LED walls. The immediacy of full virtual immersion lends itself well to a shared understanding of virtual spaces and characters. With the cast and crew fully aligned, collaboration and dynamic decision-making can flow organically, putting the indefinable energy of a traditional film set in closer reach.

Now that the concept of virtual production across AR, MR, and VR mediums has been covered, it will be helpful to define XR, a catch-all term the film and gaming industries are continuing to define.

Historically, XR has a few definitions: It is the "X" variable holder meant to represent the "A," "M," or "V" within AR, MR, and VR. It is also referred to as "cross reality," meant to describe a mixed and asynchronous interaction of players across both virtual and augmented realities. Most recently, and perhaps most commonly, XR may be elongated to "extended reality" and is a blanket term referring to anything that modifies one's native, non-digital, everyday experience of organic reality.

Just as XR is a forward-looking term, virtual production is a forward-looking workflow. Developers are working tirelessly to build XR toolsets that disrupt virtual production from an active, pre-production, and post-production standpoint.

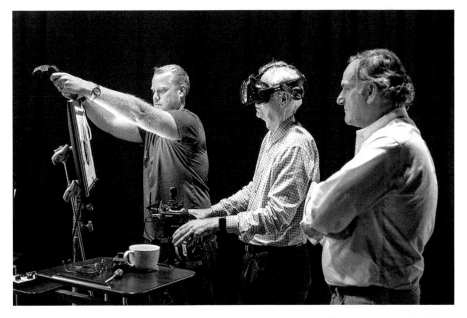

Figure 1.3 The crew develops shot cameras in virtual reality on the set of Disney's *The Lion King* (2019)
Source: (Image courtesy of Michael Legato)

It is not just XR software that will disrupt the virtual production industry; upcoming XR hardware will also play a critical role. The democratization of head-mounted displays will be a game changer for virtually driven productions. Seeing virtual elements integrated within a physical space will be a revolution in communication and reaction times on set.

For pre-production, consider everything that goes into building a safe and effective set environment. Using digital twins (the replication of a physical location in a virtual environment), set designers might work from home using XR technologies. Safety officials can remotely determine which areas of the set need to be reinforced for particular action scenes. DPs can map out where to lay dolly tracks. All of which can happen with near-vertical integration rather than the traditional waterfall workflow of Hollywood.

For post-production, the full potential of virtual production has yet to be realized. Consider the role of an editor cutting together various shots to build tension and clarify narrative direction. If only they could alter the angle a shot was captured from or the ability to render a sequence from a different character's perspective, then, perhaps, they could make the killer cut unforeseen during pre-production. This will become possible due to emerging volumetric video file formats which allow virtual cameras to re-render sequences using deterministic transform data. The future for virtual production is incredibly bright and largely unexplored!

What Types of Scenes Work Well for Virtual Production
Sally Slade – Voltaku Studios

Virtual production is not a solution in search of a problem. There is a time and place to use this workflow over other solutions.

The best use for virtual production, given its current technological limits, would be for the following types of sequences: Sequences with completely digital characters or predominantly digital environments, sequences that are cost prohibitive or inconvenient to shoot on location, or sequences where it is physically prohibitive to execute on set.

Sequences featuring digital characters or predominantly digital environments are excellent choices for virtual production. What follows are practical examples from each.

With regards to completely digital characters, consider *Alter Ego* (2021). On this production digital characters were integrated on set in such a way that a panel of judges could receive a live-operator's musical performance and interact with the corresponding virtual characters verbally as well as visually.

The unscripted nature of the interactions made virtual production and its real-time capabilities an excellent choice. Beyond that, the stylized nature of the digital characters was forgiving enough that final frames straight from the game engine met an acceptable bar of visual quality.

Figure 1.4 A motion-capture-driven avatar is composited in-camera in real-time in front of a live audience for a performance on *Alter Ego* (2021)
Source: (Clip Courtesy of Fox Entertainment. ALTER EGO © 2021 by Fox Media LLC)

It is important to note that the stylization of digital human characters is an artistic way to overcome the limitations of realistic human rendering from within game engines. For this section, readers may assume that the challenge of using photoreal CG humans has not yet been overcome by real-time game engines.

Scenes with predominantly fabricated environments are also perfect for virtual production. As an example, one might consider *The Batman* (2022), from Warner Brothers. This production made use of virtual production for various sequences: A car chase sequence and a sunset rooftop sequence stand out as two unique use-cases for the same virtual production solution.

Process shots (shooting dialogue inside a moving car, airplane, train, etc.) are excellent for virtual production because no terrain needs to be physically traversed. The prop car stays in a singular location, fans are blown at the actors, and the environment streams by on LED walls. This need not be limited to *The Batman* or even to automobiles. The same concept applies to motorcycles, trains, buses, helicopters, spaceships, and heretofore uninvented forms of high-speed locomotion.

As compared to a green screen solution, virtual production gives the cast and crew a shared point of reference and the ability to react to that reference to add specificity and nuance to a performance. As compared to an on-location solution, no time or budget is wasted moving from point A to point B during shooting or moving from point B back to point A between takes. This of course improves turnover time and the safety of the cast and crew during filming.

The sunset rooftop sequence in *The Batman* is notable for two reasons. For one, the crew could shoot the sequence without regard to the passage of time – the lighting for any shot remains

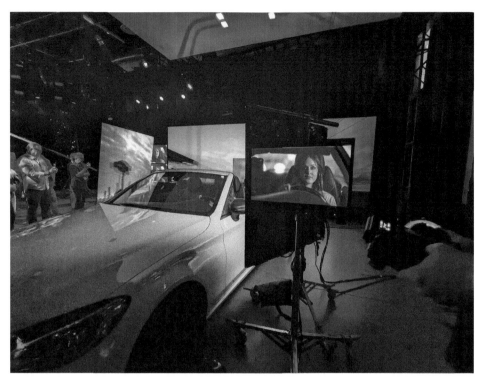

Figure 1.5 An LED volume displays a moving environment while a stationary prop car is manipulated by an actress
Source: (Image courtesy of PRG)

unchanged in a virtual environment (unless one would like it to change). For the first time in film history, cinematographers do not need to concern themselves with time pressure for the sake of capturing realistic lighting at dusk. Further, if there were qualms about the positioning of the setting sun or clouds, these parameters could be completely art directed and changed with little hassle by a virtual production operator.

Another reason virtual production was an ideal solution for the rooftop sequence in *The Batman* is that Gotham City itself is visually distinct. To shoot Gotham on location would require significant post-production work, not to mention pre-production work for location scouting, securing permits, and transportation of cast and crew. Using virtual production, such hassles are eliminated. Even more exciting, a director can make decisions at production time regarding things like skyline silhouettes or the positioning of nearby hero building assets based on what they see in the viewfinder at the time of shooting.

A final type of sequence that works well with virtual production is scenes that are physically prohibitive. This could mean scenes that take place in mid-air, underwater, or within the vacuum of outer space, to name several physically prohibitive environments.

A great example of a physically prohibitive sequence can be found in Marvel's *Black Adam* (2022). In the film, Black Adam is a superhuman flying through the sky with mercenaries in pursuit. The

laws of physics prevented the crew from shooting this sequence practically, and virtual production was leveraged to great use. The visual effects team shot the sequence using LED walls, Unreal Engine, and various suspension devices to lift the cast. Virtual production was a great choice because it provided realistic lighting and flexibility on set, allowing the project to move forward without blue screens or death-defying stunts.

Sequences for which virtual production would be a poor choice are scenes where sets are easily assembled or transported, where the natural lighting circumstances are largely unchanging, or scenes that feature dialogue between humans without significant focus on the surrounding environment. One might argue that a film such as *12 Angry Men* (1957) has no good reason to engage with a virtual production pipeline.

As the challenges and costs associated with virtual production continue to decline, choosing when to use virtual production as a solution will become a far less discerning process. The market is already saturated with consumer applications for mobile devices that do real-time sky replacements, realistic insertion of interactive virtual objects, and undetectable modifications to human faces. With machine learning and edge computing technologies on the rise, the complete democratization of virtual production for everyone from professionals to hobbyists is inevitable.

Green Screen for Virtual Production
Oscar Olarte – MR Factory

How to Shoot Green/Blue Screen Using Virtual Production
Chroma key has been used since the very earliest days of digital video production. It is therefore a trusted, familiar, and highly evolved solution for virtual productions. Real-time chroma keyers have evolved to incorporate mature and highly complex algorithms that manage the detail, spill, shadows, and reflections so that the filming crew is afforded the opportunity to concentrate on storytelling. Combining these algorithms with the latest generation of processors makes it possible to achieve very high-quality virtual productions using a chroma key.

LED Volume video displays are very good for virtual production, but the main drawbacks when compared with chroma-key-based virtual production are that the quality of the background is limited to what it is possible to compute in real-time and the lack of flexibility to change anything once everything has been shot.

Tests have been completed to discover the difference between real vs. virtual screens. Virtual green/bluescreen production produced almost the same results as the original shot.[2] An audience would be challenged to identify which is real and which is virtual.

To obtain such a high-quality real-time result using chroma-key-based virtual production, great care must be given to the set up of the green screen/blue screen shoot.[3]

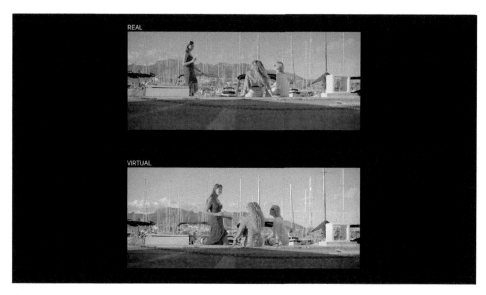

Figure 1.6 BS Virtual Production and Final Composite filmed on BS Chroma Key Stage
Source: (Image courtesy of MR Factory)

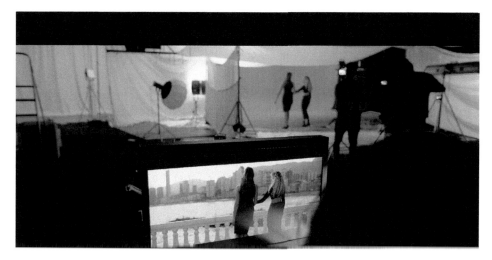

Figure 1.7 BS Real-Time Compositing for Virtual Production
Source: (Image courtesy of MR Factory)

GS/BS Background

CHROMA KEY

Cyclorama sizes larger than 300 square meters are best to get a real-time chroma key. The height of the cyclorama should also be as high as possible so that there is always a green/blue screen background to composite with the foreground, especially with low-angle shots. The curve for the endless infinite background is also very important: Wide curves are best to get infinite backgrounds.

As a rule of thumb, everything outside the camera frustum should be covered by black curtains or fabric to block any color spill.

USE OF LED SCREENS AS A BLUE/GREEN SCREEN FOR CHROMA KEY

An LED volume stage can also be used as a chroma key background, either in green or blue. The major advantage of using LED as a chroma key background is the possibility of switching the background color to green or blue. However, the quality of the light of LED panels is not as good as practical green/blue screens because it has a very low TLCI (Television Lighting Consistency Index).

Lighting for GS/BS

TLCI (TELEVISION LIGHTING CONSISTENCY INDEX)

The quality of light is measured in TLCI[4] units. The spectrometer like the Sekonic C-800 is an indispensable tool to measure TLCI and get perfect chroma key illumination. Chroma key is based on color, so the quality of light to render the colors is important. To get the best chroma key results, full RGB lightning panels with TLCI above 95 units are recommended.

To match the original light of a plate, take readings using the Sekonic C-800, and then reproduce the same light measurements, with the same intensity and color temperature, on the set of the chroma key virtual stage.

CONTROLLING THE LIGHT SPECTRUM

White lights contain the entire color spectrum, but this spectrum is not always perfectly balanced. It has a dominance, or spike, in the spectrum for certain colors. When shooting a greenscreen

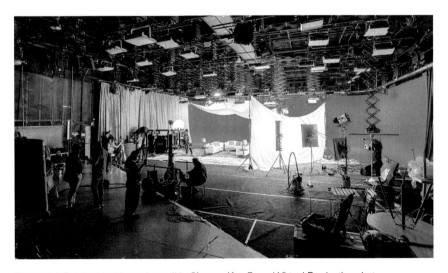

Figure 1.8 Fabrics blocking color spill in Chroma-Key-Based Virtual Production shot
Source: (Image courtesy of MR Factory)

shot, a spike in the green spectrum should be avoided at any given color temperature. The same is true for shooting on blue screen.

It is possible to control the color spectrum of any given color temperature with full RGB LED lightning panels such as Fos 4 from ETC. These panels have both very high TLCI and the flexibility to manage the color spectrum at any given color temperature.

ILLUMINATING WITH LED VIDEO DISPLAYS AND LASER PROJECTORS

LED video displays are a very good source of illumination when there is a need to recreate reflections in a chroma-key-based virtual production. Using high-luminosity LEDs on the ceiling or behind the camera for reflections is a perfect solution for illuminating objects, while illuminating with laser projectors is a perfect solution to get real-time shadows, such as in a car scene.

Real-Time GS Compositing Systems Using Virtual Sets for Background

Examples of Types of Renders

There are many ways to create and render virtual backgrounds in virtual production. To begin, choose the type of render engine, that can be either unbiased or biased.

Unbiased render engines let the light bounce in a physically correct simulation. Unbiased render is quite intuitive, and the learning curve is very shallow. Unbiased render takes less time to create a photoreal render. However, much more time and computing power are required. Biased render engines allow tweaking many of the parameters to recreate reality as close as possible. Biased render takes more labor for an artist to arrive at a photoreal render – however, the render takes less time and computing power.

It is possible to "bake" that render into polygons of a 3D scene in many Unbiased or Biased render engines. It is difficult to say which is the real photo and which is the created 3D set.

REAL-TIME RENDER ENGINES (WITH BIASED OR UNBIASED)

Unreal Engine, which is the de-facto standard for real-time render engines in virtual productions, can use both biased and unbiased engines.

Unreal Engine biased render is very good for real-time previs or final quality (ICVFX) by LED Volumes, but the quality is quite limited compared with unbiased production render engines like Arnold, OctaneRender, and Cycles, among others. For example, the OctaneRender plugin for Unreal Engine is intended for chroma-key-based virtual production workflows where Unreal Engine is used as a previs, while the final render relies on OctaneRender. A real-time path tracer, Brigade Engine, is included in the OctaneRender plugin for Unreal Engine, further augmenting its cinematic rendering pipeline for real-time rendering workflows. It is also possible to use the RNDR network for ultra-high-speed rendering.

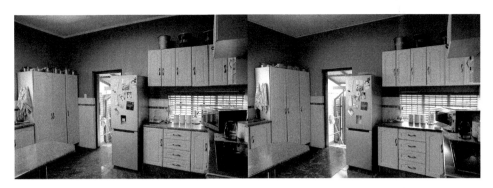

Figure 1.9 Real vs. Virtual test set created by MR Factory using the Unbiased OctaneRender Plugin for Unreal Engine, using a RTX 4090
Source: (Image courtesy of MR Factory)

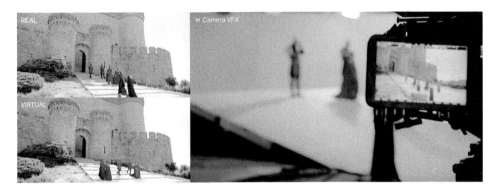

Figure 1.10 Real vs. Virtual photogrammetry test on Choma-Key-Based Virtual Production
Source: (Image courtesy of MR Factory)

CHROMA KEY COMPOSITION

Real-time chroma key integration is one of the most important things in green/bluescreen virtual production. There are many good hardware chroma keyers, and at the time of this writing, one of the best is Ultimatte-12 4k. It is a full-featured 4K HDR (Rec 2020) 4:2:2 10bit chroma key. Chroma-key-based virtual production does not allow 4:4:4 12-bit (or above) workflows since most of the cameras, including the high-end film cameras, do not allow 4:4:4 live feeds. The best approach to retain the full original RAW quality of the camera while shooting with chroma-key-based virtual production is to record the mask and render the background in full ACES AP0 2065–1 with the EDL. That makes it possible to shoot during the day and render at night (like developing film).

Summary

At the time of this writing, chroma key is still the preferred solution for traditional visual effects shooting. However, chroma-key-based virtual production is one of the most promising solutions in the virtual production arena. The new high-end 8K HDR real-time chroma keyers combined with the power of the new RTX 4090 and the Multi-GPU Real-Time PathTracers will be a game changer.

This approach will push the envelope and improve the quality of chroma-key-base virtual productions to near-perfect quality while maintaining the flexibility and productivity of this technology.

Notes
1 Diegetic: existing or occurring within the world of a narrative rather than as something external to that world.
2 To see the test, go to https://vimeo.com/720738209/ccb615ff0a.
3 To see this test footage, please go to https://vimeo.com/717562265.
4 https://tech.ebu.ch/tlci-2012.

Advantages and Disadvantages of Shooting in Virtual Production

Advantages and Disadvantages of Using LED Volumes for Production

Glenn Derry

In early cinema, set extensions were filmed "in camera" with the use of painted backdrops, then trans-lights followed by front and rear projection techniques – which added motion and realism to the set extension illusion. With the invention of the optical printer came compositing matte paintings, and other photographic effects were made possible.

While compositing digitally generated set extensions is effective, there are drawbacks to an exclusively post-production-driven process. It can be difficult to create a unified vision when each part of the effect is segmented into departments and temporally siloed. LED volumes offer a return to an "in-camera" approach for set extensions.

An LED volume, in the context of this chapter, is the combination of an LED wall acting as a backdrop for a physical set, with a game engine producing projected renders for the display from the point of view of a physically tracked camera. There can be many shapes and sizes for a LED volume, from a simple flat plane screen, such as seen out an interior set window – to a full 360° wall surrounding the entire physical set with an LED ceiling. The unifying factor is the illusion of depth and 3D parallax, as seen from the vantage point of the camera.

DOI: 10.4324/9781003366515-3

Is an LED Volume the Right Tool?

The decision to commit to an LED Volume style of production needs to happen in the earliest possible timeframe of a project – well before the budget and schedule are determined. If the LED volume is the primary methodology for principal photography, its use will influence every aspect of the production pipeline: Key creative hires, the types of scenes written, production design, as well as the practical concerns of crew members and visual effects vendor choices. Key creatives will need to embrace the prospect of "getting the shot" during principal photography and not putting off decisions until post-production. Ample time should be allocated to the pre-production period for shot planning and visualization, digital asset construction, and creative approvals to be finalized before principal photography begins.

When using an LED Volume, most digital production design and pipeline tasks, such as modeling, texturing, and lighting, are moved from post-production and moved into pre-production. Additionally, there is the added overhead of optimizing the digital environment for the game engine used to render and display content. The physical art department and Virtual Art Department (VAD) work simultaneously with the production designer to complete a cohesive design. Physical set pieces that may also appear on the LED wall need to be digitized and used as a reference for the digital content team. All of this happens at the pace of a production's shoot schedule rather than driven by an editorial request in post-production.

When deciding to use or not use an LED volume, there are many factors to consider:

Advantages of LED Volume Production

- Has the potential to reduce principal photography and post-production schedules.
- Creative decisions are made in pre-production, establishing a blueprint for principal photography while working out the technical logistics.
- Distant or exotic locations can be reproduced on the LED volume stage, minimizing crew travel and associated overhead.
- LED volumes can reduce the overall number of physical stages and associated support equipment required for a production while continuing to maintain the scope and scale of the script.
- The LED wall provides environmental illumination and reflections on the subject(s) and set surfaces. For example, sets with shiny floors, characters with chrome armor, glass surfaces on vehicles, or other reflective set pieces.
- Shooting in an LED volume allows for as much time as required to shoot sunrise, nighttime, "golden hour," or other typically time-sensitive scenes and in a comfortable environment.
- Faster turnaround time between physical shooting setups. For example, one could rotate the digital environment rather than the physical set for a quick "French Reverse.[1]"
- The LED Volume offers better continuity for reshoots and pick-ups. The shooting team can load a previously photographed scene's background into the wall for newly written dialogue or use plate photography captured on location as the background source material in the volume.

- The final look is baked into the photography, reducing editorial time and guessing games during post-production.
- The actors can see the world they are performing in, resulting in more authentic performances and sight lines.
- The LED volume is schedule-friendly for actors, especially children or other talent that may have contractual time or travel restrictions.

Disadvantages of LED Volume Production

- The learning curve, the nascent technology, and the evolving workflow.
- Creative decisions and approvals must be made much sooner, which lengthens the time and money spent in pre-production compared to the traditional film approach.
- People must be willing to go out of their comfort zone and adapt to existing processes. For example, "final pixel" quality digital environments must be approved *before* principal photography begins.
- Extreme camera moves and wide or high angles can be limited due to space constraints of the LED volume. Additionally, the camera tracking and video systems latency may introduce artifacts in the signal chain, limiting the speed of whip pans or handheld camera moves.
- There are limited camera frame rate options – 48fps maximum, at the time of this writing.
- Certain types of environments can be difficult to reproduce at "final pixel" quality in a game engine (such as foliage, water, inclement weather, etc.).
- Background "Digital Extras" and other animated content can be difficult to produce at a high fidelity early enough in the production process, requiring significant post-production fixes.
- Experienced talent and vendors are limited and in high demand. While this space is evolving rapidly, there is not a large pool of freelance labor to rely on.
- Crafts such as the camera, grip, and electric departments may need to start work earlier than typical in order to ensure a time for pre-lights and content reviews on the LED wall. All final look decisions are made looking through the lens of the camera.
- LED volumes can present challenges with sound reflections, requiring solutions to mitigate.
- LED volumes require a significant amount of power to operate and may require upgrades to stages to facilitate their usage.
- LED wall lighting can introduce color shifts on skin tones and other physical materials. Thorough camera and digital intermediate pipeline tests in pre-production are required to ensure consistent results.
- Digital asset construction and interchange with multiple vendors can be complex due to the real-time performance requirements in game engines.

(Many of these disadvantages will disappear over the next couple of years.)

Setting Up for Success

1. Key creatives on the project need to understand the process of LED volume production and design accordingly. Both physical and digital construction happen simultaneously.

2. It is critical to give the project enough lead time in development and pre-production, as well as hiring suitable HODs who can embrace the LED wall production workflow.
3. The virtual production and visual effects teams will be creating "final pixel" work that can take months to create, depending on design complexity, in pre-production instead of in post.

The Ten Commandments of LED Volume Production

1. Key creatives, such as the Director, Production Designer, and Director of Photography, must be available during project development and for the entirety of pre-production.
2. Creative decisions must be made early and acted upon with urgency.
3. The pre-production schedule will be longer.
4. Money will be spent sooner.
5. Creative transparency and open collaboration are required across all departments.
6. Every physical set piece or prop that also appears on the LED wall will need to be scanned and reconstructed digitally.
7. The VAD is an extension of the art department creating the set.
8. Virtual scouts and pre-light days in the LED volume are required for every set.
9. Final look decisions must be made in the LED volume through the camera lens.
10. Creative drives the technology.

"Plan it in Pre," not "Fix it in Post."

Note

1 French Reverse is a film term where, in an over-the-shoulder shot, the camera stays where it is, and the actors reverse positions as opposed to leaving the actors where they are and move the camera 180° to get the reverse.

3

How the Virtual Production Supervisor and Producer Relate to Other Departments

Virtual Production Supervisor Relationships
Ian Milham – ILM

What Is Unique About the Virtual Production Supervisor

The Virtual Production Supervisor is the head of a new on-set department that overlaps and interacts with many others. The work of interacting with other heads of departments may represent the majority of the VP Supervisor's time, beyond what time they spend with the virtual production team itself. The VP Supervisor is the team's advocate, champion, and early warning system.

The virtual production work may be integrated just as much with the Production Designer, Art Department, the Director of Photography, or Gaffer – not just with the VFX Supervisor. The Virtual Production Supervisor needs to build specific relationships with multiple key partners across a production, in both pre-production and on set on the day.

Partners in Pre-Production
The goal of the VP Supervisor during pre-production is to lay the groundwork for a successful shoot day. They need to accomplish specific goals with key partners.

DOI: 10.4324/9781003366515-4

The Director of Photography is perhaps the most important partner. The VP Supervisor needs to understand their visual goals so they are able to suggest how virtual production may help achieve those goals. They need to work with the DP to light the content that will be on the LED walls since it is an extension of the practical set that the DP will also be lighting. They also need to work with the DP on how that content lights talent and the practical set since it will be supplying the majority of lighting on the day.

Another key aspect of the prep partnership with the DP is making sure that the DP can get his/her shots. This comes with discussions of what parts of the virtual set might need to be dynamic, or operable on the day, or virtually wild (so they can be hidden). Or will something in the shoot plan be a challenge for camera tracking, such as occlusion in the set or an unusual camera head.

Second only to the DP, the key relationships in prep are with the Production Designer and Art Department. On the day, these partners need to stand in front of the virtual set and have it be just as much a part of their vision as the practical one. The VP Supervisor needs to understand the visual goals of the set design and, as the Art Department creates it, ensure that the virtual version extends it seamlessly. Since the content team frequently is not on site, the VP Supervisor is the point person to make sure their content blends seamlessly with the practical set. This may involve delivering feedback and notes to them, or if the shoot is close, having the on-set team make those changes themselves.

Less prominent but still key in prep is the relationship(s) with the Director(s). The VP Supervisor representing the shooting experience to the Director(s) and learning any specifics of their shooting style that may need to be accounted for. Another key relationship in prep is with the VFX Supervisor – establishing goals for finals and any notable aspects of the scene, for example, unusual frame rates or elements that may be added in post.

The First AD is key to getting the shooting days in order and making them successful. This may be one of the most important relations the VP Supervisor will have. The First AD is responsible for the schedule and the set logistics. Operations of the virtual production team are invisible to the AD department, and they count on the VP Supervisor for information on the timing of the operations. That key information flows both ways and timely information from the First AD can allow the VP Supervisor to give early warning on upcoming stage operations so the VP team is ready to roll.

On the Day

As the shooting day arrives, each of these relationships evolves.

If the pre-production relationship with the DP has done its job, the practical and virtual set should be seamlessly integrated and lit together generally before crew call on the shoot day. Now the relationship changes to focus on per-shot lighting and in-the-moment problem solving. The virtual light cards, nets, flags, and other tools will come into play as the DP and VP Supervisor work together (likely along with a colorist on the VP team) to shape the lighting per shot. As lenses are changed on the camera, the VP Supervisor will also relay that information to the Brain Bar. As

camera moves are finalized, there might be issues of content transformation affecting lighting or multiple frustums overlapping, that the VP Supervisor and DP will work together to resolve.

The Director will tend to be more of a present relationship on the day than they were in prep. Between the Director and the First AD, the VP Supervisor will gain a lot of early warning and information on how the shoot will proceed: How many takes are likely, how soon until the next roll, what the goals of a shot are, and other information that can be relayed to the Brain Bar for smoother operation, anticipating the production's needs. The Director will also sometimes have questions that a VP Supervisor can answer in a timely fashion without interrupting a member of the Brain Bar.

Lastly, the VFX Supervisor typically becomes a more prominent partner on the shoot day. The key conversation would be, "Are they getting final shots?" if not, "Are they getting what they need for post?"

The relationships a VP Supervisor forms can be a force multiplier for the whole VP team and guide the work they do to success.

How the VFX Team on a Virtual Production Show Interfaces With Other Departments
Patrick Tubach – Epic Games

The visual effects department plays an enhanced role on a virtual production show, particularly during pre-production. Many decisions that were historically pushed into post-production now require up-front answers to ensure a smooth shoot and consistent transition into post visual effects. The better informed the overall crew is about the vision for the volume and visual effects, the better the results.

In the early stages of script breakdown, the VFX Supervisor consults with the Production Designer and the Director to identify potential volume-appropriate scenes. The VFX Producer then works on the bidding and scheduling of content creation with the visual effects vendors. While the volume content is in progress, over many weeks or months before the shoot, the visual effects team provides works-in-progress to inform the heads of department who prepare the physical builds, props, stunts, and set pieces associated with each volume scene – single-use instances of which are also commonly referred to as "volume loads."

The VFX Supervisor helps the Production Designer and the Director understand the pros and cons of an LED wall for each load, including space requirements, interactivity, animated CG elements, stunts, special effects, and lighting. Effective volume loads are a collaboration between all departments. The best in-camera illusions come from having a physical set that transitions from the interior space of the volume to the LED wall, seamlessly blending color, texture,

25

and geometric complexity. Volume shoot days need to be planned with time for physical set transitions, pre-lights with the DP, and physical-to-virtual blending with the Virtual Production Supervisor.

Design decisions will be visualized by the Virtual Art Department (VAD), an extension of the traditional Art Department with an emphasis on CG visualization and prototyping. The Production Designer is the overall supervisor of the VAD, usually making a supervision handoff of volume content to the VFX Supervisor when the volume load reaches creative approval and needs final execution by the visual effects vendors. The Production Designer and VFX Supervisor will guide the Director and producers through the creative process, working in interactive creative sessions, often in virtual reality, to adjust the look and lighting of a scene.

The team needs to understand how the scene is blocked for action and how it will be used on the day of the shoot. Previs can help with this planning, and the more that visualization can use the work-in-progress volume loads, the greater the advantage. While previs and VAD efforts often happen simultaneously out of necessity, the VFX Supervisor should help advise the previs team on how shot design and composition can achieve the Director's goals, increasing the likelihood of acceptable in-camera results.

The volume motion capture team will also need to be given time to analyze construction plans and adjust the placement of tracking cameras for any enclosed parts of the set(s) that extend beyond the walls of the volume.

The most practical aspect to consider with the Art Director and construction is whether enough time is given for the build, the load-in and load-out, and blending of the set – both of which can be tricky in a space-constrained volume.

Set finishes and set decoration often need to be captured as photogrammetry before the volume content can be completed. Photogrammetry is used to build geometry and texture matches of set pieces that need digital counterparts in the virtual content. For example, if there is a stone pillar on the physical set that is meant to be seen repeating into the distance, therefore on the LED wall, the VAD will want to get a photogrammetry scan of the physical pillar to ensure accuracy of the virtual versions. Communication about deadlines is key to make sure the VAD team has enough lead time to incorporate the photogrammetry results.

Giving the costume department a preview of how the volume loads are shaping up is a good best practice – the limited color spectrum and soft light output by the wall will influence their fabric and color choices. When possible, shooting tests with costume samples in the volume is ideal.

Before any physical build begins, the VFX Supervisor, Production Designer, DP, and Director will want to discuss the overall look of the film as they collaborate in virtual scouting sessions.

The quality of the soft light given by the LED panels and how that impacts the final look must be considered. Any hard key lighting will need to come from practical sources. Care should be taken

to understand what parts of the content uses baked lighting vs. live lighting. Baked lighting is more performant but is harder to modify than live lighting because the light attributes and shadows are pre-rendered into the content.

The VFX Supervisor, Virtual Production Supervisor, DP, Gaffer, and DIT will creatively dial in the look of the volume through the camera to ensure that the physical and digital sets are blended. This might involve removing LED panels for additional physical light(s) to be placed in the ceiling or walls, providing light cards to cast or remove light from subjects, and validating choices made during the virtual scouts.

During the shoot, the DP will communicate to the volume team via the Virtual Production Supervisor when it comes to creating and moving light cards, on-set color correction, camera view priorities, and content adjustments. The VFX Supervisor will be there to weigh in and advise, as with any shoot. Content that is not satisfactory in-camera will fall to post-production visual effects to fix or replace. Adjustments might be made in the moment, including opting for a bluescreen backing on the LED wall as a last resort.

After the shoot, the VFX Supervisor and producer(s) will communicate the effect on post-production – increased or decreased visual effects shots to execute. The need for post-vis visual effects should be far less given that scenes that would typically have been green screens will be an in-camera final, or at a minimum, a rough comp to send to editorial. The VFX Supervisor will work with editorial and the Director to tag shots that need additional cleanup and then, if needed, communicate with the content team which backgrounds and cameras should be run as clean passes for visual effects vendors to use as elements in those shots.

Production Design for Virtual Production – What Has Changed, What Has Not?
Andrew Jones – ADG and Landis Fields – ILM

A Quick Definition of Virtual Production from the Art Department's Perspective

There have been several new technologies which have been working their way into the filmmaking process: previsualization, motion capture, digital asset management software, and photogrammetry, to name a few. Recently, a few technologies from the video game world have been introduced: real-time render engines, virtual reality goggles, and version control software. Rather than just attaching these methodologies to the traditional filmmaking model, some productions have started to take a holistic approach with these new technologies, creating what is referred to as virtual production.

It is not just the inclusion of new techniques; it has required a reconfiguring of the filmmaking process. One area where this has been particularly relevant is when a production is employing an LED volume to create camera-ready virtual content by combining real scenery, a virtual set extension, and immersive lighting. This process, while still in its infancy, requires a rethink of the front-end process. The need to have sets fully conceived, built, and lit (both physically and virtually) before the camera rolls has required moving work to the pre-production phase – fundamentally changing the decision-making dynamic.

In many ways, this is a return to an earlier form of filmmaking. They said of Alfred Hitchcock that, of all directors, he was probably least surprised by his dailies. He would meticulously plan and execute and get exactly the shots he desired. Likewise, a project employing virtual production tools and methodologies will have a clear plan before the cameras roll and create exactly the shots required.

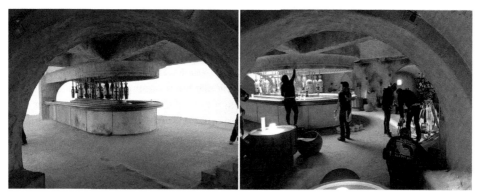

Figure 3.1 Left image: Cantina scenic build in LED volume with content turned off. Right image: Cantina scenic build in LED volume with content turned on
Source: (Image courtesy of Andrew Jones)

The Impact of Emerging Technologies on Production Design

The Virtual Art Department
The Production Designer defines a film's aesthetic and creates environments for the story to inhabit. This does not change by the adoption of virtual production methodologies. Nor does a production designer need to be fluent with this new technology. The process allows better iterative design, better collaboration, and greater efficiency for the production.

While art directors and set designers are readily adapting to these emerging technologies, there is still a need for an additional team in the Art Department referred to as the Virtual Art Department,

or VAD. This is a bit of a misnomer. This group can be thought of as a virtual construction department. Just as a physical construction department employs carpenters, sculptors, and scenic artists, the VAD has artists skilled with the digital equivalents (Maya, Unreal, Z-Brush, Substance Painter, etc.). The environments they create are used for scouting, previs, lighting studies, and in the case of a production employing an LED volume, the environments will become a virtual extension of the physical set placed in the volume. In practice, the VAD may rely on the Visual Effects Department to optimize and finalize their virtual environments to be "camera-ready." However, having this VAD team embedded in the Art Department is essential for the process to work. Traditional matte painters worked closely with the Art Department for the same reason – the whole set needs to be conceived and executed to a single vision – narratively, of course, but also practically.

Real-Time Design and World Building
Real-time render engines are well suited to world building. Created for open-world video games, they can apply global parameters, like atmospheric conditions and practical effects, to vast landscapes. They have mechanisms to apply dynamic level-of-detail (LOD) to geometry and textures, allowing extraordinary realism. Realistic lighting and shadows are now becoming dynamic and real-time. Not to mention the suite of game mechanics and emerging AI technologies.

Enhanced Inter-Departmental Collaboration
Another development borrowed from the game industry is the use of version control software. This allows scenes to be worked on and shared by multiple departments simultaneously in a non-destructive way, with sets advancing across all departments.

The Benefits of Shooting on an LED Volume
There are two main goals of shooting in the volume:

> The first goal is to create in-camera final shots. Inevitably there will be a discussion of the cost of employing an LED volume versus the cost of using traditional visual effects. But one can expect the technology to continue to get faster, cheaper, and better, with creative professionals finding new ways to employ the process.
> The second goal is to reduce the amount of physical build necessary – resulting in a time and money savings, as well as speeding up the build and strike of practical sets. The best results are achieved when there is a light physical set for the performers to interact with and helps create a blend between the real and the virtual worlds.

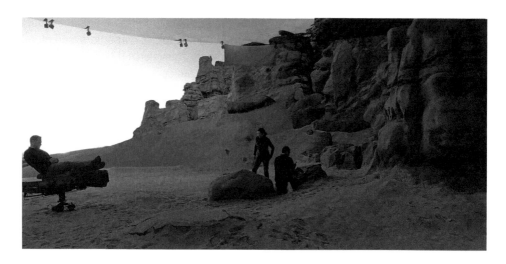

Figure 3.2 Outcropping scenic set piece in LED volume with content turned on
Source: (Image courtesy of Andrew Jones)

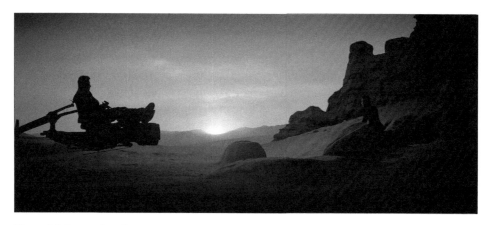

Figure 3.3 Outcropping plate

A Forward-Looking Trajectory

The technologies that support Virtual Production have come a long way, and they are receiving a great deal of development effort. It is fair to say that the technology will continue to improve their quality and capabilities as they are more widely adopted.

As software continues to get faster and better, it is also getting "smarter." The benefits that machine learning and artificial intelligence have had on the real-time creative process are staggering. Currently, one swaps in close-ups of any photo-real character in any plate and can do so on hours of footage and on the same day the footage was shot.

Natural language is now used to search through decades of existing untagged material to gather collections of resources consisting of varying data types that the AI identifies as items one may want to use together. This also allows us to interactively create new elements that never existed based on the results of that "deepsearch." Just as real-time workflows have injected efficiency into all phases of the storytelling process, from real-time design to real-time visual effects, the union of artificial intelligence with real-time is changing the way one creates.

As storytelling formats evolve, the flexibility and cross-platform capabilities of virtual production are well positioned to meet the needs and opportunities of these new developments.

4

How to Shoot and Edit Animation Using Live-Action Virtual Production

Adam Maier and Paul Fleschner – Reel FX
and Connor Murphy – The Third Floor

Introduction: The Creative Story Process

At its heart, this is a conversation about the creative story process itself. The use of real-time tools in animation enables the convergence – or intersection – of animation and live-action techniques. Many trailblazing films have led the way, from *Beowulf* (2007) to *The Adventures of Tintin* (2011), all before the advent of real-time technology as it exists at the time of this writing. Over the last decade, there have been significant advances in game engines' readiness for real-time (live) visualization on set and in camera and, in some cases, "final pixel" applications. Stylized hand-key animation can also be produced with this approach.

As real-time tools improve, their artistic and workflow benefits become impossible to ignore. The development of virtual production for animation, or "real-time animation," can be viewed as a new and complementary toolset for the animation professional. The framework of understanding also needs to integrate the impact of cinema's live-action heritage suddenly made available to the animation professional. This live-action mindset will not be right for all animated projects, and great content will continue to be made in the traditional way. Whatever the approach, the benefits of real-time are compelling enough for a deep investigation. Ultimately, the goal of animation is

DOI: 10.4324/9781003366515-5

Figure 4.1 *Super Giant Robot Brothers!* (2022) is an example of an animated series utilizing virtual production
Source: (Image courtesy of Netflix and Reel FX Animation)

telling a good story with nice pictures. Real-time animation offers a new road to that end, with some surprising benefits.

As the name implies, real-time animation accelerates the production process, which can lead to creative and/or cost savings. This acceleration does not equally impact every phase of production, but it does affect most and ripples through the entire production. There are three primary means from which this acceleration occurs:

- Immediacy of Visualization
- Increased Creative Iterations
- Making Creative Decisions in Context

The first (and the catalyst for the rest) is the immediacy of visualizing and/or rendering using a real-time renderer that renders frames in milliseconds, allowing artists to work without waiting, saving time and money. Final renders for an entire 22-minute episode of *Super Giant Robot Brothers!* (Reel FX/Netflix 2022) finished overnight on five workstations, as opposed to the traditional 500-node render farm. It is worth noting, however, that final frames can still be rendered with a traditional renderer. While real-time renderers cannot yet achieve the quality of an offline renderer,

they inch closer every day. Visualizing in real-time and translating those decisions to an offline renderer can become quite complex, and speed will be lost in later departments as they lose the real-time render speeds. Take all factors into consideration when choosing the final renderer.

The second acceleration is the reduction of the time between creative iterations. The underlying assumption is that more iteration will lead to a better story/product. It can be said that this rapid visual ideation provides a creative team with "more bites at the apple."

The third acceleration is improved context when making collaborative creative decisions. Teams can collaborate live and parallelize tasks with a real-time workflow. This saves time. Because renders are instantaneous, live "real-time" reviews are possible. Creative work that was previously accomplished asynchronously can now be realized simultaneously, and artists can react to one another. For example, camera work can interplay with performance during motion capture, or lighting and camera can interplay during the virtual camera phase. Decisions are made with more context up front, leading to fewer changes and surprises downstream.

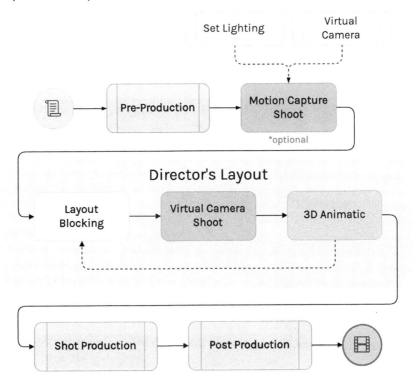

Real-Time Animation Story Workflow

Adapted from *Super Giant Robot Brothers!* workflow for 10x22 min episodes

Figure 4.2 *Super Giant Robot Brothers!* (2022) Real-Time Animation story workflow
Source: (Image courtesy of Reel FX Animation)

Chapter 4

Performance and Motion Capture for Animation

Different capture technologies balance precision and detail against budget and approachability. The challenge is to determine which technological layers will provide more benefit than cost. The flashiest technology might be needed by some, but even tried-and-true staples deserve a second look.

Timecode, genlock, hand data, facial capture, reference cameras, even props will add some amount of financial, logistical, and time cost. *Super Giant Robot Brothers!* (2022) used motion capture for creative story development and pacing, to record blocking for layout and as reference for animation (the final animation was hand-keyed). For those reasons, genlock, facial capture, and motion-edit were not needed, but virtual cameras and quality real-time visualization were crucial. For other productions this mix will differ. The technological approaches, and resulting pipeline, should support and improve the project without slowing it down.

Real-time rendering allows motion capture (mocap) actors to perform as wacky monsters or deliver more finessed emotional family moments. The Director and the performers see a near-final representation of their performance in real-time. The DP can adjust lighting right after the performance. Particle FX, dynamic materials, and extreme scale differences can be set up quickly as scenes evolve. For example, when the heroes needed to chase a four-mile-long bug through winding tunnels, a mix of high- and low-tech was needed. The tunnels were created as a long loop with actors riding along a digital path and reacting to a live view. The bug

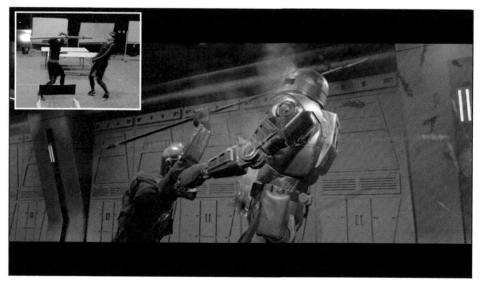

Figure 4.3 *The Mandalorian* (2019) utilizing motion capture
Source: (© Lucasfilm Ltd. All Rights Reserved and Courtesy of The Third Floor, Inc.)

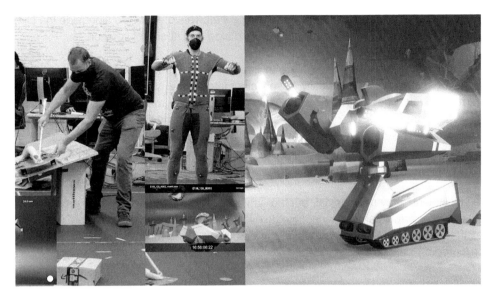

Figure 4.4 *Super Giant Robot Brothers!* (2022) utilizing motion capture
Source: (Image courtesy of Netflix and Reel FX Animation)

was a markered skateboard with a Swiffer-handle. The combination was intuitive and close enough to the final look for the performers to play off one another as they might in a traditional live-action scene.

Eyeline and blocking are discovered naturally or corrected on set on the day, rather than months later. With a few apple boxes and eyeline marks, children can argue with adults and multi-level command centers do not feel like a flat mocap stage. Days later, layout artists assemble the best takes to prep for the virtual camera, and an edit is available in weeks that includes initial lighting and tone. This helps animators and designers target their efforts to where they will be seen on screen. It encourages collaboration and dialogue. When stakeholders can view the project early, everyone is able to pull in the same direction.

Virtual Camera and Director's Layout

In filmmaking, the camera is the primary storytelling tool. It is quite literally the lens through which the story is told. Yet in digital animation, the ways to interact with cameras have been limited. The advent of the virtual camera (VCam) changes this and may be the most important new tool in the animation toolkit for this reason.

The team that drives the VCam process is called "Director's Layout" (DLO). A robust DLO team consists of operators – who drive the VCam and digital scene (think of them as the First AC, Gaffer, and Set Dresser); layout animators – who block in performance; camera artists – who animate

and refine cameras; and a coordinator – to wrangle it all. This crew works alongside the Director, Cinematographer, and Editorial, to foster creative dialog and speed of iteration.

A virtual camera simulates a film camera in its movement, its lens, and most importantly, the process and immediacy of physically based cinematography. VCam can lend a more human or cinematic touch, whether that be an organic handheld movement or a pristine dolly track. To emulate a film camera well, the details matter. Start by considering the source of inspiration – what makes a shot feel a certain way? As an example, a cinematographer could add a shoulder mount and weights to add stability and balance so the camera moves do not feel too light or handheld – mimicking the gravitas of film cameras.

These investments may seem trivial, but the audience will feel them in the final product. It is important to note a virtual camera cannot create every camera move easily. There are many stylized moves that are better animated by hand, such as those found in many anime productions that rely on incredibly precise timing and framing. Choose the camera method that best suits the shot.

Before shooting, it is important to prepare the set lighting and animation blocking. Lighting can be visualized and modified in-camera and passed to the lighting team. This means the camera can take light and shadow into account early, injecting tone into the animatic – avoiding late and costly lighting changes.

It is important to note that motion capture is not required to leverage a virtual camera workflow. Mocap can be used as a basis for layout blocking, but it can also be hand-keyed. In either case, layout blocking should always be done at the sequence level so that coverage can be shot similar to a live-action shoot. The difference between this and live action is that camera can be split from the performance. Once the best performances are captured and stitched together, the actors go home, and the camera team can shoot quickly and with great freedom (to a fault) on an infinitely repeatable virtual performance.

It is important to have characters and sets built (to a useful degree) prior to motion capture and virtual camera sessions. The up-front investment in assets unlocks the door to a new way of working and collaborating, with greater context, immediacy, and creative output. The virtual camera shoot process enables creative exploration, communication, and quick discovery of new camera compositions and ideas. It is also incredibly generative. If one is prepared, hundreds of cameras can be shot in one day. This speeds up iteration in layout, condensing the schedule. For this reason, build the pipeline to accommodate scalability – which is necessary across the entire process. The technology and the workflow allow the creative team to work at the speed of thought.

Creative Editorial

In addition to the immediate benefits of virtual camera sessions, their effect on editorial is an emergent phenomenon. What happens is more like live-action creative editorial. This is a process that embraces real-time discovery – on set and in the creative edit. This alchemy is not obvious because the craft of editing is often invisible. Using virtual production, it is now possible to bring

Figure 4.5 *Super Giant Robot Brothers!* (2022) utilizing virtual production (real-time animation) editorial workflow
Source: (Image courtesy of Netflix and Reel FX Animation)

this live-action mindset into the domain of animation editing. It can also dramatically accelerate the editorial timeline – not by shortening the process, but by changing it. Traditional animation uses storyboards to arrive at an animatic edit, but the advent of advanced virtual camera cinematography provides an alternative way to edit and construct a story.

Traditional 2D storyboarding has produced amazing feature-length results since *Snow White* (1937). However, story can be found in a different way when virtual cameras are used as the primary drivers of discovery. On *Super Giant Robot Brothers!* (2022) (a 220-minute animated series), 15,000 shots were recorded during virtual camera sessions, and the final count was approximately 5,000 shots – a 3:1 shooting ratio. In some ways, this show was as much a live-action production as an animation production. Storyboards can still inform the process as needed. The difference is working in the final medium (CG) much sooner because the creative translation to 3D happens up front.

On the same production, there were four days of mocap, four days of VCam, and four days of editorial per episode to arrive at an initial 3D animatic. These 12 days can be considered the live action "creative crucible" of each animated episode. From that, the cut is refined, and where applicable, the data can carry through when it is useful. Mocap data can be provided to animators as a head start on key-frame animation, or even just as 3D visual reference. This helps to establish the broad strokes of the character performance earlier, enabling animators to spend their time on the creative flourishes that make the shots stronger. More significantly, the director's intentionality

for each shot is expressed in the 3D animatic, so there is a reduction of guesswork, and animators can get to the finish line sooner.

This applies to lighting and effects as well. With real-time editorial, the story comes into focus more clearly and sooner. Music can even benefit from the process. Having 3D animatics in hand earlier in production allows the composer to begin work much sooner – gaining valuable time to better craft the score. Composer John Williams is quoted as preferring not to read scripts but instead to respond to the edit – the first moment in which the rhythm of the movie comes to life.[1] This is the goal of real-time animation: To bring content to life using actual footage from the virtual cameras, mocap, or reference footage, etc. Creative contributors, and ultimately the audience, can feel the difference and respond to this shift in energy.

Summary

There is a qualitative difference driven by the quantitative differences – with more shots sooner, filmmakers can "get to story faster." This has tremendous implications – imagine the ability to assess story points, comic bits, camera choices, and even the timing, speed, and pulse of the cut – all while the edit is still at a very formative stage. Beyond these efficiencies, virtual production for animation can also be a doorway for live-action directors to enter the world of animation – finding a hybrid workflow that allows them to bring themselves fully into the animation process. Whatever the application, this is not previs, it is director-driven filmmaking. The filmmaker is so embedded in this process that it allows a story to reveal its points of failure sooner rather than later. What is required more than technical know-how is an integrated mindset. The technology will continue to evolve, but the basic principle of combining the best practices of animation with the speed and fluidity of live action is the heart of the equation.

Note

1 "Normally, I try not to read scripts; I would rather sit down in a projection room and watch the film from start to finish without any talking – like an audience. I prefer to react to its rhythmic impulses and feel its kinetic thrusts." (John Williams on *Star Wars* – spring 1977, as quoted in *Star Wars: The Original Soundtrack Anthology*, 1993)

5

Visualization

What Is Storyvis

Mariana Acuña Acosta – Glassbox Technologies

Storyvis vs. Pitchvis

Pitchvis has been used for over 20 years. It is intertwined with previsualization, and it is used by directors or producers to quickly have a proxy version of a sequence or a scene of a script; this way it is easier to visualize the concept behind it and sell their IP to investors, studios, or stakeholders to have their projects green-lit or funded.

Storyvis is a newer term, where production designers, independent filmmakers, or writers use this form of 3D visualization to be able to craft a story. They may not use it for funding, the script may not even be finalized, but by being able to use newer technologies to construct part of the world and/or characters of the story they are building, it makes it easier to convey how the story would be constructed. It is also used as a teaser for stories with complex narratives, making it easier to understand where the theme of a story could go – for example, a "dream sequence."

3D Storyboards

Traditionally a storyboard is a graphic representation of a film, animation, advertising, or interactive project, displaying the sequence of events unfolding shot by shot. Once this is done, it is turned into an animatic, which is a rough version of the animation, composition, and timing with voice, pacing, etc. Both storyboards and animatics have been traditionally done in a 2D format. Using game engine technologies, one can potentially skip this process altogether

DOI: 10.4324/9781003366515-6

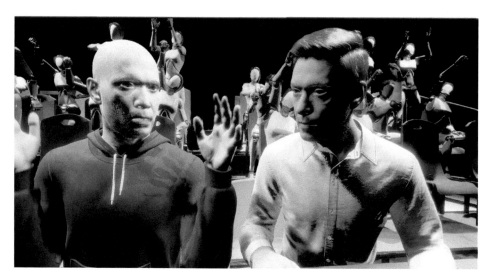

Figure 5.1 MetaHumans in "Thrown"
Source: (Image courtesy of Maya Singer)

and go straight into building a 3D storyboard. Younger generations of content creators that are used to working this way opt for simply putting together a master sequence, kitbashing characters and environments, motion capture or animation clips, adding cameras, and even physics, and they can use the camera views and the game engine timeline to take screenshots and export out image sequences or videos. This reduces not only iteration time but also creates 3D storyboards/animatics that are already lit, with effects, simulations, audio tracks, or sound effects. There are tools available that extend these capabilities to 2D storyboard artists, making it easier to transition, such as the plug-in Epos[1] for Unreal Engine. A storyboard artist does not need to know how to use Unreal to take advantage of the 2D and 3D offerings of the technology.

Interactive Workflows

The creative process is not as linear as it used to be. Storyboarding, look development, environments, and concept art can now happen at the same time, using a much more dynamic process. The beauty of incorporating real-time workflows into the pre-production, design, creation, and production processes is the ability to reinvent, reimagine, and reassess the process of linear content creation. Reducing iteration times, co-creating, collaborating, and being able to quickly use a game engine as a "playground" for interactive design have been key drivers for adoption, as well as having the ability to have a more agile and less of a waterfall model.

Linear Content

Stories transfer information, an experience, or a point of view. Stories have a beginning, a middle, and an end. Stories have a teller and an audience. The way stories are told, produced, consumed, and distributed has significantly changed over the past decade. There is immersive storytelling

in virtual reality, Roblox YouTube channels, VTubers, Tiktokers, video game streamers, branching narratives, the Metaverse, etc. The technologies that enable us to view content in different platforms, the format, and how viewers can interact with the content are in constant flux. Gone are the days when newspapers, TV, cinemas, theaters, and radio were the only means of connecting with an audience. It is only natural for the workflows on how humans create stories to evolve alongside filmmaking, which have not evolved much in the past century; however, the technology used on set has. LED walls and ICVFX (In-Camera Visual Effects) are part of that evolution, as are Augmented Reality, Virtual Reality, Volumetric Capture, etc.

How Is It Used in the Early Development Stages?

Action-heavy movies like *Mad Max: Fury Road* (2015)*, Ghost in the Shell* (2017), and *The Suicide Squad* (2021) have taken advantage of the game engine to generate their action scenes before principal photography, making it easier to plan out the stunts. Tribeca Film Festival in 2021 alongside Epic Games put together a "Writing in Unreal Program" for independent filmmakers, in which the writers could work on an excerpt from a script where they were able to see story flow and do shot revisions on the fly. Directors and cinematographers can work together to develop the desired cinematic language earlier on. By using game engines to do storyvis at the very early stages of development, guesswork can be removed, making it easier for departments and teams to work towards a shared vision.

Tools and Techniques

There are two game engines used in the industry and a myriad of different plugins and toolsets that have been developed for both. Unity is an engine that can be used to create 3D and 2D games, interactive simulations, and other experiences. Unreal Engine is a whole suite of creation tools for game development, architectural visualization, automotive, training and simulations, film and television content creation, broadcast, live events, and other real-time applications. Both engines have been adopted outside of video games, and are even used in construction, real-state, and the United States Armed Forces. Some notable tools that have been developed for Unity are Marmoset's toolbag,[2] a GPU-based real-time rendering, animation and texture baking suite, used to do quick models and mockups of sets, MiddleVR,[3] a Unity plug-in that does multi-display, stereoscopy, cluster rendering as well as VR systems such as walls, and CAVEs. For Unreal Engine, there is Iliad,[4] a plug-in designed to paint on textures and create 2D animations, Ozone by Kitestring,[5] a plug-in that enables character deformations in real-time, designed to enable more interesting and unique deformations. Cine Tracer,[6] a real-time cinematography simulator that gives the user control of real-world-based cameras and lights to visualize scenes and make storyboards. A lot of these tools are designed to bring 2D artists into a 3D system without feeling overwhelmed and to give them an environment that feels familiar, intuitive, and comfortable for them.

Cinematics

Game cinematics are very popular as they are short films with a high level of production and are not meant to be interactive. Their purpose is to attract new and existing players. Storyvis has been used for game cinematics for quite a long time since games have been made using

Figure 5.2 Like Demo – Created by Kitestring, Inc. with the technology from Ozone Rig Studio
Source: (Image courtesy of Kitestring & Epic Games)

game engines. Filmmakers and content creators adopting tools, workflows, and techniques from the game industry will continue to increase, as ultimately high-quality images that drive a story forward is what cinematography is all about – composition, lighting, cameras, lensing, camera angles, effects, etc. All of these can be done in real-time to provide an approximation of what a story will look and feel.

Animation

2D animation can feel more fluid, often reflecting an artist's style and flow. But traditional animation pipelines are very linear, taking years to complete a project, and 3D animation requires massive computational power and a lot of rendering time. By using storyvis alongside game engines, efficiencies in the animation process can be created; directors can iterate and experiment without disrupting traditional workflows. The diversity of styles and lighting options, supported by mocap libraries, and being able to visualize groom and fur instead of having to work with proxies speeds up collaboration without the need for big render farms and long render and wait times.

VCAM Use in Storyvis

Virtual cameras add functionality or behaviors to the camera tools that already exist in the game engines, giving an extra layer of control to the cameras in a project. Virtual cameras are not necessary during the very early stages or when doing storyvis, but they can be extremely useful. After putting together a quick layout, if a director, writer, or cinematographer wants to throw a sequence together to quickly start recording, playing back and reviewing how the

different physically accurate cameras, lenses, and lighting behave for framing and staging, or to see how a script change would affect the look and feel of the story, using a virtual camera would be a very agile way to do so. Using a virtual camera at the early stages could help creators review how long movements on larger environments could work, can allow for experimentation with platforming on animated assets for aerial POVs, or can provide the opportunity to try out a handheld camera move to assess if it will help the story development, saving precious time later on.

Story visualization is simply a creative sandbox, a digital playground, a place to experiment with ways to bring ideas to life, if a character or location is working, if a story change could benefit the final product and even check if the original idea works as intended while going from script to screen faster.

Previs/Mocap Pipeline and Flowchart

Brian Pohl – Epic Games

Over the past decade the previsualization community has provided the media and entertainment industries with a robust collection of different previs sub-types for specific filmmaking use cases. With the advent of real-time technologies, one can see an evolution of these sub-types to accommodate an even more live-action-oriented and real-time creation process.

Traditionally, the previs process is a keyframe-based, animation-centric workflow that occasionally implements performance capture to realize the visualization of the Director's story. When combined with the editorial department, previs can accommodate most ad-hoc, non-pipeline-compliant production workflows with little effort. However, the process can be time-consuming – especially when waiting on animators to keyframe shots and then for the editorial department to integrate them into a potential sequence. Directors can wait for days to see the potential results in context. There is also limited compatibility between the assets and scenes generated during the previs process and the actual shot that enters into a final visual effects or animation pipeline. As a result, work is usually duplicated or reconstructed at the final post-production facility. This is an unfortunate symptom of trying to adhere to a "fix-it-in-post" mentality where the production emphasis is placed towards the back end of post-production rather than properly planning in pre-production. If studios properly leverage the pre-production process with focused intent, then a number of creative possibilities and discoveries can take place. This is the paradigm shift that all studios should work towards.

Traditional rough and final layout departments can potentially stand in as a more accurate form of previs. However, these departments' work is always conducted later in the production timeline than previs and within an existing and more restrictive animation/visual effects compliant pipeline. Thus, layout ensures technical compatibility while preserving accuracy but all at the cost of speed and early production accessibility.

With the use of real-time game engines, there are three primary problems that are overcome:

- Speed, interactivity, and iterability are greatly enhanced, which is essential for good previs.
- The assets used within a game engine are typically higher in quality, real-world accurate, and are eligible for use as final pixel assets (when rendering in the engine).
- Integration with performance capture and camera tracking solutions is greatly improved.

This fusion of benefits opens the door for all principal creatives (like the Production Designer, Cinematographer, and Director) to directly participate in the process where the end product directly feeds into the production pipeline. Many within the industry refer to this way of working as "1st Unit Previs." Essentially game engine technology is allowing the evolution of previs to support a more live-action shooting paradigm.

Earlier incarnations of this type of on-set previs are found within the production process of several pioneering films like *Polar Express* (2004), *Tin Tin* (2011), *Jungle Book* (2016), and *The Lion King* (2019). But most prominently it was on the movie *Avatar* (2009) where MotionBuilder animation was combined with 3D tracked cameras to produce hybridized CG/live action images through Simulcam. Compared to the lumbering speed found in traditional keyframed previs, the *Avatar* (2009) process was a profound improvement, but it was complicated by proprietary technologies and large production costs. Thankfully, more modern previs improves upon the *Avatar* (2009) process by using lower cost and democratized technology to dramatically enhance visual fidelity of the rendered image and by introducing virtual set scouting capabilities to benefit the Production Designer and members of the Art Department. Directors are then able to respond to live mocap actors and their virtual characters in the context of the Art Department's approved scene, and cinematographers can better determine camera placement and lighting solutions while simultaneously receiving instantaneous visual feedback. Cost savings can then occur through the reduction in time involved during the revision and rendering process. The quality of assets generated during modern previs can be directly utilized within an ICVFX volume or traditional post-production environment. This is particularly true when the previs team is properly paired with a production designer and his or her art department and VAD team.

To achieve this new level of production integration, modern previs must strive for production readiness while also being capable of sharing data with traditional toolsets. Previs constructed with Unreal Engine accomplishes this through the following:

1. Providing enhanced streaming protocols, such as LiveLink, to stream data directly into the engine from various mocap volumes, suit vendors, camera/lens manufacturers, iPhones, iPads, and traditional DCC applications like MotionBuilder and Maya.
2. Leveraging a new animation framework within Unreal Engine to build animation-capable control rigs supplemented by game engine physics, key frame, and attribute recording through Take Recorder and being able to manipulate mocap animation data, lighting, and camera placements interactively through Sequencer.
3. Supplying a large digital backlot of assets from Quixel, Sketchfab, and the Unreal Engine Marketplace; robust ingestion libraries that support CAD, Alembic, and USD file formats; motion capture libraries; and procedurally generated, animation-ready MetaHumans.

From a workflow perspective, a modern previs pipeline ultimately deconstructs the older silo-based approach found in classic linear content creation pipelines. As a "microcosm" of the entire filmmaking process, modern previs must reflect a parallel effort across multiple departments for improved efficiency and early production and post-production compatibility.

To begin with, the story department and/or storyboard artists can leverage Unreal Engine (and specialized plugins such as EPOS and Iliad by Praxinos or Narrative Dynamics Inc's Monomyth) to create dynamic 2D-assisted story reels, or 3D AI blocked shots, in engines that are directly tied into Sequencer (Unreal's non-linear editing and animation tool). This process then directly informs two primary groups: Those who are constructing the scene assembly during the modeling, rigging, and surfacing phase, and the performance capture team, who with the Director, will capture fat mocap takes into an initial rough layout or blocking assembly. This first assembly in Sequencer concentrates on capturing the necessary footage that will eventually be refined and properly reindexed into potential shots that define the various sequences and conform to the necessary levels, sub-levels, or world partition maps needed for better scene organization.

Realtime Previs / Animation Studio Pipeline

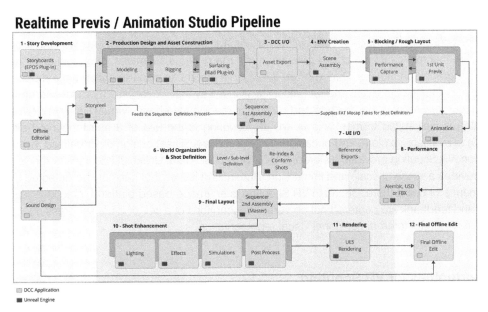

Figure 5.3 Color-coded flowchart depicting where Unreal Engine integrates into the various stages and departments of the previs and animation studio pipeline
Source: (Image courtesy of Epic Games)

Users can then choose to address the animation portion of the pipeline, either through refining the existing performance capture data (animating in engine with control rig) or exporting portions of the scene assembly, and its associated performance capture, to external DCCs to animate characters based on that capture and its intended blocking. These animated shots, if constructed in third party DCCs, are imported back into Unreal Engine and placed into Sequencer to inform shots and sequences now residing in the second or final assembly that is compliant with the studio's defined pipeline, level sequence/sub-scene track structure, and its naming conventions. From there the shot will enter various refinement stages depending on the needs of the production,

which include lighting, effects, simulations, and post processing, before being rendered through Unreal's render manager and on to final editorial.

Ultimately, the goal of modern previs should be to allow the director and his/her staff to adequately visualize the contents of the script without compromising technical compatibility down the rest of the production pipeline. By using game engine technology, paired with performance and camera capture, directors finally have a complete toolset that allows them to previsualize storyflow without the worry of losing their creative intent.

VR Scouting
Johnson Thomasson – The Third Floor

Effective Preparation for Virtual Production
A successful virtual production shoot is the culmination of multiple departments working together to ensure that the virtual world and physical world marry into a seamless, photoreal environment for photography on the day. During prep, it is critical that these departments have a medium by which to communicate visual and technical ideas in a way that leaves little room for interpretation and accurately reflects the designs and decisions made beforehand. Virtual Reality (VR)–based scouting is well-suited to meet this need. VR Scouting is the use of a head-mounted display (HMD) to evaluate, explore, and occasionally live-modify a 3D set design or virtualized real-world location. VR Scouting provides a stereo, 6-DOF view of 3D data. Unlike 2D designs or renderings, VR provides a sense of scale and immersion, illuminating issues that can only be detected by the experience of being there. Because VR Scouting is an image-based platform, reactions, discussion, and feedback are centered not on verbal descriptions of a set, or bit of set dressing, but on a scale-accurate, three-dimensional visual representation.

Opportunities for VR Scouting
VR Scouting virtualizes or simulates the established processes of Location Scouting, that is, the evaluation of possible sites for filming, and its more focused cousin, the Tech Scout. The concerns of a tech scout are varied, but most, if not all, can be served in VR. Whether it is consideration of camera angles, timing and direction of natural light, size and position of green screens, or location of craft services, all can be effectively explored and discussed in VR. The effectiveness is somewhat proportional to the quality and accuracy of the digital representation of the location. Digitally capturing a location for VR Scouting, typically by a combination of LIDAR and Photogrammetry, is beyond the scope of this section, but suffice it to say, if the location is remote, the resources required for the digital capture are significantly less than the resources required to send a full team to scout in person.

VR Scouting also facilitates the review of set designs which may be intended for construction on location or on a soundstage. Regarding virtual production on LED Volumes, a top priority in prep

is identifying which set elements compose the foreground, and therefore need to be physically constructed, and which fall into the digitally rendered background. VR Scouting tools can be tuned to aid with this, allowing tagging and color-coding of objects or demarcation based on a model of the LED volume.

VR Scouting Session: An Example

Consider this example session. There are dozens of variables involved in the makeup of an individual session. This is a common one. (The host department for a VR Scout could be one of several, so for simplicity, the term "Content Team" will be used.)

Participants

In this session, several heads of department will be reviewing a first version of a set design in VR. They are familiar with the scenes that take place on the set, and they all have seen early concept art.

The session is hosted by the content team Technical Director (the TD), who is responsible for ensuring the content is ready and synced across machines and providing tech support throughout, and the content team Art Lead, who will receive artistic notes and attempt to address them live. Neither the TD nor Art Lead will wear an HMD; they will operate machines with a traditional keyboard and mouse. In this example, three department heads will wear headsets and participate in the scout: The VFX Supervisor, the Director of Photography, and the Production Designer. Each is accompanied by a coordinator who will record notes and action items.

Hardware/Network

Four desktop workstations, equipped with high-end gaming GPUs, are connected via a high-speed LAN. Three of the machines will serve graphics to the HMDs. The fourth machine will be used by the Art Lead to address notes on the content live. Each participant will have one or two wireless handheld controllers by which they will travel through the virtual environment and make use of the scouting tools.

Collaborative Editing

At the core of this session is a multiuser system that tracks changes to the content and syncs them to the other machines. There are multiple examples of collaborative editing systems from different providers, including Unreal Engine's native multiuser editing, NVidia's Omniverse, and Glassbox's BeeHive. A record of these changes is recorded so that after the session, not only can the final state of the environment be revisited or exported, but so can any intermediate state as well.

The Session

Over the course of this session, discussion arises around the vantage point of the establishing shot. Can it be executed in the volume or is it so wide that it requires full CG along with digital

doubles? As blocked, it will certainly be too wide, but the DP quickly finds two alternate angles with the virtual viewfinder and captures them to later present to the Director.

The DP requests that the key light be rotated 45 degrees. The Art Lead responds that its current position is physically accurate to the real-world location, to which the DP responds that mood should take precedence over geographic accuracy in this scene. The lighting is revised.

The VFX Supervisor and the Production Designer consider a set piece that currently crosses over from the physical build to the digital. The VFX Supervisor is concerned about the visual transition, and the Production Designer is concerned about the workload the construction department is already facing. The Art Lead roughs in an adjusted layout of the set piece, and all parties agree it is a solid alternative. Its new position is saved.

After the session, the TD and Art Lead ensure all changes are saved, notes and media are distributed, and follow-up tasks are assigned.

Note that a variation of this session can be accomplished over the web with all parties remote. The key is establishing a fast VPN connection between all machines. Modern mesh VPNs are a good option for this. A virtual meeting solution (Zoom, Evercast, Google Meets) will be needed in parallel to support video and audio communication.

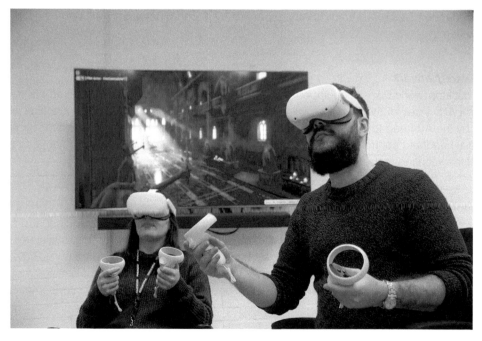

Figure 5.4 Multiple users in a collaborative VR Scouting session
Source: (Image courtesy of The Third Floor, Inc.)

Tools of VR Scouting

The standard toolset of a VR Scout is well established at this point. This section will cover the common tools. Most, if not all, of these tools are accessed via handheld controllers. Because no two productions are alike, VR Scouting systems should be built with the flexibility to quickly prototype and incorporate new tools.

Locomotion

VR users need a way to travel around the virtual world. The most common way is *teleportation*. To teleport the user aims a virtual pointer at a point in the distance, and when they click, their "presence" and point of view is instantly transferred to the new location. In some control schemes, the user also can *fly* by holding a button and pointing in the desired direction. Motion-sensitive users may find this mode nauseating as the eyes are experiencing a sensation of movement that is not felt in the rest of the body. Flying can offer unexpected aerial views and a chance to discover new perspectives.

Virtual Camera

VR provides users with new perspectives on environments and sets. The *Virtual Camera* tool allows them to capture these points of view. The virtual camera is represented in the virtual world as a rectangular viewfinder attached to the handheld controller. The user can take snapshots of the view. Snapshots are recorded with camera and lens metadata, including sensor size, focal length, f/stop, and so on. Capturing video is less common because of the performance challenge of writing a continuous stream to disk while also rendering VR. It is worth noting that while virtual camera images may be used to communicate aesthetic ideas, they can also showcase logistical concerns or capture an important measurement.

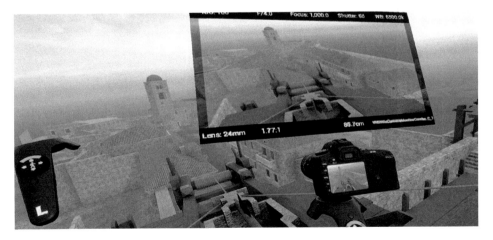

Figure 5.5 An example of a virtual camera in a VR Scout
Source: (Image courtesy of The Third Floor, Inc.)

Measurements/Annotations

The accurate representation of scale is one of the chief benefits of VR. Users can respond to the feeling of the space around them. A standard VR toolset includes *measurement* tools. One mechanic for measuring the space is to define start and end points to see the measured space between; another is for the user to measure from their hand to something. These modes can be triggered with different buttons on the handheld controller. Users are also able to draw or place 3D *annotations* in space. These could serve the function of tags, reminders to make a change later, or rough sketches of a new shape or alteration to an existing set piece.

Outputs

A VR Scouting session should generate a number of outputs that will afterward be distributed to communicate the decisions made. *Notes* are freighted with metadata associating them to a time and location. *Images* and *video* carry metadata about the virtual camera used to capture them. Along with images and video, the *cameras* and *annotations* should be exported in a common digital format (.fbx,. usd). The modified virtual environment itself is an output of the session. Sometimes modifications will be made in a temporary way to suggest an edit, but that edit will need to be reproduced properly after the session.

Other Considerations

VR Scouting presents tension in terms of content optimization. Because the content is work-in-progress, it would be premature to spend time optimizing it for runtime performance. However, VR has incredibly high demands for real-time rendering, so some optimization is almost always necessary to use the medium at all. Any team hosting VR scouts should aim for a level of performance that avoids nausea in users and facilitates a productive review without consuming too much labor in the optimization process.

VCAM – Virtual Camera System Used During Prep

Mariana Acuña Acosta Glassbox Technologies

What Is a Virtual Camera (VCAM)?

A Virtual Camera, or "VCam," is software created for use in virtual production. The software receives input data streams and uses them to drive an optical camera simulation. It can be operated using devices such as iPads, iPhones, game controllers, or using professional motion tracking systems such as OptiTrack or Vicon. A virtual camera's functionality can be extended, but not limited to, recording, playback, naming, metadata striping, heads-up information display, physical camera equipment simulation, platforming, slow motion, scaling, smoothing, rendering, and

exporting shots and takes. VCam allows the user to view the computer-generated environment rendered in real-time through a number of mediums, including the camera view finder, LCD displays, virtual reality headsets, and other devices.

DragonFly

DragonFly is a plug and play virtual camera solution for Unreal Engine and Maya, allowing DPs, virtual cinematographers, and VCam operators to visualize, record, and edit camera moves. It is also a tool for file and footage management, and DragonFly includes a Simulcam mode to preview computer-generated and live performances through real-time compositing of Game Engine scenes combined with live-action media plates. It also allows a one-step time code and Genlock setup – which is especially important when dealing with performance capture. DragonFly includes physical lens and exposure simulations that accurately reproduce real-world cameras and lenses. This includes anamorphic lenses, ISO, shutter speed, frame rate, ND filter strength, and aperture, all rendered directly into the game engine's viewport. DragonFly integrates with most motion tracking systems.

How to Use a VCAM

A VCam can be used by previsualization teams to do layout and camera blocking to visualize a scene. It can be used to visualize complex performances by stunt teams to recreate complex sequences before shooting principal photography. It is also used for on-set visualization or to shoot virtual camera during motion capture sessions, tech-viz for motion control setup, remote VR scene scouting for asset reviews, virtual sets and environments (like a physical location scout). How a VCam is used will depend on the complexity of the shoot and the type of VCam selected for the

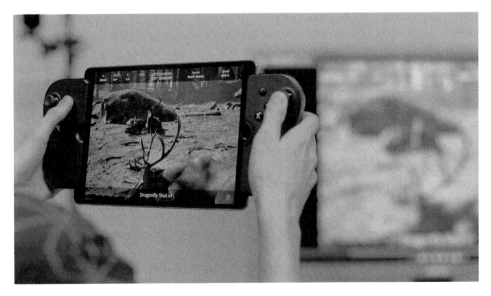

Figure 5.6 DragonFly Virtual Camera with a gamevice controller
Source: (Image courtesy of Glassbox Inc.)

project. The VCam's viewport will have a panel that will act as the viewfinder by displaying the scene from the camera's point of view. It will also display lens, camera back and focus settings. It records and has playback capabilities. Depending on the VCam used, the sequence controls and settings may differ. It will also depend on how it will be used on set, for example, if one will be using an iPad with its companion app, or if the VCam will be attached to a physical object with a tracking marker (such as a sputnik to a real-world crane or tripod).

Joystick Bindings and Controls

Input devices like joysticks or gamepad can be configured to control the VCam's behavior. On-screen controls are available on certain types of VCams through an iOS app or iPad controller accessory. Integrating a controller into a VCam workflow allows virtual cinematographers, directors, production designers, and supervisors to move the virtual camera over large distances or introduce additional movement while recording, like a dolly or a crane. (This integration is not a substitute for controlling the movement of a virtual camera with motion tracking and does not control the camera's facing direction.) Joystick movement will usually be controlled by a second operator – this type of input can only be used with a single operator if attached to an iPad or viewport rig.

Motion Tracking Systems

Since a virtual camera allows for recreation of a real-world physical camera in virtual production, it is best accomplished by using a motion capture stage setup. There are several options:

1. The Vive Tracker is a compact module that allows multi-cam tracking for up to three cameras. It uses the latest Vive Tracker for better accuracy. It has automated calibration for camera offsets and lens distortion, reduced latency, and allows filmmakers to change depth of field as they would on a traditional camera.
2. ARKit integration allows users to connect an iOS device using a VCam iOS app. This is the simplest way to set up camera movement for a VCam, and while it may not be the most accurate, it allows virtual cinematographers to work without additional technology or the use of a motion capture stage.
3. OptiTrack is an optical motion capture system that allows the use of a rigid body stream.[7] It uses Motive to drive the position and orientation of the VCam. Vicon is the preferred motion capture system by various studios in the industry, such as ILM. Vicon's flagship "Shogun"[8] biped solver has comprehensive support for Unreal Engine and has a free LiveLink[9] plug-in. If the user is running Shogun, the camera will be tracked as a prop, and the data can be read from the engine, which means the user can plug that into a VCam via an interface.
4. Mo-Sys StarTracker is an optical solution that looks for reflective stickers that can be applied to a ceiling. This allows the StarTracker to know the position and orientation of a camera in real-time and render it into engine.

How Is VCam Used in Pre-Production?

VCams can be used by the virtual art departments as well as layout teams. These teams do the world building and scanning, turning storyboards and animatics into 3D environments. They will

help decide the virtual camera language of the project by blocking shots simulating what would happen on set. They can easily hand off stored camera setups (Snapshots) for individual shots to the previsualization teams so they can continue working on more technical solutions as well as putting together different sequences.

Virtual Scouting and Layout

Virtual Scouting is doing a walk-through of a computer-generated set to determine where the action should happen, potential camera positions, and to decide if set design is working. It gives the ability to review the work done by layout. By using a VCam, the Supervisor or Production Designer can give direction or notes to Layout while doing the Virtual Scout, and new cameras can be positioned or tested. A VCam can use the movement from moving actors inside of the engine (Platforming) or go to previously saved locations via Snapshots or using a home position feature if dealing with large-scale virtual environments.

Previsualization

Previs blocking and layout are always part of the process. The previs team will be working on a master sequence, placing cameras at different angles or changing lenses. A virtual camera stores Snapshots (saved camera setups). This way teams can very quickly and easily generate multiple takes of the same shot and compare preferred versions.

Lens Simulation

DPs and directors need to be able to be as creative as they would on a live action set. With a VCam, they are free to experiment with lens characteristics, including FIZ, anamorphic squeeze, and lens distortion. If using DragonFly, it will recreate the look and field of view of specific real-world lenses beyond the game engine's default by applying physically realistic lens distortion and lens breathing – this way they can quickly understand how different shots work together by handing off real-time rendered video files for proxy editing.

Physical Cameras vs. Virtual Cameras

A virtual camera will try to recreate a physical camera as accurately as possible. It will allow two separate exposure modes: Default, that allows for quick work with consistent results; or physical simulation, that correctly takes any relevant lens characteristics like ISO, Iris, ND, etc. into account to create realistic exposure and allow for creative choices. Virtual production supervisors will benefit from a director of photography's knowledge on virtual cameras as shots created with a VCam come with robust and easily digestible metadata, as well as an integrated shot rating system to save time and decide on good or bad takes even before exporting.

Virtual Sets

The Virtual Art Department (VAD) creates and optimizes environments in engine that may be used for an LED Volume ICVFX, previs, mocap shoots, virtual scouts, scanning, and other use cases. The VAD can help decide what assets will be practical and which will be digital. They can also

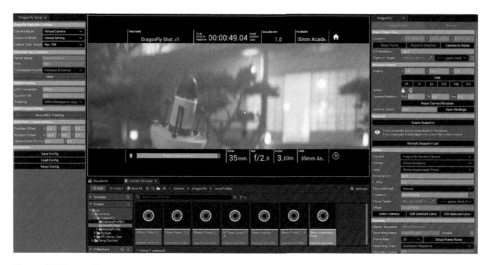

Figure 5.7 DragonFly 3.0 true-to-life camera simulation
Source: (Image courtesy of Glassbox Inc.)

help a DP pre-light with proxy environments. In this same fashion, a DP or supervisor can do camera prep, or a pre-shoot by using a VCam to figure out the best lookdev, lighting, and what assets or environments will need revisions.

Techvis

Virtual Production Supervisors, or Previs Supervisors, can create high-quality techvis sheets since any shot recorded in DragonFly includes critical metadata about all camera settings and position that can be easily exported in multiple standard formats. This can help the VAD understand the layout for the scene.

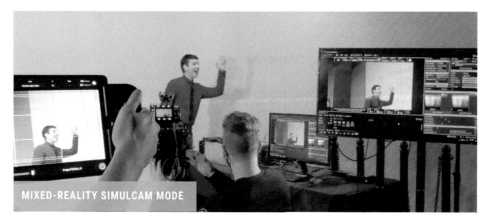

MIXED-REALITY SIMULCAM MODE

Figure 5.8 DragonFly 3.0 Simulcam mode
Source: (Image courtesy of Glassbox Inc.)

On-Set Visualization

A VCam can be used solely in-engine or as a mixed reality Simulcam solution, combining live-action media plates and turning the engine scene into a virtual set extension or even a three-layer comp. One can avoid artifacts from areas outside the green screen or wide lenses through DragonFly's pre-configured garbage matte setup and can be recorded through the viewport while doing the real-time composite.

Motion Capture Shoots

Similarly, a VCam can be used solely to do virtual camera shoots for performance capture. This way the virtual characters performances and motion edits can be done in tandem, as well as doing character reviews or tests.

Virtual cameras are widely used for previs, techvis, mocap shoots, and remote virtual scouting. VCams give the flexibility and accessibility for storytellers to iterate faster and visualize performances. Game engines and motion-tracking technology, combined with consumer electronics, will continue to help shape real-time virtual production workflows and virtual cinematography.

Techvis and Motion Control Techvis

Casey Schatz – The Third Floor

What Is Techvis?

Techvis is a branch of previsualization that enables detailed planning and execution of a shoot. It is a highly collaborative discipline coalescing visual effects and other live-action departments to create a road map for the principal photography. This migrating from the digital world to the real one emphasizes the collaborative nature of filmmaking. Each department needs to be represented. Techvis integrates the various ideas and concerns and puts together a cohesive shooting plan. From there, collectively, one practices the shoot before the shoot. When the energy is invested up front, a demanding shoot can be executed very efficiently.

Techvis can assist with other production realities like scheduling and budget. Working with the ADs is a particularly important relationship to establish. The AD has the enormous responsibility of making sure the shoot gets done efficiently, effectively, and safely. Utilizing techvis, the day's work can be economized and the most efficient shooting order discovered. Clustering shots by shooting technique, camera platform, key light direction, and whether a stunt double can be utilized are just some of the examples where techvis can help production plan the day and meet a tight deadline. Techvis can even show that an ambitious sequence is more possible than previously thought. This is applicable to more than scenes that are visual effects centric

and, ideally, can prove that a shot is possible to get in camera. LIDAR and Photogrammetry are becoming much more accessible, making it even easier to rehearse the shoot in an exact representation of the environment and the intended gear. It is possible to even include an accurate representation of the sun's path so the time of day can be informed. What might be most efficient geometrically might not be the most efficient for other considerations like actor availability and costume changes. Being able to roll with these changes solidifies techvis and helps visual effects and the production as a whole.

Techvis is usually communicated through diagrams analogous to architectural schematics. The level of detail can be anywhere from a general guide of camera and subject positions to a very precise layout of equipment and talent, where motion control is involved and/or one is matching a previously shot plate. On these more involved shoots, the techvis artist will usually place tape marks and other guidelines on set ahead of time.

Guidelines for Presentation

Measurements must be clean and easily replicated on set:

1. Use right triangles or lines triangulated to existing set architecture.
2. Adhere to architectural guidelines when employing empirical measurements (e.g., 5'4" instead of 5.333333 feet).
3. Depending on location, see if the crew prefers metric or imperial units.

Shot name, focal length, subject distance, total travel of moving elements, camera height and tilt are common pieces of information that should be represented consistently. Whether an interior or exterior shot, a compass rose, or other directional indicator will help orient the viewer.

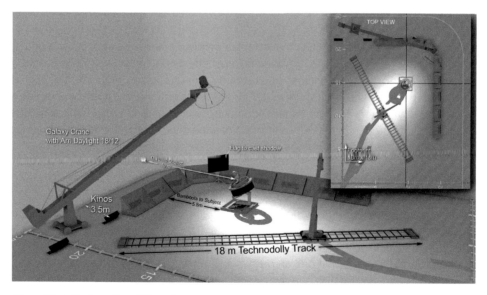

Figure 5.9 Setup for a shot of Watney's character tumbling through space, *The Martian* (2015)
Source: (Copyright 20th Century Fox and Image courtesy of The Third Floor, Inc.)

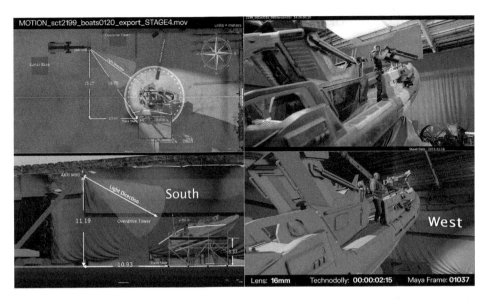

Figure 5.10 Quicktime showing what the live camera will see, the image from camera, and the measurements required on set, *Avatar: The Way of Water* (2022)
Source: (© 2022 20th Century Studios and Image courtesy of The Third Floor, Inc.)

Movie files are an excellent resource and are typically a quad view showing the intended final product, the plate against blue or green, the CG element, and a perspective view of the shoot. It is also common to be on set with the 3D scene open and answer questions on the spot.

What Is Motion Control Techvis?

Motion control is an addition to techvis where data is being exported to drive real-world equipment. Of utmost importance are the safety factors inherent in moving heavy machinery. Working closely with the AD to ensure a safe shoot is imperative.

Common uses for motion control include the following:

- *Repeat Passes:* This could be for tiling a small group to look like a crowd, for shooting dangerous elements like fire separately from the cast, getting clean plates, or variations on lighting to be mixed in compositing.
- *Elaborate Choreography:* If the camera and subject must move in perfect concert with one another.
- *Exact Match:* If the Director has done VCAM on a shot or has approved an animated camera, and the goal is to replicate this exactly on set.
- *Matching a Previous Shot:* If an element needs to be composited into footage already shot with a moving camera.

Chapter 5

Equipment: What Kind of Gear Is Typically Utilized in Motion Control?

Camera cranes are the most common implementation of on-set motion control. Moves that are programmable and/or repeatable have numerous benefits for comp because the change in perspective will be identical in each pass.

Motion bases allow one to mount props and vehicles atop it, for example a boat, an airplane cockpit, a dragon's back. Motion bases are typically 6DOF Flight Simulators and generally fall into two categories:

1. Hydraulic (greater payload).
2. Electric (greater precision).

Cable systems involve a moving camera, or other object, suspended via two, three, or four lines and can achieve high speeds and cover great distances. They have the advantage of flying to any location within the flight space, pending the cables are not snagged by any parts of the set/environment.

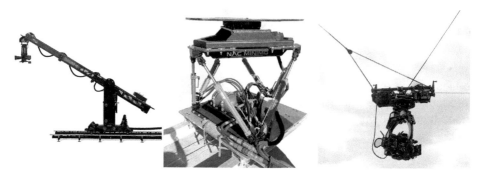

Figure 5.11 Examples of gear commonly programmed with Techvis: Technodolly, Motion Base, Spydercam
Source: (Image Courtesy of Technocrane, NAC Effects, Spydercam)

Software: How Does One Control and Interface With This Gear?

Even the most complex moves are usually communicated via a text file with columns of numbers. However, in all cases the actual software is run on set by an operator who is highly trained in the specific software and equipment. The job of the VFX Artist is to provide a translation from the animation software to the moco software that accounts for positional and temporal limits.

Below is a short list of some of the software most widely used at the time of this writing:

Kuper

Kuper Controls was developed by Bill Tondreau and is agnostic to the equipment it drives. It has been a standard for years and used on hundreds of productions. It runs on DOS and accepts a tab delimited text file in which each axis gets its own column.

Flair

Flair is specific to the Mark Roberts family of equipment (Milo, Titan, Bolt, etc.). It runs on modern Windows systems and is actively maintained and upgraded. Exports are also in a tab delimited format with a specific header.

TD Cam

TD Cam is specific to the Technodolly and uses the FBX 2011 file format. It runs on Linux.

Overdrive

An all-purpose tool with roots in puppeteering, it is most used in conjunction with motion bases and bespoke SFX rigs. Also uses the FBX format.

Techvis Best Practices: The Path From CG Software to Reality?

Positional Limits

A good model of the rig is required to ensure one is within the operating envelope of the specific equipment. Measurements for the position and orientation of the equipment are equally important to the exporting of the data.

Velocity and Acceleration

The most common pitfall in getting from CG to reality is that CG does not respect physics and is typically too fast. One must know the per axis velocity limits (not just the net camera speed). In the case of motion bases, this tends to be the actuator push and pull speeds as the Euler angles are transferred to linear motion on the pistons.

Origin

Where the numbers spring from is of vital importance, and it should be a clearly delineated accurately measured position known on set and CG. For cartesian cranes this tends to be the arm parallel to the ground and the lens nodal point over the start of the track. For motion bases the "home position" is also with the rotations zeroed and parallel to the ground and halfway between the high and low extremes.

Rotate Order

Also known as "nesting order," this is critical to an accurate migration from CG to the real equipment.

Most commonly the order of yaw, pitch, and lastly roll work best. Check with the manufacturer of the specific equipment being used.

Ramps

Because of Newton's second law,[10] a CG move must also start and end at zero velocity, giving ample time and distance for the camera/base to get up to speed. A good rule of thumb is that the velocity equals distance needed. For example, 10ft/sec would need about 10 feet to get up to speed.

Time, money, and most importantly human safety are involved in a live action production. It is the job of the techvis artist to give the utmost consideration to the real-world implications of the data he or she provides. The lack of this contributes to a feeling that VFX Artists do not understand live action. By interacting with all the departments to figure out a technical road map for the shoot, the goal is to synthesize and visually present the sum total of all their input. *Techvis presents a unified shooting plan to making the Director's vision a reality.*

Stuntvis

Harrison Norris and Guy Norris – PROXi Virtual Production

Overview of the PROXi Method

The PROXi Method, developed by Harrison and Guy Norris, is a complete virtual production sandbox that can be utilized by all departments from pre-production through to post-production. The process serves as both a comprehensive creative exploration and scouting tool and a technical-visualization solution focused on communication and logistical refinement.

Unlike traditional previs, the PROXi method functions as a malleable, sequence-length 3D animatic that can be rapidly adjusted independently of a shot-based workflow. This is achieved by creating a persistent virtual set with all blocking and performance (motion captured, hand-animated, or otherwise) seamlessly stitched together to exist as continuous, unbroken action from start to finish. With this method of working, creators can not only refine scene and camera blocking on the fly but prototype complex stunt action rigging systems, vehicle rigs, lighting, and more. This also allows for explorative sessions with key creatives and department heads, while saving time and money depleted by practical rehearsals with cast and crew present. While the typical previs pipeline relies heavily on raw animation man-hours and only involves key creatives for hands-off review sessions, the PROXi method uses smaller teams of readily accessible, cross-skilled operators, so the department heads can experiment and communicate their creative intent with free iteration and precision.

The PROXi method evolved naturally from an entirely physical process most commonly referred to as Stunt Visualization. This is where a stunt coordinator, or fight choreographer, creates a replica of the set entirely out of cardboard boxes, populate it with performers, and stage elaborate action rehearsals on camera. This video is then presented to the Director for notes, upon which, the cardboard set is reconstructed with alterations, and the sequence is shot again, incorporating the latest round of notes (from camera changes, to testing of elaborate costume pieces in motion). The PROXi method is simply the technical progression of this freeform, but sacrificial process, made possible by the processing power of the Unreal Engine and the introduction of inertial motion capture technology.

Epic Games' Unreal Engine serves as the backbone of the PROXi method, facilitating the output from various software suites into a singular sandbox: A landing pad where all

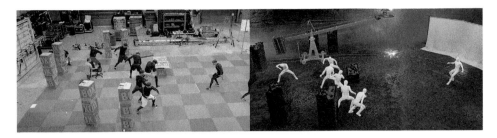

Figure 5.12 Capture of actors in cardboard set and layup of capture data on virtual set
Source: (Image courtesy of PROXi)

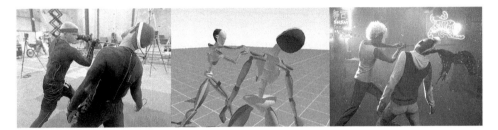

Figure 5.13 Stages of inertial fight capture processing
Source: (Image courtesy of PROXi)

interdepartmental creative and logistical decisions are concurrently represented in one shared space. This complete virtual set can visually present problems that would otherwise go unnoticed until encountered on a physical set, allowing them to be solved ahead of time. This saves both time and money and creates a safer environment for performers in physically demanding sequences.

Just as important as creative freedoms are real-world limitations and transparent accountability to them. All virtual cameras within the PROXi method are programmed to operate in adherence to real-world film backs, simulating anything from an IMAX camera to an iPhone, for complete confidence that every frame can be recreated on set. Each virtual camera can also be limited to each individual production's lens packages to ensure accountability during exploratory sessions. While a virtual camera lacks physical restrictions (traveling at 200mph through a series of winding gaps and stopping on a dime) a real-world camera cannot. The world's most meticulous previsualization is useless if it cannot be replicated on set. Virtual cameras within the PROXi method are closely monitored and discussed with camera and grip departments to ensure they are subject to the same limitations as their real-world counterparts. After a shot has been approved, digital counterparts of real-world equipment are loaded into the sandbox for techvisualization purposes. For example: if a particular camera move requires a 40-foot crane, but the production only has access to a 30-foot crane, that discrepancy would be visually apparent immediately. The shot would be flagged as non-accomplishable with the current production toolkit, requiring either specific additional equipment to be made available on set or a creative modification to the shot itself. Due to the nature of the PROXi method's persistent sandbox visualizing the entire set, as opposed to separately animated shots, techvisualization becomes part of the process early, allowing problems to be solved creatively during the coverage discovery phase.

Figure 5.14 Multiple fight captures layered together into a singular sequence wide event, independent of cameras
Source: (Image courtesy of PROXi)

The Use of MoCap Systems

Optical capture is the most common motion capture process for good reason, but it suffers many action-specific pitfalls, such as occlusion and tracking markers being unable to sustain heavy physical impacts. Alternately, inertial motion capture suits are driven by an entirely different process that allows for high-impact, full-contact action. In place of easily disrupted or obstructed markers, multiple sensors are threaded through the capture suits. Each sensor functions much like a virtual imitation of the human vestibular system, tracking gravitation acceleration and angular velocity. This data is fed to an onboard computer and streamed wirelessly to software that calculates the relations between each sensor, mapping the performers' motion. While each inertial suit does not lock fully to a global space, the drift is minimal and can be both preempted with specific techniques during capture days and corrected with small adjustments in post cleanup.

One of the biggest advantages of inertial motion capture is the complete lack of requirement for a traditional capture volume, providing complete freedom to capture anywhere with minimal setup. During shooting for *Three Nights in Namyong* (TBD), stunt performers in inertial capture suits performed an elaborate, several-minutes-long, full-contact fight sequence in a moving karaoke van. The PROXi team then scanned the van to create a 1:1 virtual model and placed the captured action inside to precisely match contact points. On another occasion PROXi was the first ever to record 12 simultaneously live-streaming stunt performers, transforming an open football field into a capture space. The capture data from this sequence was so precise that during post, each of the individual performers could be identified from their personal physical mannerisms alone. Without the requirement of a volume and the technical considerations that accompany it, the restrictions on capture space and size disappear, and the capture process itself becomes dramatically less obtrusive. During *The Suicide Squad* (2021) all performance capture for the PROXi method was done seamlessly

Figure 5.15 Inertial capture suits used in combat, without a capture volume
Source: (Image courtesy of PROXi)

during existing rehearsals, removing the need for specific capture days. On another occasion, data from the stunt performers' inertial motion capture suit was live-linked into the Unreal Engine to puppeteer a prototype model of the CG character King Shark. During this exploratory blocking session for the "Jotenheim Aquarium" sequence, the model's proportions were continually adjusted as the character's physicality and mannerisms for the remainder of the film were established.

As the PROXi method was constructed with specific focus on rapid iteration, creative changes can be explored and implemented live, without downtime or a turnaround period. Much of this is due to the Unreal Engine's original purpose as a game engine, built specifically to react in real-time to "player" input with a multitude of intelligent systems and simulations. The results of these interactions can then be recorded for consistent replay without deviation on a selected performance. In *Triple Frontier* (2019), the Director considered altering a daytime stakeout sequence to take place at night and in winds and pouring rain. The Director wanted to see a visual representation of the change before making a final decision. First, the moon's position was set in accordance with the real-world's shooting location (latitude and longitude), at the specific time of night and time of year scheduled for shooting. As all of the surrounding elements (such as foliage and bodies of water) were pre-prepared to react to new conditions, their behavior was updated automatically, without any manual input from operators. As both the motion captured blocking and virtual camera work were not affected by this aesthetic change, the same virtual cameras were immediately re-exported and conformed to the rolling draft edit. The entire overhaul was complete in a matter of minutes. When this creative change was granted final approval, the costume department sent over multiple concepts for weather protection, and the PROXi team was able to export additional versions of the same edit displaying each of the costume variations behaving under the conditions that would be present on shoot day.

The Editorial Cut

The PROXi method is at its best while employing this technique of a "rolling edit," wherein, immediately after lensing, all shots are exported (both with and without technical information included) and synced back into the edit. With the speed of creative adjustment allowing genuine creative ownership, and if an open line to editorial is established early, a near-final edit can be exported prior to rolling a single real-world camera. This edit can then be used on set in lieu of storyboards, with techvisualization information as to how to precisely recreate each shot included alongside a

representation of the intended final product. As the production progresses, the previsualization edit is swapped out for live-action footage one shot at a time.

Working With Locations and Stages

In the case of a location shoot, a Photogrammetry recreation of the real-world location is generated alongside accurate sun-pass data, allowing visual scheduling of coverage. In the case of a stage-based shoot that is reliant on green screen or LED walls to either embellish a set or generate a fantastical location from scratch, a one-to-one representation of the physical shooting stage is first created. This is followed by placement of the proposed set construction inside the recreation of the physical stage. Next, the virtual expansions that will eventually take the place of green screens and LED walls are created. Once arranged, each layer can be toggled on and off and independently adjusted. This early virtual assembly of the proposed environment and its physical, logistical constraints allows the exploration of an otherwise imaginary space. This encourages discovery of potential issues and creative adjustments prior to the commencement of construction, which will significantly reduce costs and on-set surprises.

This function was especially beneficial on *X-men: Dark Phoenix* (2019) during development of the Fifth Avenue sequence – a penultimate battle between all key characters in the film set on an approximately 7,500-square-feet replica of Fifth Avenue, in New York City. When the intended shooting stage became unavailable, a near-identical stage was found and approved. But it was not until this new stage was input into the PROXi sandbox that it became apparent the lighting gantry hung several feet lower. With this new information, the top 5 feet of the 250-foot-long set were struck from construction plans – prior to commencement of building, saving a combined 1,250 square feet of real-world replica construction. Once the virtual blocking and virtual cameras were finalized for the sequence, a rolling edit of the PROXi sandbox footage began revealing that while camera coverage featuring the east-most 50 feet of the set were highly prevalent in original storyboards, none of the shots made it to the proposed final edit. After review and approval by the Director, 50 feet of the set was struck from plans, saving another 1,500 square feet of construction. With a final edit of the sequence complete, construction began for the first time on the real-world set, dramatically reduced in size. Upon the commencement of construction, real-world shooting began without storyboards, instead using the PROXi edit as reference – shooting and replacing each shot, one at a time.

The same function was used to transformative benefit on *Triple Frontier* (2019). The final vehicular chase was due to take place across a restricted conservation area with access only permitted on the final shoot day. This presented a problem as any rehearsal was entirely prohibited in the real-world location. The chase was scripted to take place with precise timing, featuring the entire principal cast in a singular vehicle driven from an external pod and multiple real crashes across challenging terrain, within a singular take. PROXi used Photogrammetry to map the precise topography of the chase-path. Then, using physics simulations, created virtual recreations of the vehicles used during the chase, simulating the wheelbase, suspension, acceleration, and weight distribution. Using virtual reality headsets and force-feedback-enabled racing simulator wheels, stunt drivers were then able to repeatedly rehearse their paths of action across this restricted location, to the point of perfection. Meanwhile, the camera work for this singular take was similarly prototyped and rehearsed with camera operators for the "Halo rig" (a miniature remote-camera track surrounding the hero car) able to practice timing and framing across multiple takes with slightly varying action. When the timing for the escape boat's arrival was adjusted

days before the shoot, it completely invalidated a lead character's existing animation data – sequence-wide. Whereas scene-wide updates are often prohibitively costly and time-consuming to remedy in a traditionally shot-by-shot previsualization workflow, the PROXi method afforded an entirely different solution. By incorporating everything into a singular animation event, independent of cameras, changes can quickly be reflected sequence wide. To update the action, a performer simply wore both an inertial capture suit and a virtual reality headset and reacted to dialogue and incoming gunfire live. This capture data was fed back into the system, and the edit was updated within hours.

The PROXi method exists solely to provide opportunities for creative exploration, refinement, and ownership to key creatives across all departments. It improves interdepartmental communication and provides a level of confidence by ensuring everything seen within the system can be precisely recreated on set.

Virtual Production Tools for On-Set Visualization
Steven Tom and Connor Murphy – The Third Floor

When filmmakers use virtual production to aid in making decisions earlier than in the traditional production process, some of those decisions can be leveraged to provide the crew with useful tools for on-set visualization. These tools often use creative decisions made in pre-production to drive systems on set that allow the crew to make informed choices when shooting. This section will cover some strategies for leveraging information gathered in pre-production to inform the on-set crew and provide a more accurate reference for post-production.

Even the most rudimentary tools can benefit from a virtual production workflow. And sometimes the simplest gags are the most effective. For example, the classic tennis ball on a stick, used as an eyeline, can be made more effective by extracting information from previs. A simple techvis evaluation of a previs shot can yield useful data such as speed, orientation, distance traveled, and height. The visual media provided by techvis helps inform the crew of the action, and the data gives a frame of reference to work in. Eyelines can be enhanced further by incorporating programmable devices like moving lights and LED strips. These can be especially useful when the subject being followed exists beyond the physical bounds of the set or stage. The distance at which the subject exists outside of the physical shooting space is proportional to how much the eyeline's movement should be reduced. For instance, if the subject is supposed to travel 100 feet and is 100 feet from camera, but the stage wall is only 50 feet from camera, then the eyeline on the stage wall should only travel 50 feet in the same amount of time. Programmable moving lights can be keyframed on a lighting switchboard using information derived from combining previs with accurate spatial dimensions of the set in techvis. From this point, it is simply a matter of marking the set with position and timing for the moving light. This can be used to provide eyelines for more complicated movements such as a monster stopping and running or an airplane performing aerial maneuvers. This technique tends to be especially efficient on set because it can be set up ahead

of time, stay out of the way during shots that do not need it, and be queued at any point with minimal fuss for the crew. The result is a reference that is both accurate and accounts for animation that was approved ahead of time with no need for retiming the animation or the plate in post.

Mobile devices, such as tablets and smartphones, can also be used as visualization tools to provide fast, convenient references for framing. Many apps have been made that allow the user to load CG assets and composite them on top of the camera view from the handheld device. The CG assets are tracked through the device's camera lens and are designed to be used as a director's viewfinder for visual effects elements. This mobile approach to Simulcam removes the need for hardware to be attached to the production camera and can be anywhere a person can be and without the need for setup time. The fidelity of the image is limited to the mobile device that is being used and, as such, is intended to serve as a reference image.

One such app is Cyclops, developed by The Third Floor, Inc. Previsualized shots and assets can be loaded into the app, and filmmakers can use the animation and shots from pre-production, combined with the practical set, to get a more complete understanding of how the shot will be put back together in post. By loading the production lens kit into the app, it also simulates the correct field of view of the main picture camera lens. Depth compositing is calculated using the device's LiDAR camera when available. It is designed to be used during scouts or shooting to provide a "Simulcam-lite" solution.

During the pre-production phase, this tool can be used to block cameras, which can then be transferred to fully rendered previs. For example, before a set is built on an existing LED volume, the DP can have the proposed art department set loaded into Cyclops and have it aligned to the empty volume. Chess pieces, fully animated characters, or stand-ins can be used to block out camera positions to get an idea of camera coverage in a real-world space for the coming shoot.

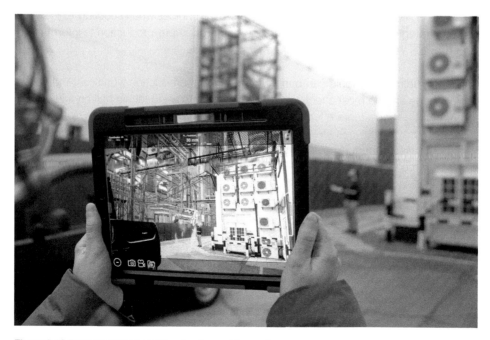

Figure 5.16 Example of Cyclops CG extension and live performance
Source: (The Third Floor, Inc. All rights reserved and Image courtesy of The Third Floor, Inc.)

This tool can also be used during rehearsals to provide proper spacing for actors. If a CG creature is present in the shot, Cyclops can be used to ensure actors are not violating its space and causing problems in post. It can also be useful for establishing eyelines. Partially built sets, that require visual effects extension, are also strong candidates for real-time compositing to ensure cameras and actors do not encroach on areas that will be extended. For instance, if actors exit a ship down a practical ramp and walk around the CG ship, Cyclops proves a useful tool for establishing spatial relationships so the actors can avoid walking through the CG ship.

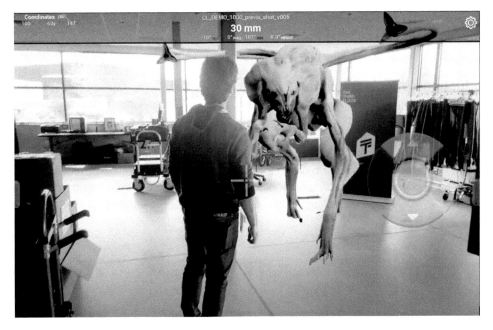

Figure 5.17 Creature from *The Tomorrow War*
Source: (© 2021 Paramount Pictures. All Rights Reserved, and Image courtesy of The Third Floor, Inc.)

While Cyclops on handheld devices is designed for camera framing, Chimera is a system that allows AR and VR headwear to be used for collaborative review during the design phase. These tools excel at allowing multiple users to simultaneously review, edit, and collaborate from single or multiple locations. The content is streamed from a desktop to individual devices, so the users have the same level of functionality as a full DCC (Digital Content Creation) package.

Simulcam, a well-known brand that has become the overarching name for any number of real-time tracking and compositing systems, allows filmmakers to see real-time composites of visual effects elements. Everything from background extensions to CG characters and creatures can be composited in real-time to inform framing, timing, and performance. These can be especially useful during blue- or greenscreen shoots, where there are limited practical set pieces. See the Simulcam section for a more in-depth explanation of how Simulcam works and benefits a production.

When it comes to utilizing visualization on set, bigger is not always better. Selecting the most effective tools to transfer creative decisions, made in pre-production, to on set is a balance between shooting speed and accuracy. The deciding factor is often what will benefit the filmmakers most in post-production. By leveraging information gathered early in production, it can enhance the quality and confidence in a shoot, which provides benefits in production and post by reducing confusion and providing a solid foundation to work upon.

Simulcam
Casey Schatz – The Third Floor

Introduction: What Is Simulcam?

Simulcam is the real-time tracking and compositing of a live-action camera and digital elements, and is derived from the words "Simultaneous Cameras."

By making the camera operator cognizant of digital elements, there is an awareness and a response to the digital world, further blurring the lines of digital and live-action shooting. Common scenarios are a physical live-action set combined with visualized CG characters in the foreground or having a physical set piece that is a small section of a larger digital world.

 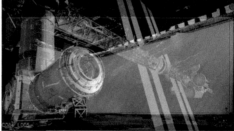

Figure 5.18 Showing the set piece relative to the ship helps to frame correctly, *The Martian* (2015)
Source. (Copyright 20th Century Fox and Image courtesy of The Third Floor, Inc.)

Some Advantages of Utilizing Simulcam

- Instantly see what is usually seen in the postvis stage.
- The camera work is motivated by the CG elements, hence not having to retrofit the CG into the footage.
- Moving CG elements can replace eyeline poles and stand-ins, reducing the need for paint-out work.
- A tracked camera move can be given to the visual effects vendor.

Basic Simulcam Workflow: Tracking, Integration, and Compositing

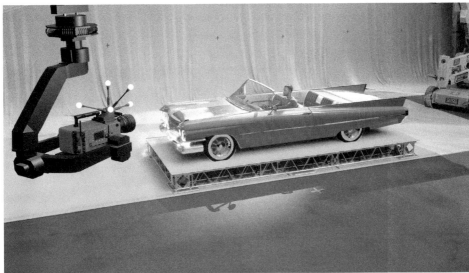

Figure 5.19 Camera position tracked on set using optical markers – there is a tape mark on the ground to denote the origin.
Source: (Images courtesy of The Third Floor, Inc.)

Tracking

Tracking is the real-time solving of the camera position on set. This data is sent to the 3D graphics software to line up the digital background or other objects correctly. This has traditionally been accomplished with active markers in a calibrated volume, or a SLAM (Simultaneous Localization and Mapping) methodology.

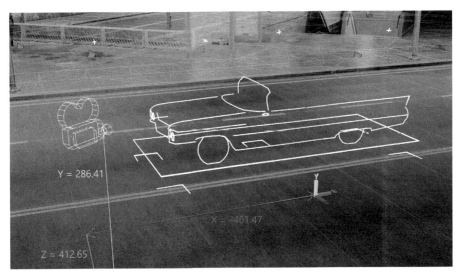

Figure 5.20 The streamed camera position in the 3D environment with the origins aligned
Source: (Images courtesy of The Third Floor, Inc.)

Integration

It is the process of aligning the physical and digital worlds based on the tracking information received. Assets and animation are played and manipulated so that the CG camera can be broadcast to set.

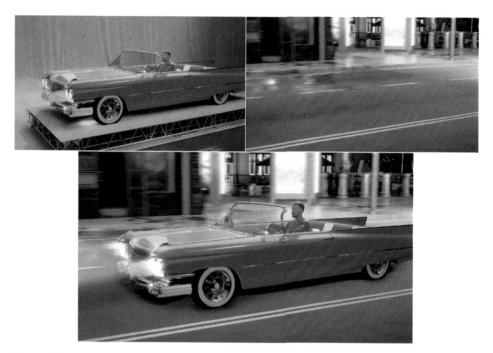

Figure 5.21 The live image and the 3D render composited in real-time
Source: (Images courtesy of The Third Floor, Inc.)

Composite

The video feed from the live-action camera is temporally synced and then keyed, or blended, to create a real-time version of the CG and the live action.

Tracking Methodologies: Tracking the Camera in Real-Time

There are a few ways to get the camera's motion into the 3D graphics software, each with its advantages and disadvantages. It should be noted that each of these techniques can greatly benefit from the addition of an Inertial Motion Unit (IMU) to the camera.

- **Motion Capture:** The live-action camera has active markers on it, and its position and movement is captured via mocap cameras placed in a calibrated volume. This method is very precise and has the added advantage of using a markered wand to map out other aspects of the CG scene. This method requires a minimum of four or more mocap cameras distributed around the camera's operating envelope.
- **SLAM Tracking:** A device is attached to the camera that performs the tracking via simultaneous localization and mapping. This feeds off the parallax of nearby static objects and typically

has a very wide FOV enabling objects to be placed to assist tracking outside of the hero camera frustum. The drawback to this system is that it can potentially lose its alignment if device's POV is blocked, or the camera is looking away from set during camera maintenance.

- **Encoded Crane:** This is a forward kinematics solve in which each axis of the crane (boom, swing, pan, tilt, and roll) drives an encoder that solves the crane's motion. The post of the crane must be very accurately surveyed and correctly positioned in the 3D software.

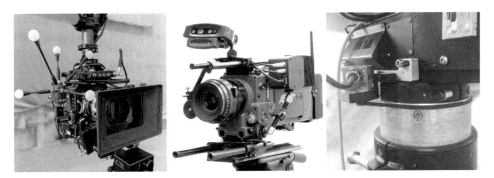

Figure 5.22 Example of a markered camera, Ncam, and an encoded Super Technocrane
Source: (Image Courtesy of Glen Derry, Ncam, Nigel Permane)

Integration: Aligning Reality and Computer Graphics

Real-Time Operation Roles

- **3D Graphics Operator**

cole, performing the duties of on-the-fly animation changes, aligning the real and digital worlds, and being a digital counterpart to multiple departments (grip, gaffer, etc.). Lights in the 3D scene might be changed to match what is happening on set. There is constant communication with the AD and/ or other key department heads. They may be supported by additional VAD artists or a second operator that can be prepping assets or animation in parallel and take over in case of a computer crash.

- **Real-Time Tracking Operator**

The Real-Time Tracking Operator oversees the tracking of the camera and is normally near the 3D Graphics Operator as communication between the two is vital. Maintaining a good track means working together with the camera team and grips to ensure marker visibility and negotiating the repositioning of occluding objects. They may also be supported by someone on set who keeps a close eye on the markers/tracking device to ensure it has not been knocked.

Technical Considerations

- **Lens Calibration**

The focal lengths and film back measurements must be identical, and testing before the shoot day is a good best practice. With Ncam, and similar through-the-lens tracking, solving the distortion coefficient via a grid/checkerboard is necessary.

- **Alignment**

The system must have a clearly defined origin point represented digitally and on set. Preferably this is a corner or other simple shape that is easily identified. For optical capture, this is a surveyed relationship between knowns and a piece of the set. For Ncam this is a card positioned on the ground plane or selecting a point at a known intersection. For encoding, this is the position and orientation of the base precisely triangulated to known marks.

Usually there is proxy geometry of what exists on set to verify the alignment. Once the relationship of subject to lens is verified and that it is 1:1 with their digital counterparts, this proxy geometry can be hidden so one will only see the extension. Simulcam is an increasingly important tool as the lines between live action and CG animation continue to blur. It requires additional time and energy before and during production, but the results in instant feedback, better footage, and less "fix it in post" are more than worth it.

Postvis
Zachary Wong – Halon Entertainment

Postvis is the intermediate phase, after filming and before final visual effects, where visual effects are required in shots for storytelling in the editing process. It can be a place to iterate quickly and play around with adding ideas that can help serve as a blueprint for the final visual effects vendor.

Uses
Postvis is predominantly used as an editorial and directing tool to fill in the gaps where certain elements could not be practically filmed and ensure the shots are telling the right story. The scope of work can range, based on what is needed in the shot. This will vary the work along the lines of adjusting an existing element in a plate, combining multiple plate elements, split-screen takes (combining best performances), bluescreen set extensions or replacements, adding elements to a character, or adding additional characters to the scene, swapping takes with the same visual effects to see which performance and timing works best in the context of the cut, to large scale explosions and destructive mayhem, to name a few.

Postvis can also be used as a technical tool during the filming phase to verify, in more complex shots, that what was captured will work for what is intended for final visual effects so production can strike a setup (to move onto the next part of the shoot).

Assets
Assets used in postvis can vary based on what the production needs and can supply. Most likely, previs has occurred, and those previs characters, vehicles, props, and environments assets are available to be repurposed for this phase. The final visual effects vendor may have

assets that could be approved and ready to pass along that can be utilized in postvis. There could also be LiDAR scans of environments, props, actors, etc. that can be used to create and implement these digital assets into shots, as well as using the data as reference for more accurate camera-tracking scenes. On-set photography is also an incredibly helpful resource. Set reference photos can also be used as a guide in understanding the extent of what was on set and to better understand how to recreate and expand the environment. HDRIs taken on set can also be an excellent aid to lighting reference and can be used as source images to add reflections to rendered postvis elements. Stock footage is also a good asset to implement into the postvis process, to layer in atmosphere into plates, and to add other visual elements required by the scene if there is no provided element.

Camera Tracking

A better integration of elements into postvis plates can be accomplished by tracking the footage to set up 3D scenes to be used for animation and compositing. Using this tracking data makes it easier to place characters, props, vehicles, and environments into the proper space and scale to fit the scene.

Animation

It may be necessary to add and animate digital assets to the shots – if required. This can include adding entirely digital characters into a scene, be they hero characters or background crowds. There may be a need to animate props and vehicles as well.

Comp

All forms of postvis will need a compositing pass to integrate the desired changes to the plates. Although every shot will have its own needs, the goal is always the same: Modify what was shot in a seamless, believable manner. The comp work can be as little as a set extension by removing a blue screen, or more complex, by layering in digital characters, spliced plates, and hero effects elements.

Notes

1 https://praxinos.coop/epos.php.
2 https://marmoset.co/toolbag/.
3 www.middlevr.com/2/.
4 https://praxinos.coop/iliad.php.
5 https://kitestringonline.com/.
6 www.cinetracer.com/.
7 A rigid body is a representation of a physical object. In Motive, rigid body assets are created from markers, either passive retro-reflective markers or active LED markers, that are attached to tracked objects. From these rigid body assets, position and orientation (six degrees of freedom) can be obtained.
8 www.vicon.com/software/shogun/?section=downloads.
9 www.vicon.com/software/third-party/unreal-engine/.
10 The acceleration of an object depends on the mass of the object and the amount of force applied.

6

What Roles Are Needed for Virtual Production?

Overview of Virtual Production Staffing and Organization

Ben Grossmann and AJ Sciutto – Magnopus
and Philip Galler – Lux Machina

It is easy to focus on the technologies and innovations that have laid the foundation for virtual production, but the key to success in this field is great people and teamwork. The needs of a film production change frequently, and the best solution is not always the one that was conceived in pre-production. Response to change is important, and the right people who know their tools and understand the needs of the production will adapt quickly and create great results. Those who are set in their ways or overly invested in a process they do not fully understand will struggle to force the needs of production into their existing solutions, or what worked before. On a complex virtual production set, the thin line between victory and defeat is measured in talent, not technology.

The best organizational structure for a virtual production is a simple one, with clear areas of responsibility, a clear reporting structure, and most importantly, suits the unique needs of that production. Because film and television crews turn over frequently, from one production to the next, it is best to maintain common roles and structures where possible to speed up onboarding with other departments and minimize operational confusion or overlap. That said, one can find a high degree of variability in the organization and staffing of a virtual production today due to several factors:

- Virtual production bridges the gap between physical production crews and digital production crews (like visual effects). Consequently, it incorporates organizational characteristics of both, and the degree to which it inherits more of one or the other can vary by production.

DOI: 10.4324/9781003366515-7

- Virtual production has experienced rapid growth in recent years, with many different technological implementations unique to productions or vendor companies, that require different organizational structures to execute efficiently.
- Different power centers can exist on a production that might cause elements of the virtual production team to be divided amongst existing departments, subordinate to a single department, or to be a department by itself.

The most common organizational structures with the most versatility to address the majority of virtual production applications are reviewed here – but these should not be taken as the final word. The overall organization and specific roles should be adapted to suit the production and the team's individual strengths.

Description of Roles and Interfaces to the Department

Virtual Production is a new department on many productions, and familiarity is a key component to acceptance, adoption, and efficiency. Filmmakers and production teams can become comfortable with new technologies faster when there are familiar aspects to the role titles and organization. Building a virtual production team that mirrors physical production organizations allows UPMs, line producers, and other department heads a sense of clarity and comfort in the way the department is run and how the process works. These roles in virtual production become synonymous with their physical production counterparts, responsible for collaborating on similar tasks and outcomes.

Integration With Traditional Film Production Departments

For those unfamiliar with traditional film and television production hierarchies, it is important to understand that they are designed to consolidate information for interdepartmental collaboration at appropriate levels while still empowering the Director to be exposed to necessary information that might influence the vision of the production. The "inner circle" of the Director is represented by the department heads, such as cinematography, production design, and visual effects. Whether virtual production is a top-level department answering to the Director is dependent on the size and complexity of the production.

It is not uncommon for the virtual production department to answer primarily to the visual effects department rather than the Director because it is a technique that can be employed to represent visual effects imagery during production. Some of the sub-departments of virtual production, such as visualization and technical visualization, may already be performed under the visual effects department. In other circumstances, such as when the content is captured footage used in playback, the department may report to the camera department or Director of Cinematography. If a production requires extensive and complex virtual production needs, or the techniques otherwise make a significant contribution to the creative aspects of the production, the Virtual Production Supervisor may be a department head answering to the Director and a peer to other departments.

In most cases, the virtual production department will be tightly integrated with the production design, visual effects, and cinematography departments and will have dedicated personnel to liaise with those departments to ensure tight collaboration. Over time, as the techniques and

technologies of virtual production mature in their adoption and the traditional departments advance in their digital capabilities, aspects of the virtual production department may be absorbed into the other departments.

It should be expected that the possible sub-departments of virtual production (VAD, visualization, stage operations) will act as bridges to other departments, even though they are managed by the virtual production team. For example, the virtual art department is most efficient and effective when it is under the creative supervision of the Production Designer and working in close collaboration with the physical production art department. Similarly, the camera tracking team in stage operations and the visualization team will be in close coordination with the camera department regarding the appropriate equipment and under the creative supervision of the Cinematographer wherever possible.

Leadership Roles

Virtual Production Supervisor

This role is an individual who has creative experience in "why" virtual production solutions might be employed to solve a production challenge, "what" virtual production configurations work best, and to a lesser extent, "how" those solutions should be implemented to best serve the production. Today, Virtual Production Supervisors come from many places but typically evolve from hands-on technical experience with real-time computer graphics systems and game engines. They may have previous experience as a VFX Supervisor or Artist, a Data Wrangler, a Motion Capture Supervisor, a Technical Director, or similar roles.

- Primarily responsible for creative and technical leadership on the project. If virtual production is large enough to warrant a department status, this role serves as the department head. If it is not, this role might report to the VFX Supervisor or the Director of Photography.
- Collaborates with the Director / Director of Photography / VFX Supervisor / Production Designer.
- Oversees the operations of any sub-departments in virtual production, such as VAD, stage operations, etc., reviews milestone progress, and oversees implementation and testing.

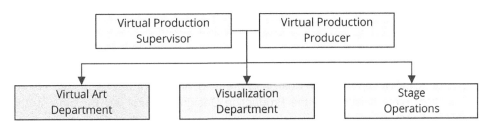

Figure 6.1 Leadership Roles
Source: (Image courtesy of Magnopus)

Virtual Production Producer

This is a role that has operational responsibility for the virtual production department, including the logistics, scheduling, budgeting, vendor management, and other key responsibilities associated with representing the virtual production department in production. Virtual Production Producers typically evolve from roles with hands-on producing experience in visual effects, previsualization, broadcast production, or similar fields. They likely have previous experience with live-action production to facilitate easy integration into a production team.

- Creates department scope and accompanying budget; reviews crew resource needs with Virtual Production Supervisor and sub-department leads or managers; engages and manages any required contractors and vendors.
- Develops schedule in conjunction with Virtual Production Supervisor and Show Producers and oversees implementation.
- Communicates upwards to Show Producers, collaborates with Line Producers or UPMs, and downwards to Sub-department Producers or Coordinators, such as VAD/techvis/previs/stage operations, and is the producing partner to the Virtual Production Supervisor.

While there exists a role of Production Supervisor in the traditional production department, the Virtual Production Supervisor is not the "virtual" version of that role. A Virtual Production Supervisor is more similar to a VFX Supervisor, a key department head responsible for creative and technological decision-making.

Departments

Virtual Art Department (VAD)

(See Chapter 7 for More Detail)

The Virtual Art Department is responsible for generating the assets that will be used in virtual production in the real-time engine, such as on an LED wall. Sometimes these assets will be very high quality for final in-camera visual effects, or they may be lower quality for virtual cinematography or on-set reference. On larger productions, the VAD may be assembled from hired individuals in its entirety under the production. On smaller productions, the VAD may be hired as an outside vendor, or it may be a service provided by a visual effects vendor.

- VAD Supervisor:
 - Visual Quality Supervisor in charge of creating virtual art and assets for use in production; often liaises with the Production Designer and/or Art Directors in the art department.

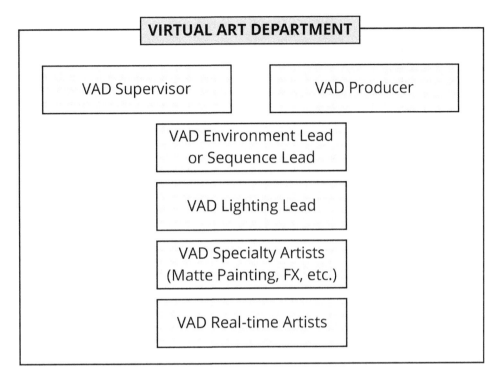

Figure 6.2 Virtual Art Department
Source: (Image courtesy of Magnopus)

- VAD Producer:
 - Larger VADs will have a dedicated producer to maintain logistics and schedules of when the material is available from the art department, or visual effects facility to build, and when the material is needed on stage to meet the shooting schedule, as well as resources and budgets required to execute the scope.
 - VAD Leads – Depending on the scope, the VAD may have leads for specific aspects of the work. Some examples are as follows:
 - VAD Lighting Lead (sometimes called Virtual Gaffer if they are on set)
- VAD Environment Lead (sometimes for different scenes of work)
 - VAD Technical Lead
 - VAD Animation Lead
 - VAD Artists:
 - 3D Real-Time Artists
 - Digital Matte Painters
 - Technical Artists
 - FX Artists
 - Animators

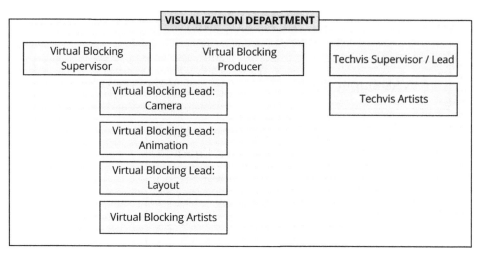

Figure 6.3 Visualization Department Chart
Source: (Image courtesy of Magnopus)

Visualization, Previsualization, or Virtual Blocking

(SEE CHAPTER 5 FOR MORE DETAIL)

The visualization department is responsible for laying out the story beats of the script and animating characters, cameras, and vehicles to create shots in the relevant sequences to be delivered to editorial. Some directors prefer to see "master scene" animation (not tailored to a specific camera), with only general camera positions, blocked out for coverage, leaving the specific camera framing and animation to the cinematographer. In this case, it is often referred to as "virtual blocking."

Visualization vs. Previsualization

Many filmmakers are already familiar with the term "previsualization," and there exists some debate about its use in virtual production because it has become associated with "work created absent of the 'hands-on' involvement of physical production department heads like a cinematographer or director." Some filmmakers have negatively associated the "pre-" in the term with "done by someone else" rather than "done before the production," and as a result, the term "visualization" has been favored in its place. Some productions will continue to use the term "previsualization" out of habit, or because it specifically describes the creation of shots and sequences "directed at a distance."

- Previs Supervisor:
 - Narratively in sync with the Director or Head of Story and/or storyboard artists.
 - Oversees the creation of sequences of action beats from a script by providing layout, animation, and cinematography notes to the team.
 - Motion Capture Creative Lead (if there is no dedicated Motion Capture Supervisor).

- Previs Lead (or Sequence Lead in the case of multiple sequences):
 - CG storyboard capability for shot design through virtual cinematography skill and capability.
 - Gives animation and camera direction to the team.
- Previs Artist/Animator:
 - Understanding of composition, blocking, and cinematography characteristics such as lens choices and camera platforms.
 - Animation capabilities for characters, vehicles, props, etc.

Technical Visualization (Techvis)

Where previsualization is focused on storytelling, technical visualization is focused on "execution methodology." This process is often used in virtual production to determine which parts of a shot will be physical, which will be virtual, and which will be added in visual effects, often through color coding. Specific lenses, camera measurements, and set piece dimensions and relationships are published for all shots, and motion control animations might be generated. This part of the process can be essential to effective budgeting and planning to ensure the complete assignment of responsibility for the elements of a shot.

- Techvis Supervisor:
 - Provides oversight of the techvis team, production needs, and output.
 - Communicates shot design details to all departments to ensure proper alignment.
 - Collaborates directly with the art department to receive or generate set design requirements.
 - Collaborates with the camera department to deliver details of camera lenses and platforms used in previs.
 - Collaborates with the special effects and/or stunts department for any relevant equipment use, planning, or choreography.
 - Collaborates with VFX Supervisor on the impact of creative decisions and technical execution plans that might require further visual effects.
- Techvis Artist:
 - Designs shots and execution information for work on stages, production locations, or LED volumes.
 - Works with previs team and art department to create shot plan PDFs and video visualizations.

Stage Operations

(See Chapter 17 for More Detail)

The virtual production stage operations crew is responsible for the operation of hardware and software virtual production systems and content during the shoot. A larger production may subdivide into groups focused on different areas of stage operations, such as content operations, volume

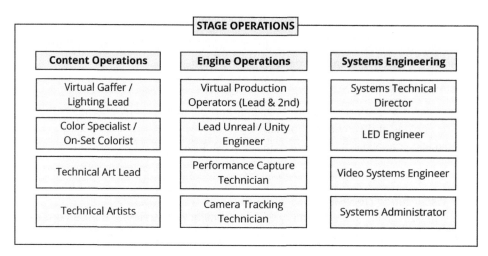

Figure 6.4 Stage Operations
Source: (Image courtesy of Magnopus)

operations, or other operations. Because these teams can represent many different disciplines of expertise, it is not uncommon for them to be provided by different vendors working together.

- Systems Engineering:

 - Systems Technical Director or Technology Supervisor:

 - Thorough understanding of technical filmmaking essentials:

 - Cameras, sync, genlock, frame rate, signal flow, servers, spectrum management, systems integration, etc.

 - Oversight of stage hardware requirements with cabling, networking, power, cooling, volume operations systems configuration, render node deployment, LED wall configuration, etc.

 - Camera Tracking Technician:

 - Primarily responsible for the overall operation of the camera tracking systems.
 - Works closely with the camera department to ensure that required technology (such as tracking devices, FIZ encoders, etc.) is installed and maintained on camera systems for all shots.
 - Responsible for ensuring the camera is properly tracking and aligned to the virtual world, and all relevant data is recorded for visual effects.
 - Often responsible for reporting slate information to virtual production operators for tracking in shot recording systems.

 - LED Engineer:

 - Works with the Systems Technical Director to ensure LED stage panels are designed and functioning to specifications.
 - Primarily responsible for the ongoing maintenance and operations of the LED infrastructure.

- Video Routing Engineer:

 - Works with the Systems Technical Director to maintain video signal flow across all content systems, distribution systems, and routers.
 - Maintains the health and functionality of the virtual production machine room infrastructure.

- Systems Administrator:

 - Networking and IT specialist to ensure that all network and computer systems are properly configured and maintained.
 - May also manage radio frequency spectrum across departments using wireless systems that could interfere with each other and IT systems.

- Engine Operations:

 - Lead Operator:

 - A critical role that responds to live requests from the Director, camera department, art department, and Virtual Production Supervisor and may take primary "command and control" of other virtual production departments during a shoot.
 - Leads troubleshooting efforts to get systems back online in the event of a crash or failure.
 - Builds game plan for the shoot day with shot lists, environment loads, and conveys that information to the virtual production and production teams.
 - Ensures systems are live and stable for shooting:

 - Systems genlock and timecode are being delivered.
 - Camera tracking is acceptable.
 - Scene and lighting are correct.
 - Color has been checked between set lighting and LED wall.
 - Recording systems and video play-out are functioning.

 - Primarily communicates directly with the VP Supervisor for production needs and with the technical artists and Engine Technical Director to execute those needs.

 - Second Operator:

 - Often a backup to the Lead Operator, shadowing them on set in the event they become unavailable or overloaded for any reason.
 - Works to offload tasks from the Primary Operator either by working ahead or by taking on additional specialist capabilities such as:

 - DMX lighting control integration with real-time engine.
 - Color correction volumes for LED stages.

 - In high-production environments, a second operator may be running and maintaining a separate system to facilitate quick swaps to new scenes or a backup system in case a primary system goes down.

 - Lead Unreal / Unity Engineer:

 - Responsible for integrating all external software solutions into the engine.
 - Responsible for troubleshooting and repairing any engine crashes or bugs blocking production.
 - May develop quick features needed for specific production needs.

- Content Operations / Creative:
 - Virtual Gaffer and/or Tech Art Lead:
 - Can respond to requests from DP/Director regarding lighting and/or content adjustments or layout changes.
 - Often the same personnel as the VAD Lighting/Environment Lead for on-set lighting/content supervision and continuity.
 - Color Specialist or On-Set Colorist:
 - Responsible for ensuring color uniformity of the LED panels relative to the camera position.
 - Responsible for maintaining proper color balance and dynamic range between LED panels and FG lighting and set pieces.
 - Depending on the nature of the production, this capability may be performed by a Digital Imaging Technician (DIT) from the camera department.
 - May also be the person responsible for calibrating all LED panels during install or may be a separate role responsible specifically for stage operations relating to color.

External Production Roles

The success of virtual production is dependent on close collaboration with other department heads and department leads. Their advanced involvement and engagement are critical to the methodology, and without their buy-in, failure is likely. Adequate time should be invested in education, relationship building, and familiarizing external production roles with virtual production strengths and weaknesses.

For efficiency and consistency of operations, some shows may choose to treat virtual production like a second unit, with a director of photography and crew dedicated to the volume.

Production team members (UPMs, line producers, etc.) need insight into how to schedule and budget virtual production shows and may assign specific production personnel, such as a production manager or UPM, to align a virtual production unit's schedule and budget with the rest of production.

Producing Virtual Production
Dane Allan Smith – The Third Floor

Virtual Production is best defined as combining physical and computer-generated graphic elements and proven filmmaking techniques to create in-camera visual effects. This simple definition, applied to the virtual production filmmaking process, can profoundly impact the order of operations, budget, schedule, and resource allocation compared to a more conventional filmmaking methodology. The role of the Producer can be described as the primary connection between each

contributing department. The Producer will schedule the production, generate and reconcile the budget, and resolve matters that arise to challenge the goal of completion on time and budget. Due diligence, an understanding of interdependencies, and a grasp of the contribution of new and emerging roles are essential components of a well-grounded proposal. For decades the budget and schedule involved planning in pre-production, critical data, and reference collection during photography. Crafting final images began in post-production, where most of the resource was earmarked for completing the final image. Virtual production rewards early decision-making and shifts a great deal of the collaboration between visual effects, art, and camera departments forward to pre-production. It is important to identify the key markers of a viable project for virtual production and help define best practices for schedule, budget, and creative proposals from start to finish.

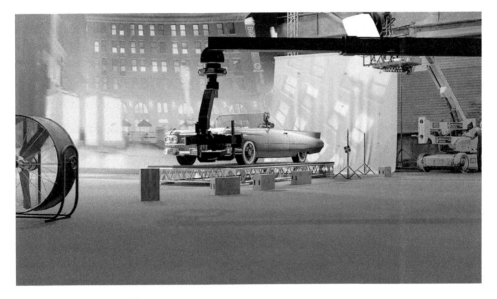

Figure 6.5 LED wall example
Source: (The Third Floor, Inc. All Rights Reserved and Courtesy of The Third Floor, Inc.)

Once the script is turned over, the potential computer-generated elements may be identified. This allows the Producer to verify practical opportunities to enhance the final image's quality, speed, and creativity via virtual production. Early cross-department collaboration that results from bringing lighting, environment, characters, and digital effects forward in the decision-making process is a critical advantage. The budget and talent allocation will shift to pre-production and impact resource planning. The Director will see a close approximation of the final result before principal photography and then can explore, define, and construct a visual blueprint that becomes the source of a viewable reference for the project. Additionally, this may also be used for traditional financiers, to gain assurance and information to validate this means of content creation.

The optimum entry point for those curious about the benefits of this technology is the virtual camera or VCam and the display of assets on an LED stage or volume. Preparation involves the import of assets, environments, and elements designed to fill the field of view of the camera with computer-generated imagery on an array of calibrated digital display panels. This environment

is referred to as "The Volume." The volume allows the VCam operator to block, compose, and capture content that may include physical set dressing, practical production design, cast, and motion capture performance of computer-generated characters – all in consistent lighting that can immediately be revised. Verification of scale, matched eyelines, animation timing, and definition of spatial relationship can be refined to achieve approval at this phase. Objects and cast lit with LED screens can create additional reflections and interactive lighting effects that previously required great skill to replicate in post-production. Kinetic lighting can be utilized via the digital multiplex or DMX network protocol, which can further aid in the final lighting choices of hue and intensity.

This early exploration results in the achievement of in-camera visual effects in advance of the final image capture. Decisions during this phase benefit from iteration and exploration of a scene, a process that is often impossible in a traditional visual effects workflow and may result in the discovery of dynamic imagery, composition, or lighting. Another advantage is remote collaboration, where any stakeholder can become an audience or participant in the digital planning via virtual reality headsets that tap into secure internet-based feeds. Editorial assembly may begin earlier and can factor in more critical data while revisions are possible with minimal cost and time impact.

The use of the volume in this manner will inform decisions by the sound department, stunt choreography, and other vital contributors by the immediate approximation of the final image are used to drive decisions that increase production value, schedule, and budget.

Visualization

The first step is often referred to as previsualization because traditional methodology relied on a CG interpretation of scene(s) to be used as a reference on set. Visualization has become the preferred terminology as tools and planning, powered by the game engine, produce results resembling final imagery. A common misconception is that technology overrides the creative influence and may dilute control of the artistic process in favor of expediency. The opposite is true in most cases, and the advocacy for virtual production may fall to the Producer when collaborating with someone new to this technique. This process delineates each vendor/contributor's role in advance of principal photography so that the VCam and discussions resulting from its use inform the show's bible. This may include motion or performance capture, digital matte paintings, digital effects products combined with practical, physical objects, cast, wardrobe, make-up, and set dressing, all in advance of principal photography. This repository of creative data becomes a shared resource that each department can rely on.

A simple example is shot composition. A camera operator can now base decisions on a tracked digital element that is visible in the viewfinder and displayed in the correct color space – in real-time.

Virtual production aligns a tracked digital element in the scene during photography, allowing correct scale, parallax, lighting, and texture to be defined. This can ensure a closer approximation of the shot(s) and informs all stakeholders earlier than previously possible. Early consensus in advance of production among production design, cinematography, visual effects, and lighting,

for example, permeates a project because everyone from the financier to the cast have a clear visual road map. Visualization establishes a clear creative goal for final assets, effects, and imagery much earlier than the traditional pipeline. Cost savings can be realized, but a more reliable outcome is the increased production value that results from this process. Reviewing the impact on schedule, it is essential to note that the typical four to five weeks preparation time in visual effects can expand to as much as four to six months.

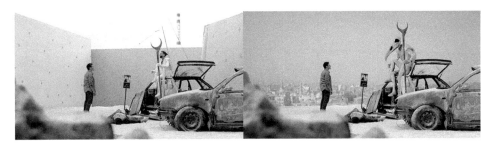

Figure 6.6 Before and after image from *Moon Knight* (2022) – Virtual Production
Source: (© 2022 MARVEL and Courtesy of The Third Floor, Inc.)

The Budget

Before a bid and schedule are completed, several department heads' costs and contributions are vital to verifying the budget, schedule, and planning of the order of operations. A selection of a few key test shots is recommended. These shots will serve as a trial run of the process and help determine show specific parameters. This test will reveal considerations to be built into the workflow and provide vendor profiles and efficacy. A set operations team led by a virtual production supervisor, working with agile project management software, will determine the best course for each production. These departments' hardware, personnel, and dependencies introduce cost and risk considerations worth noting.

It is crucial to establish an on-set video review of high-quality, color-accurate image capture displayed on large HDR monitors, to evaluate the in-camera image. Training visual effects artists in a movie set's hierarchy, etiquette, and language is another crucial step. Cost savings can be derived from eliminating travel. An overlap of effort by digital and physical artisans is eliminated, and scheduling becomes less dependent on unpredictable elements such as weather, company moves, or time of day. A producer can assemble a bid and schedule for ratification by stakeholders, informed by a visual blueprint, leaving nothing to interpretation. Location decisions based on the proximity of vital contributors, reduction of travel considerations, and elimination of delays due to weather open up new possibilities for finance, schedule, and other incentives. LED stages are a global resource, often built in locations that enjoy tax credits. Many regions incentivize environmentally friendly productions, a worthy consideration based on the impact of reduced travel. The less obvious benefits such as a reduction in rehearsal time, are not likely to show up on a budget but will help ensure costs stay closer to plan than the traditional greenscreen shoot that may require more work with cast to visualize elements not in view.

Chapter 6

Training

As with any emerging technical innovation, the need often outstrips the supply of viable candidates. Academia is adapting, while many prominent leaders in this new wave of innovation came from industries as diverse as architecture, live broadcast, and game development. A post-mortem will aid in building a knowledge base for future projects and inform recruiting practices. Shared knowledge, strategic alliances, and support from the various guilds, organizations, and professional societies benefit from this real-world production knowledge base. Sharing this experience and knowledge benefits all involved.

VAD (Virtual Art Department)

Definition of VAD/Workflow Integration

Felix Jorge – Narwhal Studios

The virtual art department (VAD) is a bespoke team with complementary skill sets to the art department, typically from film and game industries that specialize in real-time environment design. This team creates lighting studies to help the cinematographer understand mood and continuity and uses virtual production tools to help achieve the goals of the art department.

How Does the VAD Compare to the Art Department?

The virtual art department mirrors the art department, only with a trained team of real-time filmmakers. Some examples include as follows:

- Art Director = VAD Art Director.
- Set Designer = VAD Set Designer (other skills: 3D layout, 3D sculpting, real-time environment art).
- Character Designer = VAD Character Designer (other skills: 3D sculpting, real-time characters).
- Gaffer = VAD Gaffer (other skills: real-time lighting, lighting direction).
- Set Decorator = VAD Set Decorator, also known as VAD Photogrammetry Capture Artist (photogrammetry artist that works hand in hand with the set decoration team).

What Are the Benefits to Creatives?

An experienced virtual art department is an invaluable resource that provides production teams a collaborative set-building tool inviting the Production Designer, Cinematographer, Set Decorators, and other creatives to work collaboratively in a visual manner, in a real-time engine. The 3D assets

DOI: 10.4324/9781003366515-8

created during the design process can also be shared with other teams to be ingested such as previs and visual effects.

The Steps Involved

Listed below are some of the steps a virtual art department might take.

Art Department Design Stage

The traditional team is responsible for storyboards, concept art, physical set design, and physical art direction.

VAD Design Stage

There is a continuous back and forth between the virtual art department and the art department, sharing data as needed. This team is responsible for virtual set design, virtual character design, and creating techvis for virtual and physical sets.

VAD Construction Stage

This stage is not needed in traditional films but is essential for in-camera visual effects productions. During this stage, 3D assets are taken as far as needed to achieve the shots that are required out of the shoot.

Is the VAD Right for the Project?

The virtual art department can benefit almost every project, starting small with the VAD Art Director and evolving from there.

Techvis is a crucial planning tool in the production process and can be applied to any scene. Additionally, the level of detail implemented in the techvis can fluctuate based on the needs of the production. Techvis can range from executing a simple gray model with basic lighting to a photorealistic set. This level of flexibility is assessed in pre-production and is part of why it benefits such a substantial range of projects.

Where Does the Project Take Place?

Virtual art departments are a remote workflow that can take place in the office, at home, or anywhere in the world. Remote review sessions, or virtual location scouts, are held online over zoom, allowing the team to work collaboratively in virtual reality.

How Are Projects Assessed?

After the script is read, several questions need to be answered, such as, What is the project trying to achieve? What kind of process is the production considering? Where would the client like

to work from? How would the client like to work? These questions start the foundation that helps build the virtual production strategy.

Matching the Right VAD to the Right Project

To ensure that desired cost savings are achievable, it is important to understand the various specializations of different virtual art departments. Like traditional art departments, some virtual art department team members have a focus on the design of things, conceiving, helping build the creative budget, and work directly with the filmmakers in pre-production. This communication strength is a major component to the pre-production team. Other virtual art departments are good at fine detail, and final pixel rendering.

What Is Delivered by the VAD?

Virtual art department deliverables include image and video files that are compiled into lookbooks for the cinematographer and production design teams to reference on-site, game engine environments (real-time sets), 3D character sculpts (real-time character techvis), plans to pass off to the art department, and vendors.

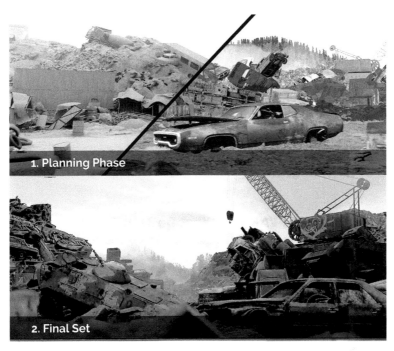

Figure 7.1 *Fathead* (2022), the real-time environments for this short film were created in collaboration with the filmmakers and shot on an LED screen stage
Source: (Image courtesy of Narwhal Studios and Entertainment Technology Center).

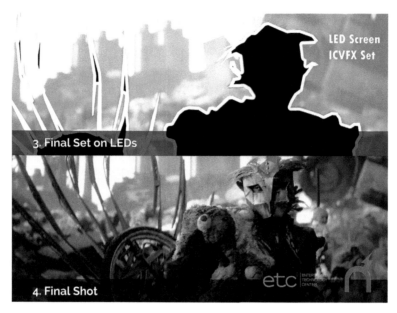

Figure 7.1 Continued

The virtual art department helps the final deliverables of a production by developing detailed plans that show all departments the information necessary to put together all the moving pieces. The look and the shots can be set up during pre-production in ways not previously possible. Key creatives being involved in pre-production lowers the potential of things changing later.

Artists for Asset Creation / Sets
Felix Jorge – Narwhal Studios

Who Are the People in the VAD and What Do They Do?
The specific talent needed for each project may vary from production to production. Best results are experienced as follows:

VAD Design Team
A nimble team that iterates quickly, the virtual art department focuses on the creative vision and execution plan, and it is not usually concerned about optimization.

Roles include the following:

- VAD Art Director: Connection point to the art department, leads the VAD design team.
- VAD Manager: Works with the Art Director to manage the team.
- VAD Set Designers: Create virtual sets under the guidance of the Art Director.
- VAD Gaffers (also known as VAD Lighters): Light the sets, works with DP if available.
- VAD Tech Artists: Support creatives with technical art such as FX and shaders.
- VAD Engineers: Set up the server and technology required for virtual location scouting, virtual pre-lights, and anything else the production may include.

VAD Construction Team

The Virtual Art Department Construction Team takes the virtual sets and characters from the design team and builds the final assets required to achieve the final shot. This is essential when building sets for in-camera visual effects but can also be applied when creating assets to be used in traditional visual effects.

Roles include the following:

- Environment Supervisor: Supervises the creation of the final sets.
- Character Supervisor: Supervises the creation of the final characters.
- VAD Construction Manager: Manages assets being built to a final quality.
- A range of different 3D Artists, dependent on the designs of the shots.

What Are the Things to Look for When Building or Engaging a VAD Team?

There is no set formula to build a virtual art department; however there are a few things to look out for:

- The number of sets that need to be created.
- The process.
- The amount of time.
- The style.
- The timeline.
- The budget.
- The tech required (i.e., photogrammetry).

Matching the Project's Needs to the Talent

Given that virtual art departments are relatively "new" to the industry, one of the most challenging aspects of building a virtual art department is pairing the needs of a project to the necessary talent. When creating a virtual art department, it is important to ask if design or final pixel is needed. During the design stage, it is important to have very experienced and collaborative planners that understand the filmmaking process and the intricacies of managing such a

department. In final pixel, the focus is less on the plan and management of the filmmakers and more on the visual quality of the final product. Splitting design and construction will identify the right talent.

Clarity Around Decision-Makers' Responsibilities

This process involves different visual aspects that happen simultaneously, therefore having clear expectations around the responsibilities of the decision-makers allows the team to move through reviews quickly and smoothly.

Where Is the Budget Coming From?

During a visual effects project, the virtual art department takes a section of the work that would traditionally happen in post-production and explores it in pre-production. Although the budget traditionally comes from visual effects departments, the benefits are just as substantial for production and the art department, which also tend to contribute to the budget.

How Does VAD Talent Compliment Physical Production?

The virtual art department complements physical production by providing tools that allow key creatives to engage with digital worlds in a familiar way. The virtual art department team ingests 3D files from physical production teams, to continue developing the look. The files are then turned back over to the art department to critique with the decision-makers as a jumping-off point. It is a back-and-forth collaborative workflow.

Physical Production Roles That Shine With a VAD

- Production Designer.
- Director of Photography.
- Set Decorators and Set Dressing.

Similarities and Differences

The virtual art department and physical art department are similar in that both departments have the same overarching goals, which are driven by the Production Designer. The key difference between the two departments is the programs and tools that are utilized. The virtual art department designs and renders are hosted in a real-time engine, whereas the traditional art department performs in the physical world.

A Team That Bridges the Physical and the Digital

A virtual art department that has been strategically and properly set up creates a space for creatives to enter the flow-state and apply their expertise. The technology acts as a bridge between physical and virtual teams, implementing processes that make communication more streamlined and manageable.

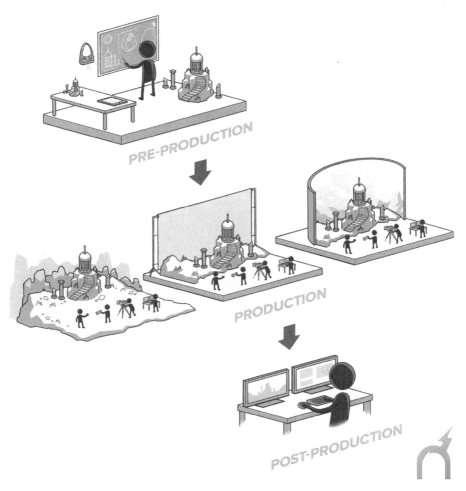

Figure 7.2 The Virtual Art Department supports pre-production, production, and post-production, helping build virtual blueprints (techvis) for all different pipelines
Source: Illustration by Pat Mendoza (Image courtesy of Narwhal Studios)

Building Assets in Game Engines / Unreal
Jess Marley – Halon Entertainment

About Asset Creation

Game engines require assets built for real-time rendering. In traditional visual effects work, the emphasis is on visual fidelity and quality of realism. Real-time assets are required to work under technical limitations and in multi-purpose situations where they can be moved, re-lit, and seen from a variety of angles – and on top of that, they will still be judged based on their visual fidelity. Success depends on preparation, flexibility of the assets, optimization, limiting the amount of draw calls, and understanding the scene's limitations into which they will be dressed.

Figure 7.3 *The Desolate City* (2022) – a real-time environment
Source: (Image courtesy of Halon Entertainment)

Preparation in Building for Game Engines

The first step towards successfully creating real-time assets is to determine the needs of the production. How will the assets and set dressing be used? What is the camera's proximity to the assets, and what angles will they be seen from? What kind of lighting will they be seen in? Next, collecting references is crucial when trying to recreate reality. Any search engine can provide images of almost any object in almost any lighting scenario. It is imperative for every artist to use references when creating assets and environments intended to mimic reality.

Before moving into asset creation, it is important to make two technical decisions: Texel density and color space. Texel is short for texture pixel, or texture element. Where pixels make up an image, texels make up textures; the density is determined by the texture's resolution in relation to the size of the asset to which it is applied. The higher the texel density, the more information is needed in the texture, but at a cost of efficiency. With real-time assets, one may determine different texel densities necessary for different assets. This can be based on the camera's distance to the subject and the assets' relation to the screen size. In general, it is smart to create assets at a higher fidelity, then export textures at the resolution needed or use the tools inside the engine to reduce resolution as needed.

Determining the range of colors that artists will be working with (or color space) for texture authoring is important. If ignored, there can be discrepancies between the look of assets in identical lighting scenarios very late in the pipeline. OpenColorIO (OCIO) is a color management system used primarily in film and virtual production. OCIO guarantees that the colors of captured video remain consistent throughout the entire pipeline. While visual effects pipelines often use ACEScg, real-time assets are rendered in sRGB. The most important thing is that all asset textures are authored the same from the start so that any color space transformations along the way can be executed consistently.

Figure 7.4 Unreal Engine Texel Density Checker Tool
Source: (Image courtesy of Halon Entertainment)

Figure 7.5 A PBR compliant asset in a lit environment
Source: (Image courtesy of Halon Entertainment)

Asset Creation for Unreal Engine (UE)

It is important to note that "asset creation" is often "asset modification." Virtual Art Departments (VAD) receive many digital assets from the physical art department and visual effects vendors that need to be altered or optimized. Depending on the job, the VAD could model, modify assets from online marketplaces, or use publicly available satellite imagery. Modeling and texturing from scratch are ideal for prominent assets and unique items, but the goal should be to use what is easily available instead of reinventing the wheel.

Regardless, assets that are created or modified go through the same "high to low" 3D modeling workflow. This is the process of baking a high-resolution model into low-resolution models and converting the surface detail information into physically based rendering (PBR) compliant texture maps. PBR is a shading approach, used by Unreal Engine, which utilizes material values from reality to emulate the way real light behaves more accurately. When set up correctly, a PBR-compliant asset reacts to computer-generated light in a realistic manner.

Once the end purpose of the assets is known, artists can also determine what mesh resolution is required. An asset placed near a camera or likewise a background asset with a strong silhouette may call for more geometric detail based on how it is seen. In most scenes, there are generally a lot of assets which can be built as a medium- or low-fidelity mesh without harming the look, where one can reduce precious frames per second.

Optimization of Assets for and Inside of UE

The crux of working with real-time assets is making sure that they run in real-time. Depending on the scenario, that could be as low as 24 fps or as high as 120 fps.

Unreal Engine has many tricks and tools for optimizing scene performance, including Hierarchical Levels of Detail, (LODs), MipMaps, the use of Material Instances, Light Baking, and Geometry Reduction, to name a few. The more technical knowledge inside the game engine, the faster a solution can be found.

Artists should pay special attention to the amount of "draw calls" an asset will require. It is important to minimize materials and limit texture size where practical. Many people look for a silver bullet to get their scene to run at speed, but in general, it is a matter of carefully examining the scene and finding efficiencies one by one.

The Future of Real-Time Assets

Real-time assets and visual effects assets will not always be different beasts. More adoption of Universal Scene Description (USD) means less time spent rebuilding assets between vendors. New technology closes the gap every year and makes the creation of real-time assets easier. Recently, Unreal Engine 5 released two new tools that are already making a difference. Nanite (a new geometry system that renders higher polygon counts) allows VADs to spend less time optimizing geometry. Lumen (a new lighting system) provides better global illumination and realism with more efficiency. It will not be long before all assets are "real-time," but until then, one should expect the technology to keep improving and the workflows to keep changing. It is important that all artists continue to learn and keep up.

Managing Asset Quality and Performance Needs for Virtual Production

Chris Swiatek – ICVR

Introduction

VAD assets created for real-time virtual production must strike a delicate balance between visual quality and performance. Performance refers to how efficiently assets can be rendered in real-time within the game engine and directly affects the maximum frame rate at which content can be played on an LED wall or viewed through a virtual camera. Performance is critical for LED in-camera visual effects where virtual scenes must function well enough to match the frame rate of the camera used during shooting to avoid visual stutter. This minimum benchmark is less strict for other types of virtual production, such as performance capture through a virtual camera or live compositing against a green screen. But it is still best practice to ensure that the virtual scenes run at the target frame rate of the final output.

Visual quality and performance of 3D assets are notoriously at odds with each other. As elements such as polygon count and draw calls[1] increase, performance generally decreases. When it comes to granular scene benchmarks like this, there is no golden rule that applies to every production because performance can be impacted by a variety of elements within the scene. For example, a scene with baked-in light (where light and shadow are pre-computed and not rendered in real-time) can afford to fill their scene with many high-quality assets, whereas the same scene with dynamic light (where light and shadows are computed in real-time at each frame) would need to cut corners in different places. The key to managing VAD asset quality and performance while achieving the highest possible visual quality is to establish performance targets, monitor them closely throughout production, and spend the performance budget on the parts of the scene that make the largest visual impact.

Scene Performance Targets

It is essential to establish scene performance targets and minimum benchmarks before VAD production begins and to strictly monitor and enforce these throughout the entire production cycle. These standards ensure that the final VAD content delivered meets the required delivery specifications and allows performance optimization challenges to be solved early on in production. Ignoring scene performance until just before delivery can be disastrous and cause a ripple effect of delays, resulting in additional expense and longer hours.

Scene performance targets are informed by the hardware the content will run on, the video output resolution, and the frame rate of the shoot. It is best practice to build virtual scenes with a comfortable frame rate overhead of around 30 percent above the target camera frame rate to account for unknown variables during shooting and provide an insurance buffer.

Performance should be benchmarked throughout production within a test environment that mimics that of the stage as closely as possible. This test environment is especially important for LED VAD production where extra performance costs incurred on stage by nDisplay[2] are not evident on artist workstations. In this case, the test environment should run the scene through nDisplay with a

101

viewport configuration and hardware matching that of the stage. Realistically, it may not be practical or time efficient to use the test environment for benchmarking every little change. Rough guidelines can be given to artists to equate performance on their workstations to the stage environment. On high-end artist workstations, a good starting point is that the scene should run in full screen 4K at two to three times the target stage frame rate. This number can be adjusted as needed by tracking the relative performance between workstations and the test environment throughout production.

Asset Quality and LODs

To best balance visual quality and scene performance, careful thought should be given to how each asset is to be positioned within the scene. Hero assets close to the camera should be represented at maximum quality, whereas middle and background assets can be represented in much lower quality without impacting visual fidelity. Desired quality of each asset should be determined at the beginning of VAD production (after concepting/blockout) so artists can spend their time and performance budget on elements of the scene that are most important. To facilitate this, place a 3D mesh of the stage within the environment and view the scene through an in-engine camera from the perspective of the stage. This helps determine which areas of the environment are high visibility and which areas are lower priority.

If an asset will be seen at multiple distances at different points during the shoot, or if different instances of the same object appear at different distances in the same shot, LODs can be used for flexibility. Game engines use level of detail, or LODs, to represent the same object at different quality levels depending on how visible they are on screen. Lower LODs have simplified geometry, lower texture resolution, and thus have less of an impact on performance. Handcrafting LODs in DCC software is recommended, as this allows for the highest quality output and level of creative control. Asset LODs in the engine should be set manually whenever possible to avoid visible popping between quality levels as the camera moves. Unreal Engine's Nanite geometry system paves the way for automatic and dynamic handling of quality levels without abrupt stepping between quality levels or the need for manual LOD creation.

Tips, Tricks, and Best Practices

There are several tips, tricks, and best practices to consider during asset production to help squeeze out additional performance. This list is by no means exhaustive, and the best approach will always depend on the specifics of the project and the tools used.

- Unreal Engine's optimization View Modes are a great way to quickly spot problem areas within a scene. Look at these first when diagnosing performance issues.
- For LED VAD production, high resolution textures are unnecessary unless an object is extremely close to the wall. Generally, there is no discernable visual quality gain above 4k except for very large objects without texture tiling.
- Reuse assets as often as possible, rather than creating unique meshes, to take advantage of engine instancing and improve performance.
- Minimize material IDs on objects (with one being ideal) to reduce draw calls.
- Similar objects can be merged with the Merge Actors feature to reduce draw calls.
- If the shoot features a practical set, communicate with the art department. If a section of the wall will be occluded, for example, one may not need to spend time on the area of the virtual scene behind it.

Virtual Scouting With Production Design – VR System

Felix Jorge – Narwhal Studios

How Do the VADs Virtual Production Workflows Serve a Production Designer?

Virtual stage walks are a daily presentation from the virtual art department to the Production Designer and team to show updates and gather feedback on digital sets. This process supplies a visual way to tackle challenges early on.

VAD Virtual Reviews

Virtual art department design reviews happen often and are driven by the VAD Art Director, who may be supported by a team of creatives, engineers, and tech artists. The Production Designer and the virtual art department talent conduct these reviews either in person, over a zoom call, or in the cloud using virtual reality headsets. These review sessions mimic a real-life production and can capture the essence of in-person production. All the information can be shared with the previsualization, traditional production, and visual effects teams. Below are some examples of virtual production review workflows.

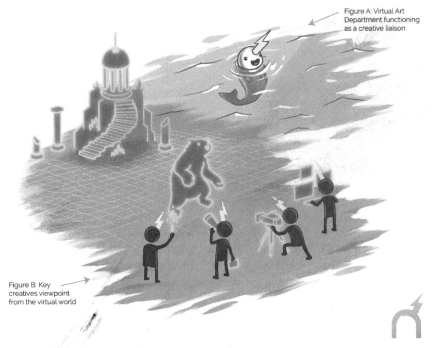

Figure A: Virtual Art Department functioning as a creative liaison

Figure B: Key creatives viewpoint from the virtual world

Figure 7.6 Illustration by Pat Mendoza showing the different key creatives reviewing their aspects of production collaboratively within virtual reality. Figure A: The virtual art department acting as a creative liaison between the virtual and physical worlds. Figure B: The key creatives viewpoint from within the virtual world. The neon blue outlines represent what is seen in the virtual world.
Source: (Image courtesy of Narwhal Studios)

Virtual Location Scouting

A virtual location scout is a review session where the Production Designer and Director of Photography share the progress of the virtual art department sets and characters with other decision-makers such as the Director and Producers. These reviews often happen weekly and become the foundation to art directing and budgeting collaboratively.

Virtual Pre-Lights

In a virtual pre-light session, the Cinematographer works directly with the virtual art department to light the virtual sets that have been approved by the Production Designer. During virtual pre-lights, the Cinematographer explores different scenes, lighting scenarios, camera options, and placements.

Virtual Techvis

Once there are several rounds of reviews around the look, the virtual sets, and previs are used to create a scene that is representative of how it would be shot on the day. This can be a very collaborative process with visual effects supervisors and other key creatives.

Tools Available to Make It a Smooth Process

Virtual reality and iPad virtual cameras are the most influential tools in the virtual art department. Different studios have unique and customized proprietary tools that are production ready. However, Unreal Engine has created a baseline virtual production suite that can be used to start discovering how virtual production can be implemented into a project. Some examples of tools include the following:

VR Tools for the Production Designer

Virtual reality tools for the Production Designers enable things such as virtual rulers, concept art viewer, virtual green screen, virtual LED volume, volume lighting approximation viewer, and more.

VR Tools for Director of Photography

Virtual replicas of camera lenses and lighting kits in the real-time engine, as well as tools to easily capture and manage camera data and frames placed by the Director of Photography.

iPad Virtual Camera for Directors and Cinematographers

An iPad virtual camera allows the Director and Cinematographer to use an iPad to move around in 3D space and use specific lens kits to frame shots in the virtual world.

Virtual Set Creation Production Tools

Used to speed up the virtual set creation process while protecting the standards of the project, these tools are typically found at the studio level and are especially important to scale production.

How Does the Production Designer Engage the Team?
The main point of contact for the Production Designer is the VAD Art Director.

Directing the Creative
The Production Designer works primarily with the VAD Art Director, who then delegates to the virtual art department team. It is important to be aware of the time commitment a virtual art department requires from a production designer. Designing and constructing sets virtually is much faster than doing so physically but still requires the same number of reviews. For this reason, it is critical to be mindful of the schedules of the key creatives and book the appropriate time needed to feel confident that all the decision-makers have been heard.

Virtual Review Sessions vs. In-Person Review Sessions
Building a remote team has its clear benefits, some of which include less office space and a global talent pull. Though there is nothing that replaces an in-person interaction, it is advised to measure the benefits and disadvantages on a project case-by-case basis.

The Results
The results are a 3D model (virtual set), virtual camera placements, and imagery and videos taken during virtual scout sessions. Virtual production tools provide transparency for all departments.

Reviewing Things With the Director and Producer
Virtual location scouts are a valuable resource for the Production Designer and the Cinematographer to present creative work to the Director and Producers. During these review sessions, a VAD art director runs a real-time session, and facilitates a discussion around storytelling, budget, and filmmaking.

Collaborating With the Director of Photography
The Cinematographer plays a critical role in lowering the cost of physical and virtual set creation by supplying camera angles and lighting data that is essential for the art department, construction, and visual effects teams to confidentially proceed with a reduced scope of work, focusing where it matters most.

From VAD to Blueprint
The virtual art department shares the 3D models with physical construction teams to build blueprints, previs, and visual effects to guide the look. Virtual art department techvis provides teams with an extra layer of context through 3D designs that help create a better product.

Chapter 7

Virtual Pre-lighting With the DP
Chris Swiatek – ICVR

Introduction

The virtual pre-lighting process allows the Director of Photography (DP), together with the VAD team and other key creatives, to achieve close to final lighting of the virtual scene before it is delivered to the stage and shooting begins. This process, together with pre-visualization (previs) and technical visualization (techvis), allows creative exploration, iteration, and problem-solving to take place before a shoot begins, maximizing efficiency on stage.

To get the most out of this process, the necessary lighting approach should be determined in advance. The virtual scene must be built to enable quick iteration, and key creatives must make full use of available tools to make informed decisions.

Lighting Solutions and Scene Preparation

The VAD team should determine early in the production process, based on the needs of the Director and DP, whether the virtual scene should utilize baked, dynamic, or stationary light.

* Baked light offers high fidelity but takes time and cannot be adjusted quickly on stage. Low performance impact.
* Dynamic light is lower fidelity but can be instantly moved and adjusted as desired. High performance impact.
* Stationary lights cannot be moved, but brightness and color can be adjusted on the fly. Medium performance impact.

These lighting methods are not mutually exclusive, and many scenes use them together in combination. A night scene, for example, may bake the moonlight, use a stationary light for a blinking streetlamp, and a dynamic light for the sweeping searchlight of a helicopter overhead.

This may all change depending on the creative needs of the Director and DP. If the Director wants to move the moon around at will, or the streetlamp to fall over on a trigger, these lights need to be dynamic. If the helicopter searchlight is fixed in one place, it can be stationary. Because these lighting methods each have differing visual quality and performance implications, it is important to clarify these decisions early in VAD production and before the virtual pre-light.

Before the pre-lighting process begins, the lighting approach should be decided, and the virtual scene organized. Lights should be placed in a separate lighting sublevel and named in a clear way. A lighting artist or supervisor from the VAD team familiar with the scene should be selected to operate the content.

Virtual Pre-Lighting Process

Virtual pre-lighting includes the DP and a lighting artist from the VAD team who is responsible for translating the DP's comments into changes within the scene. This process may take place in person, around the same computer, or remotely, through screen share. Other key creatives commonly present include the Virtual Production Supervisor, Director, and Production Designer.

It is valuable for additional creatives to be a part of this pre-lighting process because decisions made here can create a ripple effect of implications across the production. If the DP wants the sun to come from a specific direction, it necessitates a practical key light on stage placed at a matching angle. This in turn impacts the art department, which must plan around that light placement and make sure it is not blocked by set elements. If set elements are moved, it may affect the blocking that the Director had in mind. This example illustrates how virtual lighting (VAD), practical light placement (techvis), and blocking (previs) are closely tied together, much like creative collaboration on set. By treating the pre-shoot portion of virtual production in the same way as production on stage and involving key creatives at every step, issues can be efficiently identified and solved early on. In the previous example, if the Director or Production Designer identifies an issue caused by the virtual lighting, they have an opportunity to express their concerns, resolve the problem, arrive at a compromise, and see the resolution immediately reflected in the virtual scene.

Throughout the virtual pre-lighting process, each scene is reviewed and a lighting scheme agreed upon. The VAD team artist working on the virtual scene adjusts lighting at the instruction of the DP and receives confirmation that it matches the intended vision. Requested changes are often made quickly, as a close to a final representation of the intended look, and then passed to the VAD lighting team afterward for polishing. Once polishing is complete, the VAD team delivers renders and/or recordings of the scene to key creatives for final approval.

Virtual Cameras and Pre-Visualization

Throughout the virtual pre-lighting process, it is essential to visualize the scenes and shots from the perspective of virtual cameras that approximate what will be seen during shooting. Unreal Engine offers a high level of control over virtual cameras in the scene to reproduce realistic physical camera properties. Paired with a 3D model of the stage, this provides a highly realistic sense of space, perspective, framing, and composition.

The shooting environment can be further visualized by animating actor blocking through digital humans and building virtual representations of the practical set. If these previs elements are part of the production process, it is important to incorporate them into the virtual pre-lighting session to get a sense for how virtual lighting decisions will play out on the practical set and actors.

Stage Considerations

Virtual pre-lighting combined with a 3D representation of the stage and existing previs or techvis elements will give a good sense of how shots will be technically achieved. When adjusting

virtual lighting, practical lighting should always be considered at the same time. It is important to consider the space available on the stage for practical lights, infrastructure such as rigging (for hanging lights from the overhead grid), practical set design, stage boundaries, and possible light spill on the walls, when lights are placed at certain angles.

To help answer any questions, approximations of practical lights can be quickly recreated virtually and dropped into the scene. Paired with a 3D model of the stage, this method will quickly reveal any issues and give an opportunity to immediately reconsider problematic virtual lighting decisions.

Figure 7.7 An Unreal Engine screenshot depicting a scene with previs and techvis elements used to visualize the lighting environment. The red mesh represents the position of the LED wall. Areas behind the red mesh represent the virtual scene and the area in front represents plans for the practical set.
Source: (Image courtesy of ICVR)

Multi-User Virtual Location Scouting – Pre-Production
Felix Jorge – Narwhal Studios

Multi-User Virtual Scouting, a Collaborative Way to Review Digital Worlds

Traditionally, concept art for production is created using 2D images. This process often makes it hard to understand the scale of a scene, and all the elements needed to achieve it. Multi-user virtual scouting enables key creatives to collaboratively work on a project virtually, in 3D, demonstrating not only getting a sense of scale but also exposing any glaring issues and challenges ahead.

What Are the Differences Between a Multi-User Virtual Scout and Other Scouting Processes?

Multi-user virtual location scouting is a process that connects people in a virtual world, regardless of location, challenging the idea of collaboration by connecting people with virtual production tools. Think of a customized metaverse for filmmakers that includes all the necessary tools needed to achieve the desired shots, guided by a VAD art director who is there to make the process accessible to everyone. The ability to join virtual filmmaking sessions from anywhere in the world, with an unlimited number of people, is the major difference between multi-user virtual scouting and other scouting processes.

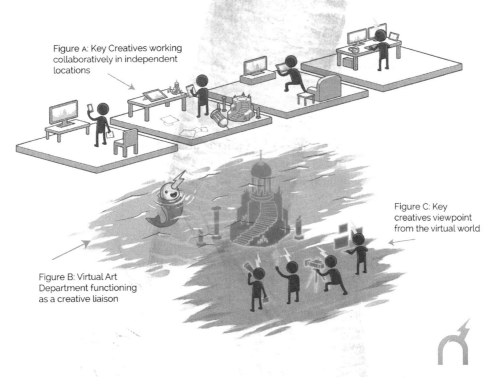

Figure A: Key Creatives working collaboratively in independent locations

Figure C: Key creatives viewpoint from the virtual world

Figure B: Virtual Art Department functioning as a creative liaison

Figure 7.8 The process and functionality of a multi-user scout showcasing key creatives meeting in the cloud to review designs. Figure A: The key creatives working collaboratively on a project from independent locations around the world. Figure B: The virtual art department acting as a creative liaison between the virtual and physical worlds. Figure C: The key creatives' viewpoint from within the virtual world. The neon blue outlines represent what is seen in the virtual world.
Source: (Image courtesy of Narwhal Studios) Illustration by Pat Mendoza

How to Set Up a Successful Multi-User Virtual Scout

There are three major areas to keep in mind when setting up a multi-user virtual scout.

1. **Virtual Art Department Team:** Virtual art department teams with multi-user virtual scouting require additional engineering support.

2. **Virtual Art Department Technology:** Workstations and virtual production equipment need to be shipped and set up for key creatives to engage with the process.
3. **Virtual Art Department Scout Management:** Scouts are live, and often there are many participants influencing the scout. The assets and people management must be carefully crafted ahead of time.

Who Are the People in a Multi-User Virtual Scout?

The participants of multi-user virtual scouts vary, ranging from just the Production Designer, to having all key creatives present, which can be up to 15 or more users, for final presentations. For all other multi-user virtual scouts in between, it is advisable to include as many people from all departments as possible, even if only viewing the screen shared perspective from one user in virtual reality. The Set Decorator, greens department, gaffers, props, and art department can and should participate in these multi-user virtual scouts to bolster the decisions being made.

The Conversation Between Decision-Makers

The conversation between decision-makers while in a virtual location scout are very similar to that of a physical location scout.

What Is the Conversation Between Decision-Makers During a Multi-User Virtual Scout?

The discussion drastically changes based on the scene that is being worked on. However, here are some common themes:

- Assessing the size of the set.
- Critiquing the architecture.
- Exploring different shooting methods (ex., green screen, LED screen, on location, or backlot).
- Camera placement and movement.
- Cinematographer needs from set decoration. (ex., set decoration that needs to be moved to achieve the shot or additional light fixtures).
- Director conveys a story tweak and wants the lighting to be modified.
- Virtual Production Supervisor voicing scheduling or budget concerns.

How Does Multi-User Virtual Scouting Enable the Conversation Between Decision-Makers?

Real-time engine technology provides creatives with a new tool that has a visual feedback loop that allows the exploration of ideas at limited risk, providing transparency to the group of experts who will help achieve success.

What Are the Participants' Responsibilities?

Story, camera, art, and visual effects responsibilities ultimately remain the same with and without the virtual art department. However, it is beneficial to give everyone a clear idea of what the virtual requirements are and how long it takes to achieve different kinds of changes.

What Are the Creative and Technical Requirements?

Creative
A VAD supervisor and manager to wrangle all needed elements for the virtual reviews.

Technical

- A server that connects all scouting machines.
- Individual machines.
- VR headsets and for people wanting to be in virtual reality and meet in the cloud.
- iPad for each key creative that is wanting to use a virtual camera.
- A multi-user driver, typically separate from the Supervisor, to manage data on key creatives machines and hot load the sets for the session.

Studios use this process on a variety of production scales and magnitudes. Virtual production workflows can be performed from home, office, and anywhere in the world using the cloud. With technological advancements making things more and more available, the future of multi-user virtual scouting is sure to impact all industries, from film, television, architecture, and fashion.

Techvis for Art Departments
Felix Jorge – Narwhal Studios

Techvis for Art Departments, a Bridge Between Physical and Digital Teams
Techvis is the planning of how the production will compose a shot. Techvis can benefit a wide range of projects, from the simplest to the most complicated. The virtual art department creates techvis directly with the filmmakers in pre-production. These real-time worlds provide the data for art, camera, story, and technical crew to find alignment around the creative and the budget. What has made this process possible are the technological advancements in real-time rendering, which have provided creative teams with the ability to render in real-time, iterate on worlds live, and drive much of the creative process similar to that in real life.

Projects That Can Use Techvis
Techvis is useful for productions of all sizes and scales. However, techvis yields the most benefits for larger-scale shoots that include more moving parts, such as stunts, visual effects, moving lights, cameras, etc.

Why Is Techvis Relevant for Art Departments?

To decrease production schedules, new shoot methodologies are becoming available, such as in-camera visual effects (ICVFX). Increasingly faster changes to production processes make it difficult for art departments to account for the different setups that a team must design.

In-camera visual effects have an added challenge. The virtual sets and real-time set extensions need to be created *before* the day of the shoot. If the set extension is not ready for the shoot, corrections will be required in post-production. Techvis helps art departments plan for how much of a shot can be executed on the LED screen stage and what physical assets and sets are needed. This information helps divide how much the physical art department, virtual art department, and the visual effects team will build.

What Does Techvis With a VAD Provide?

Techvis that is created with an experienced virtual art department provides the production with a real-time 3D visualization tool that can be used to communicate the creative vision while guaranteeing attainable shots.

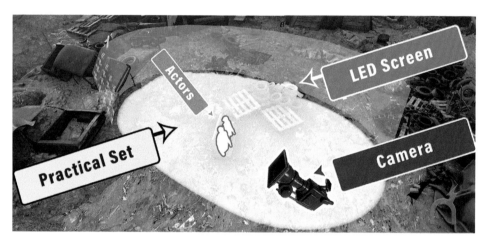

Figure 7.9 *Fathead* (2022) – Techvis information for the Ragamuffin Camp environment, with blue representing LED volume placement, green representing the actors, and yellow representing physical assets
Source: (Image courtesy of Narwhal Studios and Entertainment Technology Center)

The Bridge

The bridge is the real-time collaborative process that the VAD provides. This process empowers physical production members to directly modify digital worlds in a way that feels comfortable and familiar.

How to Create Effective Techvis That Is Less Likely to Change Later

An agreement with the decision-makers and an approval process that is inclusive of other voices is crucial to creating effective techvis. Approvals can be made on story beats, camera, lighting, architecture, shoot methodology, and other creative aspects of the production.

Entering Agreements With Decision-Makers

To achieve success when engaging filmmakers, one must listen and build an agreement around the process and results. Part of this agreement involves discussing the approval responsibilities of each key creative and introducing a sign-off step to the techvis process. This is more important than one would think. The techvis requires all members responsible for achieving the shot to sign off on the creative and the budget, before turning over the techvis.

Communication Up and Down the Ladder

Techvis is an invaluable tool that visually communicates what to expect in the shoot, allowing all teams to easily assess creative vision, technical challenges, and budgetary resources. Although techvis is not a new development, it is exciting to see techvis expanding, supporting not only the story team (previs) but also the art team, and creating a more complete techvis that can help guide productions to success in an efficient, collaborative, and transparent way.

Optimization and Delivery

Chris Swiatek – ICVR

Introduction

The VAD production period concludes with final optimization, stage testing, and delivery of the content to the stage before shooting. Depending on the delineation of production responsibilities, members of the VAD team may also be present during the pre-light and/or shoot to assist the Operator and key creatives in making requested artistic and technical changes.

This period begins with delivery of the VAD content to the stage, after which it is thoroughly tested in the target environment. Any remaining issues are identified, resolved, re-tested and approved before shooting begins.

The specifics of this process vary depending on the nature of the production and how closely the VAD and stage operations team are connected. On some productions these responsibilities are handled by the same vendor, while other times they may operate as distinctly separate teams. Regardless of team structure, the delivery and testing period should be a collaborative process between the stage operations and VAD teams and requires efficient two-way exchange of communication and data.

Asset Delivery

Content is first delivered to the stage, then loaded onto the target hardware and tested before shooting begins. Game engine assets are managed using source control software, which stores files on a central server and enables collaboration between large teams without overwriting work. At the time of this writing, Perforce Helix Core is the industry standard source control solution for Unreal Engine and therefore the best method for asset delivery to the stage. As the content should

already be stored on a Perforce Helix Core server, the VAD team can provide a login to the stage operations team to download the project. Depending on security concerns or vendor preferences, the content may also be re-hosted to an intermediary Perforce server or transferred from the VAD team's Perforce server to the stage's Perforce server.

Because the testing stage should be a collaboration between the VAD team and stage operations team, keeping the project hosted on source control is critical to ensuring a smooth two-way exchange of data. The stage team receives the content, tests it on the wall, and makes initial tweaks to fix any obvious issues. The stage team can then push these changes back to the Perforce Helix Core server so they are instantly received by the VAD team. Subsequent changes can then be made by the VAD team without fear of overwriting the initial changes made by the stage team. Without source control, any changes made by either team would have to be manually merged, introducing a higher likelihood of error and slowing down the testing process.

Delivery of content to the stage without the use of source control is only recommended in situations where the VAD team is not involved at all in testing or optimization and performs a strict linear handoff. This scenario is not recommended as it is always more efficient for the same team who originally created the content to also perform optimization and technical fixes.

Stage Testing
Once the content is delivered to the stage operations team, it is tested on stage hardware in the final shooting environment. The content is benchmarked and stress-tested to ensure it hits the target frame rate. For an LED shoot, the visual quality of the content is analyzed on the wall and through a camera lens. Any performance issues or visual issues are recorded and documented so they can be fixed before the shoot. In the interest of efficiency, the stage operations team may immediately fix simple issues that come up during testing, while more in-depth issues are relayed back to the VAD team.

Optimizing for Target Hardware
By the time content is delivered to the stage, it should already be optimized well for the target hardware (see "Managing Asset Quality and Performance Needs for Virtual Production"). Even with careful planning and testing, unexpected performance issues sometimes appear during stage testing that were not obvious in the VAD test environment.

Many issues can be narrowed down quickly by using Unreal Engine's optimization View Modes to identify problem areas or using Multi-user Editor on stage to turn scene objects on and off until the culprit object(s) is found. These techniques are helpful for revealing simple problems with straightforward fixes, like overlapping transparent textures, too many emissive light sources, or too much foliage. If these techniques do not pinpoint the problem, scene profiling can be used to identify bottlenecks.

Scene Profiling
Advanced profiling of a scene is used to identify specific bottlenecks. In Unreal Engine, this is done through runtime console commands as well as the Profiler tool. This is useful for tracking

down less obvious issues but requires a thorough understanding of real-time rendering to translate profiler output data into actionable tasks. While the technical specifics of this are outside the scope of this section, there is comprehensive documentation on the Unreal Engine website covering this. It is strongly recommended for any VAD team to have at least one game engine optimization specialist who is familiar with this process.

Visual Artifacts

For LED productions, stage testing is also used to identify visual artifacts – rendering imperfections visible on the wall and through the camera that may not be apparent to artists on their monitors. (Note that this section refers only to imperfections caused by the rendering of content on an LED wall and not in-camera artifacts like moiré, which are not content related.)

The most common of these issues is aliasing. Aliasing problems generally affect very thin objects like wires or areas of high, fine detail like tree leaves, grass, or a chain-link fence. These issues are often imperceptible on a monitor but stand out on an LED wall due to the much lower relative pixel density. Aliasing appears as visual noise or jittering when finely detailed objects (most commonly in the mid or background) jump between pixels due to micro-movements of the camera. Similar problems can also be caused by reflective objects. The easiest way to prevent these issues is to avoid problematic patterns, thin lines, and fine details in the middle or background of scenes. Alternatively, these issues can be mitigated or eliminated by tweaking anti-aliasing settings through console variables.

Digital Content Creation Software Used in VAD
Ihar Heneralau and Chris Swiatek – ICVR

Introduction

VAD production uses a variety of digital content creation (or DCC) software to perform different specialized art tasks. There is a large amount of overlap between the functionality of different DCC software, and as such, there is no "one-size-fits-all" list used by every VAD team. DCC usage varies depending on the requirements of the production and the personal preferences of artists and teams. VAD artists create assets within this DCC software and import them into Unity, Unreal Engine, or others, for scene assembly once completed.

3D asset creation can be broken down into the following series of steps, with different DCC software being preferred for each:

* Modeling.
* Surfacing.

- Animation.
- Surfacing and Look Development.
- Simulation.

Modeling

Modeling, or sculpting, refers to the creation of the 3D geometry and shape of an asset. Modeling tasks are separated into two types, with different DCC software excelling at each:

- Hard surface (prop, mechanical, environmental).
- Organic (character, animals, trees, etc.).

Hard surfaces are any solid objects that have sharp corners (generally) and are not easily deformable. Hard surface objects are typically real environment objects or mechanical equipment such as cars, props, etc.

The most commonly used tools for hard surface modeling are as follows:

- Autodesk Maya.
- Autodesk 3D Max.
- SideFX Houdini.
- Blender.
- Maxon Cinema4D.

For organic models, any of the previously mentioned modeling software can be used, but there are also specialized DCCs that excel at this task:

- Pixologic ZBrush.
- Autodesk Mudbox.

Artists may also choose specialized DCC software built for creating specific objects. Examples include SpeedTree, which is a great tool for Foliage creation, or Marvelous Designer for clothing.

Texturing / Surfacing

Texturing and surfacing include the creation of images and materials that are displayed on top of a 3D mesh. This gives the models texture, color, material, and lighting behavior. Texturing and surfacing simulate the realistic surfaces of various objects, the effects of aging, weather conditions, mechanical stress, etc.

Texturing is accomplished by applying images known as textures to the surface of a model. The textures are created in specialized software and can be generated from photographs, painted by hand, or created using a combination of both methods. The texturing process involves mapping the textures onto the 3D model in a way that conforms to its shape and allows for realistic-looking surfaces. Textures can be created in 2D using Adobe Photoshop, or within a 3D environment using the following software:

- Adobe Substance 3D Designer.
- Autodesk Mudbox.
- The Foundry Mari.
- Pilgway 3D-Coat.

The texture and base materials are created in the DCCs listed previously, then finalized during the look development stage inside of the game engine during scene assembly.

Photogrammetry

Photogrammetry is often used by VAD teams to quickly and accurately create detailed 3D models and environments by using photographs of real-world objects and locations. This process generates true-to-life textures and geometry without having to create them from scratch and is commonly used when replicating real-world locations or props. Many of the most popular Unreal Engine asset libraries, such as Quixel Megascans, use photogrammetry to create their assets.

Photogrammetry reconstruction is often performed with the following software:

- Agisoft Metashape.
- RealityCapture.

After reconstruction, textures are exported and go through a cleanup and delighting process (to remove shadows baked into the scanned assets) using the standard 3D pipeline.

Simulation

Simulation, or FX, refers to the use of computer algorithms and models to create physically realistic effects and behaviors. Simulation is used for things like weather effects, fluids, destruction (i.e., a collapsing brick wall), and movement of clothing. Because these examples are difficult or impossible to animate realistically by hand, simulation allows artists to define the behavior that is required, and then, let the software handle the heavy lifting of generating each animation frame. This results in a higher level of realism for a scene than can be achieved through pure traditional animation.

Simulation can be pre-baked or performed in real-time. Pre-baked simulation offers a higher quality output, but it cannot be changed once baked and cannot respond to any dynamic interaction in the scene. The following software is used for pre-baked simulation:

- Autodesk Maya.
- Blender.
- SideFX Houdini.

For real-time simulation, Unreal Engine has its own integrated simulation tools: Niagara and Chaos. These generally produce a lower-quality result than pre-baked simulations but offer more flexibility if there is a need to have dynamic interactions in the scene.

Content Library – Digital Backlot of Assets

Daniel Gregoire – Halon Entertainment

Content Library Assets for Virtual Production (Defined)

While many 3D asset libraries can be used for virtual production (VP), the impact of building scene files from assets not meant to run in real-time will extract a frustrating toll on the success of an LED stage shoot. Conversely, being sure library assets are conceived, scanned, built, optimized, and tested with real-time VP in mind can ensure one makes their day. The key to choosing an asset library for use in VP hinges on the aesthetic and technical way the library assets are built. Ideally, they are organized in modular pieces with various levels of selectable resolution that when assembled into larger scenes will continue to run in real-time on a defined set of hardware and displays (within reason).

There are several classes of library assets which can be considered for backgrounds in VP shoots. The first are fully 3D and include photogrammetry, 3D sculpts, and more traditional hand modeling. 3D assets typically come as individual pieces which are assembled by VAD teams into scenes allowing cinema camera tracking and parallax. They can also be digitally location scouted, re-lit, and shuffled to accommodate changes on the day. 3D scene files typically require VAD teams and powerful server infrastructure to display reliably on an LED stage.

The second class of assets is video clips, or plates. This content is usually panning, trucking, or dollying, but these assets do not contain the ability to parallax if the cinema camera is moving.

A third class of assets are still frames or video plates that have been separated into a 2.5D scene file. Using 2D layers in space allows for limited parallax when the cinema camera is moving.

Finding and Evaluating Library Assets for Integration

Commercial asset stores, such as Quixel, Kitbash 3D, Big Medium Small, and Turbosquid, are some of the better-known commercial 3D libraries with more coming online every day. These companies are continually adding new assets to their catalogs, with new companies entering the market and finding niches to fill on a regular basis, like drivingplates.com. The typical asset store has a plethora of modular assets organized by category, which sell by the piece, or as collections of pieces, any of which can be assembled by VAD teams into viable cinematic backgrounds.

Understanding how assets will be modified, assembled, and used is paramount before committing to any library. Digging into a library's technical strengths and weaknesses can help one avoid costly time and budget overruns. Looking at a library's volume and consistency of assets can prevent needing to purchase from additional libraries because of a lack of depth. Additionally, having a clearly defined and agreed-upon VAD pipeline can help match project technical requirements to library features that will provide the best results. Any manipulation of library assets will require time

and expertise to execute efficiently, whether it is a reference that will be replaced in visual effects, LED lighting, or a final ICVFX. But choosing the right starting point will save time, budget, and frustration.

To help assist artists and VAD teams in deciding which library of assets is best for the project, many companies supply DCC plug-ins (Digital Content Creation), web apps, or desktop apps to connect artists directly to search, format identification, resolution, and direct downloading into an artist's application of choice. One example is Epic Games' Quixel Bridge, which can be downloaded and used across DCC applications and in Unreal Engine. Additional middleware tools exist to extend the flexibility and lifespan of assets by allowing artists to modify aspects of an asset before downloading. Quixel Mixer is an example.

Extending Library Assets

Inevitably, through the course of production, a VAD team will find itself combining models from different sources, with the objective of creating a cohesive background that serves the needs of the shot or scene to be filmed. This process is known as kitbashing.[3]

Successful kitbashing requires a review of source assets to ensure they share common technical and aesthetic qualities. Technical specs to review include color space, texture resolution, Texel density, polygon count, native scale, acquisition, or creation method, PBR maps included, native file formats, render targets, and more. Not reviewing these technical requirements can lead to difficulties when trying to match models from one library, or store, to another in the same project. If one decides, or must, use assets that do not have similar technical or aesthetic foundations, expect to spend a significant amount of time in the VAD manually changing those assets in any multitude of ways to get them to work technically and fit visually for the desired output.

Utilizing Library Assets

No matter the use of library assets, if they will appear on camera or on screen in the final product, licensing must be reviewed per store, library, or artist source before assets are downloaded and used in a commercial production. While policies on downloaded assets should exist or be created by producers and the studio early in production, everyone in production must take responsibility for identifying where assets come from, documenting what has been used, and making sure the appropriate decision-makers are following policy for licensing review and approval before assets are integrated into any project.

As every asset store and library has different payment scenes and licensing agreements, there will be multiple business models to consider and review. Licensing can range from a store setting the same license across its entire library all the way to allowing individual authors to set their own creative commons license per asset. The same is true with payment. Some stores charge for kits, others per asset, and some have subscription fees and limits to how much one can download in a set period. Others are free for use in certain software packages and not others. Whatever business model one chooses, ensure the licensing and payment models fit the needs of the production.

Chapter 7

Version Control Software
Katie Cole and Jase Lindgren – Perforce Software

Introduction to Version Control

Tracking file versions is a common requirement in visual effects pipelines. Traditionally, studios have used a combination of naming conventions, custom scripting, and project tracking software to track file paths and statuses of different versions. Changing asset versions requires changing all file paths in all projects, leaving room for human error or requiring bespoke automation scripts. Additionally, there is no guarantee that someone will not save over a versioned file, destroying the existing data. Version control keeps an immutable history of file versions with metadata such as username, date, and comments, without relying on file renaming or manually updating paths per project. Using centralized version control provides an extra layer of backup and data protection. Version control has been used in software and video game development to manage file versions in collaborative environments for decades.

Version Control Uses in Virtual Productions

When and Why Is Version Control Used?
As the number of a project's individual assets and files increases, the burden of manually duplicating and renaming files, updating file references, and tracking changes becomes unmanageable. In virtual production and visual effects, this is especially prevalent when using real-time game engine projects and in 3D layout. Because of this, the virtual art department (VAD) is usually the first department to take advantage of version control, though many other departments – particularly any 3D departments – can utilize version control to great effect.

Beyond limiting opportunities for human error, a centralized version control system enables sharing, reuse, and continued development of assets throughout the entire production process, greatly reducing time spent on duplicate work. For example, a previsualization team can share assets with techvisualization to iterate faster. Meanwhile, the VAD works on the full-quality versions of those assets, sharing them with previs/techvis to create higher-quality visuals in less time. Version control software can also manage permissions to ensure safe file transfers to specific users and companies.

How to Choose the Right Version Control for a Production
When choosing a version control solution, there are a few key considerations:

- Binary file handling: Because 3D workflows utilize binary files (which tend to be large and cannot be read in most text editors), the version control system must be optimized to handle binary files rather than just text.
- Security and permission management: To satisfy production requirements, choose a solution that allows the studio to retain control of their assets and supports granular permissions for users.

- File locking: To avoid duplicated or conflicting work and to save many hours when collaborating, the version control system should prevent multiple users from working on the same file at the same time.
- Scalability: The ability to replicate version control across multiple servers around the world is critical for international teams.
- Flexibility: Studios may require version control to be installed on-premises, while others require the flexibility and performance of cloud-based or hybrid solutions. Version control software should support many variations.
- Integrations: To customize workflows and create software to increase productivity, version control with a robust application programming interface (API) is essential. To accelerate development, seek solutions that have existing integrations with game engines and other DCCs.

Version Control Set-up

Version control is an incredibly powerful tool in virtual production pipelines when set up effectively. Below are some important considerations when setting up version control:

1. **Decide who is responsible for the main server.** The main server acts as the final authority on all versions in a production, so deciding which entity will own and maintain the server is crucial. Even if individual studios have their own servers, one should be designated as the main server for a project, and all data should flow there. Ideally, this will be the primary production company, lead visual effects studio, or another entity, seeing the project from inception to completion.

2. **Decide where to deploy the server(s).** Many productions choose to deploy their main server in the cloud for scalability, redundancy, and global accessibility, while others choose to host theirs on-premises. In general, the cloud is the most flexible and scalable option, while an on-premises solution may be best for studios that already own and maintain physical server hardware and networking infrastructure.

3. **Determine who will administer the server.** Besides maintaining the server hardware, it is important to establish a team of day-to-day administrators who will be responsible for adding user accounts, monitoring the server, and determining user permissions. They should have experience with version control or reach out to the version control provider for guidance on best practices and security.

4. **Define collaborative workflows and branching.** Workflows vary significantly between companies and even between projects, but there are a few key principles to consider:

 a. Organize the version control by project. A separate high-level container (a "depot" or "repository") should be created for each project to facilitate easier permissions and archival storage.

 b. If the version control system can import or share files between depots, this allows for managing common assets, plug-ins, and pipeline utilities that can be used in multiple projects.

 c. Control users' ability to make conflicting changes to the same files. Binary files, such as 3D models, textures, and project files should not be edited by multiple people simultaneously because they cannot be merged. Utilize version control with exclusive locking capabilities and set exclusive file types on the server.

 d. Use branching (or streams) to isolate parallel work or enforce approval processes. By working in a single branch, users can gain immediate access to new versions and

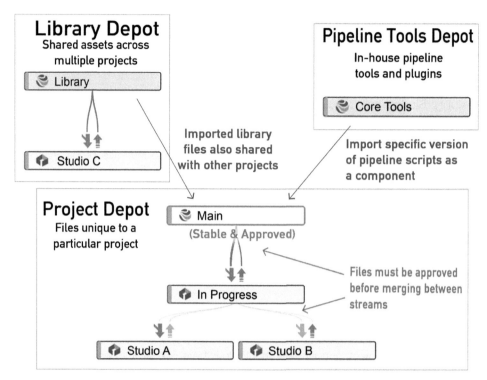

Figure 7.10 Example of multiple depots and streams in virtual production
Source: (Image courtesy of Perforce)

exclusive file locking. However, sometimes it is best to limit the flow of new data. For example, a separate LED volume branch can ensure only approved changes are updated on stage. Separate studios often use their own branches to better limit permissions and to require a producer or coordinator to approve work before it is merged into other branches.

Additional resources on version control in virtual production and visual effects:

www.perforce.com/vp-field-guide
https://perforceu.perforce.com

Notes

1 A draw call is a rendering step that occurs multiple times each frame as the graphics card requests information about objects in the scene, such as textures, states, shaders, rendering objects buffers, etc., live. The time it takes to perform a draw call is measured in milliseconds. The more draw calls that occur per frame, the longer it takes the frame to render, potentially resulting in stutter or worse.
2 Unreal Engine's system for displaying and syncing video output between multiple displays, such as the segments of paneling in an LED volume.
3 Kitbashing: "Kit" refers to "model kit." When a model maker is "kitbashing," they blend parts from different model kits. The model maker combines several individual models into an entirely new model.

8

Digital Asset Creation

Building 3D Assets in a Visual Effects Facility
Walter Schulz – 3500 Kelvin Studios

Facility-Specific Digital Assets
Visual effects studios often specialize in specific types of projects; however, in the last few years, as software advances have allowed a wider range of tools within the same package, studios have become more generalized and can tackle most projects with specific requirements.

Types of Digital Assets
From the pre-production stages and concept art, decisions are made to create the necessary digital assets for the production. These range from environments, organic and non-organic, to characters and all applied technologies such as cloth, hair, and effects.

Once a pipeline has been established, the flow from modeling to rigging, then layout and final assets, has made dealing with environments a matter of being able to procedurally create them, saving time and cost.

As of December 2022, Unreal Engine 5.1 included major developments oriented to virtual production, including Nanite, a tool that synthesizes high poly count geometry into clusters. These clusters make better use of RAM and computer resources, allowing them to run higher frame rates. The latest NVidia RTX 3000 video cards can handle the playback to maximum performance.

DOI: 10.4324/9781003366515-9

The multi-facility visual effects house can now take full advantage of these new tools to handle major visual effects shots.

Textures should be handled via Master Materials in UE5, allowing propagation of changes in the entire scene quickly and efficiently.

Acquiring Models, LiDAR, Stock, and Building Proprietary Models

In the past, creating a digital double was a costly process that required hard-to-get special equipment. But with the development of AI-based apps, such as Unreal Engine's MetaHuman, that can run on any smartphone, can take photos, and create a reconstruction with unprecedented accuracy, creating believable digital humans is easily possible. In fact, MetaHuman software has reduced the process of creating a digital double workflow to minutes instead of weeks.

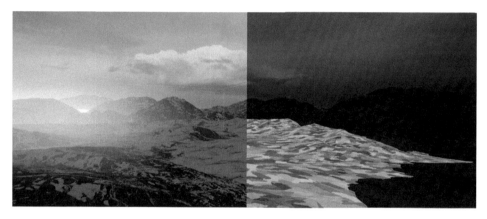

Figure 8.1 Digital landscape in UE5 showing Nanite breakdown
Source: (Image courtesy of Walter Schulz / 3500Kelvin)

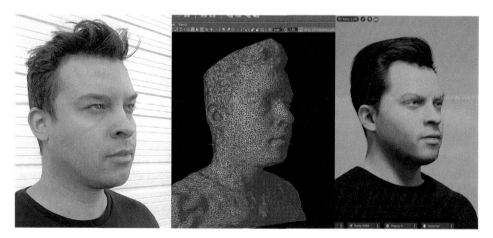

Figure 8.2 MetaHuman digital double built from photos with Poly.Cam app, optimized in Maya
Source: (Image courtesy of Walter Schulz / 3500Kelvin)

High-end visual effects studios develop their own environment and digital double pipelines with different tools. Many of these recent developments, which usually involve AI, have changed the field of digital asset creation and management.

Particle Systems

Most 3D packages have advanced tools for creating particle systems – like smoke, fire, water, etc. In the past, the procedural creation of large particle data has always been a challenge to manage. In a virtual production environment, this is still true. Due to the current state of applied technologies, streaming a scene with real-time particle systems can slow the system down and potentially crash a scene on certain configurations.

At the time of this writing, a simple NDisplay genlocked computer array can only handle so much throughput. One of the most effective hardware/software solutions currently is disguise with its flagship servers VX4, VX2, and render nodes RX running their native Designer software. This software/hardware significantly helps to allow greater loads without the unintended consequences of systems slowdowns or crashes.

In a virtual stage pipeline, they can run animated characters and multi-level particle systems from an Unreal Engine scene directly to final pixel without loss of speed or frame rate.

Production-Based Workflows

Specifications for digital assets vary with each type of production. Requiring camera approximation (close-up or extreme close-up) to any digital asset increases the cost and complexity of any object, character, or effect.

The evolution of real-time graphics was necessitated by the need to automate processes and workflows. Pipelines and established software packages continue to evolve, improving all aspects of virtual production.

High-resolution objects from libraries, such as Quixel's MegaScans, bring production value and photorealistic results almost immediately. But beware! A simple tree stump might be adding millions of polygons into the data stream going to the LED wall. This kind of "invisible" data increase could potentially slow down the playback rate or even crash the scene. Unreal Engine's 5.1 Nanite technology improvements help synthesize that geometry, bringing it into the wall in a safer way that was not possible previously.

Virtual Production Specifications for Digital Assets/UE5 – Unity

Whether a facility is running an NDisplay array or a disguise VX4/RX setup, testing the pipeline before the shoot day for frame rates and speeds is essential. Baking a scene in the Unreal Engine does not guarantee it will run the same way on the disguise VX4 or GX2 server side to project the content. Always allow enough time for optimization and testing before the day of the shoot.

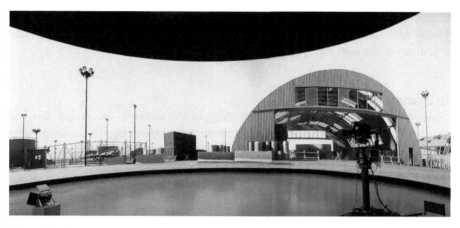

Figure 8.3 Digital scene projected on an LED wall
Source: (Image courtesy of Walter Schulz & Mac Jeffries / 3500Kelvin)

Unity is another alternative that is making significant progress in the virtual production realm through the acquisition of Ziva Dynamics, which has extraordinary muscle, skin, and real physics simulations applied to characters.

Copyright Considerations

Replicating real-world objects is easier than ever before, but just because it can be done does not mean it should be done. New legal boundaries have been increasing in the intricate copyright laws. For example, some countries have decided to start copyrighting their famous landmarks. If there is a way to recreate a character or an object from photographs, it would be nearly impossible to regulate the replication of any specific valuable assets.

The future is opening other possibilities, such as reactivating franchises from celebrities who are no longer alive and making new movies with their digital doubles.

Ultimately, experimentation is what will propel virtual production asset building in the future, especially with AI and machine learning's contributions.

Capturing Surfaces With Photogrammetry to Create Assets
Luis Cataldi – Epic Games

Introduction

Photogrammetry is the technique of taking dozens (if not hundreds) of overlapping images of a particular surface or object with the goal of creating 3D models. The process requires that those

images be fed into very specialized software, which then evaluates the images for common data points. That data is then processed and aligned to generate a high-resolution 3D model with associated texture for output to real-time or offline software tools.

Since the mid 1990s, groundbreaking films such as *Godzilla* (1998) and *Fight Club* (1999) utilized a game-changing technology known as photogrammetry to provide solutions to the challenges of creating photorealistic digital content. Specialized photogrammetry software has become a viable solution for building photorealistic digital worlds.

An excellent example of consistent quality professional photogrammetry-based content is available within Unreal Engine 5 via Quixel Bridge. With the help of RealityCapture software, Quixel has developed expertise in photogrammetry in the development of the Megascan library. Both Quixel and RealityCapture provide a wealth of additional learning resources on their websites and YouTube channels.

Core Principles of Photogrammetry

Creating 3D objects from photographs requires taking lots and lots of images of a given object. Another term for this process is "scanning." The process of scanning can be performed using professional DSLR cameras configured to take images from every possible angle of an object. Drones mounted with cameras can be flown to capture images where humans are challenged to navigate. Even current generation smartphones have the capacity to capture high-resolution scans due to the quality of their built-in cameras.

Typically, the biggest considerations for scanning include image quality, subject coverage, and information overlap. Image quality is related to capturing the largest and sharpest images possible. This requires the subject to be consistently in focus, with minimal to no depth-of-field, and little to no image noise. Subject coverage is calculated by ensuring that every possible angle and detail of the subject is captured during the scanning process. This is done by encircling and enveloping the subject with images. The third consideration is overlap between each of the images in each scan. For a computer to be able to align the scans into a three-dimensional object, it typically compares detail and color information from image to image to determine how the subject is to be reconstructed in three dimensions. To provide the computer with enough information to complete this task, scanned images need to have approximately 70 percent overlap to be the most effective.

Applied Principles of Image Capture for Photogrammetry

The quality of images taken from digital cameras and smartphones differs as well as between photographers. A skilled and aware photographer can produce high-quality images sufficient for photogrammetry from almost any digital camera and most smartphones with a little practice.

IMAGE RESOLUTION

This is the level of detail captured in an image by a camera or smartphone. The higher the image resolution, the more accurate the photogrammetry alignment is during the 3D reconstruction. This is a result of the software having more detailed pixels to evaluate per each high-resolution image.

127

Figure 8.4 A good example of dense subject coverage for a fence
Source: (Image courtesy of Quixel)

The higher the resolution that a camera can capture (or scan) of a subject, the more pixels per image are provided to the alignment software during reconstruction. The ideal camera for photogrammetry is often a high-resolution, full-frame digital camera capable of capturing in the RAW file format.

LENSES

Any camera lens capable of taking sharp images can be used for photogrammetry; however prime lenses are typically known for producing very sharp images and tend to be desirable. It is not uncommon to scan with 35mm lenses because they allow one to stay relatively close to the subject while minimizing lens distortion. There are times when shooting with a zoom lens can be helpful if maintaining distance to the subject is not always within one's control. Another key consideration is lighting. Scanning with lighting that is consistent and has reduced shadows and highlights produces the best results. In photography this is often called "flat lighting," which allows accurate capture of the subject's shape and surface texture without capturing the light sources affecting the subject with reflections and shadows.

DEPTH OF FIELD

Creating a deep depth of field by using a higher f/stop number and a smaller aperture setting will help reduce blurring in the image and achieve greater overall sharpness. A faster shutter speed

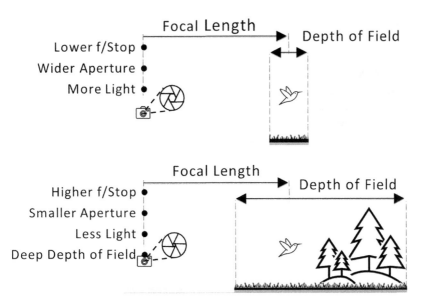

Figure 8.5 The effects of aperture on depth of field
Source: (Image courtesy of Quixel)

will also help to keep the subject in sharp focus, but the combination of all of these settings may require additional illumination.

A technique known as Cross Polarization has been developed to help eliminate reflections and shadows on a given subject – in essence de-lighting the subject through the use of polarizing filters. There are many helpful online resources that teach how Cross Polarization works and how it can be applied with off-the-shelf camera equipment for those interested.

The reason for de-lighting a subject is related to how the final 3D asset is to be used in a digital space. In 3D environments, the lighting and environmental settings may not match the lighting of the real world. For example, if the sun were to cast a warm light and strong directional shadows on a given subject in the real world, the ability to use as many different lighting setups as possible is needed to match the real world with the final 3D asset in the virtual environment. Using de-lighting techniques helps to ensure that the final digital asset can be used in as many digitally recreated settings as possible.

Capture Methods and Workflows

There are various methods for capturing a subject:

- Handheld scanning: This is the process of making concentric circles around the subject while maintaining proper distance to the subject and achieving the desired amount of overlap. Though this process takes some practice, it is not overly complicated or difficult depending on the environment or subject.
- Turntables: When the subject is small and portable enough that it can be placed on a turntable, and instead of moving around the subject with a camera, the camera stays stationary,

and the subject is rotated on the turntable to achieve the desired amount of overlap and coverage. These techniques can yield consistent results particularly with controlled light sources.

- Drones: With hard-to-reach areas, a drone with a high-resolution camera can also be utilized to scan cliffs, sides of buildings, or many other types of subjects that could be dangerous or impossible for handheld scanning to achieve. Typically, this process is very similar to handheld scanning with the exception of the fact that camera controls are done through a different type of interface.
- Laser and LiDAR: Laser scanning is the process of employing laser pulses to capture precise, three-dimensional information from a subject to create point cloud data which can be crafted into a digital model. LiDAR scanning functions in a similar way to capture surrounding environments while generating and measuring the millions of data points to create three-dimensional representations of an entire environment.

After scanning a subject, it typically needs to be processed on a computer by specialized software. There are various types and qualities of software on the market for achieving these outcomes, and now smartphones are capable of both capturing and processing scans all on one device. Quixel utilizes RealityCapture by Capturing Reality. Capturing Reality also makes a smartphone application called RealityScan that can deliver very high-quality scans.

Final Thoughts

In a world where "content is king," having the ability to scan the things around or in one's home with one's smartphone is game-changing technology. The craft and skills required to build digital worlds require a lot of three-dimensional content, and photogrammetry can provide pivotal game-changing technology to help artists and designers focus on the task at hand. Photogrammetry may be tackled at various levels of precision and expertise depending on the desired outcomes. Armed with a bit of knowledge, some easily accessible tools, this game changing technology can be utilized by anyone with an appetite for content or a need and desire to build digital worlds.

Procedural Digital Asset Creation
Jeff Farris – Epic Games

Procedural Digital Asset Creation

Procedural asset creation involves using automated systems and computer software to author digital content. There are many forms of procedural systems, and they vary widely in complexity, capability, and cost. They can be simple, such as choosing random T-shirt colors for a crowd of characters or making every tree asset above a certain altitude be a spruce tree. They can model complex physical phenomena like the motion of fluids or the interactions of millions of dynamic rigid bodies. Or they can even lean on advanced AI techniques like machine learning to

synthesize new content from minimal inputs. By becoming familiar with the capabilities of procedural approaches, digital content creators can have another powerful tool in their toolbox.

Why Create Assets Procedurally?

Computers are excellent at automating repetitive tasks. This alone can be leveraged for massive efficiency gains. But computers are also excellent at quickly performing complex calculations at scales necessary to simulate complex physical processes in the real world. Together, these can even allow individuals to produce assets at a quality and scale that would otherwise be achievable only by large teams at great expense. The benefits are straightforward and quantifiable. Consider generating a forest scene as an example; finishing the layout in a day instead of a week is attractive to any production's bottom line.

There are intangible benefits to consider as well. Quality is a harder concept to model in a cost-benefit analysis but is no less important. Imagine building an environment that contains a collapsed building. It would be a tall order to ask an artist to manually arrange thousands of pieces of rubble in a plausible configuration, ensuring no interpenetrations, and having the result look natural. The incentive in a case like this is to achieve a minimally adequate result and move on. But by using procedural techniques to simulate the physical processes of the settling rubble, an artist could achieve high-quality and visually plausible results rapidly while maintaining the opportunity for ongoing iteration and improvement. The bar for what is considered "good enough" becomes "as good as possible."

The opportunity for more iteration also increases creative flexibility. Allowing creators to efficiently experiment and refine their content is critical to quality creative output. Think of a forest setting again. Using a system to procedurally generate and arrange tree meshes, it could be possible to test different tree species within minutes. It would also be possible to re-run the procedural system after changes to the ground geometry or when adding a clearing or moving a building. Without such a system, it would likely be cost-prohibitive to explore creative possibilities in this way.

What Kinds of Assets Can Be Created Procedurally

Proceduralism is an appropriate approach in many scenarios. But different problem domains can require widely different techniques, algorithms, and tools. While there exists some generalized procedural simulation products that are broadly useful (such as SideFX's Houdini software), there is no universal procedural tool that can handle every use case out of the box. Below are some examples of commonly synthesized asset types. This is by no means exhaustive but is meant to illustrate some common cases and the range of possibilities within the space.

Characters

Character creators are a staple in the video game industry. These are typically presented as parameterized human mesh generators, implemented with techniques like swappable segmented meshes, morph target blending, and shader choices. Similar techniques can be used in virtual production contexts as well to help rapidly produce character meshes for cases like backgrounds or crowds.

Figure 8.6 A procedurally generated MetaHuman, from the MetaHuman sample in Unreal Engine 5.1
Source: (Image courtesy of Epic Games)

Newer advancements (like Unreal Engine's MetaHumans) aim to raise the quality bar by using machine learning AI techniques to quickly generate customizable high-fidelity characters that are rigged for animation and ready to use.

Environments

City generation is a well-researched area with many algorithms, papers, and commercial products available. The same is true for many other biomes, such as forests or mountains. There are even specialized generators that can simulate natural processes like wind and water flow to sculpt terrain and produce entire lifelike worlds.

Some environmental elements are also common targets for procedural generation. Algorithmic tree and foliage generation is an excellent example, with commercial packages like SpeedTree available that can produce fast, high-quality results.

Concept Art

AI-generated art is a new, and rapidly evolving, field with potential to massively impact many creative industries. Products in this space can take a text description as input and use it to produce relevant, complex, and occasionally stunning images. This technique is not a substitute for traditional concept art but can augment traditional methods and accelerate the early phases of creative exploration.

Animations

An animation-synthesis technique called "motion matching" has become widely used in recent years. This is a technique that leverages a database of pre-recorded animation sequences to

Figure 8.7 A procedurally generated city featured in the CitySample sample project in Unreal Engine 5.1
Source: (Image courtesy of Epic Games)

continually choose and blend poses based on what a digital character is doing at any given moment. The result is a very fluid and satisfying synthesized motion.

When to Generate Assets Procedurally

Though there can be many benefits to procedural asset generation techniques, they are not appropriate in every situation. It is critical to understand the needs of a project to make informed decisions about tools and techniques required to execute it. Like many other technologies, procedural generation is one of many options available to solve a problem when the right situation arises.

Identifying the right situation can be a challenge. One common case, such as when many similar variations of an asset are needed, is a situation suitable for automation. As an example, consider using a procedural tree generator to make randomized variations of an oak tree or using a scatter tool to place thousands of rocks across a terrain.

Another situation to look for is where the challenge is scale. Imagine a sports show with many stadium crowd shots. It would be impractical to fill a virtual stadium with 100,000 hand-authored crowd characters, whereas a character generator could do that job order of magnitude faster.

Of course, there can be downsides. It is important to carefully consider the costs of adopting procedural techniques. In practical terms, this is typically a straightforward trade-off; invest some effort up front to establish a system and get a long-term win on efficient content creation. But this initial investment can be significant. Projects can choose to purchase a commercial software package, or they can build a custom system with a team of engineers and technical

artists. Often it is a combination of both as commercial systems rarely produce exactly what is needed directly out of the box and can still require non-trivial development work to get the desired results. Weigh this carefully against the anticipated payoff. Building a complex procedural system may not make sense for a few shots in a single show but could make sense for a long-running series or a studio interested in leveraging this technology for several projects.

It is also important to think about the asset quality requirements. Procedural approaches can sometimes produce results that *feel* algorithmic, containing subtle patterns or missing creative flair that a skilled artist would provide. They may not always stand up to scrutiny as foreground elements in a shot or for hero characters. Hybrid approaches are worth considering in cases like this, where proceduralism is used to do the initial pass on the asset. This can then be refined by hand to achieve the desired quality.

Workflow Considerations

A key aspect of using procedural content creation techniques is knowing when to abandon them. Sometimes a system can produce final content at adequate quality. But it is often necessary for human intervention to get to the finish line. In these cases, try to avoid hand-editing the content, if possible, until it is clear that the procedural system is no longer useful. Re-generating assets with the system is likely to destroy any hand-made adjustments – meaning they will have to be made again.

For this reason, try to favor systems with a high degree of customizability. Having a larger possibility space will make it easier to avoid hand-editing too early. Sometimes procedural systems will feature the ability to introduce certain kinds of manual edits that can survive a regeneration step. Prioritize having this capability, whether choosing or designing such a system.

Finally, look for systems that offer the ability to control content generation at a high level of granularity. The ability to limit generation to a subset of an asset can be very powerful. Similarly, the ability to run a partial re-simulation by only executing certain steps in a process can greatly increase flexibility by making it easier to preserve manual work.

Move AI – Markerless Motion Capture
Niall Hendry – Move AI

Move AI has created a markerless motion capture system which utilizes artificial intelligence and advanced mathematics to process multiple video sources to generate production-level-quality motion capture data.

The Move platform is able to capture the authentic performance of multiple people and objects – without the need for marker-based optical or inertial-based suits. The platform only requires regular, off-the-shelf cameras, for example, iPhones, GoPros, or more professional

cameras such as Panasonic Lumix BGH1 or Blackmagic Ursa cameras. The platform can process video at a minimum of 1920 x 1080 HD at 30 frames per second and can run up to 120 frames per second, or up to a maximum resolution of 2160 × 3840 4K at up to 120 frames per second. Video is captured using a suitable camera system which is arranged around the capture volume. The cameras can be rigged to fixed points or tripods. The system is flexible enough to be deployed across different environments (indoor studio, skateboard park, basketball court, staircase, etc.) and different scales (4 meters by 4 meters, up to 100 meters by 75 meters) capturing between 1 and 22 people – depending on the requirements of the production. The platform tracks body, hands, and objects. The full technical workflow is comprised of the following:

- Artificial Intelligence to extract full human body motion, using convolutional neural networks, and object tracking, using neural networks.
- Computer Vision, providing automatic 3D scene reconstruction and calibration.
- Biomechanics, providing in-built modelling and understanding of human body capabilities and limitations.
- Statistics, using advanced mathematical models to remove anomalistic data.
- Physics, for understanding the dynamic forces that result from the interaction of the performers with the surrounding real-world.

The resulting animation output files are then downloaded as an FBX, BVH, BLEND, MB, C4D or USD file to the user's preferred graphics engine, such as Unreal Engine or Unity, at the click of a button. Use cases for the data include character animation for film, TV and video games, and compositing in visual effects.

Move AI has also built a real-time system deployed on local hardware using power-over-ethernet cameras. The real-time system uses a minimum of four cameras and a maximum of eight cameras, running at a maximum of 4K resolution at 60 frames per second. The real-time system can track anywhere from one person to a maximum of five people, with a delay from video capture to visual output of approximately five frames. The real-time system has a plug-in that streams data directly into Epic Games' Unreal Engine that retargets the motion capture data for performers within the capture volume to character rigs within the render engine. These rigs can be either the Unreal Engine 4 Mannequin or the MetaHuman. The system is also integrated into the disguise d3 software for usage in virtual production and extended reality use cases.

Specific technical workflows and uses for real-time motion capture data include the following:

- Real-time shadow casting within virtual production volumes where lighting cannot be utilized to create shadows on LED walls or floors.
- Real-time puppeteering, where rigged character files are animated in real-time based upon a performer's movement (as seen in Figure 8.8).
- Real-time particle dispersion of effects such as fire, water, gas, or fog.
- Real-time augmented effects triggered by, or linked to, the performer's limbs.

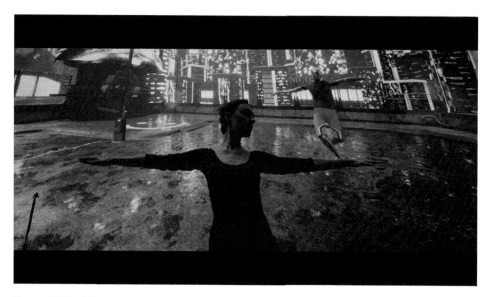

Figure 8.8 Real-time motion performance captured by Move AI's markerless motion capture system, displayed in Unreal Engine behind the performer
Source: (Image courtesy of Move AI)

Using Miniatures for Virtual Production
Fon Davis – Fonco Studios and Matt Altman

There are two main categories of using miniatures for virtual production:

1. Miniatures shot in front of an LED wall: Using practical, physical miniatures and placing them *in front of* a virtual environment, such as an LED wall.
2. Miniatures are scanned and inserted into a virtual environment: Creating a digital asset that can be imported *into* a virtual environment.

The Design, Planning, and Budgeting of Miniatures for Virtual Production

How to Utilize Different Techniques to Balance Budget, Schedule, and Quality

Using miniatures in virtual production sometimes makes it easier to achieve photorealism faster and less expensively than trying to achieve in CG exclusively. The benefit of using miniatures versus digitized assets depends largely on how the miniatures are interacting with the virtual environment if there are high-frequency details or other chaos effects in the scene. The benefits of utilizing miniatures are capturing photoreal randomness like complex paint finishes, reflective surfaces, high-frequency textures, explosions, smoke, fire, water, or other chaos effects that require a great deal of labor or sophisticated, time-consuming physics simulators.

The design process for miniatures has not changed much with the advent of virtual production except for the need to start sooner in the production timeline to have assets ready for principal

photography. Just like any other element of virtual production scheduling, what was traditionally created in post-production for visual effects now must be ready for principal photography. Since principal photography scheduling is usually less flexible than post-production, it is important to have the assets ready when required during production.

The choice of creating a miniature or digital model is based on levels of difficulty and considering if a digital asset needs to be created. The reason not to create the model in CG is that it is often possible to achieve a higher photoreal quality in a shorter timeline using a miniature.

Budgeting for miniatures in virtual production is similar to budgeting for most elements that go into production. Costs for digital models should be weighed against costs for physical versions of each element while considering quality and photorealism and balancing it with the schedule.

One popular budgeting method is to look at the number of shots that the asset is to be utilized in and amortize that cost over that number of shots. For example, when an asset is only used in one or two shots, the cost should probably be kept as low as possible. If an asset is used in many shots, it can justify a greater cost.

Regarding budget, consider the artist's labor, schedule, quality level achievable, LED wall operation and camera crew, and the cost of the LED wall itself. Having a producer who understands the process and has the experience to flag problems, balance the workload between the departments to achieve the most beneficial budget, schedule, and quality is essential.

Preparation of Physical and Digital Assets

Model Fabrication Techniques for the Best Results Against LED Walls and Their Lighting

Model fabrication techniques do not change much between shooting in front of the LED wall or shooting in front of a green screen. There are some advantages to shooting in front of an LED wall though, such as being able to use shiny or reflective surfaces and no greenscreen lighting spill.

Miniatures and full-sized sets have similar considerations when filming in front of an LED wall. Additional lighting is important to illuminate the miniature and usually necessary beyond the LED wall's own capacity to light objects. An LED wall color spectrum is not, at the time of this writing, comparable to movie lights. A good movie light's CRI (color rendering index) could be 90, or 95, while the LED wall's CRI is about 13. The brightness of the elements in the display must be balanced with the physical object, which helps create a lighting match between the physical environment and the LED (virtual) environment. However, one must be careful to keep the practical light's spill off the LED wall because the spill light will potentially wash out the LED wall image.

DIGITIZING PHYSICAL ASSETS FOR UNREAL ENVIRONMENTS

One technique is to create a computer model in digital form using any computer modeling software. Once the computer model exists, a 3D print of it can be produced and handed off to artists

137

for real-world painting. Then that physical asset can be photographed to use as texture maps on the existing digital asset. This allows photorealistic paint jobs to be applied to the digital model to quickly make it more photoreal.

Another technique is to create a physical version of the asset in miniature and then 3D scan that to create a digital model. This technique needs an artist to create the physical object as well as the painting and texturing it so it can be scanned or photographed. It is a different technique to arrive at the same product: A more photoreal digital model.

There are multiple methods to digitize physical assets. The time-consuming technique is to measure, photograph, and build it using references. The faster way to do it is 3D laser scanning, which captures the surface and texture as virtual data, while also photographing the object. Taking photographic reference of a physical miniature or model for use as texture maps can be effective as well. To digitize texture maps, it is important to get good photographs in flat, neutral lighting, avoiding shadows and reflections.

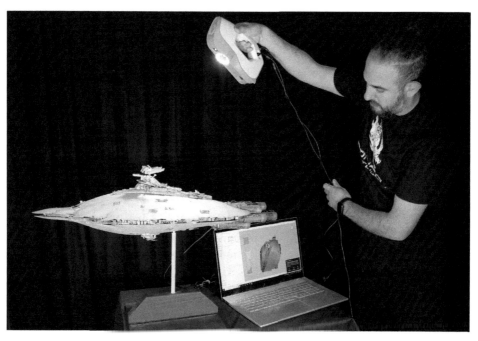

Figure 8.9 Miniature getting 3D scanned
Source: (Image courtesy of Fon Davis)

Another popular method being used is photogrammetry. This tends to be less accurate, but it is improving with evolving software. Whichever method used is influenced by the time, budget, and quality required. For a foreground hero element, building it from scratch and 3D scanning it with a laser might be the best method. For a background object, the same level of accuracy and detail may not be required, and a lower polygon count may be preferred.

There are many differences between LED walls and green screen. LED walls are permanent stages that can be altered and changed from scene to scene, create entire virtual environments, or maintain

the same effects and extended sets. A green screen is not as versatile, and any special effects on a green screen must be created each time it is used, which often requires months of labor. LED walls can also track the camera, allowing alternate rod removal for miniatures. As mentioned, shiny and reflective surfaces are not as big of a challenge with an LED wall. In some ways, one cannot really equate an LED wall and a green screen at all. The LED wall is a production tool that lasts throughout pre-production, production, and all the way through post-production. It may not be used for every shot but will probably be used for a number of shots that would have required months of green-screen comp work and may not result in the same quality or realism in the end.

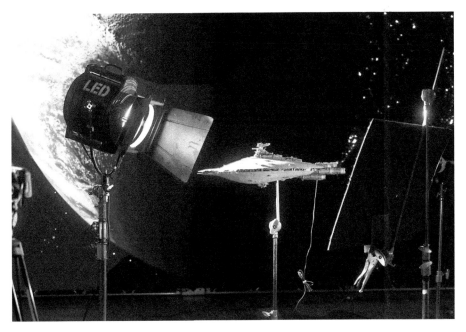

Figure 8.10 Miniature in front of LED wall
Source: (Image courtesy of Fon Davis)

Photography in the Volume as It Relates to Miniatures

Photography of Movement
When creating a set extension for a miniature, it is useful to design transition points between the LED wall and the miniature itself. The texture should be such that it helps disguise the transition between it and the LED wall. One method to achieve this is to have the foreground miniature landscape drop off and have the LED wall landscape take over. If it is an undulated surface, like a sand dune, the edge of the model should curve down. A hard edge will pick up highlights and stand out. Curving it down eliminates the edge, avoids the edge light, and creates a smooth transition. Building in "cutters" such as a horizon, cars, buildings, or foreground elements also helps disguise the transition.

Lighting, Focal Length, and Lens Choices
The same things that are important in shooting miniatures on a forced perspective shot are important in shooting miniatures in front of an LED wall. The LED wall should be as bright as possible, though

additional lighting will probably be required. The miniature should be brightly lit enough to allow the iris of the camera to be closed enough to create the maximum focal length, which puts the entire miniature and the LED wall in focus. Maximum focal length is desirable to get the optimum result.

Distance between physical objects, like miniatures and the LED wall, depends on the pixel pitch. 2.8- or 2.6-pixel pitch is standard for many virtual stages around the world. This means that the camera must be at least 18 feet away. Allowing closer camera shots makes shooting miniatures easier. A 1.9-pixel pitch or a 1.5-pixel pitch allows the camera to be closer, which is better for miniatures. With a 1.5-pixel pitch, the camera can be as close as three feet from the wall.

Stop Motion Photography

Stop motion photography on an LED wall requires a still image on the LED wall, or the LED wall needs to match the frame rate of the camera for cohesive stop motion photography.

The considerations with stop motion are the same as shooting any miniatures, but a decision must be made about how much of the foreground in miniature should be built and how much of it is extended on the LED wall.

Because miniatures often require shooting at higher film speeds, for the scale of motion, the LED wall must play its frames at that same speed to achieve the maximum believability of the shot.

Using Difference Matte and Image Sync for Rod Removal and Composites

Rod removal is often necessary with miniatures. The same considerations for rod removal on a green screen are the same as on an LED wall. Essentially, paint the rod green and comp it out. An alternate method for rod removal is a difference matte, which will extract whatever is different between frames. It is possible to run Take Recorder software so that all camera tracking information exists, recording what is on the wall – specifically with the camera movements.

Preparing 2D Plates for Virtual Production

Sam Nicholson, ASC – Stargate Studios

Introduction to Preparing 2D Assets for Virtual Production

The Photographic Plates vs. Computer-Generated Plates

Photographic plates are a great source of real-world backgrounds for virtual production. They are photoreal, highly detailed, and economical to capture compared to computer-generated assets. One can also build very high-resolution images for large-scale LED walls using multiple camera

configurations. When considering the advantages of photographic plates, it is important to keep in mind that despite their benefits, they are flat. One can create a convincing illusion of depth and parallax using flat photographic plates, using off-axis projection techniques such as Unreal Engine – NDisplay. But if one is planning on a great deal of camera movement on an LED stage, with a high level of parallax on foreground and mid-ground objects, computer-generated 3D models or a hybrid mix of the two techniques are recommended.

Static Plates vs. Moving Plates

Static plates are considerably easier to shoot and prepare for playback than are moving plates. When shooting static plates for a virtual production scene, like an outdoor restaurant background, a single camera can create large-scale panoramic backgrounds by simply panning the camera on a nodal head and then stitching the individual shots into a single very high-resolution background.

Moving plates are more complex to shoot and manage on set. However, they are essential for dynamic driving or train sequences. Multiple camera configurations are generally employed to shoot moving plates for scenes involving a great deal of motion or travel.

Camera Choices

Choosing the right camera is essential to achieve optimal playback on set. There are a number of excellent cameras and lenses available from multiple manufacturers that all perform well. Camera choice should be something that one is comfortable with and provides the best possible quality, at an affordable price. One will generally be shooting wide shots for background projection. Therefore, a wide lens, or the wide-angle end of a zoom lens, is up to the task. When shooting with multiple cameras it is also important to consider the camera weight, power requirements, sync camera control, and rigging points that will be used in the final setup.

Resolution

One is striving to recreate reality on a virtual production stage. And the real world has unlimited resolution with zero noise. Pristine original plate quality will translate into the most photoreal results when rephotographed on an LED volume. Therefore, one wants as much resolution, dynamic range, sharpness, and low noise, on the original camera data and background plates as possible. Photographic images for virtual production backgrounds may be displayed thousands of times their original size on very large-scale LED walls. Lack of resolution or signal noise will be compounded multiple times and destroy the realism. Any lack of quality and compression artifacts in the original footage will be magnified many times on a large LED wall.

Dynamic Range

Always capture the most dynamic range possible in the original plate photography. Shooting in LOG space or RAW is recommended and at the highest bit rate, which is practical. At least 8K, 4:2:2, 10-bit camera originals are recommended for playback and color grading. The dynamic

range of the photographic plates should always exceed the dynamic range of the video wall. This will provide greater latitude to adjust the image during playback.

360° Image Capture

360° cameras offer seamless immersive images and are very effective for static background plate capture. However, they pose a number of challenges to mobile setups. The size and weight of the larger camera platforms present a considerable rigging challenge on vehicles. 360° cameras limited overall horizontal resolution makes it extremely difficult to get very high-resolution images displayed on large video walls. If one is planning a continuous 360° move around a car, a seamless 360° background is essential; however for traditional dramatic coverage, multiple separate high-resolution camera angles are more effective.

Global Illumination Mapping

Global illumination maps generated with smaller 360° cameras are easy to shoot with and are a great tool on set when employing pixel-mapped lighting. A 360° illumination map will provide detailed input for any DMX addressable LED studio light. A 360° HDRI global illumination map is also essential if adding computer-generated models in post-production visual effects.

GPS and Location Data

Location data is convenient but not essential when shooting photographic plates for virtual production. Sun angles, time of day, and location specifics are a great help in roughing in the set lighting to match the location. GPS data can also be used to create a location-specific road map for archive and stock library purposes. Well-organized plates are essential for smooth playback on set. Most shows employing virtual production will be highly demanding on set, so it pays to be organized. Detailed notes, camera logs, and the ability to trace back and find the original camera data is essential for a smooth shoot.

Documentation for Visual Effects Pre-Compositing

If one is going to pre-composite material for playback on set, it is important to document the additions or changes to the original footage. Time intensive adjustments to the footage, such as stitching and stabilization, must be done prior to shooting. Image processing, such as blur, color correction, and editorial adjustments, will most likely be done live on set depending on the specific playback system.

Playback Considerations

Organization and prep of photographic assets before the LED shoot is essential. All assets must be loaded into the playback system and tested *before the shoot day*. The more information and plate selects one can get ahead of the shoot day from the Director and the Director of Photography, the easier it will be to anticipate the proper playback elements, ensuring a smooth shoot day.

9

Volumetric Capture for Humans

Overview of Volumetric Capture
Spencer Reynolds, Jason Waskey, and Steve Sullivan – Microsoft

Introduction to Volumetric Video

Volumetric video is a type of content that captures the full three-dimensional shape and appearance of subject for viewing from any angle at any time. While 2D film/video intrinsically represents a fixed viewpoint from the perspective of a single camera, volumetric video utilizes views from multiple cameras capturing a defined volume, separating the viewing perspective from the capture perspectives. The size and shape of the capture volume can vary based on the number of cameras employed and their collective coverage of the volume. For example, today's large systems capture entire athletic fields, while smaller volumes are a few feet or even inches wide. These camera views are subject to occlusion, so a sufficiently dense array of cameras is required to provide proper coverage. Similarly, the capture resolution and distance determine the detail available at viewing time, so a stadium-sized capture volume would not lend itself to viewing an athlete's facial expressions. In practice, most volumetric video today is captured from camera rigs surrounding an enclosed volume, and most captures tend to focus on human and animal performances. There is nothing about the content type requiring this, but human subjects at full-body scale tend to be the most common scenario.

In some ways, volumetric video capture systems are similar to optical motion capture (mocap) installations, but the assets each system generates and production use-cases are very different. Both use arrays of synchronized cameras that are calibrated for intrinsic and extrinsic properties (3D position, view frustum, resolution, lens parameters, etc.) to capture content within a defined

DOI: 10.4324/9781003366515-10

volume. Motion capture generates the 4D trajectories of fixed markers and saves the resulting data for further use. Volumetric video, on the other hand, is focused on recording the *integrated* shape, color, and motion of content within the volume. In short, mocap is solving for the skeletal motion of a performer or rigid objects, while volumetric video is for the recording and playback of the surface and appearance. The two technologies can be used in conjunction, for example, to mocap a tool like a golf club being used by a volumetric performer, and then replace it with a higher fidelity CGI club.

There are several approaches for volumetric data to be captured, represented, and viewed. All support the free-viewpoint requirement and have unique pros and cons.

Capture Approaches

Most commercial systems for volumetric video rely on depth estimates from a range of viewpoints, which are then fused into coherent geometry and textured. The exact sensors, estimation approach, and accuracy varies widely. Several common techniques:

- Stereo solutions generate sets of depth maps utilizing cameras arranged in dense stereo pairs around the volume. With more views, occlusion is reduced, and a wider array of computer vision (CV) and machine learning (ML) algorithms can be leveraged to generate higher quality meshes/points/voxels and textures. While more source material permits flexibility when processing a final asset, there is a larger data load and offline processing requirement.
- Depth (RGBD) camera solutions capture both the color and shape of content directly from a single device, and this data can be merged/stitched across camera views using methods similar to the stereo approach. Because the depth and color data generated from current RGBD cameras are lower fidelity compared with stereo solutions, the results tend to be lower quality. However, the hardware is often lower cost, and the lower data rates are more suitable for real-time scenarios.
- View-interpolation solutions do not explicitly reconstruct the detailed shape but instead use a sparser array of 2D cameras to generate estimated views between distinct camera positions. This approach is often used for larger volume scenarios and will sometimes use CV and ML methods such as wide baseline stereo and hull carving to roughly estimate the shape/volume of objects within the scene, but the fidelity of reconstructed objects in the scene is lower and generally are only viable for wide shots.

Representations

Volumetric content can be represented in many ways, but three approaches are most common:

- Point-clouds are the collection of individual 3D points computed during depth reconstruction. Because volumetric video generates multiple point-clouds from disparate viewing anvgles, these clouds are combined and can become very dense and often redundant. With proper filtering, clouds can retain shape and detail of the content and reduce data size, but size can still be cumbersome for some post-production and viewing scenarios, and rendering must account for gaps between the points.
- Mesh solutions convert point-cloud or depth-map data into tessellated geometry and textures. Meshes span the gaps between points to represent the full surface, and they are widely

supported in content creation tools and interactive renderers/game engines. They are currently the most common format for commercial volumetric systems, though they present challenges in areas of fine detail such as some hairstyles where a single surface is not a good representation.

- Voxel solutions are inherently volumetric, decomposing space into 3D pixels (a.k.a. "voxels") indicating where the surface lies. The voxels often carry extra information such as color, opacity, surface normal, material properties, etc. Voxel representations account for the gaps between points, are easy to render, and can flexibly represent different levels of detail in different regions. Voxels are not as well supported in common content creation pipelines and renderers, though solutions do exist.

Use-Cases

The last half decade has seen volumetric capture used across a wide range of scenarios, including feature film production, sports, music, education, training, and fashion, to name a few. Volumetric captures have been used in traditional 2D outlets like film and video and increasingly in emerging experiences that take advantage of virtual or augmented reality.

In traditional 2D filmmaking, volumetric capture is typically used to add humans to background or medium-close shots that are assembled in post-production. The ability to change both camera view and lighting environment makes the capture especially valuable for these use cases, relative to traditional techniques with locked perspective and lighting. Advertising productions have even used volumetric capture to replace the majority of traditional principal photography for a project, in order to produce multiple camera shots and locations in post-production from a single day-long capture session, where there is no need to break down and set up each physical shot at each individual location.

Volumetric video is especially well-suited for mixed reality experiences, where the content engages stereo perception and supports full six-degree-of-freedom motion by the viewer. The volumetric assets can be added to scenes like other 3D content in applications like Unity and Unreal Engine and can be compressed and streamed on their own to web viewers and mobile phones. Most volumetric capture providers supply plug-ins to view volumetric video nearly everywhere 2D content can be seen: On TV, desktop screens, mobile devices, and specialty hardware like HoloLens and Quest.

Volumetric Capture / Considerations for Production – Wardrobe, Hair, Makeup, and Blocking

Christina Heller, Skylar Sweetman, and Mari Young – Metastage

Welcome to volumetric video production. The goal as a producer working with this frontier technology is to be detail-obsessed, eagle-eyed facilitators of calm and creativity with boundary-pushing spirit.

Chapter 9

Volumetric capture, or "volcap," production is like 2D film production with a few key differences outlined in this section. It is crucial to remember that many clients are new to volumetric capture and will depend on outside expertise to make informed decisions about their productions. Burgeoning volumetric professionals are also *educators* – tasked with bringing ambitious creative concepts to life while implementing the necessary limitations to ensure a successful 3D project.

It is best to begin pre-production with a checklist that can be tracked via email exchange or production tracking software. Touching upon these details as early in the process as possible will set client expectations for what is feasible using a volumetric capture system.

Production Tracking List
- Dates:
 - ○ Pre-production calls and milestones
 - ○ Production Dates
 - ○ Wrap Days
 - ○ Post Delivery schedule: Processing / prop replacement / audio editing
- Schedule:
 - ○ Detailed schedule breakdown of the production day
- Creative Outline:
 - ○ Shot List / Storyboard
 - ○ Actions
 - ○ Dialogue / Audio recording needs
 - ○ Characters / Talent
 - ○ Wardrobe
 - ○ Hair
 - ○ Makeup
 - ○ Props for practical capture
- Technical Factors:
 - ○ Dev Kit and sample assets for integration testing
 - ○ Capture volume
 - ○ Lighting
 - ○ Props for mocap replacement
- Additional Production Services:
 - ○ Craft Services (Breakfast / Lunch / Dinner / Snacks / Beverages)
 - ○ Star Trailers / VIP Trailers / Make-up Trailers
 - ○ Hair Stylist
 - ○ Make-up Artist
 - ○ Wardrobe Design & Styling
 - ○ Audio Recording and Editing
 - ○ Behind the Scenes Footage (BTS)
 - ○ Supplementary 2D Shoot / Staging (dependent on studio space)

As production kicks off, it is important to keep a few key areas of focus in mind. Not all volumetric systems are the same, and limitations will vary depending on the system. The considerations outlined below are broadly applicable to most volumetric technology stacks.

Capture Volume

All actions must take place inside of an eight-foot diameter circle, although total capture space may vary from system to system. Creative problem solving will be especially necessary for any project that involves a subject walking a greater distance than eight feet around the virtual space, or if more than three characters are engaging with each other.

Thin Items

The capture software is looking for geometry to create a mesh. Anything in the capture volume that is too thin – strands of hair, glasses, stiletto heels, golf clubs – make it difficult for the system to generate the correct geometry to which to assign texture data. In the case of hair, the processing software will mistake thin strands as geometry that belongs with the chin or collar of the clothing, falsely attaching it to those areas. The resulting "texture splash," or "artifacting," means that the capture will fail to meet the "integrity test" – it often looks crunchy and incorrect, especially around the face. With glasses, the frames will warp into temples of the subject, again, creating an unauthentic capture of the person. Oftentimes, the only solution for facial accessories is to add them later with visual effects.

Props

Some props "solve" or "capture" well (the system detects them and creates geometry) whereas others do not. Thin items often disappear entirely. The best approach is to run a test capture to find out. If the item does not solve correctly due to size, thinness, or because it is too reflective, a fabricated substitution must be created, which can either be clipped out or replaced with visual effects in post.

Increasingly, motion capture systems are used in tandem with volumetric systems to help with tracking fast-moving props. Other important tools to help props solve better include dulling spray, or in the case of cellular devices (a highly desired prop for capture), alpha matting can be used to mattify the screen.

Choreography

Complex movement can impede the capture of clean geometry. Movements that are on the floor, like crawling or rolling around, can be tricky to process. It is also challenging if two characters are choreographed together. If two subjects engage in an embrace, for example, the system will have trouble understanding that they are two distinct bodies, which require individual meshes. As the software starts merging their meshes, a "globbing" effect is seen. The globbing effect is harder to notice when movements are slower, and strategic choreography or positioning of dancers further apart can also mitigate this problem. Camera occlusion (when a performer or prop blocks another performer, thus preventing texture data from being gathered at a certain angle)

is also an issue when multiple figures are in the capture volume. It is important to make sure enough cameras are getting enough data from the right angles so that the textures and meshes resolve with integrity.

Wardrobe

As with props, certain clothing items will not solve well – especially items that are thin, such as the fringe on a jacket. Shiny or reflective fabrics are also extremely difficult to capture. If a subject comes in with such items, suggest other wardrobe options or use dulling spray to remove the shine. The list below outlines wardrobe considerations and restrictions in further detail.

NO FRINGE, FUR, OR FEATHERS

Accessories and accents that are thin tend to reconstruct poorly.

NO GREEN CLOTHING

Many volumetric stages use something similar to a green screen to help create a good silhouette. Avoid green wardrobe items as they will make it impossible for the system to reconstruct a mesh.

NO SHEER AND TRANSPARENT FABRICS

The green color of the stage might show through and cause a loss of texture data.

AVOID BLACK AND VERY DARK COLORS

Some of the dyes that are used for dark colors absorb infrared light, which is used to capture depth data. Black is also transparent for devices such as the HoloLens and should be avoided if that is the destination for deployment.

NO VERY SHINY LEATHER, METAL, OR PLASTIC

High mirror polish armor, for example, could be an issue. One can apply dulling spray if something shiny must be worn.

NO HIGH-FREQUENCY PATTERNS

They tend to moiré.

AVOID HATS

Particularly those with visors, like a baseball cap. Hats cast shadows that hide the eyes, and brims are oftentimes hard to reconstruct. Beanies and skull caps are okay.

NO VERY THIN HEELS

Thick-heeled shoes or flats are best.

JEWELRY

Jewelry is treated on a case-by-case basis. In many cases, a single-frame test is required.

NO EYEGLASSES

Transparent lenses and some thin frames are beyond the resolution limits of many systems. It is oftentimes best to have a subject wear contact lenses, if possible, then recreate eyeglasses using CGI.

CHECK BUSHY OR DISHEVELED BEARDS AND/OR MUSTACHES

Beards and mustaches can sometimes be problematic, though that varies from case to case. It is best to trim facial hair neatly or have subjects come clean-shaven.

NO WISPY HAIR

Hair that has wispy features, especially flyaways, will need to be smoothed down. Some hair may need to be pulled back in a tight updo. As hair is often a defining feature of a performer or celebrity, it is important to find balance between hair that looks great and hair that captures well.

Overall, building "volumetrically friendly creative" takes time and practice. With adequate preparation, it is possible to achieve top-quality results with minimal visual effects work. Below is a summary of high-level best practices that smooth both the production and post-production process:

- It is easiest if subject(s) are standing, but if complex movement must be accommodated, keep globbing and occlusion in mind – choreograph accordingly.
- All key movement must happen in an eight-foot diameter circle (for most stages – check with the stage being used for their specific limitations).
- Cast actors with short haircuts, tight braids, or style longer hair into updos.
- Wardrobe should be formfitting, tidy, and follow the rules outlined above as closely as possible.

With these items taken into consideration, most major technical complications are avoided. The focus then becomes on getting the best performances possible from the people and actors on the stage.

TV and film actors rely on editing their strongest of various takes together to create a performance. Although tools are evolving to make volumetric editing more viable, ideal to capture a seamless performance requiring little to no changes. Film and TV actors are often used to being captured (filmed) in extreme close-up. Thus, their performance style focuses on evocative facial expressions rather than full body language. If possible, encourage performers and subjects to assert a strong physical presence when working with the volumetric medium – namely, utilizing the whole body to express emotion. Acting for immersive content, which is free from the frame and in full dimensional space, is ultimately more akin to the craft of live acting for theater than film or TV. Although it helps to have experience with performance for 2D mediums, using one's full body as an expressive tool is most salient for volumetric video.

Volumetric Capture With Actors for Virtual Production
Jason Waskey – Microsoft

Capture Workflow Overview

A volumetric capture production will feel familiar to people with traditional film set experience as it has a similar workflow and vocabulary. A key difference though is that volumetric production is streamlined with no need to break down and set every shot up from scratch. As a result, capture sessions usually last no more than a couple days while producing hours of usable footage.

Because of this concentrated schedule, careful pre-production and testing before the full shoot is required to ensure things go smoothly and to avoid costly mistakes that are hard to fix in post-production.

Where possible, a test capture session prior to the main shoot day will allow the cast and crew to solve open questions and gain familiarity with the full process by generating short examples that drive the production forward. During the full capture session, make sure to budget time in the schedule for quality control checks (like multiple camera calibrations or processing short clips to verify the system). Doing so may slow production down a small amount but pays dividends after shoot day.

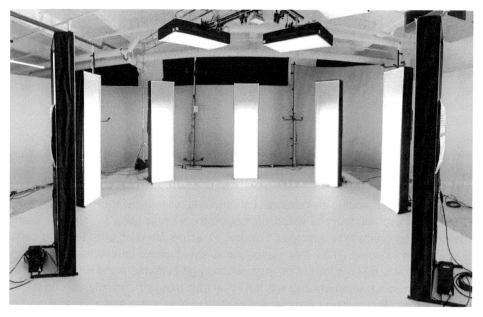

Figure 9.1 A conventional volumetric capture stage, with lights, cameras, and microphones arranged around a hemisphere. The green color (not a standard green screen) is used to help create clean background masks, used in processing.
Source: (Image courtesy of Microsoft Corporation)

Capture Workflow

While the capture workflow contains echoes of traditional 2D film and video, volumetric production introduces new elements to be managed and concepts to master.

- **Calibration**

From a handful to a hundred, volumetric capture systems take advantage of many cameras, and if camera alignment is not precise, it may produce noticeable artifacts in one part or all of the capture that are very difficult or even impossible to repair. For systems with a calibration step, it is recommended to create multiple calibrations throughout the day. At a minimum, calibrate before the first shot, during lunch, and then at the end.

- **Lighting**

Like traditional 2D film and photography, volumetric capture can be lit practically, using physical lights. This approach delivers superior results over re-lighting the output after the capture.

- **Audio**

Raw sound is recorded at the same time as video during a performance, often using a multi-track system with synchronized time code. Microphones are placed strategically in the set or on the body to minimize interfering with the cameras.

- **Volume configuration**

Unless the capture system allows for on-the-fly adjustment, this is set in advance of the shoot and determines how large the capture volume is. Smaller volumes allow for less movement but have higher resolution.

- **Camera**

The camera operator uses specialized software to sync and record footage from all cameras. The capture process between the director and the camera operator is very similar to traditional 2D filmmaking, with calls of "speed," "action," and "cut."

Where data sizes are very large, only a few takes each of a performance are saved during the day. In those cases, the director and key stakeholders are asked to make decisions about saving or deleting a given take after "cut" has been called.

Standard capture frame rate is 30fps, though many systems are capable of recording higher rates. Because volumetric output is 3D rather than a 2D frame of film, the human response to higher frame rates is different from film. As higher frame rates generate considerably more data, capture higher fps only if absolutely needed.

- **Testing**

It is important to verify the system is producing the expected quality by capturing and processing short clips (1–10 frames) throughout the day. Ideally every performer should have at least

a single frame test in wardrobe and final hair for each scene they are in that day to validate results.

- **Wardrobe, hair, and makeup**

Hair and wardrobe need to be as friendly to the volumetric reconstruction process as possible. On shoot day this means styling and smoothing hair and making sure wardrobe components like lapels and pockets are taped down. Pre-production should help the client avoid choices that will fail (e.g., wispy, flyaway hair or a translucent cape). Look for lulls between takes to smooth hair and tape as needed.

- **Blocking**

Prior to shooting, make sure that all performers in the capture area remain within the volume and that they minimize camera occlusions. Particularly review any positions and movements that are near the volume boundary to ensure hands, feet, and other body parts will not be missing.

- **Props**

The quality of prop reconstruction (e.g., golf clubs) varies widely between systems. Confer with the technical director to assess which props are appropriate to capture and those that ought to be eliminated or replaced. Consider whether motion capture solutions (like tracking markers) might be appropriate. Finally, make sure to note any elements in the scene, such as an apple box or a chair, that must be removed during processing.

- **Shot management**

Each production needs a person on set assigned to track each shot and provide documentation for the director and post-production personnel.

- **Playback and review**

It takes time to produce the 3D results for review, and it is usually not feasible to do this while on set. A 2D witness camera can be used for near instant playback of a take. After the shoot is complete, a set of 2D movies are produced of every saved shot. This enables production teams to review material and even to use it as a proxy for editing clip length.

Processing Workflow Overview

After the shoot is complete and the selected files chosen, the data must be prepared for processing. Volumetric capture creates substantial amounts of data which need complex computation. This often calls for the use of either a local compute cluster or cloud computing to process the workflows. While many pipelines are mostly automated, a person with the necessary expertise can ensure optimum results that align to end user needs.

Each vendor's system and approach is a bit different, but below is a simplified overview of a common processing workflow for volumetric output.

Processing Workflow

- **2D to 3D**

Calibrated camera results are brought into the pipeline, and raw RGB (and/or IR) imagery is then processed to turn 2D data first into point clouds and then into an initial pass at mesh-based geometry.

- **Refine Geometry**

The mesh results are further refined, smoothed, and simplified. Machine learning applications may be applied at this stage (e.g., mesh tracking for temporal smoothness). Motion capture data can be integrated at this point, and common tasks like the addition or removal of props as well. Higher triangle counts do not always deliver higher fidelity results. Use testing to determine the appropriate mesh density for a given scenario.

- **Generate 2D texture atlases**

Diffuse texture maps are created at this point. Additional material maps, such as for specularity, may be produced at this time as well. Enhancements like post rendered re-lighting or simple color grading may also be applied at this stage. Texture output is generally 8-bit color, though it may be possible to generate a higher bit depth such as 10-bit color, useful for higher fidelity color work.

- **Audio**

Scratch timecoded audio, recorded at the same time as the camera output, is added into the results. Edited or otherwise "sweetened" audio can be added at this point as well or integrated later during encoding.

- **Intermediate output**

Uncompressed mesh and texture files are produced to client specification for geometry triangle count and texture map resolution. Out-of-band post-production editing work such as additional color grading or reanimation of the meshes can also be done using these results. The source files in the processing pipeline retain the highest possible fidelity.

- **Encode for delivery**

The intermediate output is fused into a single playable file (like MP4, or DASH) that contains compressed geometry, texture, and audio suitable for delivery to the client for playback in the final experience.

Post-Production Workflow Overview

With a few exceptions, volumetric content does not lend itself easily to post-production work. In current systems, the results are temporally coherent only between keyframes, or not coherent at all (each frame can be new geometry and texture layout). This drives up both the time and cost to edit elements after capture and processing. Pre-production and effective communication with the volumetric content provider is critical given this limited scope for edits and enhancements in post-production.

If post-production work is a must, there are a few things to consider. Some of the larger volumetric capture providers and some enterprising third-party providers do have tools designed to work with existing applications like Maya, Nuke, and Photoshop. Where the post-production work happens in the pipeline is also important; if possible, try to work as early in the pipeline as possible. This will ensure that edits propagate through successive iterations, rather than being lost if the work is reprocessed.

Common Post-Production Tasks

- **Texture edits**

Painting texture edits in temporally incoherent UV layouts is time-consuming and may be prohibitive. It is much easier to work with capture results that create some consistent UV layouts across keyframes (or even use a single mesh and texture layout). Capture providers can provide information about existing tools that help make this process feasible.

- **Geometry edits**

Small edits on stray geometry can use standard 3D editing applications, but for systematic issues, use tools created by capture providers or third parties to overcome issues with temporal coherence when needing to address mesh issues after processing is complete.

Motion capture systems are commonly used to accurately place and animate a prop (such as a golf club), and even small 3mm trackers can be used during a shoot. For best results, work with the capture provider to remove existing geometry and associated texture from the capture at the processing level, making it easier to add the new geometry and texture.

- **Performance alteration**

By adding a skeleton to a mesh, a performance can be altered after the fact to meet a desired outcome (e.g., a loop) that was not captured on set. This can be used to "re-bake" a performance, or also in a real-time engine to support interactivity. AI-based approaches that generate a skeleton from 2D video seem to work well with volumetric results.

Another approach that works well for light touches are shaders that warp geometry. This works reasonably well for a "gaze shader" that moves the head of a capture to face a set point (such as a viewer in VR).

It is important to consider that because some amount of lighting is baked into the results (e.g., folds in clothing), drastic changes of original captured performance will look odd if pushed too far. Use sparingly.

- **Re-lighting**

When it is not possible to use the studio to light volumetric captures, re-lighting the capture by either rendering new light and baking into the map, or using an engine's built-in lighting tools is a common task. Most capture solutions provide only a diffuse texture in their results, leading to the need to generate a materials map after the fact, which runs into the same problem as a general texture edit due to lack of temporal coherence of frames.

154

How to Make Characters for Use in Virtual Production

Smart Simulated Characters (Digital Extras)
Jeff Farris – Epic Games

How Characters React to Their Virtual Environment and How Virtual Characters React to the Physical Environment

Smart Simulated Characters

Smart AI-driven characters have been a staple in the video game industry for decades. But this technology is also well-suited to virtual production applications. Many useful tools and resources are widely available. And commercially available game engines come fully equipped with deep technology stacks, capable of producing sophisticated and believable AI characters that can be simulated in real-time on consumer hardware.

A CRASH COURSE IN REAL-TIME ARTIFICIAL INTELLIGENCE

Fundamentally there are a few important concepts to consider when creating an AI character:

- How an AI agent perceives the world.
- How an AI agent decides what to do.
- How an AI agent executes that decision.

Systems to define these elements are all fundamental, and game engines will reliably have the tools to implement the behaviors needed.

DOI: 10.4324/9781003366515-11

PERCEPTION

The key challenge of modeling AI perception is crafting which data to use and which data to ignore. For an AI agent to perceive its environment it needs access to state data for the simulation where it exists. This is typically the easy part, as it is common that an AI system has nearly the entire state of the simulation available to query. But omniscient AI is rarely interesting. How an AI reacts to limited information is what makes it seem lifelike and believable.

DECISION-MAKING

Decisions happen in the "brain" of the AI character. This is the internal logic that processes the gathered perception data and chooses what to do. The output of this step is a goal or command that the character knows how to execute.

This is usually expressed as a form of executable logic such as a text script or a visual flow graph. It can be as simple as a few "if-then" statements, or as complex as a deep-learning neural network, but the goal is the same: To transform knowledge into action.

ACTION

The ability to execute a decision is the final step. The actions an AI needs to perform can seem simple, such as walking towards a destination or playing a custom animation. But making them happen convincingly can be complex, often involving many interacting systems.

Consider the common case of making a character walk from one point to another. First, an animation-control system is necessary to play the correct walk cycle, to play start and stop animations when appropriate, and to seamlessly control blending between them. It must be carefully synchronized with the character's movement system to prevent the appearance of sliding across the ground.

A collision query system is also necessary to prevent the character from interpenetrating with the environment and to properly respect the contours of the ground. The visible geometry for the world is often too complex to be efficient for this purpose, so a simpler proxy representation is authored for use in physics and collision.

Finally, a spatial navigation system is necessary to make sure the AI character can take a valid route to a goal destination. This system must be able to generate paths around obstacles in the environment, and it must be able to move a character realistically along these paths. It may even need to be able to detect and avoid dynamic obstacles in the environment, including other AI agents. This system relies on another set of custom metadata to define traversable areas in the environment. One common approach to this is called a navigation mesh.

CONTROLLING PERCEPTION

The most effective methods of filtering perception data are often reproductions of human limitations. For example, objects behind an obstacle can be ignored by the AI's "sight" to prevent it from reacting to things through walls. Testing visibility in this way relies on having collision data for any obstacles in the environment.

Figure 10.1 A simple navigation mesh, which is one type of navigation metadata that AI characters can use to generate paths.
Source: (Image courtesy of Epic Games)

CONTROLLING DECISIONS

It is up to the AI implementer to decide how to translate perception into action – meaning using the AI authoring tools to examine the current perception data, prioritize what is important, and choose an action. This action will not change from the previous update typically. This logic is a crucial element that defines what an AI does. It should be considered carefully and tested thoroughly.

CONTROLLING THE ABILITIES OF THE CHARACTER

It is important to think about what abilities an AI character should have and in what contexts they will need to be performed. A well-defined set of needs can reduce the problem space considerably. This can be a tough trade-off though, as fewer implemented abilities can mean decreased flexibility to handle different situations.

Making a character perform these abilities will require animation data and a well-tested control system to choose animations, transition between animation states, and handle blending. Do not under-budget here – this is critical to creating believable characters and can take significant time to implement, test, and debug.

The setup of collision and navigation metadata in the environment can provide very useful levers for defining the final behavior of the AI. Collision data can be used to smooth out snaggy corners or to prevent a character from going where it should not go. This allows for fine-grained control of possible destinations and character paths, which can be useful for keeping pedestrians on a sidewalk or virtual campers from walking too close to a campfire.

MAKING CHARACTERS REACT TO A PHYSICAL ENVIRONMENT

There is one more possible step to take things to the next level – making the AI react to stimuli in the real world.

157

Any device that can collect data from the physical world can route that data into the simulation, where AI characters can perceive it and react to it. In a mocap tracking volume, a live actor's motion data could drive a virtual proxy character that a crowd of zombies could pursue. Or an actor could throw a motion-tracked prop that represents a grenade in the virtual world, causing the virtual AI to flee.

Tracking a physical camera could help cue AI actions once they appear in the camera's frustum. Or it could be used to disable AI that are off-screen to save processing time and help maintain an interactive frame rate.

Even physical devices like control panels or flight sticks can be captured and broadcast to the simulation. Microphones can send real-world audio data to the virtual world for AI to hear and react to. The possibilities are limitless.

TRADE-OFFS

Smart digital characters can be very powerful in certain situations but are not appropriate for every situation. One trade-off to consider is interactivity versus fidelity. A core strength of real-time character simulation is the ability to get good results from unpredictable inputs. If it is important to be able to experiment and be creative, robust virtual character systems can provide the flexibility needed to make that a viable workflow. On the other hand, more interactivity can sometimes mean lower fidelity. This is partially due to the natural patterns that can emerge in algorithmic approaches and partially due to the limited processing time available due to the need for interactive frame rates.

Another major trade-off is short-term cost versus long-term benefit. There can be a significant initial investment to develop, test, and deploy a smart character system. But as is true with many systemic processes, this type of system shines at scale and can enable certain types of workflows or results that might not be otherwise achievable.

Of course, both trade-offs are highly situational and content-dependent, but they are key to understand to make effective choices.

MetaHumans: Creating Digital Humans for Production
Vladimir Mastilović – Epic Games

Definitions

MetaHuman: A multi-resolution, high-fidelity parametric model of human appearance optimized for real-time computer graphics. The MetaHuman parametric model is based on a database of high-resolution 3D and photometric data, as well as on a database of advanced non-linear

deformation models, making it capable of representing a wide variety of plausible human appearances in motion. MetaHuman comes with a full facial and body rig, face and body textures, hairstyle, and clothing options, ready to animate in Unreal Engine and Autodesk Maya.

MetaHuman Creator: A cloud-based tool built with Unreal Engine for defining and visualizing the appearance of MetaHumans.

MetaHuman Identity: A set of parameters that fully represent the appearance of a MetaHuman, as created by the user. MetaHuman Identity is the key output of MetaHuman Creator and input to the MetaHuman Backend.

MetaHuman Backend: The cloud service that builds a full set of high-resolution assets based on the MetaHuman Identity and makes them available through Quixel Bridge.

MetaHuman Plug-in for Unreal Engine: A plug-in available in Unreal Engine that processes data (3D scans and models) associated with digital humans into MetaHumans through the usage of machine learning and statistical models that dramatically reduce the production time compared to traditional workflows.

Workflows

The MetaHuman product currently supports three workflows:

- **Parametric.** A MetaHuman that is made based on intent, specific verbal art direction, or reference material by utilizing parametric tools in MetaHuman Creator.
- **Mesh to MetaHuman with an artist-created mesh.** A MetaHuman that is made based on an artist-built model that is parameterized into a MetaHuman through the Unreal Engine plug-in and then finalized in the MetaHuman Creator.
- **Mesh to MetaHuman with 3D scan.** MetaHuman that is based on a scan of a real person which is recognized, fitted, and parameterized into a MetaHuman, through the Unreal Engine plug-in, and then finalized in the MetaHuman Creator.

Parametric Workflow

MetaHuman Creator application runs on a cloud instance and pixel streams interactive 3D scenes to the user through a web browser. MetaHuman Creator is designed as a gamified tool similar to character customization mini-games that can be seen in many RPG and MMO games, with key differentiating factor being its focus on high quality representation of plausible digital humans.

The user starts with one or more preset MetaHumans to provide a faster convergence to the desired look. The user can either blend between multiple presets or define appearance of a MetaHuman through intuitive user experience that resembles sculpting. In this case, sculpting takes place by manipulating 3D positions of control points located on the surface of the MetaHumans skin that are constrained with anatomical data models in a way that almost always produces excellent outcomes.

High quality texture can be synthesized based on 2D color tone selection for low frequencies and a selection of high-frequency detail.

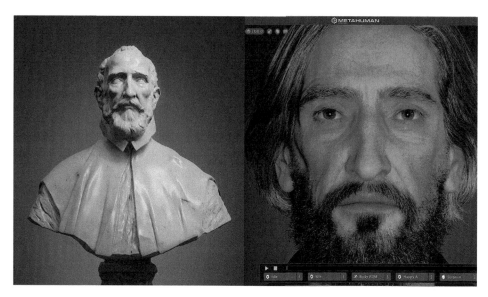

Figure 10.2 Character designed via Mesh to MetaHuman pipeline with an artist-created mesh used as input.
Source: (Image courtesy of Epic Games)

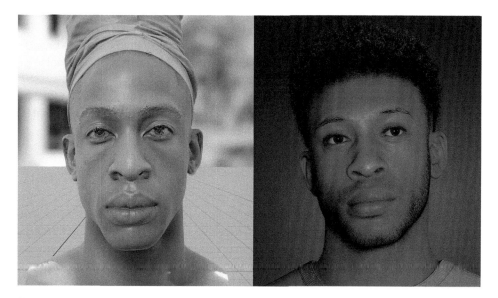

Figure 10.3 Character designed via mesh to MetaHuman pipeline with 3D scan used as input
Source: (Image courtesy of Epic Games)

Makeup, hairstyles, facial hair, body types, and clothing are available as a set of discrete options. This workflow makes it possible for a nonexpert to produce a professional-grade 3D asset that would otherwise take a whole team and months to produce.

MetaHuman Creator provides visualization of the final outcome in real-time and creates MetaHuman Identity that is used by the MetaHuman Backend to build a full set of assets that will be delivered

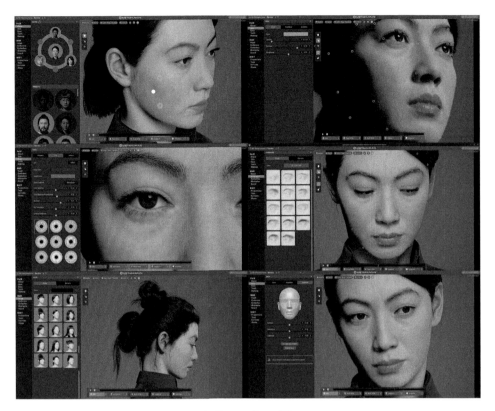

Figure 10.4 MetaHuman creation process via Parametric workflow
Source: (Image courtesy of Epic Games)

to the user via Quixel Bridge. A gamified user experience that produces professional results, combined with a delivery through a web browser, and at no cost to the user enables easy adoption by users ranging from casual creators to professionals that traditionally would not engage directly with CG character creation. These enabling new capabilities and workflows allow for more complex stories in games than would otherwise not be possible due to budget and time constraints and allows directors to engage directly with character creation for the needs of virtual production.

MetaHuman Backend service runs in non-real-time and requires approximately ten minutes to build a MetaHuman delivery package. After that is built, it is made available for download via Quixel Bridge. Delivery contains UE assets, source textures, in high resolution, and data packages that enable the user to import the MetaHuman in Autodesk Maya or Unreal Engine, which offers a more flexible animation pipeline and appearance customization options. Parametric models can be used as is or as a starting position for artistic treatment.

Mesh to MetaHuman Workflow

Mesh to MetaHuman workflow is available to the user through the MetaHuman plug-in in Unreal Engine. The MetaHuman plug-in is connected to the MetaHuman Backend and MetaHuman

Creator with which it forms a complete workflow, through the user account. The mesh can be fitted to a scan with tools contained in the plugin, sent to Creator, for completing the whole digital human, which is built on the backend, and delivered back to Unreal Engine via Quixel Bridge. Thanks to the usage of advanced machine learning and statistical models, production time is significantly reduced compared to traditional workflows.

Once the model is imported, key facial features can be detected automatically, and MetaHuman mesh is fitted to the input model. Likeness is then interpreted to the MetaHuman parametric space and, as such, sent to MetaHuman Backend, where the new MetaHuman is created and becomes available for editing in MetaHuman Creator soon after. MetaHuman Creator will predict a full facial rig with unique facial shapes based on the input geometry.

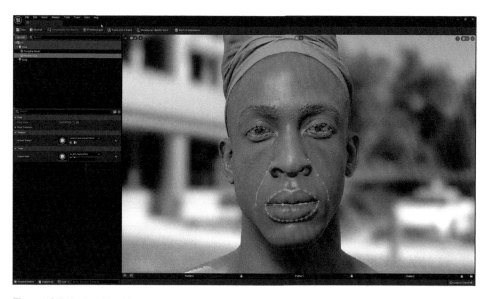

Figure 10.5 Mesh to MetaHuman facial contours detection process
Source: (Image courtesy of Epic Games)

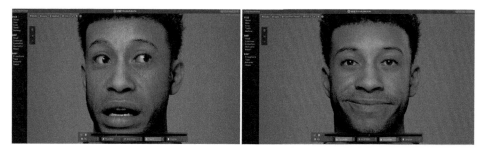

Figure 10.6 MetaHuman Creator enables users to check facial expressions within seconds from creation
Source: (Image courtesy of Epic Games)

Textures, hairstyle, facial hair, eyebrows, eyelashes, body type, and clothing can be chosen from the sets supported in the MetaHuman Creator in the same way as with parametric MetaHumans.

This is an iterative process that allows users to experiment with the tool until the desired character look is attained.

Users can further upgrade likenesses manually by implementing the following:

- Creating custom textures – via manual editing of the MetaHuman Creator synthesized textures or by applying scan data derived textures.
- Creating and applying custom hair (hairstyle, facial hair, eyebrows, eyelashes).
- Creating and applying custom clothing or any other additional character outlook elements like sunglasses, jewelry, etc.

Export and Integration
Quixel Bridge provides 3D asset management for MetaHuman Creator derived assets.

Users can use Quixel Bridge to access both the UAssets[1] and source assets available like those assets found in Autodesk Maya.

Animating MetaHumans With Motion Capture
Gabriella Krousaniotakis – Feeding Wolves

Required Knowledge and Tools
Integrating Metahuman performances into virtual production workflows involves a learning curve and require a combination of artistic and technical skills. The body and facial performance must be captured and mapped onto the digital human, either in real-time or with an offline workflow, cleaned up, fine-tuned, and then rendered as either an image sequence or for real-time. Required technical skills include experience with built-in animation tools in Unreal, an understanding of the MetaHuman blueprint component functionalities, and the ability to develop pipelines for utilizing motion capture data from various sources. This includes integrating external Digital Content Creation tools (DCC) whether it is for modifying MetaHuman components or for motion capture cleanup. For believable body and facial performances that elicit emotion and do not lean toward the "uncanny valley," artistic skills require attention to detail in facial expressions and human anatomy combined with an understanding of the MetaHuman body and facial rig.

Significant processing power is required for capturing motion capture performances while maintaining high frame rates in Unreal. This means powerful workstations tailored specifically for this workflow because digital humans have high-resolution textures, grooms, and cloth physics.

163

MetaHumans are modular, composed of a body, face, torso, feet, grooms, and Levels of Detail (LOD), each with its own functions, combined in a blueprint. They share one base skeleton for the body and one base skeleton for the face, and for this reason, animation data is shared between different MetaHumans. The body and facial performances are handled separately, although they can be captured simultaneously. Each component comes with its own corresponding control rig, that allows control of individual bones or blendshapes directly in sequencer[2] or in external DCCs.

MetaHuman Facial Rig

The facial rig has hundreds of joints, controls for expressions, and over a thousand corrective expressions. This allows high-fidelity facial motion performances to be achieved and is based on a facial action coding system (FACS) so that regardless of differences in the bone structure or wrinkle maps, blendshapes will be driven the same way.[3]

The face control rig allows for facial expressions to be animated through controls and includes additional blendshapes such as lip thickness, inhale/exhale, chin compress, and pupil constriction. These are not poses typically driven by facial motion solutions. Facial motion solution integrations with the MetaHuman face rig range from Epic's free UE Live Link Face ARkit solution to higher-end options capable of allowing poses driving facial expressions to be customized by either modifying pose values or tailoring multiple controls to drive more complex expressions. This customization allows the talent's performance to be matched to the MetaHuman being driven more accurately and reduces the time and resources that will be needed for animators to clean and keyframe on top of the existing performance.

MetaHuman Body Rig

The body base skeleton is shared among proportionally different body sizes, for males and females, from short to tall, from thin to overweight, underweight, or normal. In total there are 18 different body types available. Differences in dimensions can affect the way body performances will appear and by using the body control rig, or by making offsets during retargeting, body performances can be fine-tuned to match the performer's body movement to the MetaHuman so that they are proportionately and anatomically the same. The body control rig allows for the bone hierarchy to be controlled through forward kinematics (FK) by being rotated based on the local or world space and through inverse kinematics (IK), where certain controls such as the arm and feet can affect a hierarchy of bones.

MetaHuman Motion Capture Integrations

Body and facial motion solutions involve either a real-time or offline processed pipeline which comes with their own benefits and challenges. Performances captured using Live Link allow data to be streamed directly into Unreal and applied to a character in real-time. This pipeline is commonly Wi-Fi dependent, uses significant processing power, and causes lower fps in Unreal. This can lead to pops and breaks in the animation data. For live performances, pipelines should incorporate optimization techniques such as lowering the MetaHuman LODs and using levels/

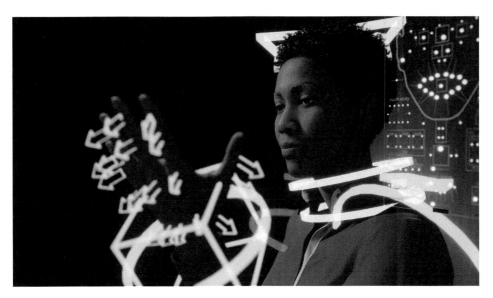

Figure 10.7 Example of the MetaHuman body and face control rig
Source: (Image courtesy of Epic Games)

environments that do not impact fps, along with methods of adjusting the body or facial motion data as it is being streamed in.

Offline processed pipelines that bring performance data directly into the Engine, for example via FBX, bypass the need for maintaining high fps in Unreal and allows data to be cleaned and fine-tuned directly in the Engine or using external DCCs. The challenge with this method is importing the data with timecode, which requires a method of syncing body and facial performances along with audio that is currently only available via Live Link pipelines.

Developing Workflows and Pipelines

A collaborative relationship with motion capture companies will allow for continuous improvements in integrations with MetaHuman and Unreal as engine versions change or MetaHuman updates occur. The greatest challenge for productions is to allocate learning curve time, for testing and developing effective and reliable pipelines (when working with MetaHumans and motion capture), and to continue to keep abreast of the continuously evolving technology in motion capture and Unreal Engine.

Notes

1 UAsset file is an asset file used by Unreal Editor.
2 Sequencer is an editor in Unreal that allows actors to be added as individual tracks to be animated.
3 FACs is a universal system of categorizing human facial movements so that regardless of differences in the bone structure or wrinkle maps the blendshapes will be driven the same way.

How to Capture Environments for LED Walls

Photogrammetry and LiDAR Sets for Virtual Production

Tripp Topping – Halon Entertainment

Optimization

Scanning Sets and Assets for Virtual Production?

The main attraction for productions to use a virtual art department (VAD) is it allows the production to save sets, exactly how they looked on the day of the original shoot, for future use, whether that be in the background or to recreate the set for continuity purposes. It also allows the creatives to see the sets with set-deck in the shot and with all of the effects in a specific shot in an extremely fast fashion. Quickly being able to see the set in the shot offers incredible flexibility to modify or change it before shoot day. To capture assets and/or props for set dressing, photogrammetry, or any other scanning method, will do this "one-to-one" in detail and color. It is almost impossible for an artist to get real-life assets one-to-one with their CG counterpart without help from scan data. But once the asset is in the engine and optimized, it will be the exact asset scanned and can be used in future productions.

When to Scan a Set and/or Assets for Virtual Production?

There are a lot of reasons to scan a set. If the production is working on a multi-season show, for example, it will have the virtual sets in their show library for reference and/or use. If the production wants to check the set on the screen to make sure it is the correct dimensions, or if the set is going to need to be physically built and/or transported to a specific location.

DOI: 10.4324/9781003366515-12

How Is a Set Captured for Future Use?

After a production decides to capture the sets for future use, they will need to decide what kind of capture will be needed. There are a couple of things to keep in mind that may cause capturing the set more difficult, depending on what type of capture they use.

First, what type of scanning method will be used, and which one is best to use? There are two main methods of capturing for this use case. The first one is LiDAR capturing; this method is mostly used when the scan must be precise and captured quickly. The downside to this method is there is quite a bit of time at the back end to decompress the data. Additionally, LiDAR captures do not capture much color data.

The second method is traditional photogrammetry. This method is much slower than LiDAR capturing and is not exact – but what is lost in speed and precision is made up in the quality of texture and mesh captured. If the production only has thirty minutes for capturing, LiDAR might be the way to go. But if there is extra time for the set to be up, also doing a traditional photogrammetry pass would go a long way in future use cases.

Note that there are also inherent downsides for both types of capture when there is any foliage or transparent material on or in the set. Capturing these materials may cause some misalignment when solving out.

Why Capture Assets, and Capturing Assets for Future Use

The reason to capture an asset is to get a one-to-one representation of that asset in the digital world so it can be used whenever needed. When picking which assets need to be digitized, consider what materials the asset is made of. As mentioned above, if the asset has reflective or transparent material, the meshes may be misaligned unless those offending parts/materials are covered with a matt spray or by using cross-polarization. Any assets that are going to be in the foreground (on the physical set) and background (in the virtual world) will need to be scanned so that when they appear on camera, they will look exactly like the physical version on set.

Photogrammetry Optimization
Tripp Topping – Halon Entertainment

Optimization

How Important Is Optimization, and When Should It Be Done?

Optimization is one of the most significant aspects of photogrammetry. A fine line is drawn when it comes to balancing high-end photogrammetry for virtual production (including but not limited to scan and production when designing). The goal is to keep maximum detail while still having the assets run between 60fps and 120fps in engine. The game engine enhances this ability to access extremely high fidelity and set dressing assets. With the engine, costs must be kept at a low rate; there should not be an asset at ten million polygons. If this were to occur, the outcome would

cause a scene to run poorly, leading to a coarse or grained look that would create a higher cost to correct and a possibility of making people motion sick.

Where Does the Optimization Start?

The optimization process starts when production is assessing and planning the process of the production. This planning process includes the following: Foreground, midground, or background of each set. The planning process should be done with the Photogrammetry Lead. The Photogrammetry Lead focuses on image amount and/or time range of the workflow for the team and is dependent on whether it is more cost-effective to utilize capture or hand molding. To speed up the optimization process, it helps when the clean-up artists are informed of how much detail a piece needs. For example, there is little need to capture thousands of images for midground or background types of assets. Low costs and a more rapidly completed product come with effective processing.

There is a fine line between the number of images that can be captured for an asset and not putting a lot of work on the Clean-up Artist. For instance, if there are assets that have complex shapes (i.e., a cage), there would be a need for an abundance of solid images for that asset. If the Capture Artist takes a low number of images for an asset to save time, this could hinder a clean-up artist. The low number of images sent to the clean-up artists could create a poor asset as a whole. This causes the Clean-up Artist to spend double – sometimes triple the time – on an asset than if the needed number of images were originally captured. Now the artists not only need to remodel most of the assets while matching the scanned pieces, but they also have to match the real-life color, wear and tear, with its real-life counterpart.

Pros and Cons of Automation and Manual Workflows?

Optimizing the mesh after the capture is as critical a step as the capturing. If this step is not correctly done, the detail, no matter how perfect it is, will be lost, and the images captured may not retain their quality due to a faulty workflow.

There are two defined workflows a production can utilize: automatic or manual. These workflows are exercised for different reasons; however, both have their weaknesses. Automated workflow consists of making sure every capture has the correct amount of scanning coverage. Having the correct amount of scanning coverage will limit the cleanup of what is wanted in a fully automated workflow. The benefit of the automated workflow is that if the assets are captured correctly, a production can pump out background assets and other assets that are approximately 20 feet from the camera. But with automated workflow, there is a bit of mesh detail lost compared to that of a manual workflow.

Manual workflow is highly recommended for any scans that are not captured in a dedicated area or for any props that are going to be used in a camera shot. The results for manual workflow are far greater in quality – in both mesh detail and texture. However, a drawback of using manual workflow is that it can be significantly slower.

If the proper number of images were taken, then they can be run through the corresponding workflow to derive amazing meshes. The easiest way to get ready-to-go assets straight out of photogrammetry software is to have a dedicated capture artist on-site daily. This will pay dividends

in both speed and production. With a capture artist on site, the clean-up team will not run out of assets to clean up. The clean-up team will be able to feed the VAD team with as much set decoration as is needed for the production.

Plate Photography for Playback on LED Walls
Sam Nicholson, ASC – Stargate Studios

Immersive Plate Photography / Shooting Plates for Unreal Environments

Introduction to Capturing Environments for LED Walls

Reverse Engineering the Shoot to Match the Creative Needs of the Project
Design the plate shoot by fully understanding the creative requirements of the virtual production shoot. The pace and editorial style of a situation comedy is entirely different from a dramatic action film, commercial, or music video. Comedy generally requires long takes with multiple cameras, while dramatic action sequences are carefully choreographed with short takes. Commercials are carefully storyboarded and shot to exact length. Music videos use very long improvisational takes. Anticipating the demands on set allows one to reverse engineer the plate shoot and will ensure creating plates that fit the *cinematic style* of the production.

If one is shooting plates for blending with an Unreal environment, it is best to meet with the computer graphic modeling team and design the shoot to meet their needs. This will most likely involve shooting extensive texture maps, lighting references, LiDAR, and photogrammetry elements in both still photography and motion.

Immersive Shooting for Virtual Production vs. Normal Plate Photography
A virtual production set is totally immersive in that a director can look in any direction and compose a shot. While traditional plate photography for greenscreen visual effects is generally composed for specific, limited camera angles. The virtual production background therefore should cover 360 degrees, while the traditional visual effect background is a limited field of view.

Shooting for 2D Playback vs. Shooting for 3D Modeling and Ingest
2D playback on set is completely different from 3D playback on set. 2D playback is quite like existing video playback but uses multiple screens specific to the video wall. 3D playback involves rendering computer-generated images in real-time that are matched to specific camera movements. 2D playback is typically file-based, large-scale SSD storage and retrieval. 3D playback

is game engine project based. The project must be opened and rendered via fast multiple GPU servers. It is essential to rehearse any 2D or 3D assets in pre-production to ensure seamless playback on set.

HDR vs. LOG vs. Linear Color Space Shooting

One is always striving to display images as close to reality as possible on a virtual production set. Playback from LOG or RAW original camera data is ideal, however a display LUT will be applied by the playback operator on set *before* the images are sent to the LED wall.

LiDAR for Set Extensions

LiDAR is an essential component of the virtual production process. This is especially important when doing set extensions that must match seamlessly with the principal photography. Accurate dimensions, textures, and lighting are critical to building a seamless blend between 3D computer models and reality.

Frame Rate Options

On a virtual production set, the frame rate is directly correlated to the capabilities of the LED wall and the system drivers. Older LED panels have a very narrow band between the LED screen frequency and the camera shutter. It is important to remember that *all LED stages are emissive screens that flicker*. In all cases, the screen frequency will determine the acceptable frame rates. Genlocking camera(s) to the LED screens is highly recommended.

Camera Options

Principal photography on a virtual set is dictated by the capabilities of the LED screens and system drivers. Global shutters, extremely fast shutter refresh rates, and genlock capabilities are all good matches for virtual production. However, if working with a newer high frequency screen (ROE, Unilumen, AOTO, Planar) and advanced processor, these screens can be adjusted to fit any camera platform.

Camera Lenses

Any lens and filter combination will work on a virtual production set. One of the major benefits of shooting against an LED wall is preserving the original lens distortions and bouquet specific to art lenses.

Data Layoff and Ingest for Plate Prep

Shooting photographic plates will inevitably generate massive amounts of data. Using a large number of SSD for data layoff in the field and returning them to the studio is highly recommended. When shooting with multiple cameras, one must account for data layoff, storage, pre-processing (9-Way Splits), and loading into the servers on set for the virtual production shoot.

Process Work on LED Stage

General Understanding of Process Work

Jeroen Hallaert – PRG

Since the dawn of cinema, scenes in moving vehicles have challenged the ingenuity of filmmakers. The difficulties of fitting equipment into cramped cars/cabins, capturing clean sound, and of course, safety issues, have led to various techniques being developed over the decades.

There are several ways to shoot and light a vehicle scene, but "Poor Man's Process" continues to be a popular approach to simulate a moving vehicle safely and affordably. This method focuses on the actor's performance inside the vehicle and having the actors interact with the images while giving full control to the DP and Director. The vehicle and camera are static, and the illusion of the movement is made real by surrounding the vehicle with moving imagery, lights, and visual effects, sometimes in combination with manual or automated movements of the vehicle (a cantilevered 2×4 on an apple box, to fully automated gimbals). Using projection or LED screens for process work is an in-camera technique, "when you are done you are done," resulting in a final image. When traveling by vehicle in the daytime, most of the light inside the vehicle comes from outside. A lot of the light is reflected: Bouncing off trees, houses, fields, and other things that are passing by. This is very difficult to simulate using traditional means. But by using big, bright screens, displaying moving backgrounds, this interactive lighting comes with the technique.

DOI: 10.4324/9781003366515-13

Chapter 12

Logistics on Process Work

Rear Projection

Rear projection was a groundbreaking technology at its invention in the 1930s. It gave filmmakers more control, consistency, and creative freedom to shoot what they wanted where they wanted. And yet while rear projection's in-camera process effectively streamlined production workflows, it regularly failed to achieve any sense of naturalism.

Front Projection

Front projection solved several of the problems of rear projection. The process involves carefully angled mirrors that allow the projected image to align with the camera's focal angle and appear on a highly reflective screen, in-camera. This technique would become the basis for what is now (2022) achieved with camera tracking. The main reason for using front projection over rear projection is a noted improvement in image quality. Rather than looking at a diffused image projected from behind, the camera now looks at a reflection of light projected from the same POV as the camera, which makes all the difference. Using projectors for background images is the only way, even today, that allows a camera to focus straight on the screen without the LED side effects like moiré or visible pixels.

The 2013 movie *Oblivion* used front projection to convey an encompassing sky that reflected off spaceships, floors, glass furniture, and even into its actors' eyes. Twenty-one projectors created a 500 × 42 foot image that wrapped 270° around the set. A significant portion of the film takes place inside a "sky tower." Since the tower rose to the level of the clouds and was almost completely made of glass and reflective materials, a major challenge arose of just how to film scenes with the actors for different times of the day. Combining all the projectors gave the filmmakers a front projection, real-time, 15K, motion picture background. The production shot cloud formations from a high vantage point, then stitched the image of multiple cameras together to create the 15K image that would play live on set.

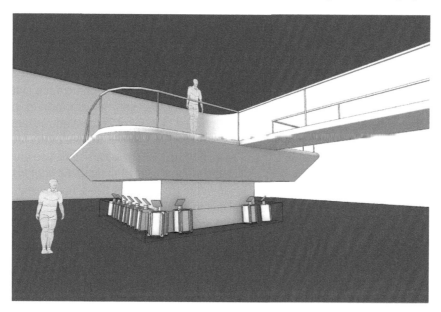

Figure 12.1 Drawing of the projection process set up for *Oblivion* (2013)
Source: (Image courtesy of Jeroen Hallaert)

174

The movie *Gravity* (2013) placed its performers on a robotic gimbal in the "Light Box" that represented the spaceship interior, or the void in space. The box was basically a hollow cube measuring 10 × 10 feet of low-resolution LED screens that "projected" moving images onto their faces, allowing animators to composite them perfectly. The light box was necessary because animators had to match the lighting in the animation to the live-action shoot perfectly. Like a green screen, except for more accuracy, efficiency, and lower maintenance, it was fitted with LED panels that could display any CG image to get the correct lighting. Rather than trying to figure out how to move Sandra Bullock through space, they realized they could move space around her by sliding the content inside the light box. (The low-resolution LED was not used as ICVFX but only to "project" light on the performers and give them a sense of location.) Projection is no longer an actual projector throwing an image on a surface with a camera capturing it. LED screens today will provide the backgrounds, reflections, and interactive lighting with more realistic looks and illusions and in darker environments.

LED

There is a perception that using LED walls means always getting the final imagery in-camera. And while this can be true for many shots, it is not true for every shot. The finality of a shot can vary from ready-to-edit to requiring additional enhancements. Compared to traditional greenscreen work, the LED walls provide correct highlights, reflections, and hits on reflective surfaces made possible using the right techniques.

Think of LED panels as LEGO blocks, they come in several different block sizes. They can be assembled in a variety of shapes and sizes by stacking or hanging them. LED panels can be built from the ground up using a ground support system, or they can be flown using motors, tracks, and beams. From flat walls to 360° curved LED volumes that wrap around the vehicle, to four-sided LED cubes, to straight LED walls with 90° returns, one can custom build the LED walls to meet the production requirements and budgets.

Planning and choosing the setup for vehicle processing starts with identifying the vehicle that will be used and then determining which shots are possible and what the required camera angles are. This is done in previs or 3D CAD models and drawings. It helps determine wall sizes and configuration, positioning, and even the required pixel pitch.

Pixel pitch is the distance between each pixel on an LED panel. This is typically presented as a "2mm" or "5mm" LED, but there are variations within each range: For example, the "2mm" range has 2.3, 2.6, and 2.8 as common pitches. (The same holds true for the 3mm range.) Usually, a coarser pitch panel, like a +5mm, is used for lighting and reflections as they tend to be brighter, whereas finer pixel pitches, typically +2mm, are used for final pixel. Height-adjustable LED ceilings usually use coarser pixel pitches to light from above. Also, coarser pixel pitch movable LED dollies ("wild cards") can be used for additional lighting purposes. All are running on the same processors, these high-brightness panels can simulate real-world lighting environments while providing even coverage and are controlled from the same Brain Bar.

It is important to note that more pixels are not always better. While a finer pixel pitch panel might give more flexibility as relates to avoiding moiré, it may also require one to make thermal

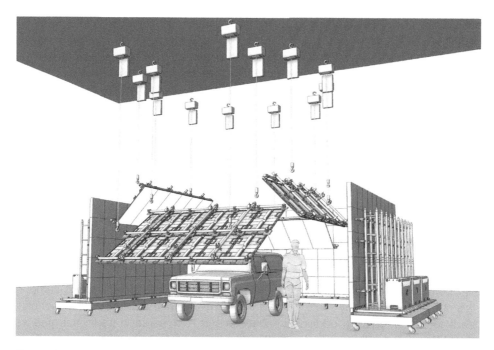

Figure 12.2 Drawing of the LED process set up for *Dog* (2022)
Source: (Image courtesy of Jeroen Hallaert)

and color gamut tradeoffs. Moreover, the greater the number of pixels, the greater the render time and delivery loads become. This makes finer pitches more expensive in terms of cost and time.

When selecting a panel for vehicle process work and ICVFX, it is important to consider what brightness and color performance will be the most desirable. For example, panels being used to deliver final pixel results typically have a maximum brightness of between 900 and 2,000 nits. While panels used for reflections and lighting are typically much brighter – up to 5,000 or 6,000 nits.

The VAD needs to render the virtual sets and play pre-shot plates, on the chosen LED panels *before* the formal production, testing every (virtual) location with the chosen camera and lens. During this process, one should also test some practical pieces because the practical set is also extended to the virtual world. The team should ensure the real and virtual elements match each other.

Because the LED screen is the light source, all props, set pieces, performers, and of course the vehicle will be illuminated by the LED wall and ceiling pieces, and it will also reflect colors from the screen. When adjusting the color of the LED wall, one must pay attention to the lighting cast on the physical set pieces and performers. At the same time, the reflected light from the physical items (especially large objects) will bounce back, illuminating the LED wall. LED

screens can be true black – emitting no light at all. But pure black depends entirely on how dark the surface is when the screen is turned off. The complication is that such a wide surface will always have a reflection factor. That is why the frontal design of LED panels is so important – it must be dark without being flat and reflective as a mirror. Why is pure black so important? Because it defines the contrast levels of the LED screen. The contrast level is the difference between the light emitted by the display and the environmental light reflected by the screen's surface. The less light is reflected, the higher the contrast and, therefore, the color depth and the naturalness of the images.

When the production wants to get a strong exterior lighting profile to produce sharp shadows for the performers (like a daylight scene), the LED wall brightness may be not enough. To accomplish this, the DP will add traditional movie lights.

Recording audio on or in an LED stage is problematic. The LED walls wrap the stage like a cave. The hard surface walls, therefore, are reflective and stand on the right, left, and back and hang from the ceiling. In this cave-shaped half-sealed space, any sound will be heard, even if meters away. Therefore, it is best to keep the stage as quiet as possible to avoid unwanted noise on the dialogue tracks recorded.

Once the LED panel choice of sizes and position are determined, more flexibility for shooting different angles can be had by making some of the walls movable by building them on rolling risers or platforms. This allows the walls to be placed around the vehicle at any location – it also helps avoid unwanted moiré effects by slightly changing the angle of the wall to the camera.

Putting the vehicle itself on rolling risers, or in the case of a car, on go-jacks, will give unlimited flexibility for all sorts of angles and again helps avoid moiré. Automated turntables have also found their way on set, and some vehicles have even been placed on a multi-axis gimbal. Whether one wants to rock a boat or fly a plane, a multi-axis gimbal can give that precise movement. This piece of equipment can move large heavy objects to a maximum pitch and roll defined by the length of the hydraulic shaft. The gimbal is a hydraulic motion platform and is the perfect choice for moving sets, cars, and boats. Speed and acceleration can be set to meet the desired effect – from a sudden movement of a bumpy street to the smooth movement of a spacecraft.

For more elaborate stunt-related process work, a rotating gimbal (a spit roast) allows the simulation of a vehicle rolling with the opportunity to have the performer inside and therefore achieve close-up shots both from a hood and/or door mount. The vehicle is secured inside the rig, with the performer inside and held safely by a full stunt harness. These gimbal systems are tied into the Brain Bar for all the automated movement control and will be programmed to the imagery on the screens – so all action is perfectly choreographed.

On the low end of the spectrum, the illusion of movement, rocking, or driving over a bumpy street can be achieved by putting a 2 × 4 foot beam under the car, cantilevered across an apple box with a grip shaking that 2 × 4. Effective and simple.

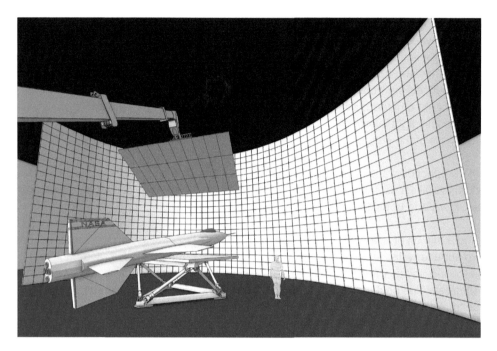

Figure 12.3 Drawing of the LED process set up for *First Man* (2018)
Source: Image courtesy of Jeroen Hallaert)

The planning and construction of such scenes can be time-consuming, but when imaginatively applied, the results can be captivating, frightening, and exhilarating. The set becomes incredibly realistic for the performers inside the vehicles, surrounded by moving images on screens in combination with rocking/rotating/shaking. But this can cause motion sickness. Sir Kenneth Branagh confined a huge all-star cast in a tiny train for his new adaptation of Agatha Christie's *Murder on the Orient Express* (2017). The filmmakers made everything seem so authentic that the cast came down with motion sickness when they began shooting. The production used a gimballed train set and displayed footage on the LED screens that production went to great trouble to shoot for the various environments.

Warner Brothers' *Joker* (2019) also features a train sequence. It was not shot on a subway, and for compelling reasons. The production used LED screens where the DP could control the motion and lighting of the subway and other subway cars, by hitting different buttons on a remote control, which was cueing the Brain Bar for instant playback. The film cleverly used a period New York subway characteristic, blackouts, to enhance the performance of the Joker, who did so much with his body and face that they were able to capture those small pieces without having the extra variable of a moving subway. Extreme angles creating disorientation and tension were achieved this way.

Summary

Process work using virtual production and ICVFX is reimagining the methods of storytelling and content creation across a growing number of industries, from film and entertainment to corporate,

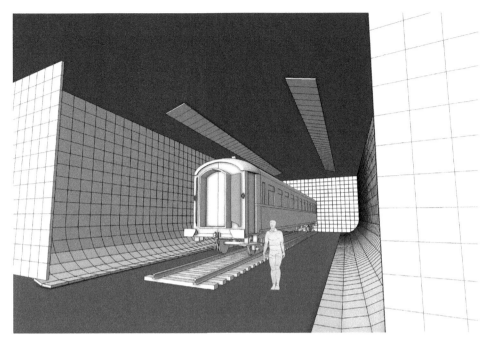

Figure 12.4 Drawing of the process set up for *Murder on the Orient Express* (2017)
Source: (Image courtesy of Jeroen Hallaert)

education, and others. Advancements in LED display and Brain Bar technology are empowering visual storytellers to deliver deeply immersive experiences that engage audiences like never before.

On an LED stage, one is outputting data from a 3D program with a fixed color space through to an LED wall. The LED wall portrays colors that can slightly change dependent on the point of observation. This footage is then captured by cameras that have their own internal color reproduction as well. Then production is introducing physical set items as well, like people and objects in the real world, which are lit by physical lighting. Industry-standard color management pipelines like ACES help with this. There is a lot of complexity involved with LED stage production. As an industry, the need to work out a trade-off between camera settings and 3D settings, along with improving the accuracy of LEDs, is a must.

Recent developments like Cinematic XR Focus software will transform final pixel LED wall cinematography by enabling DPs to pull focus between real foreground objects (like performers) and virtual LED displayed objects (like vehicles) – something that could only be done in post-production compositing.

These continuous advancements uniquely empower virtual production filmmakers to shoot more creatively with more ambitious setups while saving them valuable time and enhancing their storytelling.

Break It Down Into Techniques

Gary Marshall – NantStudios and A.J. Wedding – Orbital Studios

Car Process Common Techniques

Car process work on LED stages is extremely economical compared to the alternatives of permits, process trailers, police escort, closing a street, timely resets, etc. The value grows with every scene shot in a day because it does not matter how many different cars or backgrounds are being used. Beyond that, being on a sound stage provides a degree of safety and comfort for the crew.

What follows is a discussion of the three common techniques for LED car process work: 2D video playback (the most common), 3D environments, and XR (extended reality).

2D Video Playback Approach

The first step in this method is plate acquisition. While there are websites where one can purchase stock driving plates and other vendors who can create tailored plates for a fee, there will be some compromises in final output versus having complete ownership of the acquisition process. Best practices dictate that the footage should be the same frame rate as the final recording. Most often in the US, this is 23.976, usually a post-production supervisor/producer will or can find out the proper specifications needed.

An 11-camera array is preferred for this type of plate photography. It is important to have all the angles covered to match whichever angle the Director chooses when lining up the shots during principal photography. An important piece is syncing the cameras to one another so that they are all representing the environment simultaneously when used on the stage. This is incredibly important if any of the angles will need to be stitched together for use on a curved LED stage.

Processing the footage for playback on the wall requires specific attention to detail. If the footage is not stabilized when recorded, it will require stabilization in post, which is time- and cost-consuming. It is important to be cognizant of the method used for stabilization as it can create ghosting in the frame that could trigger QC issues in post. Post stabilization will also result in an image that is "zoomed-in" because of the processing. Therefore, it is better to use stabilized camera platforms when capturing the footage or a scaling issue may arise that will degrade the quality of the image.

When it comes to color, it is best to keep it basic. The DP will have a specific LUT that they want for the overall shot. Therefore, never apply that LUT to the footage before it is filmed on the stage. This would result in a double application of the LUT, which greatly skews the color out of the desired look. It is best to keep as much flexibility as possible to allow the operator to dial in the color and contrast ratios to match what the DP is creating on the foreground subjects. Assuming the footage was shot in a camera RAW format, a transcoded ProRes 4444 file will suffice for distribution from the plate vendor to the stage operation team.

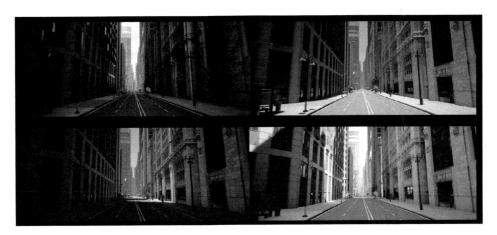

Figure 12.5 A 3D environment map for a driving sequence created by 3rd Films
Source: All Rights Reserved (Image courtesy of Orbital Studios)

At the time of this writing, the most widely accepted codec for playback is 10-bit Quicktime Notch LC. Converting to Notch LC creates a very large file, but it runs smoothly without dropping frames.

3D Approach

Using a 3D environment for car process work offers greater flexibility and more realistic parallax but requires a larger team to execute. The first step is the Virtual Art Department (VAD) creating a concept for the environment needed. In this example a city street that is 3km in length, designed to provide one minute of drive time before it resets. The functionality of being in motion needs to be programmed to follow the path needed, usually via a spline or other such system. There are other parameters that can be set for live adjustment, like speed and left/right movement on the path/track. Using a 3D environment offers greater flexibility for time of day, lighting, and direct control of every element present in the final image.

If post-production visual effects are a consideration, it is important that the virtual production operators keep a record of the positional data within the scene for each take. This will allow the visual effects team to use that tracking data for the visual effects being added. Care must be taken to reconcile the global transform of any camera data, in the context of stage coordinates, with any positional offsets in the render engine environment.

LED Stage Use

To understand the color pipeline of the stage, it is important to know what settings are being applied across the entire video signal chain. While most LED products are capable of a 10-bit HDR throughput, that does not mean the stage has that capability. These capabilities change based on how many panels exist on each signal path. For example, if ten LED panels with 1.9mm pixel pitch are on a single path, the panels are no longer capable of 10-bit, limiting one to 8-bit. It is important to check the display setting in the Nvidia control panel to see what the stage color limitations are. EDIDs (Extended Display Identification), in addition to scaling software/hardware, also

manipulate the video signal at any point in the path. Between Nvidia settings, EDIDs, controller software, and playback or render engine, there are multiple places in the signal path where it can be manipulated. Stage operations crew should have performed any sensor/lens color calibrations by shooting known charts on the LED wall and computing an appropriate matrix LUT prior to shooting, which then should be loaded and enabled in the rendering engine.

Brightness, contrast, and color reproduction are the main controls that are manipulated on production days. The operator can adjust brightness to suit the DP's chosen camera settings and adjust contrast ratios to match the lighting on the subject. Matching color is the final piece that is dialed in, based on the chosen color temp of the camera and lights, and to the DP's needs.

The LED stage layout can affect decisions regarding the approach chosen for the project. For a show like *Justified: City Primeval* (2023), the LEDs needed to be brought to the main stage. This required a system of multiple flat walls and a ceiling to be brought in, allowing the Director of Photography to move the walls around as needed to find the areas where reflections were present on the vehicles. With a flat wall setup, the choice to use video plates, as opposed to a 3D environment, made more sense since the camera moves would be limited by the size of the LED screens.

Curved wall stages offer more freedom to move the camera since there are fewer breaks in the image than with flat walls. For an SAP commercial, the Director of Photography was able to move the camera freely around the vehicle while the scene ran, getting proper parallax as the camera is tracked. He was also able to adjust the speed of the vehicle's movement and the time of day as he saw fit.

LED ceilings tend to have a wider pixel pitch than the walls, which may require diffusion. In the examples, the ceiling had a 3.9mm pixel pitch, which means the ceiling requires diffusion if it is

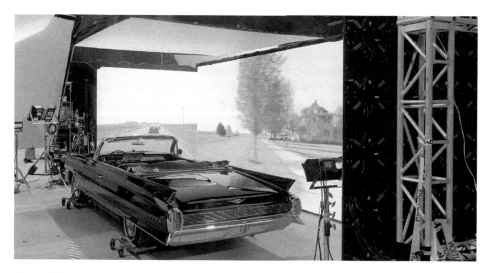

Figure 12.6 A system of flat LED walls
Source: (Image courtesy of Orbital Studios)

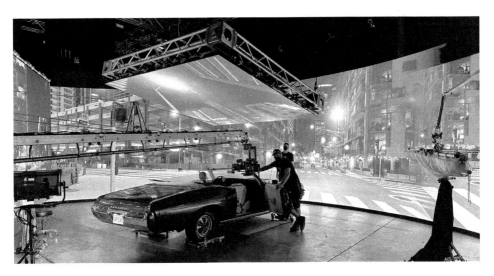

Figure 12.7 Car shoot using a 3D tracked camera, Orbital Studios
Source: All Rights Reserved (Image courtesy of Orbital Studios)

within eight feet of the vehicle. Without it, the reflections created by the ceiling will showcase the moiré pattern created by the widely spaced LEDs. Some LED stages are moving toward tighter pixel pitches on walls and ceilings to mitigate this issue (such as the stage pictured above), but it is something to keep an eye on.

If the 3D scene also requires set extensions, the setup is XR. This requires the camera, computers, controllers, and tracking system to be genlocked so that the latency in the system can be identical across the entire setup. This allows for the live set extensions to track properly with the LED wall. There is additional calibration required for this method, as well as color considerations, to blend the extension with the image on the LEDs.

Motion bases are often used with LED walls for cars, planes, spaceships, etc. The positional data of the motion base can serve as input data to the rendering software to manipulate the 3D environment.

The number of possible setups in a day depends on the complexity of each setup. It is possible to shoot multiple scenes in various vehicles and backgrounds in a single day, demonstrating the economy of shooting car process work on LED stages as well as the ease and safety of working in a soundstage.

Projects Shot on an LED Stage

LED Wall ICVFX

A.J. Wedding – Orbital Studios and Gary Marshall – NantStudios

Episodic Content

LED in-camera visual effects (ICVFX) represents a significant leap forward in the art and craft of filmmaking, akin to the paradigm shift when the industry adopted digital formats as the medium of choice, relegating film to a style. When ICVFX and analog film production collide, myriad challenges result; however, it can also be a beautiful fusion of the old and new. For example, on HBO's *Westworld* (2022), the narrative centered around capturing a Times Square metaverse concept at various stages of degradation, incorporating elements such as city skyscrapers, crowds, various time-of-day setups, billboards/signage, foliage, and complex lighting/point cloud rendering. The physical set pieces were also of an elaborate nature and needed to blend seamlessly with the digital elements being rendered from the game engine. This was successfully accomplished.

Another example of this is using the Unreal Engine and LED wall to seamlessly blend backgrounds and a car for convincing process shots, such as seen in Figure 13.1.

Sync and Color Workflows

Contemporary digital cameras use a standard method to sync their shutter to the other components on an LED volume, while traditional film cameras do not. Digital cameras sync via a BNC input (genlock) signal originating from a master clock, or some such time-keeping device.

DOI: 10.4324/9781003366515-14

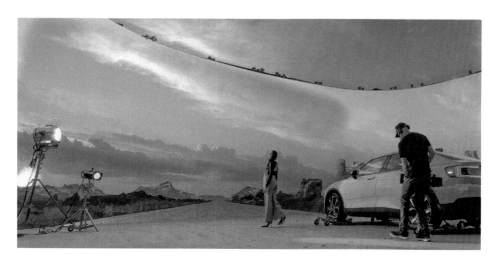

Figure 13.1 Example of 3D Unreal Engine content being used for vehicle process shots at NantStudios
Source: (Image courtesy of NantStudios and Impossible Objects / Vincent Valentin)

Using film cameras with LED wall technology presents a challenge. It is essential to ensure the frame generation of the rendering engine, the LED panel, and the imaging sensor (in this case, a mechanical film camera shutter) are all perfectly synchronized. Failure to do so will result in artifacts in the final image such as black rolling bars. A major positive when utilizing film is that film cameras have a global shutter as opposed to a rolling shutter, which eliminates some of the issues related to the write speed of a frame with most digital cameras.

Standards and best-practice methods are beginning to emerge for a good portion of on-set activities concerning ICVFX. Timecode and genlock are well understood technologies, and there are deeply experienced individuals in video engineering, network engineering, source control management, and other disparate technical matters that should be involved.

There is still one large area that causes confusion and debate: The color pipeline. Traditional visual effects have long established methods of ensuring a sanitized end-to-end color environment. With ICVFX, things are a little more ad hoc. Artists from VAD teams can be spread globally, working on radically different computing equipment and displays and often in environments that are not conducive to performing color critical work. The final destination for content is usually a real-time rendering/game engine which has no explicit control for working color space. The video signal path from GPU to LED tile travels through various manipulations, such as signal conversion, routing matrices, and an LED "processor" before it reaches the physical diodes themselves. There are additional variables, such as EDID information for the displays, and the bit-depth of the signal itself to contend with. One best practice is to perform calibrations of each camera sensor to LED tile combination, at a minimum. Preferably each sensor, *lens*, and tile combination should be tested, particularly in the case of anamorphic lenses. Signal sniffer hardware can also help sanity check exactly the video signal.

On *Westworld*, the convenience and confidence of being able to instantly pull digital negatives from the cine camera and transcode them to verify color accuracy were not possible. Any

errors would not come to light until the film was processed and viewed in a telecine session the next day. A major concern for the DP was preserving color temperature consistency across foreground talent/set pieces and digital background content. The solution used was to hire a dedicated color scientist with their lab-grade color measuring equipment, a spectroradiometer. This device measures both the wavelength and amplitude of the light emitted from a source with an exceptional degree of accuracy. Spectroradiometers differentiate the wavelength based on the position the light hits the detector array, allowing the full spectrum to be obtained with a single acquisition.

A default tile calibration of D65 white point is usually standard on most LED tiles (per factory settings) and can be altered with processor software dynamically. The practical lights on set were tungsten (~3200K) and had to be adjusted accordingly. Anytime more practical lights were added to the set, the lighting crew needed to ensure they were not "washing out" the physical tile, and anytime more digital light was added, via "light card" elements, a measurement was taken with the spectroradiometer to ensure the physical and digital worlds were not diverging in their overall lighting balance. Macbeth charts (physical and digital) and gray balls were also used as tools in the color management workflow.

Working With Production Design

Related to the color points above, ICVFX tends to live or die on the effectiveness of how convincingly the digital environment and the physical environment are composed and blended in the final image. Usually, this is helped by selecting organic material that can easily be scanned and replicated in CG or defined procedurally; for example, rocks, mountainous terrain, desert, dunes, etc. When shooting in instances where the set design is non-organic, hard surfaces such as streets, bridges, skyscrapers, etc., the task facing the production team becomes harder:

- Parallel lines that extend from practical props or sets and handoff into digital content need pixel-perfect lineups to avoid having to fix in post. In the *Westworld* example, the practical city street element, center stage, is extended digitally into the LED wall content.
- Uniform colors of objects (e.g., metal, concrete) need to be more accurately matched in the CG content. The natural color variation found in organic objects is often not present in these man-made materials, so the job of the on-set colorist becomes more difficult.
- Reflections and transparency need to match what is being seen on set in the physical content. This often involves enabling more advanced rendering features that can hamper the frame rate of the real-time playback.

Short Film and Lower Budget Productions

It is often mistakenly thought that ICVFX production is the sole domain of productions with large budgets and long lead times with regard to content prep. An increasing number of shows are exposing that myth and have been incredibly successful in utilizing LED ICVFX. Not all projects will need a medium to large volumes with permanent wall installations. Some examples:

- Music videos and live events
- Game shows

- Mid- and lower-budget commercials
- Short film content

Often these projects can engineer content to take advantage of optimizations, like using pre-rendered content on cards, pre-baked lighting, marketplace assets, etc. The Disney+ short *Remembering* (2021) was one such instance where there were five environments to be shot over a limited number of shoot days, including having a child actor as part of the talent, limiting shooting hours permitted. Virtual production helped achieve the goals of the creative, with enough flexibility to allow the Director to dial in his intentions on the day of the shoot, without having to have spent months in pre-production.

Utilizing 2D Playback

A producer's decision to utilize an LED stage or volume is difficult due to how many budget line items must be shifted from post-production to pre-production since LED stage workflows are front-loaded. However, using 2D playback is a method to showcase the fidelity and flexibility of virtual production without changing workflow. In the series *Snowfall* (2022), Orbital Studios was able to bring LED walls into the production's stages to provide the massive view out of the windows of the main set, as well as offer roaming LED walls that were used on various other sets. The DP was able to dial in exactly the look and color desired for the skies in each scene. The actors' performances were more believable because they could see what they were reacting to in real-time. One-third of the show's locations were projected on the LED walls, saving over a million dollars for the season. The "positivity" that this created led the producers and creative team to ask what else might be possible with virtual production. In the subsequent season, the team became so comfortable with these tools that they quickly dialed in specific adjustments and added pixel-mapped lighting into the equation.

Figure 13.2 *Snowfall* Season 5 (2022)
Source: (Image courtesy of Orbital Studios)

LED Volume – 3D Tracking Full Volume vs. 2D Playback on Set

A.J. Wedding – Orbital Studios and Gary Marshall – NantStudios

How the LED Specifications Affect Options

The detailed specifications of LED panels are covered in another chapter, but it is important to note how the variations will affect the production. Panels with a pixel pitch below 2.0mm allow the camera to be closer to the screen without moiré and have less off-axis color shift than what is present in 2.6mm and 2.8mm panels. There is an LED design known as "flip-chip" which eliminates off-axis shift and allows for more freedom of movement with the camera.

2D Playback

While 3D virtual production is often preferred, the changes in a necessary workflow can lead productions to the option of 2D playback. Though video plates do not offer full 3D tracking, there is still some believable parallax between the subject, foreground set, and LED wall. Specialized software/hardware such as disguise and Pixera can offer proper frame accuracy and color/focus adjustment tools. Car process and translight replacement are solid use cases for 2D playback. Normally a production will have two translights, one for day and one for night. LED walls offer an unlimited number of possible times of day, varying cloud formations, sunsets, and realistic movement of background objects such as traffic.

3D Tracking Volume

There will often be multiple cases where 2D plate playback is not sufficient for the project; for example, there is a greater need to sell the parallax of the scene where there are multiple elements at various depths, or there is a need to display "otherworldly" content – hence not possible to capture in the real world. While these things can be accomplished in 2D with some effort, it is often more practical to turn to a full 3D approach. (There are also 2.5D or hybrid approaches, but that is beyond the scope of this chapter.)

After an initial concept is decided, it is time to hire a virtual art department to fulfill the asset creation needs. There are myriad vendors available that range in quality from those that will scrape together lower quality, cheap asset marketplace models and textures, to those who will handcraft a bespoke environment with beautifully painted high-res textures, sky domes, etc., to generate scene files that are sub-hair width away from being a real-time photoreal asset indistinguishable from a traditional offline render.

The timelines for preparing 3D volume content can vary widely depending on the type of project and the workflow chosen by the art department. As is the case with any creative endeavor, the longer the lead time the better. Best practice guidelines suggest the following:

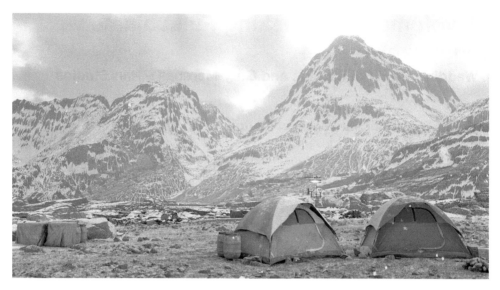

Figure 13.3 Example of a full 3D real-time environment © NantStudios
Source: All Rights Reserved (Image courtesy of NantStudios Real-Time Art Department)

- Music Video/Lower End Commercial: One and a half to two weeks per environment at a minimum.
- Mid to High-End Commercial: Three to six weeks per environment at a minimum.
- Episodic/Feature: Two to three months per environment, assuming multiple creative iterations (see below).

With 3D scenes running in a real-time game engine, there are more tools available to the creative stakeholders to iterate and refine the vision. Platforms such as VR Scouting and Virtual Camera (VCAM) allow multiple users to simultaneously "walk" the CG environment as if it were a physical location, making annotations, moving set decorations, testing time-of-day scenarios, etc. Those findings are relayed back to the asset development teams by exporting a scene description, engine project update, PA notes, or a combination of all. With 2D plates, the elements become baked-in at the time of acquisition, and it is very difficult to go back and make changes without having to reshoot the entire plate. Using full 3D virtual production allows many changes to be made on the fly, even on the day of shooting.

Once the assets are given to the stage, they pass through a stage operation vendor; sometimes this will be happening under one roof, but often assets will be authored by a separate team from those performing stage operations. As a rule, the team should be doing a stage validation exercise at the end of any content production week or as necessary if there are major updates to art assets.

A major concern at this time is how performant the scene files are when projected to the LED wall. Essentially, the rendering engine should be able to comfortably output *above* the desired project frame rate. The sync pipeline will then ensure that the engine frame generation is happening in

proper sync with the camera FPS. Most medium- to large-sized stages run variations on the idea of having multiple render nodes be responsible for rendering a portion of the entire canvas. Usually, this is broken up into discrete 4K resolution patches, but this is not always the case. Hardware and software are then able to aggregate the separate patches into an overall seamlessly rendered canvas.

The stage vendor should be running tools that can perform a variety of benchmarks in a particular scene file and feed that back to the artists creating assets. A good rule of thumb is to aim for double the intended final frame rate. This will give some buffer because frame rates tend to drop as more content is added. (Testing this on a single machine, not running a clustered render environment, can guide but will NOT be a final indicator of performance.)

Additional game engine issues to be aware of include the following:

- Improper use of particle systems – certain methods of authoring particles can be heavier than others.
- Card-based models vs. 3D hero models – sometimes an element that is in the far background can be cheated with a pre-rendered element on a 2D plane, which will save performance.
- Inner and outer frustum control –there are usually dynamic controls that let an operator dial up or down the resolution of each pixel, allowing adjusting performance.
- Baked lighting vs. dynamic lighting – the latter will cost more in terms of computation.
- Color management – (see "LED Wall ICVFX") being aware of the entire end-to-end color pipeline is essential to getting the desired final result. Sensor/wall calibrations and calibrated monitors are essential.

The 3D parallax is achieved by tracking the physical camera position and passing that streamed data to a virtual camera representation that has been built in the render engine. The physical and virtual cameras need to have their parameters matched: Sensor sizes, lenses, and aperture. Specialist encoding equipment can additionally be added to the camera that will solve for focus distance and zoom (if not using a prime lens). Typically, the tracking is solved via an optical tracking system set up around the perimeter of the volume in the adjacent edges between the top of the LED wall and the plane of the ceiling (if ceiling LEDs are present).

A small device ("the Sputnik" or "CinePuck"), which contains an array of markers and potentially other rotational and acceleration sensors, is then attached to the camera. The markers are triangulated by the tracking cameras, and a "rigid body" solve is performed producing a 6-DOF transform that is sent to the game engine to give the final virtual camera position.

Tracking systems have various potential issues to be aware of:

- Tracking latency – the data that issues from the physical camera to the render engine updates can incur several frames of delay. There are tools to measure the exact end-to-end latency.
 - Fiber vs. copper – the networking infrastructure affects latency. The stage vendor may have solutions to their network that may improve this latency issue.

Figure 13.4 Typical production camera sputnik configuration
Source: (Image courtesy of NantStudios)

- Avoiding interference – production personnel can bring devices to stage that operate on channels/frequencies that interfere with motion capture equipment channels/frequencies. Be sure to communicate with production on who is using what.
- Occlusion – large set pieces, and/or production equipment, can block the line of sight from the capture cameras to the sputnik markers. This is where additional sensors on the sputnik can act as backup for tracking positional data and assist in the event of losing optical tracking.

14

Challenges and Limitations of Shooting in a Volume

Limitations to Be Aware of When Shooting in a Volume

Justin van der Lek – ILM

Intro

The filmmaking community finds itself once more at the leading edge of a new storytelling tool. LED volumes are a powerful, exciting technology that brings the world of visual effects even closer to practical and physical filmmaking by putting the virtual world right in front of the lens, in real-time. This invites other on-set departments to the creative table in a way visual effects have rarely experienced in the past. With this seemingly limitless technology however, filmmakers would benefit from knowing some of the creative and technical caveats in order to navigate a more successful shoot. Being able to communicate and prepare accordingly will benefit all, particularly regarding the technique's strengths and its current shooting limitations.

Volume Size and Specifications

Proximity to the Walls
Given the variety of LED volume stages, it is important to be aware of the size, shape, and technical specifications of the particular volume being considered. Content creation should be tuned to the volume it is meant to be used in. This applies to not only the virtual extension into the LED walls but also the corresponding physical set build. As a rule, one does not want to build sets or block action where subject/set proximity is too close to the LED walls. This introduces constraints

DOI: 10.4324/9781003366515-15

for almost every department with the consequence of a shot or sequence not being successful or having to replace or heavily augment the shot/sequence in post-production. Keeping subjects within the accepted distance and range from the LED walls will avoid having to deal with certain artifacts like incorrect depth of field and depth cueing of the virtual environment. This range varies, depending on the lens and camera package, as well as the LED products used and other variables.

Build Flexibility and Infrastructure

Different LED products allow for different levels of flexibility. Some LED volumes are constructed in such a way that the removal of LED panels to create access for practical lighting, stunt rigging, etc., is relatively easy. In other LED volumes, this is a major undertaking. It is incredibly important to be aware of the limitations of the infrastructure of the LED volume one is going to be working in.

Content Scale vs. Volume Size

Productions with experience shooting in the volume will frequently devise scenes which match the physical scale of the LED walls. However, when the size of the virtual set is mismatched with the virtual one (small cockpits and narrow canyons, or even larger expanses), it is important to pay close attention to the disparity between the physical and the virtual.

If the scale of the content is smaller than the dimensions of the LED volume, one must be wary of "Space Violations." Positional and scale artifacting is something that can occur as a result of wall-to-content scale mismatch. This is due to the content projecting much closer in virtual proximity than the actual LED walls, which can lead to "over translation" of content as well as lighting or reflection artifacts. On *The Mandalorian* (2019) series, the team designed a pair of articulating LED panels that could be positioned to effectively enclose the volume. In later seasons, these were converted into a mobile, curved LED wall. This allowed for more flexibility with the scale of content via pulling the curved LED wall into the volume.

Tall virtual spaces: If the virtual environment has geometry that is taller than the LED ceiling, the geometry can warp and translate across the ceiling, which negatively affects the lighting on the physical set.

Loads

Having the Right Amount of Control vs. Having Too Much

With a variety of real-time engines available for virtual production work, one has the option of creating a load[1] with plenty of creative control to dial in during shooting. Depending on the sequence needs, the content can vary from a fully built 3D load to spherical video playback of either prerendered CG or filmed material. Pre-rendered and filmed content has the advantage of having higher photoreal quality and cleaner feeds, but one might compromise on flexibility of content adjustment on the day.

It is wise to make early decisions on how flexible the 3D loads should be. This may require them to be trimmed down to the most important and agreed-on controls, enabling the virtual production operators to adjust notes in a timely manner. Being able to fully adjust a load from top to bottom can severely strain the virtual production crew and trickle down to other departments, such as the lighting department, and cost valuable time on set. Translation of the creative vision and needs to a robust lean toolset for the load is preferred. This may be variable from scene to scene.

High Contrast Loads

High contrast loads can pose challenges to keeping the black levels consistent and deep. This is due to having the brighter part of the load overpowering and flashing the darker parts of the load. There are a few possible workarounds that require the cooperation of the DIT, Gaffer, and DP. Balancing the highlights and shadows, compensating in the CDL with the DIT, and virtually adding negative blockers on the LED wall are some of the workarounds applied.

Artifacting – What to Watch Out For

Listed are several types of artifacting to watch out for when shooting in an LED volume:

- Moiré: Moiré is generated whenever the pixels of the LED wall come into focus. Several factors, such as depth of field, LED pixel pitch, and lens resolving power, can play a factor in how much of the LED volume is usable for staging action.
- Pulse Width Modulation Artifacts (PWMA): PWMA occurs when LEDs function at low output levels. The result is a blurry afterimage around practical objects in motion. PWMA can be produced by actors moving quickly in front of a static camera, or it can be produced on all practical objects in view of a moving camera.
- "False Reflections": False Reflections occur when the content from the LED walls reflects onto practical set pieces in an incorrect way. This phenomenon can be difficult to spot. Some examples are as follows:
 - Low horizons in content will reflect onto the practical floor they are near when they should not.
 - Double/Counter False Reflections are possible when employing reflections within specular geometry within the content. A reflection in geometry will appear in the reflection *of* the geometry on practical sets.
- Noise: Render or sampling noise that might otherwise be acceptable and difficult to observe on standard computer monitors but can be intolerable when viewed at scale on the LED walls. It is one of the reasons that viewing the content on the LED walls while it is being iterated is so important. Rotational noise from camera tracking can also create noise.
- Aliasing: Like render noise, fine detail, dense geometry that might otherwise be acceptable can be intolerable on LED walls. Certain architectural features like grates, vents, and filigree may not be employable as geometry and may have to be replaced with 2D elements to mitigate the appearance of aliasing. Rotational noise from camera tracking can also create aliasing.

Camera Language

It is vital that the Director of Photography and camera department understand the limitations and power of the volume. They should be completely on board with the methodology and work closely with the Virtual Production Supervisor(s) and VFX Supervisor(s) to help devise the most efficient order of shooting, as well as upholding the integrity of this workflow. Productions should streamline and properly prepare by having in-depth methodology meetings, virtual scout meetings, virtual art department (VAD) dailies, and physical walkthroughs and pre-lights before shooting. All of this supports the DP's responsibility to cinematically tell the story with minimal compromise on time and budget.

The volume currently limits the way the camera can be used technically and creatively. The crew must understand the camera language of the volume. For example, system latency is currently too large in most LED volumes to accommodate certain shooting styles. The need to shoot multiple cameras at the same time can also have its challenges depending on certain factors. Within the multitude of camera equipment options, there are certain rigs that pose more problems than others.

Shooting in a style that is more reactionary, cinema verité, with rapid translations and rotations can be problematic due to the latency of the LED wall. This spontaneous, action/reaction camera language can still be achieved by taking a bit of the spontaneity out and rehearsing beforehand. The virtual production crew can accommodate, in certain situations, with a locked frustum, as well as guidance where to slow down and accelerate camera moves.

Certain camera equipment require testing because the use of some of it could potentially exacerbate the latency, like "Zero Gravity" rigs.

Shooting multiple cameras on the volume requires testing to make sure that the load performs at the preferred frame rate when introducing an additional frustum. One does not want to overlap such frusta because that breaks the illusion of the perspective projection by seeing the other camera's perspective. With reflective subjects and sets, one needs to be aware that multiple frustums could contaminate the reflections by seeing the incorrect reflection from other frusta.

Outro

Prep Is Everything

Even though the volume is regarded as a flexible technology and explorative tool, preparing the days in the volume is key. Educating the crew on the volume workflow will hopefully result in making better decisions on how and when to use the volume on productions.

The production will be most successful and will get the most "bang for its buck" if everyone has the same goal of either using the volume for its ability to get in camera finals or using it as a sophisticated lighting device. These choices need to be made early in the pre-production process, long before the camera is on the set with the actors.

This requires involvement and collaboration of all on-set heads of departments (HODS) and will allow for "on the day" exploration and tweaking of details.

Moiré, Viewing Angle, Banding, Latency, Artifacts, and Frame Sync
Patrick Tubach – Epic Games

Challenges and Limitations
There are tremendous aesthetic and practical benefits to shooting in an LED volume, but LED volume productions are not without unique challenges and limitations. These challenges can arise from stage operations, technical difficulties, or content issues.

Stage Operations

Movement
The lack of entrances and exits from a volume set presents a tough logistical challenge. If many actors need to circulate in the scene, their exits and entrances must be cleverly hidden by set pieces to avoid repetition. Walk-and-talk scenes are also hard to accomplish when the longest straight path will not accommodate a long line of dialogue. That said, staging overlapping volumes, splitting the volume in half with physical set walls, employing treadmills, rotating sets, and using motion bases with traveling loads (where the content is animated past the actors) are all ways productions have made the space feel larger. Building practical sets outside the mouth of the volume is also a popular way to expand and break up the typically circular shape that most volumes provide.

Stunts
Stunts are possible to achieve in the volume but require some careful planning and negotiation ahead of time. Many volumes are built with a steel frame around them that can accommodate stunt rigging, provided that the correct LED panels are removed from the ceiling. However, mounting and rigging points are not as freely available as they might be on a greenscreen stage or set. Furthermore, the space is limited, and some stunts will have a hard time conforming to the volume's shape.

Special Effects
Special effects atmosphere and haze is used on most productions, and volume productions are no exception. This can be difficult to deal with on a volume when the wall content is very bright. In those cases, the atmosphere and smoke in the volume is illuminated by the LEDs, which act

as an additional light source, and to make matters worse, spills light back onto the LED panels, unbalancing the contrast and color. It is possible to find a balance, but atmosphere and smoke need content-specific testing ahead of time.

Equipment

Care should be taken by the stage team to ensure that the panels are also kept clean – dust and dirt accumulation can affect light output and create visible discoloration in content. Pixel drop-outs in panels happen, usually resulting in an intense single-color pixel appearing on the wall. But a responsive stage team can replace the panel(s) rapidly so production can resume.

Technical Difficulties

Camera Tracking

Optical camera tracking systems require line of sight by a good number of cameras to be accurate. When dealing with large set pieces or sets with a roof, the volume team will need some time to ensure coverage. This is usually tested on prep days.

The sound department will often need some help from the volume team to get clean dialogue recordings. Because of the curved shape of most volumes, sounds in the volume space produce an audible echo. This can require audio baffles and/or large sheets of sound-dampening material that are positioned on stands to help break up the echoes.

MOIRÉ

Moiré patterns are a phenomenon that plagued photography of televisions and screens long before LED volume technology. But there are ways to avoid and mitigate it.

The best way to combat the moiré is to find a way to force the content to be at least slightly out of focus, either by lens choice, camera position, focal distance to the wall, or some combination of all three. Putting the background out of focus with depth of field is the simplest and best solution. Getting the camera far enough away from the wall that the pixel pitch is not perceived as a gap will also solve moiré, but that solution is not always possible for every shot or in a space-constrained volume. LED walls with a tighter pixel pitch will help, but unless the gap is eliminated, the moiré pattern will still show up in some combination of distance and focus.

VIEWING ANGLE AND REFLECTANCE

The reason that most LED volumes are curved by design is to ensure that the maximum number of LEDs are facing the camera. This avoids oblique camera angles on the wall where the LED brightness appears to drop because the entire surface of the LED is not being seen. Modern LED panel production techniques have improved this dimming to the point where it is a minor inconvenience, with the loss of brightness only appearing at extremely oblique angles.

Content Issues

Latency and Frame Sync

LED panels can have reflectance issues (light bouncing back into the panels from the scene they are illuminating) because of the unlit gaps in between the LEDs. Manufacturers are exploring less reflective materials and finishes to cut down on that light reflection. Until they solve this, it is another part of the color and contrast balance for the Colorist and Virtual Production Supervisor to work out while blending wall content to the physical volume set.

Frame latency, or lag, is caused by the time it takes for the content to be updated once the camera moves. This is usually six or seven frames, which means that extremely fast whip pans will be hard for the walls to keep up with. This is dealt with by expanding the rendering area of the inner frustum (the area of the wall that is intercepting the camera's field of view). In other words, the active image area is larger and therefore always has image real estate "ahead" of where the camera is headed next.

One drawback of a larger frustum is that it can impact the frame rate of the overall scene, causing the wall content to jump or skip as it struggles to render in real-time. However, this effect can be mitigated by expanding the frustum in only the leading direction. At a minimum, the frame rate of the wall content should be 24 FPS. Still, most virtual production supervisors prefer a frame rate at least double that to accommodate other camera frustums, or simply ensure smooth performance of more complex scenes. Content like animated objects, moving lights, and volumetric effects will also eat up performance and need to be monitored and optimized.

REFLECTIVE SURFACES

Reflective surfaces have a great volume reputation. One of the big benefits of a volume is the environment reflection looks great on glass, helmets, visors, shiny floors, etc. Reflections can be problematic when objects are reflected into the floor content and then end up reflected in the physical floor because the wall itself reflects the object a second time. To avoid this, allow for a break in flat, shiny surfaces so they do not have to be continuous from the physical into the virtual. Always check reflective surfaces for moiré – a wall that looks good to the camera can display moiré on the reflected image in the set. Color shifts may also be observed if the reflection is off axis to the wall it is reflecting. A solution is to either manually adjust the color of the reflection or to adjust that position.

Artifacts

There are other image artifacts that can show up. Color banding is one of them. Color banding results from textures that have been overly compressed or low-res images that are stretched or displayed much larger than anticipated. Some of those flaws will be hidden by the camera, but it is good practice to fix the problems in the source material and not rely on hiding flaws in the defocus.

Chapter 14

Color Gamut and Color Shift
Rod Bogart – Epic Games

Color Gamut

Gamut of LED Wall Pixels

The possible set of colors that are produced by a display is called the Color Gamut. For LED panels, the individual red, green, and blue LED diodes define the gamut of the panel. Typically, a single LED panel product will have a particular gamut, but it can be different than the gamut of another LED product. Additionally, the individual LEDs within a panel can have slightly different performance, resulting in an average gamut for the panel. The LED manufacturers that provide panels for ICVFX go to great lengths to produce panels that have an average gamut with minimal outlier pixels.

When pixels are displayed on the LED panel, the LED processor manages the difference between the native gamut of the panels and the gamut of the input signal. Because LED processors differ from each other, not all have the same options for controlling the conversion from input gamut to native gamut. In general, however, there is typically a section of the UI which indicates the measured gamut of the panels, along with UI for describing the input signal. The measured gamut of the panels is normally an average of measurements of panels in the full set of panels.

Depending on the LED processor vendor, there may be additional calibrations that they perform to ensure that each panel meets that target gamut to the best of its ability. A full calibration solution would involve measurement of every panel and of each pixel on each panel, resulting in a map of the differences between the actual panel and the overall average gamut. The LED processor uses this information to equalize the individual panels so that the overall response of the wall evenly hits the average native gamut. The visual result is that a user could set all panels to display a single color, and the distinctions between panels would be not visible because the vendor calibration had been performed. In an uncalibrated environment, however, the intended flat color might look noisy or have obvious examples of bright or dark panels within the wall.

Note that not all panels are the same, but typical panels used in ICVFX have color primaries similar to those shown in Figure 14.1. The gamut diagram shows a triangle connecting the red, green, and blue color primaries. This is within a curve that shows the limit of colors that humans can see, which is called the spectrum locus. Most display gamuts are shown in this type of diagram, called the CIE1931 xy chromaticity diagram. For comparing gamuts, however, the u'v' chromaticity diagram provides a better sense of how similar or different the gamuts are.

In Figure 14.2, the smallest triangle is Rec.709 (also called BT.709) and is the gamut of most televisions and desktop monitors. The largest triangle is Rec.2020 (BT.2020) and is the defined gamut for future UHD production. It should be noted that Rec.2020 uses color primaries that are only possible with lasers as the light source. There are no common display devices that cover the entire Rec.2020 gamut. But many displays accept Rec.2020 as the gamut of the input signal.

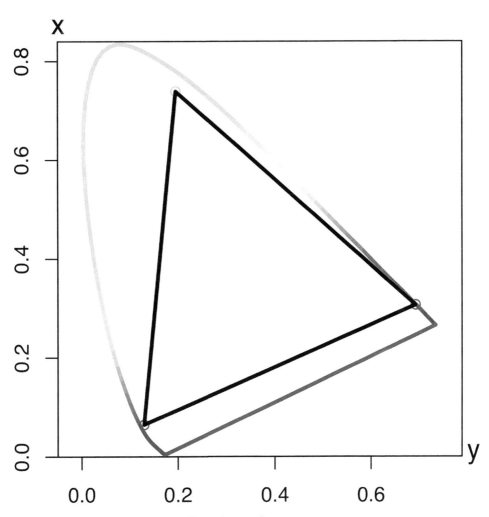

Figure 14.1 Shows an example of an LED panel gamut diagram
Source: (Image courtesy of Epic Games)

When a larger gamut is provided as input, the output device accurately shows the pixels that are within both gamuts and clips those that are outside of the display capabilities.

The question that arises is, "What color gamut should be sent to the wall?" One has choices based on the capabilities of the LED processor. The choice needs to match the gamut that is being produced by the real-time engine or playback engine that is driving the LED wall. If the engine creates a Rec.709 signal, but the LED processor is set to interpret the signal as Rec.2020, the content on the wall will appear oversaturated. This is because the engine content is being displayed wrong, with the color primaries being expanded outward, oversaturating the image. Further considerations in matching the color are discussed in Chapter 21. Still, for now, it is important to match the color gamut of the LED processor's input signal to the color gamut of the engine.

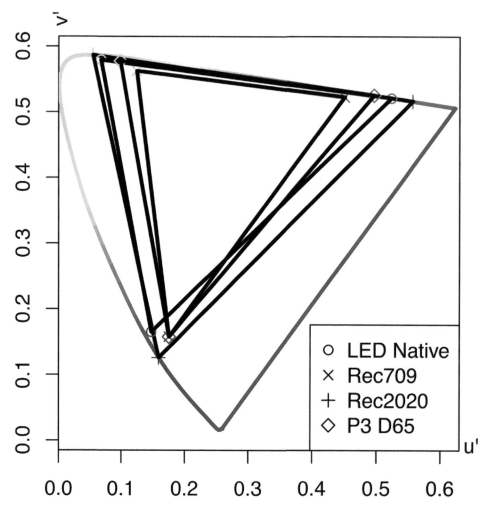

Figure 14.2 Shows the LED gamut along with some common output gamuts used in production, shown in the u'v' diagram
Source: (Image courtesy of Epic Games)

Since the average gamut of panels is unlikely to be the same as the gamut of the input signal, some color processing must occur in the LED processor. This processing is based on the settings provided to the LED processor, so it is important to set those properly and to measure the end-to-end result to confirm that the processing is happening as expected.

Spectral Response of LED Wall Pixels

The red, green, and blue primaries of the LED are specific colors that specify the gamut. Additionally, those individual colors have particular spectral responses that affect the effectiveness of the LED wall as the sole lighting instrument.

In Figure 14.3, note that the individual color components are quite distinct, and the responses of the LEDs have a very narrow sharp shape. If the LED wall is used to light sets, props, costumes,

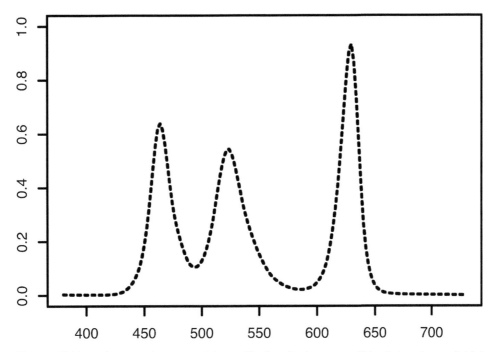

Figure 14.3 Shows the spectral response of the combination of red, green, and blue that produces a "white" color shown on a typical LED panel
Source: (Image courtesy of Epic Games)

and characters without any additional light source, the response from those objects can have unexpected appearance changes.

The spectral responses of two different illumination sources are shown at the top of Figure 14.4. On the left is the response with only a "white" from the LED wall. On the right is the same chart photographed under sunlight.

In many patches of the chart, the colors are quite similar. But some of the patches exhibit a large difference between the two sources. In particular, notice the orange patches at each end of the second row. When those orange colors are lit by LEDs alone, the result appears very dark relative to the same patches lit by sunlight. The explanation for this is shown in Figure 14.5, where the spectral responses of some individual patches are shown against the response of the LEDs.

When a colored object is lit by a colored light source, the spectra of each of them is combined. The individual spectral values are multiplied together, causing the overall spectral response of the object to be reduced in the regions where the light source has little or no spectral information. This is particularly noticeable in the orange patches, which have a large difference between their spectra. However, that difference mostly lies in the gap between the green LED and the red LED. Since there is no light between those two strong peaks, the difference in the objects cannot be seen because the only light reflected from the object is the attenuated green and red peaks.

It is important to realize that changing the color of the signal to the wall (e.g., making an "orange" color on the wall) does not fill in the gap between green and red. Every pixel on the wall is simply

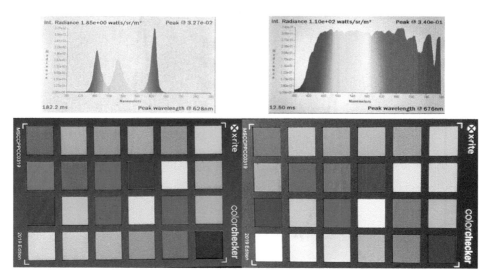

Figure 14.4 Shows a ColorChecker chart photographed under two different illumination sources
Source: (Image courtesy of Epic Games)

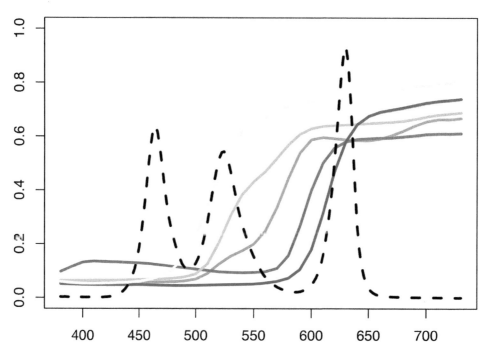

Figure 14.5 The spectral responses of some individual patches are shown against the response of the LEDs
Source: (Image courtesy of Epic Games)

a combination of the three narrow shapes but with different heights. The shapes cannot be moved horizontally; they can only be brighter or darker, which changes them vertically. This means that the orange patches cannot receive any light to illuminate the main portion of their spectra that distinguishes them from each other.

Another pair of patches to note is the red patch and the rose patch above it. In sunlight, it is clear that the patches have an obvious saturation difference. However, in the LED-only case, the rose patch appears quite saturated and looks very similar to the red. This is explained in the spectral response graph. The lines for the red and the rose patch cross each other. And they do so right in the center of the spectral illumination of the red LED. Therefore, from the point of view of the patches, they are each returning almost the same amount of red light from that illumination. Although the portion of the graph that distinguishes the patches is near the red LED response, it is far enough away not to be significantly illuminated by that LED.

Human skin looks overly red under LEDs alone for the same reason that the rose patch looks too saturated. This similarity to the rose patch is quite noticeable in light skin tones, but even with darker skin tones, the red appearance is greatly increased under LEDs alone. Also, the presence of hemoglobin has a particular effect on the spectral response of human skin, which causes the spectral response curves to vary slightly in a way that they would not vary if a person had no flowing hemoglobin (because they are dead). This difference also resides mostly in between the green and red LED responses. Therefore, LED illumination can cause humans to not appear as life-like as they would under broader spectrum sources.

Since objects appear quite different when lit only by LED versus other lighting environments, care should be taken to provide additional spectral illumination that fills the gaps. Many advanced lighting instruments from motion picture industry vendors include broad spectra in addition to their overall color control. For the fixtures which use LEDs, they have typical narrow red, green, and blue diodes (RGB), along with one or more "white" diodes that have broad spectra to fill in the gaps. When these types of lights are used in conjunction with the LED wall, the overall illuminated objects can appear very similar to other lighting environments.

It is reasonable to ask whether the LED panels could include additional "white" diodes to help fill in the gaps. LED panel manufacturers are aware of this issue and are working to produce panels with broader spectral response. However, this comes at additional cost. Not only is it more expensive to include more diodes in each pixel, but the dimension of each pixel would also get larger and would affect the overall pixel pitch of the panels. This leads to considerations of whether all LED panels in a volume need to be the same. For LED walls, which are the panels that are typically seen directly by the camera, the broader spectrum is not required because the LED spectra are roughly centered in the spectral sensitivities of the camera. But the ceiling panels might benefit from broader spectral inclusion because they provide more of the lighting from above for characters, props, costumes, and sets.

Color Shift

Directional Response of LED Wall Pixels

Like all light sources, the color and intensity depend on the angle of the viewer. For LED wall panels, there are specific aspects of the geometry of the manufacturer that can cause further changes.

Most shooting of an LED wall is directly at the face of the LED wall panels. Because many volumes have curved walls that surround the stage, it is possible for the camera to view some of the panels at a more oblique angle. In this case, there can be some falloff of the intensity and some shift of the color of the panels. With high quality panels that are designed to be seen by the shooting camera, the falloff is not extreme. However, with some panels that are used mostly for lighting and reflections, there can be larger differences based on angle.

Often the LED panels used for a ceiling will be different than those used for the vertical walls. Typically, those panels are chosen because of their weight or cost. For example, some currently available panels have an overall color shift from cyan to magenta when a viewer looks from one side to the other. This is because the three LED are positioned in a line with green on one end and red on the other. When a viewer sees this panel from an extreme angle, the red LED can be partially obscured by the plastic material that houses the LED diodes, resulting in a cyan cast. When viewed from the opposite extreme angle, the plastic walls between the LEDs hide the green LED somewhat, resulting in a magenta cast. In this example, the shift is most noticeable in one direction, that is, east to west. The perpendicular direction has less shift because the issue is oriented with the alignment of the individual diodes.

Mitigation of Color Shift

While it is not common to point the camera into the ceiling panels, it can occur, so it may be necessary to adjust the color to account for the viewing direction. This can be accomplished using different methods. It is tempting to consider using the LED processor to adjust the colors somehow, but this is likely to cause additional problems and does not consider the various angles that might be used during shooting. The engine that is driving the wall is a better location for the color correction, if possible. A common method is to provide a region with a falloff that has a particular tint. That tint can make the angled panels appear more neutral from the camera's viewpoint. This same type of adjustment may be needed if the panels are seen in reflections of objects, such as vehicles or shiny flooring.

For extreme examples of the color shift, the lighting of objects may be a larger issue than the direct view of panels. For example, a physical set with largely neutral objects like snow or linens may have obvious shading differences across their surfaces. The same region-based approach to controlling the color can still be used but with attention to the lighting the panels produce on objects rather than the direct view of the panels themselves.

Sound Dampening
Eric Rigney – RG Entertainment

Introduction: Final Sample Defined

The goal of *final sample* is to capture dialogue performance recordings on a LED volumetric stage that carry to and through sound mastering, with little post-production processing beyond de-reverb and added backgrounds.

Acoustical Challenges on a Virtual Production Volume Stage

Acoustical Reflection: LED volumetric stages are built to create visual environments that are captured in real-time with the actors "live." Currently, these walls are made of hard, smooth, vertical surfaces, sandwiched between hard, smooth, horizontal ceilings and floors that create, in effect, an acoustical echo chamber.

Acoustical Noise:

A) A vertical LED wall curved into a semicircular shape and capped with a flat vertical ceiling behaves like a parabolic microphone. Undesirable sounds, generated outside the stage, are picked up through the stage opening(s), amplified, and subsequently, pollute audio recordings.
B) Virtual production equipment, such as computers, uninterrupted power supplies, power conditioners, and keyboards that support virtual art departments' control bar personnel (a.k.a. Brain Bar), are often placed in front of a stage opening and will unwittingly generate equipment noise that can be picked up in the stage and recorded.

Image-centric Bias: Production sound is usually not afforded the same level of support or consideration as are camera and lighting departments. The quality of dialogue recordings is often compromised as a result of the current on-set hierarchical structure.

Solutions: Tools and Practices

Sound reflection and unwanted noise can be effectively mitigated from a virtual production volume stage, but it takes an amalgamation of cumulative efforts of various departments and equipment starting with the panel technology, stage design, and construction that create the problem in the first place. Previs/Techvis: Sound reflection and noise mitigation should be considered before production commences. The previs/techvis process not only aids the departments dealing in visuals but can, and should, also be used as an aid in mitigating sound reflection and creating an awareness and greater understanding among the other departments of the challenges sound faces.

On-Set Best Practices

Personnel: Minimize how many personnel actually remain inside the volume during shooting.
Stage opening: Keep stage openings clear of or blocked from personnel and noisy equipment.
Equipment room and KVM: Employ KVM switches to remotely connect keyboards, monitors, and mice, allowing production to keep equipment noise away from the stage area.

Mitigation Tools and Practices

Traditional Gear: Common materials used to mitigate sound reflection – such as furniture blankets, carpeted rubber floor mats, foam insulation, etc. – should be used as much as possible. Cover as much of the set floor and areas behind large set pieces that are unseen by camera as possible.

Additional Gear: There are other solutions to help solve the sound issue – some costly and others not so costly. At the time of this writing, there are three acoustical screen types available for this purpose:

1) *Simplest (DIY):* Duvetyne and/or furniture pads hanging from C-Stands.
2) *Echo Shade (DIY):* A more effective solution is an echo shade. Similar to the previous DIY example but using a panel frame and attaching a polyester honeycomb grid light diffuser in front of it.
3) *ZR Screen (manufactured):* Available for purchase or rent are solutions like zero-reflection screens specifically designed to address acoustical reflection.

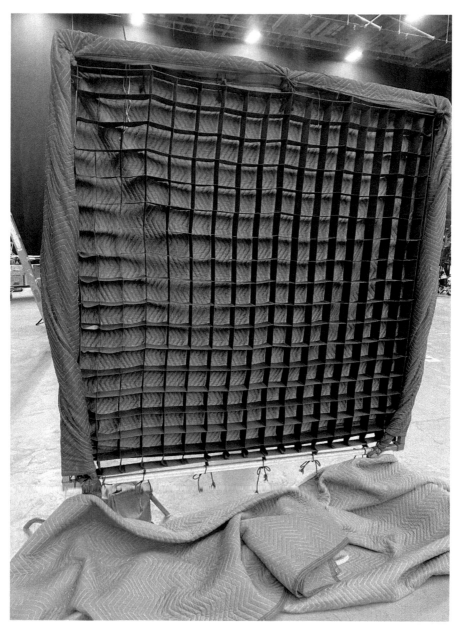

Figure 14.6 DIY Echo Shade, 6' × 6' example
Source: (Image courtesy of Eric Rigney, behind the scenes of ETC's *Fathead* (2022))

Placement: Screens should be placed as close to a speaking actor as camera framing will allow. The screens should be faced toward the actor's mouth when they are speaking and/or toward reflective surfaces.

Quantity: The more acoustical mitigation screens used the better. The minimum one should use is three. On a test project, nine screens were used, and that proved to be more than sufficient.

Cooperation: Sound mitigation requires collaboration with the AD, camera, lighting, and production set departments. These discussions are best addressed in pre-production and rehearsals. One cannot overstate the need for cooperation and understanding between the departments, particularly *before* a problem occurs.

Additional Sound Personnel

The sound department is more than fully occupied with their responsibilities. The efforts to position and reposition the above mitigation elements without holding the crew or production up usually will require additional support – a dedicated set PA, grip, or a sound apprentice supervised by production sound.

Summary

Sound is an integral part of production. The quality of sound determines how audiences perceive visual effects and virtual production. The steps required to successfully mitigate sound reflection and unwanted noise on an LED virtual production stage is production's responsibility. Through preparation, collaboration, detailed previs/techvis, additional equipment and personnel, and supportive relationships among all the on-set creative professionals, productions can succeed in capturing original performance dialogue that carry over to the final sound mix.

Post Cleanup of the LED Wall
Patrick Tubach – Epic Games

The goal of shooting in an LED volume is to achieve as many in-camera shots as possible, but it is important to note that due to the complexity of final visual effects, the result is not often a clear "final" or "not final." Setting accurate expectations with the client is an important part of preparing for the post work needed. If successful, less post visual effects work will be needed, but there will often be some shots that need adjustment. The results of a volume shoot tend to fall into one or more of these broad categories:

- In-camera shots: In-camera shots are those which can go straight to editorial and then, upon cut approval, straight to color grading and post.
- In-camera shots requiring cleanup: In-camera shots requiring cleanup are shots that contain all the visual effects elements but need minor paint or patching. These are common and are

still considered to be captured in-camera because the complexity and cost of the post visual effects is significantly lower than on a bluescreen shoot.

- Volume set extensions: Volume set extensions are shots that require an additional set extension to blend the physical content into the virtual.
- Shots needing additional animation and/or visual effects: There are shots that need additional animation or visual effects work, like adding particle effects.

For the shots requiring paint cleanup, it is worth understanding what artifacts are commonplace and easy to deal with. Motion capture cameras are frequently seen in the background of shots and considered a minor visual effects fix to paint out. While it would be ideal to remove those from camera view, it is not always possible given the time to de-rig the cameras, and they are often needed at those locations for complete tracking coverage. The same theory applies to seams in the ceiling or floor edges. Those are a fact of life on the volume but are relatively easy to fix.

Another frequent issue is overlapping camera frustums. That is when one camera view overlaps another. The DP and Virtual Production Supervisor can decide ahead of time which frustum they want to be dominant, but if the alternate camera gets a better view of the action, it might be used in the cut. In those cases, the overlapping parts of the content will need to be patched. Content might also require touch-up when there is a lag or sync problem on the wall, meaning that the image stutters from performance problems or the virtual camera frustum is not keeping pace with physical camera motion. These errors tend to be short and infrequent, so they do not require a full replacement of the content.

Crew members ending up in a shot is nothing new. It happens all the time on large productions that are moving rapidly. But in a volume, when space is so limited, it happens more frequently, as does the need to erase lights or lighting equipment from the frame. Practical lights are often used to enhance the brightness and sharpness of a key light and can easily sneak into frame.

Shooting the Volume Ceiling

The success of shooting the volume ceiling can depend on what volume one is shooting in and what the pixel pitch of the ceiling panels are. It is not uncommon for the ceiling panels to be a larger pixel pitch than the wall panels, meaning bigger gaps between LED diodes. These alternate panels are typically cheaper to purchase, more rugged, relatively lighter in weight, and produce brighter light than their tighter-pitched counterparts. Unfortunately, a larger pixel pitch means that one needs to get significantly further away before the panels will be considered in-camera quality. And the ceiling panels are at such an extreme angle to the camera that they often run into the LED viewing angle problem, causing the color to shift significantly. Due to these compounding issues and the fact that there will often be ceiling seams and/or removed panel holes to deal with, most shots featuring a volume ceiling will be replaced in post. That said, the edges and lighting of the subjects are still improved greatly over traditional bluescreen shots.

Lighting Cards

As convenient as light cards are when used as lighting instruments on the LED walls, their proximity to action means that it is possible that they will glow or glare unnaturally in a shot. The LED output does not tend to be bright enough to cause an actual flare into the lens, but even a relatively dim light card in a dark volume can be picked up and scattered in the atmosphere or haze, which can give away the card's position in 3D space. These errors will need correction in post but are often simple color corrections for a compositor or a quick fix on the DI stage.

More Involved Post Visual Effects on Volume Shots

Shots requiring more involved visual effects extensions and additions can often benefit from clean outputs of the camera and clean background renders from the shoot session. Since the camera is always tracked in the volume, a camera path can be exported for any take by the Volume Operator. This camera data is not likely to be as clean as a CG camera matchmove and should not be counted on to completely replace matchmoving in post. Still, it can provide helpful data about camera position in 3D space that will make matchmoves faster and more accurate. Similarly, the Volume Operator can output a clean render of the content that was projected to the wall on any take. This data will be a representation of the CG scene as displayed on the wall, but it will not include any anomalies from camera lens distortion, flaring, vignetting, or special effects atmosphere. Matching the look of the wall on the day will still need to be done manually, but there is a benefit in being able to quickly recreate the content that should have been there.

Is Blue Screen/Green Screen Required?

There may be times during a volume shoot where there is a realization that the content is not going to work for a particular scene for a wide variety of reasons. In those cases, the VFX Supervisor may ask for a blue screen to be used around a character or behind someone's hair to make for a better extraction off the background in post. To further reduce the size of the screen, the backing screen can be tracked to a character to minimize the spill. In many cases, the overall scene lighting can still benefit from most of the environmental lighting, even if one small part of the wall or ceiling has been turned blue or green.

Digital Tracking Markers

If the bluescreen replacement area is large enough, it can be helpful to add digital tracking markers to those blue or green patches just as would be done on physical screens. Despite all the information about the camera and wall position coming from the 3D scene, there is value in getting trackable visual data from the image to help lock the background replacement in place. Matchmoving with only foreground characters, blurry background detail, or only CG volume content visible can be challenging.

Alternate Content

It is worth noting that interesting work is being done exploring delivering multiple streams of alternate content to the wall at once. This could potentially provide the option to change the background content later in post or to have one stream providing a blue screen just in case the content needs to change, all while still providing a main feed that is an in-camera shot. This kind of replacement flexibility could help reduce concerns about locking in to visual effects content before the overall show design is complete.

Notes

1 A load is an optimized real-time scene, prepped to be used on the LED walls.
2 KVM switch, abbreviation for "keyboard, video, and mouse" is a hardware device that allows a user to control multiple computers from one or more sets of keyboards, video monitors, and mice.

Setting up an LED Volume Stage – Permanent vs. Pop-Up

Setting up a Full Volume for LED Walls
Philip Galler – Lux Machina

An LED volume for virtual production can be built in a myriad of ways, both as a permanent structure and as a pop-up, or temporary, structure. Both methods of setup have their strengths and weaknesses.

Permanent LED Volumes
A permanent LED volume is a volume that is intended to stay in place, typically at least three years. Usually, it is designed to cater to various types of productions, including film, episodic TV, live broadcast, and even live events. These volumes represent a design solution that would benefit multiple projects and are not designed for a specific production. Permanent volumes can take many shapes and sizes, with variations such as flat walls, cylinders, movable sections, free-floating walls, and LED panel ceilings. They often have the benefit of being built on traditional sound stages and therefore receive the benefit of production support services such as mills, rental facilities, and prop shops.

Pop-Up LED Volumes
A "pop-up" LED volume is a temporary structure built for a singular production, to address the needs of specific script sequences and shooting styles. The shelf life of a pop-up volume may be the entirety of principal photography, or as short as one to two weeks; it is entirely dependent on the exact use case designated with production. They can be built in as little as a week or as long as a month.

DOI: 10.4324/9781003366515-16

These types of LED volumes can be built anywhere and are often found in sound stages, warehouses, and even outdoors. The primary shape of a pop-up volume is often dictated by the Production Designer, to fit around an existing set plan as opposed to the Production Designer trying to fit into a known permanent LED volume shape. Production departments are typically engaged in the pre-production, building, and testing phase of a pop-up, unlike a permanent volume, where the volume is already standing.

Pop-up volumes can often look very similar to permanent volumes but typically lack extra features beyond what is required for the specific sequences at hand. They can still be very large, have ceilings, moveable sections, etc., but may be missing the components and structural considerations for multi-year longevity. They also typically do not require any building construction permitting, unlike permanent volumes.

When considering whether to build a temporary or a permanent volume, there are many things to take into consideration. Existing projects, followed by locations, tax incentives, and types of projects in the local region, are all questions that can impact this decision. There are additional government funds which can also play into the decision to build a permanent, or temporary, facility. Some questions can help narrow down the viability of an LED volume regardless of permanent or temporary nature. Location and facility/building capacity are the most important: Is there enough power and A/C, and if not, is there space for a generator? If the answer is "no," then building anything substantial would be counterproductive. Ultimately, one should build an LED volume that best suits the business case and model. It is critical that the numbers are run and financially analyzed to ensure the viability of the volume in mind.

Volume Design Considerations

The process of designing and constructing an LED volume is deeply rooted in the needs of traditional physical production and combined with the bleeding edges of technology. A strong pre-production decision-making process within a design team is required to help cut through the thousands of choices at hand.

Budgetary constraints are the most critical and obvious of all design considerations. It will pervade every step of the process and is the simplest to contemplate: "How much money is available to spend?" Once a baseline answer to this question has been established, the fun can begin.

It starts with the stage: The ultimate limiting factors are square footage, height, weight, power, connectivity, ceiling capacity, and door height. While many design constraints will be given to an LED volume architect by the building itself, there are still choices to be made:

- What is the main production purpose of the stage?
- How much stage power should be left for grip, electric, scenic, etc.?
- How much stage space should be left clear for the needs of set storage and first unit?
- Should ceiling capacity be left for production riggers, stunt riggers, and scenic?

Questions like these can often be answered by attempting to narrow down the clientele an LED volume is being crafted for. The production needs of a car process LED stage are different from an

XR stage, which are different from major motion picture volumes. Traditional (non-LED) production sets are extraordinary reference points to answer these questions, and design teams should attend them as often as possible. When looking around a working set, take note of all the equipment and crew there, and try to replicate that into the volume design plans.

Air Conditioning, Power, Security, and Fire Management

Air conditioning, power, and security considerations must be taken into account. Air conditioning is straightforward: It is based on the overall power draw and BTU count. Consider what is the best to get air in and moving in the LED volume.

As for power, both LED peak power *and* production power needs must be accounted for, particularly if a permanent volume is being built out. This amount of power can be significant, and it is important to be aware of the potential timeline delays in getting large amounts of permanent power supplied, whether permanent or temporary. It is imperative to work with the proper authorities and trained staff to get this power installed and set up on the stage. It can be dangerous and, in some cases, can be life-threatening if mishandled.

Security is a complex topic, and physical security is only going to be covered briefly. As the permanent or temporary stage is being built, be aware that expensive equipment and proprietary

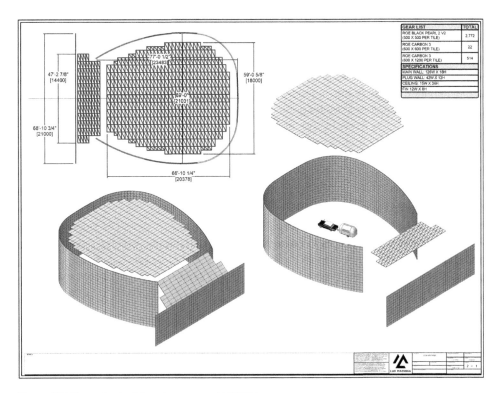

Figure 15.1 Example of a full-scale permanent LED Volume
Source: (Image courtesy of Lux Machina Consulting)

content need security precautions to protect them. It is important that a record of proper access and attendance is made, staff identification cards, biometric access (where needed), and the use of security equipment such as cameras are all assessed. Of specific security concern will be the machine room, any operation stations, and any rack equipment that could easily be accessed, stolen, or damaged. These items should be physically secured and access monitored and track-able. This will enable the expedient resolution of any issues. But one must always have the fore-sight to identify any upcoming security challenges as well.

Along with security there is the need for appropriate fire management. This should also be done with an accredited consultant and the local authorities. Both parties can advise what the proper tools and methods for creating a safe working environment is. There are significant concerns, varying by location, around creating an enclosed LED volume that would potentially trap actors and staff inside in the event of a fire. This *must* be managed appropriately and is often achieved using fire sprinklers, active fire department monitoring, and even volume redesign to allow for proper and safe egress.

Rigging and Structure

With a variety of available off-the-shelf and custom rigging solutions available, a large portion of LED volume design time is spent on structure and safety. For example, using chain motors to hold up LED ceilings can provide a benefit, but there are some concerns such as required regular maintenance and cost. Furthermore, motors for LED ceilings are required to be certified on a yearly basis, which may require highly specialized skills and internationally recognized certi-fications. Additionally, local requirements must be considered, such as seismic and architectural requirements, which are vastly different around the world. An LED volume in Los Angeles, USA, has significantly higher seismic and ballast requirements than one built in Vancouver, Canada. While maintenance needs of the various technologies on a stage are wildly different, they should be laid on top of one another to better understand if they will be capable of being met concurrently or separately and, perhaps most importantly, within the allotted utilization periods in the business model of the stage. This process alone can often yield the answers to the question: "How much redundancy is needed?"

Redundancy and Serviceability

Redundancy is a critical component to any LED volume stage and should be prioritized in the de-sign process. At its core, an LED volume becomes the world through which a cinematographer is capturing their story. If it is not hardened against mechanical or technological failure, it becomes an unacceptable liability to the creative process. "How long will it take to replace this component if it fails?" must be asked of almost every design choice and will often lead to further design itera-tions around component level access and repair.

Serviceability must be considered along with redundancy. This means, how easy is it to trouble-shoot, access, and fix an LED volume, including all of the hardware and support structures? Has getting machinery to the tiles above head height been accounted for? Have storage, spare parts, and plenty of time to assess issues that arise as the LED wall is being put up for the first time? An important item to discuss during design is whether the LED tiles are replaceable and removable,

and specifically, whether they are front and rear serviceable. The answers to those questions inform how to properly build in the necessary access and pathways to and around the volume.

Staffing

Additional constraints encountered often center around personnel. More technically complex smart-motor rigging packages for LED ceilings, for example, may require an experienced full-time staff rigger to operate. A staffing plan and skill set requirements sheet should be drawn up early in the design process to ensure that a design has not become too technically complex to be operated by the staff on hand. Which particular skill set and experience are needed to operate this design and how many people are there in the labor market is important to qualify.

Stage Designs
Mitchel Lathrop – Fuse Technical Group

Background: Dynamic Lighting, ICVFX, and XR Broadcast

LED volumes are used across the entertainment industry to dynamically light subjects and to be photographed as the background of a scene. The use of LED video surfaces for virtual production can be broken down into a few broad categories: Dynamic lighting, in-camera visual effects (ICVFX), and extended reality (XR).

LED panels were initially designed for image magnification and creative video content for music concerts, live events, and advertising purposes. It took several years to get the manufacturers of LED panels and processors to understand and respond to the challenges and needs of the virtual production community and then several more years to have newer products ready and reliable for on-set use.

In 2012, LED panels were widely available only with a pixel pitch of approximately nine millimeters or greater. This limited them to be only used as dynamic lighting instruments (since the individual pixels were visible in-camera in most practical shot setups). A few notable productions that broke ground using LED surfaces as dynamic light sources were *Gravity* (2013), *Guardians of the Galaxy* (2014), *The Jungle Book* (2016), *Passengers* (2016), and *Deadpool* (2016). The concept of using LED panels as a dynamic light paved the road to where the industry is today. Once LED panels were available with a 3.8 millimeter pixel pitch (+/-), they were able to be used as in-camera digital backgrounds. Dynamic lighting is still a solid solution today, especially when shooting on green or blue screens.

ICVFX ushered in the use of LED panels as a digital backdrop that could be captured in camera to reduce the need for rotoscoping, color keying, and other post-production processes. Bringing these processes into principal photography allowed greater control of visual effects elements in real-time and enabled visual effects artists to interface directly with the DP and the rest of production.

XR's defining function is adding a content layer on top of the camera video feed as a composed image in real-time. The composited elements are captured in conjunction with a physical backdrop, LED surfaces, or traditional greenscreen background to create a mixed-reality scene. Camera tracking data is used to place the overlayed composited imagery and the LED or greenscreen background content in the scene in the correct perspective for the viewers. Examples of this practice are commonly found in live broadcast events for sports, music, live entertainment, and news programs in the form of virtual set extension and the addition of virtual set pieces that are only visible through the composited camera feed. Some widely recognized uses of this process are Katie Perry's "Daisies" music video that was shown live on the *American Idol Finale* (2020), MTV's Music Video Awards broadcasts, and visually flashy sports statistics displayed during sports broadcasts.

ICVFX shots can use XR techniques to extend backgrounds past the edge of an LED surface or add to oversized vehicles or large scenic elements. This method has been used on projects like *The Mandalorian* (2019); however, it is usually only a reference for the on-set crew and talent, with the final image overlays to be rendered in post. Typically, XR is ideal for live or live-to-tape productions, while ICVFX is preferable for features and scripted episodic. XR can only work on digital cameras whereas ICVFX can work on both digital and film.

What Is the Right Size Volume?

There have been volumes of all shapes and sizes: From massive 270° cylindrical LED arrays with movable end cap doors and high-resolution ceilings to small stages with LED panels crammed into a well-planned space. Understanding a production's requirements are critical; it dictates the size of the crew, the configuration of the LED volume, and the rigging implications. Here are general guidelines to consider:

- Wide shots, large cast, big scenery = large volumes ~150-feet diameter volume.
- Medium shots, medium cast, some scenery = medium volume ~100-feet diameter.
- Tight shots, plated pickup shots, reshoots = small volume ~50-feet diameter.
- Vehicles, out-the-window shots = car process ~14 feet from lens to wall.

There have been productions with all the tech in the world that were underprepared and did not achieve the results they were looking for: Success comes from meticulous planning, a skilled crew, and a well-informed production team.

LED Surfaces: Flat Walls, Curved Walls, Ceiling, Doors, Wild Panels, Floor, and Beyond

Volumes can have flat LED surfaces, curved LED surfaces, hi-res or lo-res LED ceilings, LED doors, wild LED panels, LED floors, and other bespoke solutions. Each of these LED element types requires rigging, and each rigging method has its own challenges and benefits that must be considered as this technology continues to be pushed beyond its original flat truss and ground-supported design.

Nearly all the custom innovative rigging solutions and methods used on set, until recently, have been after-market retrofit solutions engineered by grips, gaffers, and virtual production houses that maintain and rent LED volumes. New methods are constantly being developed and manufactured

to better suit the needs discovered on stage. LED surfaces, rigging infrastructure, cables, and other hardware are quite heavy, and large volumes may require additional truss solutions to support the weight properly.

Flat LED surfaces are quick and easy to assemble but limit camera angles and movements. This configuration could be a good solution for second unit shots, plate shots, and reshoots. Curved surfaces can have up to approximately five degrees of curvature before the shape of the wall becomes noticeable at a distance. There are additional challenges to large, curved surfaces over 180° with sound and recording: Audio bounces off the front of the LED surfaces and reflects quite noticeably.

Wild or removable panels, useful for lighting and stunt rigging access, are popular where flexibility from shot to shot is required. However, these methods can come with tedious processes and longer timelines with standard rigging solutions. As a result, a few companies manufacture custom mounting plates and design solutions for the rapid and safe removal of wall and ceiling panels so that grips can easily mount lighting or stunt points quickly.

There are several paradigms on the LED ceiling: High-resolution is great for high-quality reflections and maintaining ICVFX capabilities. Medium-resolution ceilings can be brighter and less expensive when reflections and dynamic lighting are the goals rather than ICVFX. New techniques are currently being explored using ceiling pods mounted to a trolly system for easy travel and adaptability in the volume.

Volume Infrastructure

Server Room or Container

Even for smaller volumes, there is a lot of equipment supporting the content displayed on the LED surfaces and supporting the volume operators. Most of the equipment is noisy, generates substantial heat that needs to be managed and needs to be somewhere close to the LED stage. While single-mode fiber can technically move data and video signals to and from the LED volume stage at distances up to ten kilometers, that is not exactly practical. Some successful solutions that have been implemented:

- **On-Stage Server Room:** A soundproof room assembled on set, sometimes behind the LED wall or elevated to a second level on stage to save space. This room typically needs industrial HVAC, a fire suppression system, a powerful battery backup system (UPS), and around 8 to 16 full-size equipment racks. These rooms can be costly and take up a large footprint on stage – around 20 × 40 feet on average. End-of-production budget considerations include deconstruction costs. The arguments for having this on stage are usually that there is no space outside the stage or that quick and direct access to the servers is required.
- **Server Shipping Container:** An alternative to housing the equipment on stage is building out a standard 40-foot shipping container (or other mobile unit) to house the supporting video engineering equipment, network infrastructure, data storage, and rendering systems. The container can be placed outside the stage or creatively placed to maximize efficiency. This method can reduce installation, equipment, and labor costs, allowing for rapid deployment to get the virtual production teams up and running faster.

Render Nodes and Operator Workstations

Render nodes and operator workstations are doing the "heavy lifting": Getting images to the LED surfaces and lighting fixtures. These machines are usually top-of-the-line, cutting-edge workstations with the newest and fastest graphics cards available. The render nodes are responsible for rendering the 3D scenes or playing back plates. The operator workstation's roles include the "director" computer rallying the render nodes for playback, artist workstations for content manipulation, metadata logging, camera tracking management, and other utility functions for the volume operations team.

Screen Management and Control

Screen management refers to a group of video systems that manage what can be referred to as the "mission control" displays; they present critical information to the teams on stage. These displays can include a multi-view array of feeds that allow viewing all the LED surfaces on one screen, camera tracking system information, confidence monitoring cameras, system health indicators, and feeds from the production cameras. The screens management system can route different feeds and presets to different displays. In a well-designed setup, it automatically shows contextually relevant information that the operations team requires to react quickly to the ever-changing on-set environment. Additionally, several software and hardware solutions can be implemented to control the volume operator resources. Custom controls and interfaces can be built with Unreal's blueprints, TouchDesigner, Elgato's Stream Deck and Companion software, or purpose-built apps like Stage Manager.

Sync and Timecode

Sync can be one of the hardest things to manage. The two methods commonly used in virtual production are genlock and timecode. The goal of sync is that once the render nodes generate a frame of video, that all devices in the render chain transmit that frame, in sync, while the LED volume panels draw the image on set, and the camera shutter snaps precisely at that moment. (For a more detailed explanation, please see the section on Sync and Timecode.)

When the devices are out of sync with each other, it becomes easy to spot seams in the LED wall where two separate sources or processors meet. When playback, or the LED processors, are out of sync with the camera shutter, a tearing effect can be captured as the camera pans quickly. Global shutter cameras can be more forgiving than rolling shutter cameras in general with sync and content in the volume.

Network and Storage

The management of the network and content storage can be an awkward jurisdictional area that varies from studio to studio. The network is the communications backbone responsible for accessing and controlling all the devices running the volume. Additionally, features like camera tracking, lighting control systems, and remote wireless tools rely on fast network speeds and good wireless coverage.

Tracking Systems

Tracking the camera's movement is the prime directive of the tracking systems on stage. On some more advanced systems, there are secondary functions like tracking objects or integrated mocap. There are two significant paradigms of camera tracking: Inside-out and outside-in. Both

methods have pros and cons, but they rely on a robust network and infrastructure to operate smoothly. (For a more detailed explanation, please see the section on tracking systems.)

Remote Production Functions

The idea that production staff could do some of the virtual production functions remotely became an accepted discussion topic due to the COVID shutdown. With well-designed and secure networks, utilizing VPN protocols to secure network traffic, remote solutions for some previously on-set roles can confidently be explored. VR/AR headsets, virtual meeting software, and custom applications allow immersive on-set visualization and connection to production stakeholders wherever in the world they may be.

Permanent, Long-Term, and Single-Show Volumes

Building a Permanent Stage From Scratch

When building a permanent LED volume, consider the following points:

- Build the foundation and floor capacity to support the weight of the LED wall and for the rigging hardware to be lagged into a concrete base.
- Consider building a steel beam system with extra supports to hang an LED ceiling and have plenty of room from the perms.
- Install enough electrical services (and some to spare) to support the LED wall panels, ceiling panels, wild wall panels, a lighting rig, additional production power, the server room electronics, and the HVAC system. Airflow is important.
- If possible, construct a server room to house and cool the server racks and video engineering system.
- Consider having pathways cut into the stage floor for power, data, hydraulics, air, and water to be routed under the LED wall.
- If possible, plan a high-capacity fiber patch system with connection points around the stage.
- Consider a tiered area for volume operation workstations and engineering positions.
- Install one gigabit, or better, fiber internet.

What to Look for in Existing Stages for Long-Term Builds

Always know the specs of the stage floor and how much weight can be hung from the perms. A best practice is asking for stamped engineering drawings or having a study done before assuming that anything is safe.

Most stages built before 2015 will likely need additional power, HVAC, and supplemental rigging installed to support medium-sized and larger. Working with experienced partners and venues is highly recommended.

Pop-Up Stage: Making Single-Serving Volumes Practical for Production

A pop-up stage, or a rented LED volume setup that is rapidly deployed for a single production to film in and then deconstructed after the virtual production shots have been captured, has been a challenge in the past but is becoming a more realistic option for productions.

- Fact one: Only a few institutions can efficiently keep an LED volume stage booked with back-to-back productions and enforce the use of the same configuration across multiple productions.
- Fact two: Producers desire to film in locations convenient for their overall production, both logistically and financially, especially regarding tax incentives. In many cases, a production should build an LED volume on a sound stage and only use it for their single production and then have it packed up and taken away when the shots are in the can.

Predominately, at least up until the publication of this book, it has been financially challenging for a single production to show cost savings or, at the minimum, a breakeven from traditional visual effects methods compared to building a single-use LED volume. Nevertheless, a handful of risk-taking virtual production companies, producers, and supervisors have found ways to get the job done in a cost-efficient manner – and manage not to get fired. However, the scale is beginning to tip.

During the pandemic's most brutal months, parts of the virtual production community came together to tackle challenging engineering problems, develop new software, and try out new techniques that the lockdown provided the time to do. As a result, several key areas of virtual production planning were re-tooled and perfected. Substantial time gains were achieved in rigging, LED surface builds, and video engineering system deployments of virtual production volume installations. Additionally, render engines and playback software developers significantly improved how the volume operators set up and control the imagery on the LED surfaces and the stability of the overall system architecture.

Looking to the future, the virtual production community is rapidly expanding, ideas are being widely shared, and technology is becoming exponentially more reliable with each production.

Mobile LED Stages and Walls
Sam Nicholson, ASC – Stargate Studios

Introduction to Mobile LED Stages and Walls

Mobile LED walls are an excellent alternative to fixed LED volumes. These pop-up installations are typically used for smaller setups, such as cars and intimate scenes involving one or two actors. The advantage of a mobile LED setup is that it can be custom designed to fit the exact needs of the production, rather than the production fitting into an existing LED volume. Mobile virtual production LED walls are generally smaller, lighter, higher resolution, and more flexible than permanent installations.

When designing a mobile virtual production volume, a computer-generated model depicting the final setup should be provided prior to production to ensure that one's design matches the demands of the production. Maya, Blender, Rhino, Sketchup, Unreal, and Unity are all good

modeling and real-time previsualization tools for laying out a virtual production stage. They should be matched to the camera and lenses for accuracy.

LED Panel Choices

LED panels used for virtual production are continually improving to meet the demands of virtual production. High-frequency LED panels, designed for cinematic shooting, ensure the best quality. These panels will typically have a much higher frequency, a low refresh rate, and higher technical specifications than standard LED panels. It is essential to test the specific LED wall and shooting camera in pre-production to avoid any unforeseen synchronization or color issues.

Mobile LED Wall Configurations and Considerations

Mobile LED wall configurations are rapidly assembled, easy to use, and quick to strike. Due to their modular design, they can be almost any shape, however, manageable weight is essential for ease of use. Most LED panels are not designed for mobile applications, so smaller overall screen size with higher resolution is a better solution for this application.

Weight

Current rental LED panels weigh about ten kilos per cabinet, or about 50 pounds per square meter – a 4 × 8 meter screen and frame weighs almost 2,000 pounds. Excessive weight adversely affects the handling of any mobile LED wall. Be sure to check with the rigging grips to ensure a smooth operation on set.

Viewing Angle

Most LED screens have an excellent viewing angle with little or no falloff. Newer LED panels are typically 170° (at the time of this writing). There can be a slight color shift at extreme angles, however this can generally be corrected in signal processing on set.

Ambient Light Absorption

Controlling ambient, or spill light on a virtual production set is always a challenge. While most LED panels have a matte finish to absorb ambient light, when powered off they appear light gray, not black. LED panels designed for virtual production are designed to absorb light rather than reflect it. The challenge when shooting, in any fixed or mobile LED volume, is to not contaminate the blacks or have them properly balanced with the black levels of the foreground action.

Contrast Ratio

Depth perception is largely connected to the contrast ratio of a scene. Closer objects appear to have more contrast, with brighter whites and darker blacks. Objects further away tend to have less contrast, with muted highlights and softer blacks. By controlling the contrast ratio of the LED wall, one can adjust the background images to the right depth of the image in Z space.[1]

Visual Effects Augmentation

Post-production visual effect enhancements are an effective tool to augment the work accomplished on a virtual production volume. Everything from simple post color and contrast adjustments to full background replacement may be required due to repairs or creative changes. Keep in mind that there is no alpha matte channel (as opposed to shooting on green screen). If changes are made to virtual production footage without mattes, a significant amount of rotoscoping will be required to create window mattes.

Volumetric Lighting

Lighting the actors and the set in one's volume is critical to achieve the optimum results. A common misconception is that the LED walls will magically "self-illuminate" the foreground actors and set. While the LED walls provide a soft, blended light, which is great for highly reflective objects, the only way to create hard sunlight and shadows is with traditional cinema lights.

Kinetic Lighting and Pixel Mapping

When shooting moving objects on a virtual production stage, such as cars, trains, and planes, kinetic lighting is a highly effective tool to achieve a realistic end result. Pixel mapping lights on set allows all the lights to be driven by the images on the LED walls. The end goal is to achieve a perfect exposure on the LED background that blends seamlessly into color-balanced light on the actors and foreground set.

LED Display Wall – LED Modules, Processors, and Rigging

Philip Galler – Lux Machina

An LED volume is comprised of a number of individual products, all working harmoniously to create a functioning LED display. At its core, a volume has LED tiles, which are basically modular bricks arranged to make a larger display. Each of these tiles has a receiving card connected to an LED processor and some type of rigging physically holding it up. These pieces come from a variety of manufacturers and in a variety of qualities and classifications.

LED Tile

An LED tile is the display piece of an LED volume. It is comprised of all the individual LEDs, or light-emitting diodes, that are individually illuminated to make up a cohesive image displaying digital content.

The number of LEDs in a tile determines its overall resolution, often depicted as X resolution by Y resolution. For example, ROE Black Pearl 2 is 176 LEDs wide by 176 LEDs tall. These numbers increase as the resolution, or pixel pitch, of the tile increases, specifically when comparing LED

tiles of the same size. LED tiles are often created in a square or rectangular shape and are usually referred to in size by millimeters. Using the same example tile, ROE Black Pearl 2, the tiles are 500mm × 500mm. There are many different manufacturers of LED tiles of varying quality in their display and physical construction.

Some of the common LED tiles seen on LED volumes are made by companies such as ROE, Megapixel VR, Sony, and AOTO, among others. These tiles are usually referred to by their pixel pitch, which is a reference to the density of the LEDs on each tile. Black Pearl 2 has a pixel pitch of 2.84mm, center to center, on each LED, and attributes the number "2" to its model number. It is important to choose the right LED tile for the LED volume. Consider the resolution of the tile, camera specifications, shooting requirements, and physical set demands.

Other elements to consider are the coating on the LED panel, the overall quality of the electronics, and the color reproduction capability of the LED tiles. Some of these topics will be covered in a different section. LED tiles themselves are also made up and connected to a variety of other important components.

LED Modules

An LED tile is made up of smaller parts called LED modules. Each of these modules holds a specific number of LEDs in it – usually a quarter of the total LEDs on a tile. For example, each ROE Black Pearl 2 tile is made up of four quadrants, each represented by an individual LED module, with an 88 × 88 array of LEDs (a quarter of the total tiles' 176 × 176 LED array). The LED modules are specific to each LED tile and are usually the smallest and fastest component to replace on an LED tile when there is a display issue.

Receiving Card

An LED tile is more than just LEDs; they often include a variety of other parts that are important to be aware of as when designing an LED volume. Each LED tile has a specific brand of receiving card inside it that is responsible for handling the display signal transmission from the LED processor and properly displaying the digital content on the LED tile. These receiving cards are specific to each LED processor manufacturer, that is, Brompton Technologies relies on the Brompton R2 receiving card, and Megapixel VR relies on the PX1 receiving card. These cards *must* be paired with the appropriate LED processor, or the LED tiles will not work.

LED Processor

Along with the receiving card, an LED tile must be connected to an LED processor. Unlike the modules, these devices are remote and connect to multiple sets of LED tiles over ethernet cable usually. The LED processor is responsible for the proper assignment of the digital content to the tile. This is the hardware responsible for taking video inputs and managing the "mapping" of the LED tile array to the digital content being displayed. Think of LED tiles as little modular windows. Each sits on top of a specific piece of the video input's digital content, and the LED processor manages this, then ensures that each receiving card is receiving the proper signal for the LED tile

to display. Common LED processors include Brompton Technologies' Tessera line and MegaPixel VR's Helios products.

Display Considerations
Philip Galler – Lux Machina

When considering which LED tile to choose and what type of volume to set up, there are a few physical features that are important to consider. These include deployment flexibility, install time, overall weight, noise, and support and rigging. These various features, and their variety, make each type of LED tile unique and make applications better than others. These features carry varying importance depending on whether one is building a permanent or temporary LED volume. (See example in Figure 15.2)

Deployment Flexibility
As an LED volume is designed, one should take into account how much reconfiguration might be needed for the production. Many tiles have several features that make reconfiguration easier. For

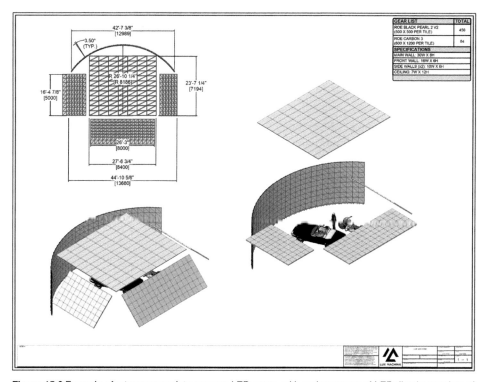

Figure 15.2 Example of a temporary plate process LED setup, with various types of LED tiles in a variety of reconfigurable positions
Source: (Image courtesy of Lux Machina Consulting)

example, some LED tiles have adjustable angle brackets built into them, allowing for the crew to easily change the angle between tiles, while some setups require that separate angle brackets are milled and manufactured separately.

Another example of this type of installation flexibility is represented in the way some tiles interconnect with each other, offering a magnetic lineup and ratcheting adjustable handles. Magnets are a great feature for lining up LED tiles because they help automate part of the process by creating strong connection points between the bottom and side of one tile and the top and side of its neighboring tiles. This is often paired with handles that double as physical fitments that hold tiles together, creating a resilient structure that will have the proper display lineup. This is crucial for virtual production, particularly as LED tiles get higher in resolution and the tolerance between pixel pitch gets tighter.

Also, consider whether a tile can be easily changed between being ground-supported and hung. This can be an important consideration, especially with limited prep time and fast-changing sets or shooting environments.

Install Time

Some LED tiles have features that make setup time faster. Usually, this is more important for a temporary LED volume, but it can have a significant impact. Specifically, install time refers to how much time it physically takes to construct the rigging and arrange the LED tiles in the proper array to make up the LED volume design. This can vary depending on shape, size, and LED ceiling, among other variables. It is not uncommon for an installation to take days or even multiple weeks. This usually is directly correlated with the overall number of LED tiles. Making sure that the proper LED tile is chosen. LED tiles that make installation easier or provides simple setup options is important for maximizing the shooting time and schedule. There are usually classifications of LED tiles, such as "rental" or "permanent." And these classifications are usually good indicators of whether a tile is intended to be installed quickly. Often a tile classified as a rental product has features for speedy and efficient installation. Depending on the needs of the production, this may or may not be a deciding factor. There are reasons for using LED tiles that are intended for permanent installation, such as one is building a permanent structure for a specific purpose, budget constraints, and sometimes a need for higher resolution than rental tiles offer.

Weight and Power

Properly understanding the ramifications of the weight and power needs of LED tiles when designing an LED volume is essential. Two of the biggest factors in deciding a venue for the LED stage is usually building weight and power capacity. This is a direct result of how many tiles are being utilized in the LED volume design and the total estimated weight and power needs for the tile count. Usually, LED tiles are measured with two power classifications: Max and average. Max is how much the LED tile would use if run at 100 percent brightness and full white. The average power draw is an estimate for how much an LED tile might draw during normal expected use – typically one-half of the max power draw. It is important to understand the shooting situation and content expectations. If one is planning for mostly bright scenes, then, most likely, the panels will use more than the average power draw. Alternately, using mostly dark environments will significantly use less than the average. In the most ideal circumstances, the facility can support the max

power, plus some percentage more (10 to 20 percent), even if it will not be used. This will allow for adding additional tiles later without being concerned about available power.

This is also important for a temporary LED volume that might be powered by a generator. Never design a power solution that does not have flexibility and overhead because production is often unpredictable. Always consult with knowledgeable electrical personnel for the support needed to safely calculate and assess how much power is right.

Weight is very similar to power in that every tile has a listed weight. Typically LED tiles can be anywhere from 20 to 50 pounds on average. Knowing how much weight an LED volume, and associated hardware, adds up to is an important design variable. Many buildings do not have a ceiling weight capacity and, in some cases, the floor capacity for safely holding an LED volume's weight. It is not uncommon to see LED volumes that weigh anywhere from 25 to 40 tons. Always work with the proper local authorities, riggers, and structural engineers to ensure that the LED volume is erected safely and that all weight and rigging calculations are done properly. This can be a life-and-death matter.

LED Rigging

LED tiles often include a variety of rigging connections, and usually, but not always, they come with some pre-manufactured rigging pieces. For LED volumes that are hung from the ceiling, there are usually hanging bars. These allow LED tiles to hang some distance below them, usually limited by the size of the overall LED wall. It is not uncommon to see LED volumes hanging from overhead brackets that are six to ten meters tall. These brackets can be faster to put up than ground-supported LED volumes but often take up more valuable air space, where other departments might want to rig, as well as being extremely heavy, possibly taxing the ceiling in most buildings.

When ground-supported, most LED manufacturers can provide some standard upright rigging structures that are modular and support a pre-determined number of LED tiles. These are usually a maximum height of six to ten meters. These modular ground support structures still require proper ballasting, and a qualified engineer should be responsible for assessing and commissioning any rigged LED volume.

Note
1 "X" space and "Y" space in CGI are directly related to pan and tilt on set. "Z" space describes the third axis: Depth.

LED Display Technology and Hardware

Characteristics of LED Displays
Ritchie Argue – Do Equals Glory

Among the myriad characteristics of an LED display, several are important to elevate in consideration for in-camera use. Historically, both accurate image reproduction and camera compatibility have not been a priority for most LED display use cases; as a result, characteristics related to image quality need to be examined carefully when selecting a display to ensure they meet one's expectations. Fortunately, virtual production has become a significant market for LED display manufacturers, and as of 2022, they are rapidly beginning to address deficits in these aspects of their performance.

This chapter will consider LED displays (Characteristics of LED Displays) as separate from LED processors (Key Characteristics of LED Display Processors). In truth, displays and processors are inseparably linked, and one cannot be used without the other. Of particular importance to this distinction is the *receiver card*, which physically resides within the LED display panel, even though it is a part of the LED processing system and is linked to the processor via a proprietary protocol. It may seem to be easy to disconnect the network cables between processors and the display to exchange a rack of LED processors for those from another brand, but to do so, the receiver cards and interface boards must also be swapped. Do careful research because this is an expensive change once everything has been purchased and installed.

Characteristic Dimensions
LED displays operate in a few distinct dimensions or axes and have a range of capabilities in each. From an image perspective, the axes are light (e.g., color, luminance), time (e.g., framerate, latency), and space (e.g., pixel pitch, off-axis angle). From a studio operation standpoint, key dimensions to consider are physical rigging and power consumption.

DOI: 10.4324/9781003366515-17

229

Characteristics in different dimensions may be correlated, and trade-offs are common; improving the capabilities in one dimension is often at the expense of another. Understanding and optimizing these trade-offs for in-camera use is the goal of this chapter.

Color Reproduction Characteristics

Color reproduction is the most critical area to consider when selecting an LED display, primarily because it has been neglected the longest with regards to LED display design.

Precision and Accuracy

The term *color calibration* is used frequently regarding LED displays. Historically, this has meant the process of making a display appear more *uniform*, where each pixel is adjusted to be close in color reproduction capability to its neighbor, but not to any color standard. In scientific terms, these displays are considered *precise* but not *accurate*, and certainly not calibrated (which requires a standard to be calibrated to).

Effective uniformity compensation is indeed important and results in a display that looks clear and free of speckles or haze. If a display is insufficiently precise, it will appear as though there is a textured gauze installed at the surface plane of the display; this is especially evident when the camera and its frustum moves.

To achieve a color-managed workflow in which the color an artist sees at her workstation while designing assets is the same color that is reproduced on set and a DP sees in camera, color accuracy is also required. This means that for any given color value sent to an LED display, an expected color is produced. Far more time will be spent on set troubleshooting color accuracy than display uniformity.

Native LED Primaries vs. Colorspace Standards

Color accuracy has been difficult to achieve in the past due to the LED chemistries that result in red, green, and blue primaries being different (often but not always more saturated) than the primaries specified in colorspace standards. This is like "vivid mode" on consumer TVs, and if content was produced to appear lifelike in a colorspace such as Rec709, it will appear cartoony, with sunburned skin tones, when expanded to the native gamut of the display. This can be resolved by running an actual color calibration process, which generates a corrective or technical 3D look up table (LUT). In a virtual production studio, this color calibration should include the production camera in the signal pipeline as the color matching function of the camera may not be the same as that of a calibration colorimeter or spectroradiometer. This is an active area of research and development, and much work is currently underway to improve the state of color reproduction in camera. Notable projects include OpenVPCal and Light Illusion's Matchlight.

Spectral Response and Illumination

Each pixel in a contemporary LED display consists of (at least) a red, green, and blue sub-pixel. Due to the material science of the emitters, they generate narrow wavelengths which tend not to line up with the spectral reflectivity properties of physical objects. This can cause an issue known

as *illuminant metameric failure* when the light being emitted from an LED display interacts with a physical object. For example, an object which looks one way when viewed under a tungsten or HMI light may look completely different when viewed when illuminated by the narrow primaries of the display. As a result, it is recommended not to attempt to light a scene with LED displays. They can still be used to add reflective texture, but due to metamerism, it is still suggested to use traditional production lighting where possible.

Shadows

Shadow details are especially difficult to reproduce accurately. As image content becomes darker, there is less light available to mix to create the image due to the way different light intensities are created by an LED, which can only be fully off or fully on. Different luminance levels are simulated via a form of time division multiplexing that varies the duty cycle through time. As a result, the step size between different intensities is fixed. At low levels, the step size may be large enough to result in visible banding between steps. If this is visible in the final image, it may be possible to lift the black level of the display and crush it down again using a neutral density filter on the camera, resulting in smoother gradients at the low end.

Luminance Characteristics

Light Reflectance Value (Shadow Capability)

Unlike display technologies that use a filtered or attenuated backlight to produce an image, LED displays are true emissive displays that do not emit any light when black content is desired. In a light-controlled environment, they are truly black.

While production stages are light controlled, they still do require significant additional lighting to illuminate the set and talent. Spill that lands on the LED display can raise the black levels and wash out shadow detail. To counteract this, LED display designers often apply a *mask* or *louver* between LEDs to reduce light reflections from the PCB, solder joints, and other aspects of the physical construction of the display. Even if this mask is entirely light absorbing, LED packages themselves tend to be somewhat reflective.

Making the LED package smaller will help with this, however, this decreases the *fill factor* and will have an impact on *moiré*, discussed in the next section.

To increase the light output of an LED package, a reflector is often placed behind the LED die; while this does improve the efficiency of the LED package and increase the maximum luminance, it also increases the reflectivity of ambient light. This is another trade-off where peak luminance is focused on, without mentioning the impact on the black level. A *light reflectance value* (LRV) of four and a half percent or lower is a good target to aim for in-studio use.

Maximum Luminance

Maximum luminance, like pixel pitch, is a metric that is easy to understand and compare, and larger seems better. Peak luminance can be important for simulating outdoor scenes with their

wide dynamic ranges, and indeed it is worth considering a maximum luminance capability greater than 1000cd/m².

Increased peak luminance comes at a cost, however. It directly impacts the display reflectivity and is also responsible for the banding in shadow detail reproduction.

The maximum bit depth of the display is evenly divided into the maximum luminance – setting the maximum luminance to anything other than 100 percent in the LED processor results in fewer bits to render the content luminance range. For example, if a display is designed to achieve a maximum luminance of 2000cd/m² but is primarily used in the range 0–1000cd/m², the step size between each luminance level will be twice as large as a display designed for a maximum luminance of 1000cd/m², all other characteristics relating to bit depth being held constant. Based on this, it is recommended to aim for a maximum luminance of roughly 1500cd/m², as well as to use the HDR PQ (SMPTE ST.2084) encoding to allow the content source to work efficiently with the capabilities of the display.

Maximum Luminance and Illumination

A last note on maximum luminance: Panels intended for direct viewing do not approach the 6000cd/m² and up of dedicated lighting fixtures. While it is tempting to close this gap and use LED display panels as primary illumination, it is still not possible to influence the hardness or direction of the light being emitted by an LED display. It may be possible to map a bright patch onto the LED display ceiling of a virtual production stage to simulate the position of the sun, but this is not yet directional enough compared to a dedicated lighting fixture.

Even with these limitations, it is still possible to achieve some clever reflective lighting gags with an LED display panel, but much experimentation should be done, and it should not be assumed that it will work first try.

Temporal Characteristics

Resistance to Artifacts During Camera Movement

The primary temporal concern with LED display panel design is the artifacts that can occur during camera movement, especially in the vertical axis when using a rolling shutter camera sensor. If a film camera or global shutter digital sensor is used, this is considerably less of an issue.

Due to the way a rolling shutter sensor scans horizontal lines one or two at a time, each line is exposed and read at a different time from its neighbors. In a similar way, the pixels of an LED display are also repeatedly scanned to efficiently utilize expensive, space-consuming, and heat-generating LED driver chips. In a typical LED display, each driver chip will control between 6 and 64 LEDs in a time division scheme, meaning that of the pixels controlled by one driver, only one is on at a given time. The *persistence of vision* phenomenon of the human vision system integrates the rapid switching of the LEDs, making them appear to the eye to be constantly lit. However, when viewed with a mechanical sensor such as a digital camera, the scanning of the display

pixels and the scanning of the imaging sensor can temporally alias, especially during camera movement when a given imaging sensor line may observe more or less of the LED scans than its neighbor. This results in light and dark banding throughout the image, especially in low mid-tones on the display when the impact of the scanning is the most extreme in the time domain.

The best predictor of resistance to temporal artifacts is a low driver multiplexing rate, coupled with moderate camera tilt rates. The amount of artifacting is somewhat empirically determined and depends on the camera in use, but a good rule of thumb if final pixel is desired is to aim for a multiplexing rate of 1:8 or lower.

Spatial Characteristics

Much is made of the *pixel pitch*, or *spatial resolution* of LED displays. Unlike human eyes, cameras do not respond linearly to improvements in pixel pitch, and a 10 percent decrease in pixel pitch does not correspond to a 10 percent improvement in moiré performance. Equally if not more important in the studio is off-axis performance or the impacts of viewing from an angle other than directly perpendicular to the display.

Pixel Pitch

Pixel pitch is the distance from some location on a pixel to the same location on a horizontal or vertically neighboring pixel, measured in millimeters.

Typical pixel pitches for LED displays directly viewed in camera range from 1.5–2.8mm. Displays only seen in reflection can be in the range of 3–6mm due to the additional ray distance, as well as some fidelity loss in the reflective surface.

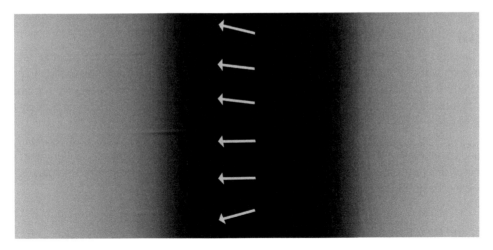

Figure 16.1 Horizontal artifacts caused by vertical motion of a rolling shutter camera combined with a high multiplex ratio display. On the left, the display consists of panels using a 1:18 multiplex ratio with clearly visible banding artifacts in the mid shadows, indicated by the blue arrows. On the right, panels with 1:6 driver multiplexing minimize the artifact below the visible threshold at this camera movement rate.

Fill Factor

While it intuitively seems like a tighter pixel pitch is necessarily better for in camera use, a corresponding characteristic is fill factor, or the ratio of active illuminated area to inactive background. As discussed in the section on Luminance Characteristics, the area between active emitters is filled with a mask designed to trap ambient light. This results in a spatial structure that is incredibly high contrast – an interstitial area that is non-emissive and effectively non-reflective, punctuated by emitters that in isolation are generating roughly five times the rated luminance of the display.

Consider a painted white wall being illuminated by a standard lighting fixture, with a resulting luminance of 1000cd/m². No matter how a camera package is configured and positioned, this wall will not moiré – it has an effectively infinite fill factor at an arbitrary pixel pitch. Compare this to a 2.3mm pixel pitch LED display with a fill factor of roughly 20 percent and a maximum luminance of 1000cd/m², set to full white. In this case, at a sufficient distance the eye or a camera system is unable to resolve the difference between the emitters and the interstitial masking, and it appears as a smooth white surface. However, sufficient distance is a complex subject, as the next section will cover.

Rendering Capacity

While decreasing the pixel pitch may or may not have a desired effect on moiré and ability to focus on the LED display, it will have an impact on rendering capacity, unless a smaller frame is scaled up. Consider the overall physical dimensions of a studio design and run some scenarios at different pixel pitches to determine how much a decrease in pixel pitch will increase the rendering workload.

Physical Characteristics

The final characteristics of considerable significance to in-camera use of LED displays is related to the physical handling of the display components and the impact on the rest of the studio.

Rigging

LED displays should be easy to curve at various angles between panels to support the design of circular or oval cyclorama shapes. A variety of preset angled blocks machined to high tolerance is preferred over a fully adjustable hinge mechanism that is subsequently locked in place; the latter is tedious to adjust on-site and extremely difficult to adjust repeatedly and accurately to the same angle.

Display panels with a live events heritage have good flexibility for dynamic reconfiguration to the needs of different productions. Removing individual panels from a completed display is commonly needed to provide access for lighting or camera positions.

Front and Rear Service

Both front and rear serviceability of LED display panels (the ability to remove and replace a faulty or damaged module or power supply) is valuable. If complicated set pieces are in the way, it can be difficult to get a lift in to front service a display. The top side of ceiling displays is rarely straightforward to access, thus necessitating front serviceability.

Power and Thermal

As most of the energy consumed by an LED display is converted into heat, a critical part of studio planning is to ensure that there is sufficient service available, as well as HVAC to remove the additional thermal load.

Acoustic Considerations

Without adequate baffling or other mitigation techniques, a large, curved LED display can quickly turn a stage into an echo chamber.

If the panels themselves have fans in them, be sure it is possible to disable them at least temporarily while shooting – one panel does not seem that loud on its own, but in aggregate, with a few thousand others the noise quickly adds up.

Color Consistency and Predictability
Kris Murray – Lux Machina

Defining Key Elements

When working with LED panels it is common to find oneself comparing commonly characterized features of products offered by competing manufacturers to better understand what is available on the market. At first glance, it may look like many of the panels are barely indistinguishable from one another, but as always, the devil is in the details.

Pixel Density

Pitch refers to the spacing between adjacent LED diodes, in most cases both the horizontal and vertical spacing, most typically a grid. Common examples would be 2.84mm, 2.3mm, or 1.5mm. For a 1.5mm case there is 1.5mm of spacing from the center of each adjacent group of LED emitters, often referred to as a *Package*. It is common for products to be referred to as "2mm" when the specific product might be 2.9mm, 2.84mm, 2.5mm, etc., or "3mm" when the product is 3.9mm, 3.6mm, 3.4mm, etc. Pitch and resolution have an inverse relationship as "high res" (or "higher resolution") generally refers to a lower pitch product because the spacing between the LED packages is reduced. "Low res" ("lower resolution") refers to a higher pitch product. The lower the resolution, the larger the distance is between each LED emitter given the same size panels.

Another term is *pixel density*, which refers to how tightly or loosely packed the LEDs are over a given distance or area, usually described as pixels-per-foot, inch, or meter; or pixels per square foot, inch, or meter. This term can sometimes help when communicating LED surfaces in physical

dimensions that can then be quickly converted to an approximate overall resolution. This is especially helpful when working with LED products whose dimensions are not easily factorable into feet or meters like the very common tile size of 500mm × 500mm.

Moiré Concerns

Moiré patterns are one of many artifacts that may arise while shooting LED panels. This is caused by a complex relationship between the physical spacing of the individual LEDs, the size of the individual LEDs, resolution of the camera sensor, size of the photosites of the sensor, optical resolution of the lens, field of view of the lens, focus position, depth of field, and distance between the camera and LEDs. It is very difficult to put a rule of thumb for safe distances, but it could be stated that the likelihood of encountering moiré patterns increases with higher pitch LED and lessens with lower pitch LED. That said, focusing directly on the LED at any practical resolution will likely result in seeing moiré on the frame, which is caused by some of the camera's photosites *seeing*, and being able to resolve, some of the illuminated LEDs as well as the dark area between the individual LEDs in the same frame. Modulating these parameters will impact the sharpness of focus on the LED, which can remove or diminish moiré effects when experienced.

Brightness

Brightness of the LED panels is typically measured in Nits, which is a unit of light that factors brightness over a given area of the panel surface. This is also how HDR TVs are also measured. Most panels of interest for virtual production would fall somewhere between 500 and 6,000 nits, with many panels falling between 1,000 and 2,000 nits for ICVFX use. Interactive lighting may tend towards something brighter, in the 2,000 to 6,000 range. There are also panels that are very dim, and some that are exceptionally bright, nearing 10,000 nits.

Refresh Rate

Refresh Rate refers to the number of times each of the individual LEDs are pulsed per second, generally stated at the maximum rate. But typical use will likely vary from the stated value to achieve specific values. Most of the panels today utilize "PWM" (Pulse Width Modulation) to change the values of the individual pixels, which fluctuates how long each of the pulses is displayed, which changes their apparent brightness. Many of the cheaper panels will update at slower rates than the higher-end panels, which can create artifacts in the camera image.

Something that is not immediately apparent is that each individual LED is *off* more than it is *on*. Each tile goes through a complex sequence where the display essentially "draws" the image line-by-line – like an old CRT – usually over some fixed rate like "1:8," "1:16," "1:12," etc., which means that after every eighth, sixteenth, or twelfth line, that line would be illuminated simultaneously, then the next line and so on, repeating many thousands of times a second in some cases. These rates, in conjunction with the type of sensor that is being used and how "fast" or "slow" the rolling shutter is, may contribute to artifacts that may be present when shooting. These typically manifest in dark or bright bands, typically in the dark sections of the image. This is also the range of values where most LED product manufacturers create their proprietary techniques to display values near black,

which further contributes to these potential timing related artifacts. These are some of the reasons why synchronization between camera and LEDs is incredibly important in virtual production.

Shader and Reflectivity

Another important aspect of the LED tile is how reflective the *shader* or the individual LEDs are. The shader, which is the typically dark space around the individual LED packages, is responsible for protecting the LEDs, but it also has a significant role in determining black level. Reflectivity is generally measured in the percentage of light that is reflected off the surface at a given angle. The more reflective the LED tile, the more careful the crew will need to be with practical lighting as any ambient light hitting the panel will increase the apparent black levels – making the image feel "washed out". The less reflective the tile is, the darker the black levels can be, which will be able to produce a higher contrast image – particularly in typical lighting conditions on set. The LED emitters can often be specified in "white" or "black" versions, where the "white" variants will be capable of producing a brighter overall image but more reflective, and the "black" ones will be less reflective but darker. Today it is common for panels to be in the 4 to 5 percent reflectivity range, with some higher-quality panels lower than that, and many lower-quality products being two to three times more reflective.

Color Consistency and Predictability

Color accuracy is very important. A defining factor for this is *bit-depth*, which effectively describes how many different values can be expressed for each pixel. The more values, the less likely to encounter banding (staircasing) in the overall image. Ideally, there should be no differentiation of the individual steps in a gradient. Another contributing factor is the uniformity of the image. The more uniform the better, otherwise the overall image may look "splotchy" or "noisy" in an obvious and unacceptable way. Higher-end panels typically go through rigorous calibration at manufacturing to lessen or remove the variation between adjacent pixels.

It is also very important for the LED tile and processor to accurately display the encoded signal appropriately, or to have accurate internal knowledge of its own display characteristics. Many lower-end products do not understand the importance of accurately mapping values to appropriate brightness levels. Instead, they make their own decisions to make something "look pleasant," which are often not obvious to the user, but detrimental to the overall virtual production process as it impacts predictability in the system.

Another important trait is individual color selection for each color component and whether the selected camera is sensitive to that range of color. Most of these effects can be corrected through a calibration process, but the less that needs to be corrected, the better it will be for the process. Consistency over time and temperature is another important factor as variations can have an impact on image quality and predictability.

The viewing angle is a measure of an acceptable angle that light is emitted from the LED package. If the viewing angle is too narrow, the panel surface may appear very dark or even off at extreme angles. Ideally the camera and/or set would continue to receive light for all angles that are required for the shot to avoid fixes in post. Falloff is a measure of the diminishing of light intensity, typically at the edges of viewing angles. Most light is emitted directly out of the front of the LED with the intensity slowly diminishing as one moves to the edges, however, it is not always uniform.

If the falloff is too great, there may be noticeable differences with different camera angles. Color Shift, or Off-Axis Color Shift, is a measure of shifting color values as the viewer moves off-axis. This is often caused by physical occlusion of adjacent LEDs from how they are manufactured, the arrangement of adjacent emitters, or variations in the emission patterns between the components. The individual emitters are often arranged in a line in a package, which creates a great viewing angle perpendicular to the line – at the sacrifice of color shift in the opposing axis. Newer technologies such as Micro-LED or Flip Chip LED will minimize these effects.

Conclusion

There is no perfect product for all situations. There will always be a trade-off between each of the products in terms of the features, as well as the price. It is important to strike the right balance depending on the goal – be it ICVFX or interactive lighting.

Organizing a camera test is always going to be the safest option for the key creatives to understand the technical limitations of the systems and which products can help them achieve their vision.

LED Display Validation Protocols

Ritchie Argue – Do Equals Glory

This section will step through pragmatic techniques to evaluate several key characteristics of LED displays on camera and will help determine whether a given display's characteristics (e.g., pixel pitch, maximum luminance, color reproduction capability) will meet a production's requirements.

Regardless of what test is being done, ensure that the display is evaluated by both camera and eye, across a range of synthetic and captured[1] content. An artifact that may be clearly present to the eye may disappear in camera, and vice versa. Do not assume that something that looks good to the eye will look good on camera. In all cases, any camera package being used for validation should be synchronized to the display. When possible, positioning two or more different displays side-by-side will allow for efficient A/B testing and make any artifacts more readily apparent.

The examples given in this section are a starting point for what is currently known to cause issues and for processes to reproduce them.

Spatial Validation: Aliasing

Although the impact of pixel pitch on in-camera moiré is not the most important consideration when selecting an LED display, it is one of the more challenging characteristics to understand and benefits the most from direct experience.

Validation Set-up and Procedure

Prepare a section of LED display, typically two-by-two panels (1m × 1m) or larger. For content, consider mid-tone and highlight content, flat fields, gradients, and high-contrast diagonal edges (both synthetic and captured). Set a focus subject at an appropriate distance in front of the LED display. Using a representative camera and lens package, explore different depths of field and note any moiré in the background.

Notes

If possible, test the combination of sensor, lens, and display at various camera and focus distances during camera package prep. As a form of aliasing, moiré is sensitive to small changes in configuration, and a small adjustment to any given parameter may cause significant differences in the captured image. For example, shifting the camera position forward/backward as little as 0.25m may eliminate (or cause) moiré.

Shadow Banding and Coloration

If the luminance step size of a display is larger than that of the video signal, banding will result. The panel design and processor configuration can also cause shadow coloration, or the ability to maintain a given hue as luminance is reduced. Both artifacts are most apparent in the deep shadows and will impact the ability of an LED display to accurately reproduce shadow detail in the virtual scene.

Validation Set-up and Procedure

Set up a black-to-white gradient, with a step size of one luminance level per pixel in the gradient direction. Next, move the gradient around the display looking for any banding in the shadows that is wider than one pixel. This would indicate that multiple luminance levels are being quantized together resulting in a loss of luminance resolution. Note that this can also include the bottom-most steps, resulting in crushed blacks.

While doing this test, ensure that each luminance level remains neutral with regards to the gradient color. Artifacts include shifting colors toward different primaries or secondaries at different luminance levels and increased banding of those levels. Be sure to check at a selection of frame rates and shutter angles. To minimize these artifacts, select an LED display with a lower LED driver multiplexing ratio, or a lower maximum luminance.

Off-Axis Viewing Angle

For cinematic use, the off-axis viewing angle of an LED display will most impact ceilings and the intersection between the ceiling and a wall. A secondary consideration is acute angles between a camera and a wall. Check for both luma and chroma shifts as they are critical for virtual production. Be aware of any left-right asymmetry, or possible batch-to-batch differences in the panels.

239

Validation Set-up and Procedure

First, mount a section of the LED display on a turntable, or place camera positions on an arc centered at the LED display. Then, capture each patch at 90° (perpendicular) to the display, and make note of the RGB values. Next, rotate the turntable by 3° to 5° increments (or move the camera position) and re-capture the same color patch. Compare the resulting values with a Delta E calculator and note when the off-axis angle has resulted in a Delta E of >5 (conservative) or >10 (liberal), which indicates that the color shift is likely to break the illusion of a virtual scene.

Notes

To minimize this issue, select a display with a flip-chip LED package, or one that uses less masking between pixels.

Temporal Validation: Vertical Camera (Tilt) Motion

Vertical camera moves are the most difficult to keep artifact-free and is the primary motivation for low LED driver multiplexing ratios. To evaluate this, the camera should be moved vertically while shooting mid-grays, which can result in lighter or darker horizontal banding artifacts that appear to remain in position relative to the camera frame.

Validation Set-up and Procedure

Display low/mid grays on a section of the display. Flat field or gradients in the 25 to 45 percent of maximum luminance range generally work well. Simulate a dusky sunset or an underwater scene.

Vertically tilt the camera up and down at rates that might be used in production, sweeping the camera field over the LED display. Look for the presence or absence of horizontal bands that appear to move up and down the display, staying relatively stationary relative to the camera frame.

Characterize the artifact, if present, at different movement speeds, display luminance levels and shutter angles. It can vary in the height and spacing of the band or bands and the intensity of the lightness or darkness of the band. To minimize this issue, select a global shutter camera or a display with a lower LED driver multiplexing ratio.

What Are the Aspects of Choosing a Panel
Kris Murray – Lux Machina

There is a near-infinite number of LED panels on the market and about as many ways to leverage them for a production's needs. Important decisions, based on the specific attributes of certain products, that could save production money, time, or both, are based on what the

production is trying to achieve. Understanding the end goal illuminates the most relevant solution.

With interactive lighting, where light is cast from the panels onto the set or actors were to impart a certain level of interactive dynamism, the panels are not viewed or recorded by the camera. Therefore, utilizing much lower-resolution LED products that are brighter and cheaper than what is used for in-camera visual effects may be perfect for the end goal.

When in-camera visuals are important, consider the role the image plays in the frame. The more in, or out, of focus the background will play in the shots, the higher or lower the density the product can be. Avoiding moiré patterns is the end goal. If the camera is focused directly on the LED, the moiré cannot be avoided without incredible resolutions or large distances.

Interactive lighting solutions can also benefit from lighter panels that are often easier to rig or place in confined spaces. These lighter panels often have a trade-off of being more difficult to seam together in a way that is perfectly contiguous for ICVFX.

Another common variation that is somewhere in the middle is where the backgrounds will be replaced in post, due to some incompatibility with the final vision, such as 2D plates that have an incorrect perspective or subject matter, previs, or unfinished assets that will not be completed until post but are close enough to the desired goal to contribute to the lighting and reflections of the shot. In this context, moiré matters much less because the backgrounds will be replaced. But it is *still* important to consider if the backgrounds will contain solid fields for chroma key because moiré patterns can greatly impact the ability to pull a key and may result in time-consuming and/or costly roto.

The physical construction of the set plays a large role in the size required for some of these LED surfaces. Wide-open expanses, where the set must be extended in every direction, often require large contiguous surfaces where the dressed ground can fade into the LED background. Additionally, the set, or parts of it, may need to reflect large portions of the environment, like a vast sunset or reflection of a distant city skyline. So a large surface may need to be erected to cover the reflected angles. This is one reason it is common to use lower density products for ceilings. In most cases, reflections can be achieved with a much lower resolution product that is out of frame, depending on the variations in the materials on set. Mirror finishes present a difficult challenge that will likely require higher-density products.

Surfaces outside of windows, down hallways, out windscreens, or portholes are more forgiving and can be achieved with much smaller LED surfaces. The edges of the set provide a very natural-looking break between the physical set and digital background that often sells the overall image. Some of this is due to the natural parallax that comes from the physical build against the LED background even if, in many cases, it is a cheat.

The more known about the physical set build and the camera placement, the easier it is to design a solution that fits the specific constraints of the shot. If the shot is a lock-off and looks in a specific direction, for example, the design solution to cover the specific frame with additional LED panels rigged outside of the frame boundary to provide the interactive lighting will be much simpler. This illustrates

a best-case scenario but there is almost always a need for more freedom on the day. But the more freedom required, the larger the LED build may be to account for all the places the camera may point.

Each of these parameters can be mixed and matched to get to the right solution for production. Whether it is technical or financial goals, there is almost always a way to achieve it.

Types of Tools That Connect Cameras, Monitors, and LED Displays to Computers
Kris Murray – Lux Machina

When first conceptualizing a virtual production system it is easy to think about the LED surfaces and the rendering system as a monitor connected to a computer much like what would be found at a desk. While this analogy is simple and easy to communicate, it unfortunately ignores some key components of the system that are often required at scale.

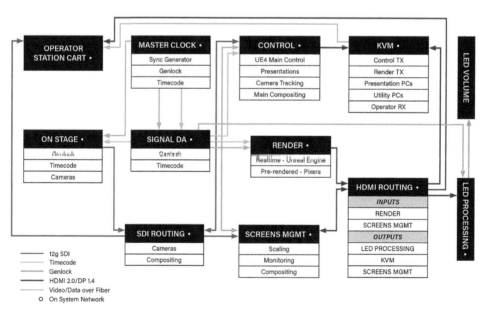

Figure 16.2 A high-level system diagram that shows how some of the equipment in an LED volume system may connect
Source: (Image courtesy of Nicole Vos – Lux Machina Consulting)

Routing

A router, or matrix, is essentially a device capable of receiving many input signals that can be electronically connected to outputs, or a single input can be sent to many outputs at once. They are often used to create a complex patch of inputs-to-outputs that can be triggered, typically through physical hardware buttons, software, or remote control via various protocols. One common example is, when a problem has occurred, a user can switch between redundant sets of servers. Another example is providing the ability to send a signal to an LED processor at the same time as a local monitor to provide some assessment of the signal without interrupting the signal at the processor.

Most of the devices can be divided into two categories: "Broadcast" and "AV." Broadcast devices are generally based around SDI signals, which are very common for monitoring signals found on most cine cameras. It is not uncommon to find these devices on set with DIT or video assist. AV devices are typically based around signals commonly found on computers and AV equipment (which would typically be DVI or HDMI or DisplayPort signals). HDMI is the most common today as it is a signal that is easier to route in comparison to DisplayPort, which generally requires much more expensive electronics to route. DVI is a legacy signal at this point, which has been superseded by both HDMI and DisplayPort.

Devices in both categories come in many configurations. A fixed router will generally have a fixed set of inputs and outputs that cannot be modified after purchase. A modular router will generally be comprised of a frame or chassis that can accept some number of input or output cards that are installed into slots on that frame. It is also common for these devices to work with copper and/or fiber-based signal types. Some very large high-end systems may use a decentralized version of these routers that are distributed over a network or proprietary signaling.

Network Switching

A critical element of a virtual production system is the network infrastructure. It is the mechanism by which synchronization and coordination are done between control and render nodes. It moves data between mocap cameras and their software; it ensures tracking and FIZ data can be distributed to every piece of software that needs to react in a system; it is the basis by which assets and configurations are controlled and updated.

At its core, this infrastructure is made up of a network switch or switches connected in various topologies. When many are connected, they are often configured as a *Stack*. Each of these switches typically have a fixed number of ports operating at various speeds – usually described at 1GbE (One Gigabit Ethernet) or 10GbE (Ten Gigabit Ethernet) or 25GbE (Twenty-five Gigabit Ethernet) or more.

Each of these network devices, including the switches, is connected via specific cabling, such as RJ45 terminated CAT5, CAT6, or CAT7, etc., which are very common cables between generic network devices. DAC (Direct Attach Copper) cables connect two SFP slots together. SFP modules are generally used to connect two switches or network ports together over fiber optics which come in single mode or multi-mode variants. There are RJ45-based SFP modules, but these are lesser used.

The configuration of these networks can be a complex task. Many of the systems communicating across these networks have exacting requirements for their protocols that must be understood to ensure successful operations.

KVM (Keyboard Video Mouse)

As systems grow in complexity, it becomes increasingly important to be able to quickly navigate between many computers. There are often designated computers for specific functions that may need to be accessed by multiple operators. There will also be a need to quickly remedy issues that may arise on critical infrastructure such as the rendering hardware, where having to connect a monitor, keyboard, and mouse repeatedly can create significant issues that will require some troubleshooting. The time that takes will add up over time.

KVM (Keyboard Video Mouse), which is exactly what these systems are responsible for controlling. In many ways these systems are very similar to routers or matrices, except that they also transport peripherals and have specific functionality that is tailored to specific user control, that is, switching computers via keyboard shortcuts or on-screen display menus, which a typical router or matrix would not do. These devices also come in fixed and modular formats and can be found in decentralized systems that are connected by networks or proprietary signals. There is a very broad spectrum of products offered on the market that can range from a few hundred dollars to many hundreds of thousands, depending on what is necessary for the project.

Knowing the importance of video quality to an operator, or a requirement for passing HDR metadata, are some requirements that can play a huge role in KVM selection. Many systems will compress or limit their video signals, often resulting in significant losses in quality as a trade-off for simplifying deployment over a standard network. Systems that target the highest levels of quality or flexibility often require dedicated fiber connections that often add considerable system complexity.

At first glance KVM systems can feel unnecessary and expensive, but over the course of a production, they are often worth the gains in efficient operations and reduced troubleshooting times alone.

Signal Transmission

Large systems often need devices to communicate with each other over distances further than the standard protocols were designed for. This is often accomplished through specialized converters that convert signals from an electrical signal to an optical signal to move across fiber optics, expanding the reach of these devices many times over. This is a common technique for HDMI and DisplayPort signals, whose primary design was to transmit between a source and display device that are only a few meters apart. Alternatively, this same technique can be applied to analog signals to avoid interference from adjacent long-run cabling, or inconsistencies between power circuits in segregated parts of the system, that is, genlock and timecode signals. This also allows for moving noisy equipment away from set, to lessen or remove the impact it might have on sound.

Synchronization

Synchronization in virtual production is a common requirement for many different functions in a system like capturing visuals in camera, operating a mocap system, or doing SimulCam compositing. In each of these cases, and there are many more, genlock and timecode need to be distributed throughout the system so that rendering hardware, cameras, routers, signal processors, etc., are all working in lockstep with one another.

At the heart of this synchronization is the Master *Clock*. Its specific function is to produce accurate clock signals, in various formats, for the many devices of production. It is very common for these clocks to be borrowed from broadcast technology, which often interface to GPS signals for highly accurate timing. These clocks have a plethora of support for many different formats to simultaneously synchronize signal timing, time, and audio signals, at once from one device. It is also common to interact with more compact devices targeted specifically at film workflows. These devices may make concessions over timing accuracy and quantity of input or output types and port counts, however, often with an added benefit of wireless synchronization, which is different for devices servicing the broadcast market. In some high-end systems, both methodologies are deployed together for the best of both worlds.

Genlock is an analog signal that comes in a variety of formats, frequencies, and types. It provides a timing signal that precisely controls the rate at which devices are working. It is important to understand the specific signals necessary for each device in a system to ensure that the master clock, and associated devices, have the capability and quantity to drive everything together.

It is important to have one source of reference in a system to ensure that everything is working together. Subtle differences between devices, even if set to the same frequency, such as 24Hz, if not specifically locked together, will drift apart, leading to adverse effects.

Timecode in the virtual production workflow provides a time of day, in the traditional production sense for take recording, but it is also utilized to work out varying delays throughout the system. For example, the render engine may need to understand the delays of the camera tracking or mocap systems in order to appropriately delay signals so that the action captured in the data can be synchronized with the rendered visuals. Like genlock, timecode is often distributed as an analog signal called LTC (Longitudinal or Linear Timecode). There are other versions of timecode embedded in video signals such as ATC (Ancillary Timecode) or VITC (Vertical Interlaced Timecode) and others. Their functions are the same but with subtle differences in capability.

Many of these systems work in the analog domain. Special considerations need to be made for varying types of interference to keep signal integrity optimal.

PTP (Precision Time Protocol) seeks to replace traditional genlock and timecode signals as the industry moves to network-based protocols.

Key Characteristics of LED Display Processors

Ritchie Argue – Do Equals Glory

The interaction between an *LED processor* and an *LED panel* is substantially deeper than it appears from the outside. Initially, it seems like the processor is a distinct device upstream of the LED panels,

and all the relevant image transformations happen in the processor while the panels themselves just present whatever the processor sends. However, a lot of the critical image calculations occur on the *receiver card*, especially those related to luminance and color transformations. This allows the processing system to send OETF-compressed images at 8–12bpc (bits per channel) over the network links between the processor and the panels and do the final expansion to a 14–18bpc linear encoding within the panel itself. This results in a critical dependency between the LED processor and the functionality on the receiver card and ensures that one cannot be changed without the other.

Bandwidth

The primary metric of an LED processing system is bandwidth – how many gigabits per second can the system process, transcode,[2] and distribute to all the LED panels that comprise the display. All the other image characteristics: Spatial, luminance, and temporal, compete for and trade off using this fixed amount of bandwidth.

$$bandwidth = width * height * channels * bpc * fps$$

It is preferred to use *gigabits per second* as the bandwidth metric as it matches well with standardized data rates that are used by the equipment in the LED display distribution network: A Cat 5e cable can carry 1, 2.5, or 5Gbps; SFP optical transceivers might operate at 10 or 20Gbps. Becoming familiar with the bandwidth equation will significantly help in understanding the design and constraints of the LED display network.

Keep bandwidth in mind while considering the following characteristics, and be aware that bandwidth is allocated at system design time and somewhat fixed once the hardware is installed and connected. If a production changes direction mid-shoot and suddenly wants a slow-motion effect or multi-camera overlapping frustums, expect to have to add processors or re-cable the LED display network at the very least, unless it was specified to allow for this additional bandwidth usage during the design process.

Spatial Characteristics

Pixel Capacity and Processor Stacking

While the capacity of a single processor is important, it is unlikely to approach the number of pixels required to build a display that is large enough for in-camera visual effects (ICVFX).

A more critical capability is the ability to *stack* LED display processors, or tile LED displays together in much the same way that individual LED panels are tiled to make up a display. In this case, processors are tiled at the control layer, allowing technicians to adjust properties of the entire logical display, even though it can be thought of as being comprised of many smaller displays.

Modern LED processors natively support display stacking, automatically replicating configuration between processors in the cluster and providing a unified control interface for the overall display. If a processing platform does not support stacking, it may be possible to simulate it by developing an upstream control layer that manages this via API calls.

Luminance Characteristics

Bit Depth and Transfer Functions

Banding artifacts in the shadows and mid-tone gradients is often caused by insufficient bit depth somewhere in the system between initial scene capture, rendering, or playback, and the final output as light from the display. This means that an image with sufficient luminance resolution is being re-quantized into a smaller number of bits, or steps between dark and light.

Transfer Functions

All image data is encoded from a linear light value to a perceptual value to better utilize storage and transmission media: The eye is more sensitive to absolute differences in light levels at low levels compared to high levels, so it makes sense to spend more bandwidth to encode those differences at low levels. This is accomplished by what is known as an optical-electro transfer function (OETF) on the encoding side, and electro-optical transfer function (EOTF) on the decode side. The EOTF should invert the OETF and result in a unity function for the optical-optical transfer function (OOTF).

In the standard dynamic range (SDR) era, the OETF and EOTF were gamma exponent functions, and their values would be manually set on the source and destination devices. If the exponent value matched on both devices, the transmission mechanism would be accurate. However, it was common to abuse the manual configurability of either the OETF or EOTF to manipulate the OOTF for the creative purpose of contrast adjustment.

It is preferred to expose creative controls as separate from technical controls so a reference baseline can be established, on top of which a creative adjustment can be made. Doing so significantly aids debugging and diagnosis as the creative adjustment can be enabled independently to confirm that the devices are operating in an artifact-free way at their maximum technical capabilities.

The demands of display devices with greater luminance ranges (e.g., 0–2000cd/m^2 for an LED display vs. 0–100cd/m^2 of the historical CRT technology on which SDR was based), combined with increased computation capability of the encoders and decoders means more complex equations can be used that better map to the nonlinear response of human visual perception, resulting in the advent of HDR encode and decode transfer functions. As of 2022, the recommended encoding for high fidelity and efficient bandwidth use for LED displays is 10bpc HDR PQ (SMPTE ST 2084).

Temporal Characteristics

Frame Rate Support

LED display processors intended for virtual production must support the usual cinematic and television production frame rates (including the 1000/1001 rates).

Be aware that LED display processors with a fixed installation heritage may only support computer monitor rates of 50 and 60fps. Attempting to run a 60fps display on a 23.976fps production will result in temporal aliasing, appearing as strobing or beating in the final captured output.

Running the display at multiples of a base frame rate is used to achieve slow-motion effects and should be supported for multiples up to roughly 250fps. Off-speed rates (fractional multiples) are not well supported as of 2022, as most genlock or timecode synchronization systems only support standard rates. With the advent of precision time protocol (PTP) timing systems, it may be possible to successfully sync all the devices in an off-speed production. In both cases, higher frame rates will consume more bandwidth than lower frame rates, and the video distribution network should be planned accordingly.

Synchronization

Synchronization between devices in a virtual production system is critical to reducing tearing artifacts that can occur if devices are displaying or capturing at the wrong time.

In a production setting, there are two things to sync: All the rendering and displays so that the same frame is shown at the same time across all the various display components, and the camera(s) to the display.

Video signals are inherently synchronized. A display connected directly to a playback device will be in sync with that playback device unless extra effort has been put in to allow it to *free run* at a different frame rate. Once a video link has been established, the *phase offset* between a source and a sink is fixed. Typically, image processing and display manufacturers attempt to minimize this processing time to reduce latency; the only way to synchronize with another signal is to add latency.

Distributing genlock to every device in an image processing chain will indeed synchronize all the devices, at the cost of increasing the overall system latency. In complex broadcast situations with significantly varying sources (e.g., media players, multiple camera types, live feeds from other studios) and somewhat higher limits on acceptable latency, it may be necessary to apply synchronization stages throughout the plant to allow for seamless switching.

In a traditional virtual production environment with deterministic and limited devices in the video pipeline between the render cluster and the LED display and a significant need to minimize system latency, a request to genlock every device in the chain to solve a problem is usually indicative that there is a uniformity issue in the parallelism of the signal chain – an intermediate device is running a different firmware than all its peers, for example. Applying genlock with abandon may get through the day, but it is a bandage that is adding latency.

The place where genlock-style synchronization is critical, however, is to help synchronization information span the optical gap between the LED display and the camera system. In this case, there is no electronic signal carrying frame synchronization information between the LED display and the camera, and as of 2022, no production cameras optically extract sync information from the refresh rate of the LED display. Without this synchronization signal, the exposure timing of a camera will not match with the refresh timing of the display, resulting in tearing artifacts.

To synchronize between a display system and a camera system, a multi-format device that can output both genlock (typical for displays and image processing devices) and timecode (typical for cameras) is helpful. Some modern cameras directly support genlock input, simplifying sync distribution throughout the studio.

Phase Offset

Until all devices support configuring their internal phase offset, or delay to align with a sync signal, it can be helpful if the sync generator can offset the phase between multiple outputs to allow the studio technician to adjust the phase between the LED display and the camera system. Inexpensive throw-down style sync generators do not have this capability and should only be used in situations where the render cluster, LED display processor, or camera system is known to be able to provide a phase offset. Note that only one end of the chain requires it, as the offset is relative to the other devices.

Latency Between Camera Movement and Frustum Movement

Overall round-trip latency from the camera tracker through to the rendered frustum is critical to consider, and the various components in an LED display system each contribute.

It is important to consider latency measurements in milliseconds rather than frames as this is how latency is perceived by humans: A difference between 80 and 210ms is noticeable, rather than five frames of delay at 60fps vs. the same five frames of delay at 23.976fps. Put another way, removing a frame of delay at 23.976fps (41.7ms) makes a significantly greater impact on perceived latency than shaving a frame of delay off at 60fps (16.6ms).

If camera shutter angles will always be ≤180°, it is possible to run the rendering cluster and LED display processor at double the production frame rate to save half a frame (20.8ms at 23.976fps) of latency.

Image Processing

In addition to all the critical plumbing discussed above, the topic most think of when considering LED display processors is *image transformations*.

Calibration

Calibration is a catch-all term for both uniformity correction (display *precision*, from section 14A), as well as more recently, *accuracy*, or the ability to reproduce an input value in an expected way. The math for this is executed by the receiver card and should make use of measurement data stored on the LED module. This way, if a module is swapped within a panel, the appropriate data for the replacement module comes along with it. In some older systems, the measurement data is stored in the receiver card, and it requires a manual process to look up the correct replacement data by serial number or some other identifier, extract it from a manufacturer database, and re-install it to the receiver card. It is advised to avoid systems that rely on this scheme; it is time-consuming and extremely error prone.

Color Reproduction

The LED processing system is where technical and creative LUTs can be added. It is recommended to baseline the system to a known colorspace and input using a corrective or technical LUT. Generating such a LUT is out of the scope of this document, but systems such as Portrait Display's Calman can be helpful. Resist the urge to create a technical LUT by eye; it just is not possible.

Once a technical LUT has been installed to baseline the system, creative LUTs can be modified if the LED display processor supports loading multiple LUTs. Try to avoid the temptation to use the built-in color replacement mechanisms or color adjustment tools; as of 2022, most processors do not have interfaces that reflect the adjustments that a DP may wish to make. Integrations with tools such as Pomfort LiveGrade Pro are closer to what is needed for creative adjustments.

Configuration and Integration APIs

Network Interface
Modern LED processors are configured over a standard IP network connection, either using a web browser, or proprietary desktop or mobile apps. This allows straightforward management of processors that are far from a control desk, racked in an equipment room or behind the display. Avoid processing systems that use a direct USB connection between a PC and the processing hardware. Not only do these systems not scale well in a stacked configuration, but they also require physically local access to the processing devices.

Real-Time Configuration
It is advised to consider an LED processing system that allows for real-time configuration, in which changes made are computed by the LED processor itself and immediately reflected on the display. Some older or less sophisticated systems do these calculations in PC software, which then produce a configuration file that needs to be uploaded to the receiver cards. These older systems are error prone as they require manual management of state between the active display and an offline configuration.

APIs, Third-Party Control, and Monitoring
As studios become larger and increase in complexity, it is advantageous to employ stage management systems to ensure that all the various components are operating correctly, and to uniformly configure the parallel components that enable scalability in an efficient way. Having devices that are network-first in their configuration design and having robust APIs which cover the same set of controls and configuration handles that are available in the vendor's UIs is critical as integrations between devices and control systems deepen.

LED, OLED, and Playback Servers
Henrique "Koby" Kobylko – Fuse Technical Group

Monitoring in an LED Volume
Monitoring equipment in an LED volume is the same as in any other film set, with the caveat that special attention must be taken when both monitoring for aesthetics and technical validity.

To judge aesthetics, one looks at the video feed, framing, and color. One also looks for the standard technical aesthetics elements: Motion artifacts, image artifacts, ghosting, flare, focus, and safe areas.

Special attention aesthetic items for an LED stage are the following: The frame rate of content and genlock signal, skin tones derived from LED lighting, moiré and banding on the LED wall, color rendition and contrast of the LED wall, and camera tracking delay with inner frustum exiting the frame.

When monitoring for technical validation, one looks at the data interpreted as a waveform, vectorscope, false color, and/or other information. When working with an LED volume, pay particular attention to the levels, highlight and shadow clipping, color gamut, color balance, noise in different channels, and exposure.

Video Signals, Bit Depth, and Technology

SDI, NDI, HDMI, and DisplayPort
The SDI standard with BNC connector is used for all feeds except some witness cameras that may be set up via NDI.

SDI is designed with long cable runs in mind, ensuring one can come from a switch in the server room to the LED volume operation control (Brain Bar), Video Village, or production offices without disruptions. Wireless video on a portable monitor is being used for some key creatives on set.

HDMI and display ports have been the standard in the video signal chain from the render nodes and playback servers to the LED processors, usually with a router and a screens management system in the middle of the chain that will deal with the EDIDs management in between other things.

SDR, HDR, Color Space, and Gamut Choices (Rec. 709, Rec. 2020, DCI-P3)
SDR (Standard Dynamic Range) has been utilized in production for many years and is the current standard in 2022. Alternately, HDR (High Dynamic Range) has been quickly adopted in virtual production. That is because one typically wants to shoot an LED volume at its maximum achievable gamut and range.

A reference monitor color gamut defines the range of colors it displays. Two common color spaces for HDR content are the DCI-P3, used in most HDR content, and Rec. 2020, which is growing in popularity. The difference between the two is the number of colors each space covers – Rec. 2020 is wider. Both cover a comprehensive range of colors compared to SDR. Pay attention to the differences in brightness, color gamut, and color depth, when choosing between HDR and SDR.

Brightness: HDR allows brightness from 1,000-nits, at the top, and 1-nit, at the bottom. SDR can output 100-nits or 100cd/m2. HDR allows creatives to see more varieties of primary and secondary colors.
Color gamut: HDR usually adopts P3, and even Rec.2020 color gamut, while SDR uses Rec.709 in general. With the larger color space of HDR, filmmakers will have a significantly larger spectrum of color to portray their work.

Color depth: HDR can be in 8-bit, 10-bit, and 12-bit color depth. While SDR is usually 8-bit and, rarely, 10-bit. Although the human eye sees the approximate same range of blues in 8 and 10-bit, reds and greens will be more visible using a 10-bit or 12-bit color depth. A 10-bit video has been the standard coming out of the render nodes to the LED wall. This is because of the way game engines and nDisplay currently work. Key creatives will make this choice when discussing shooting HDR vs. SDR.

OLED vs. LCD

Watching content on OLED is usually spectacular, smooth, fluid, colorful, and contrasty.

But consider that the OLED display still needs to be color accurate, be able to be calibrated, and receive LUTs.

Some OLED critical reference monitors, like the Sony Trimaster, are the golden standard but come with a hefty price tag. Considering that an LED volume requires many more reference monitors than a standard film set, and they are expensive, the budget quickly skyrockets.

A combination of OLED and LCD should be sufficient to cover different positions' needs but consider OLED necessary for the extra dynamic range if one is reviewing and delivering HDR content.

Volume Operation Control (Brain Bar) and Video Village Monitoring

Volume Operations

The volume control operation comprises a team of artists and engineers that are critical members of a virtual production shoot. They operate the systems and manipulate the content, which means each operational station will usually have monitoring gear.

Operator Multiviews

The operators also usually rely on custom control programs and interfaces, including multiple sets of multiviews. These are typically put together with a screens management system and constitute a comprehensive overview of any system input and output, allowing for complete situational awareness.

The essential Operator Multiviews are as follows:

- **Render Node Composited Multiview:** A composite of all the render nodes' video signals that are real-time rendered and fed to the LED processor.
- **Pixel Map Composited Multiview:** A pixel map composite showing all the rows and columns of LED tiles with labels to diagnose issues with the LED wall or ceiling quickly.
- **Witness Cameras Multiview:** An LED volume usually has multiple PTZ witness cameras. A multiview of these feeds is essential to keep the volume control team informed of the action.

- **Camera Feeds Multiview:** A multiview of all camera feeds. In a single-cam shoot, it is helpful to have a multiview of the raw feed next to the show LUT feed.
- **System Report Multiview:** A technical multiview of various control systems' GUIs. It may include camera tracking, performance capture, stage monitor report, and any control program offering essential data for the LED volume operation.

Media/Playback Servers

3D vs. 2D vs. 2.5D Hybrid

In most cases, ICVFX is accomplished with real-time 3D content created and manipulated inside a game engine with full dynamic or baked lighting.

Some shots will require 2D playback with timeline control – usually, when a show needs to shoot against actual footage captured on location, or at times when using pre-rendered content. An example is shooting vehicles against LED walls displaying pre-captured moving background plates.

There is also a 2.5D approach:

- Create foreground layers with 3D elements, while the background layers are composed of 2D elements on cards set at multiple distance points. This technique speeds up the content creation process and preserves the parallax effect.
- Placing multiple 2D layers with alpha masks in 3D space. This technique will preserve some parallax and can be created inside a game engine or media server software.

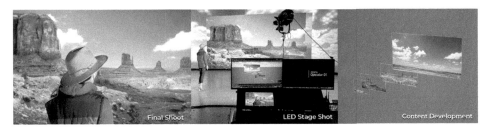

Figure 16.3 Example of hybrid 3D and 2D content
Source: (Image courtesy of Henrique "Koby" Kobylko)

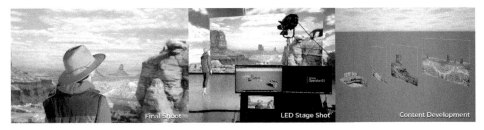

Figure 16.4 Example of 2D layers in 3D space
Source: (Image courtesy of Henrique "Koby" Kobylko)

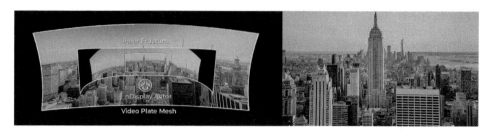

Figure 16.5 Example of video projected on 3D geometry
Source: (Image courtesy of Henrique "Koby" Kobylko)

- Projecting footage in a simple 3D geometry, such as a semi-sphere. Although this technique will not preserve the parallax, it is helpful to create a digital rig and manipulate the footage's position, rotation, and scale in 3D space.

Notes

1 StEM2 from the ASC is a good freely available reference piece, with well-produced dynamic range and varied color palette.
2 The term "transcode" often has a negative connotation, implying some loss of quality. In this case, it is simply a digital-to-digital conversion from one video stream format designed for a single baseband link or cable such as HDMI or 12G-SDI to a protocol suited to be split in both parallel and series to efficiently match the physical cabling requirements of an LED display's tiled architecture. It is not cost-effective to route a ~4K image (~12-20Gbps) to each LED display panel that typically displays less than 512 × 512px worth of information.

Volume Control – Brain Bar Labor

Description of Labor Types for the Brain Bar

Wyatt Bartel – Lux Machina

A good analogy to a virtual production crew is the definition of a Formula One racing team: a group of individuals of the highest caliber assembled to operate a finely tuned machine to within an inch of its limits in a demanding and stressful environment, that changes by the minute.

Many traits are common to all members in a successful team dynamic as complex as this: Experience, critical thinking, level-headedness, dedication, troubleshooting skills, attention to detail, stress management skills, task prioritization skills, and understanding of their teammate's roles. Respect and community, within the Brain Bar crew, are required above all else, to propel each other forward and build each other up during production.

There are significant distinctions between permanent volume teams and temporary pop-up volumes. A permanent volume Brain Bar crew has a working relationship with each other because the crew is maintained from project to project – unlike most entertainment projects, where the crew is disbanded at the end of the project. Crew dynamics and structure in a permanent volume must be capable of surviving long-term together in highly stressful environments, and as such, additional requirements are imposed on them. The relative permanency of a multi-project/year team contrasts with the temporary volume Brain Bar team, which only lasts until the specific project ends.

Virtual production Brain Bars expand and contract the various types of labor required to achieve any sequence of a project – the following list of labor types is a good example of typical Brain Bars.

DOI: 10.4324/9781003366515-18

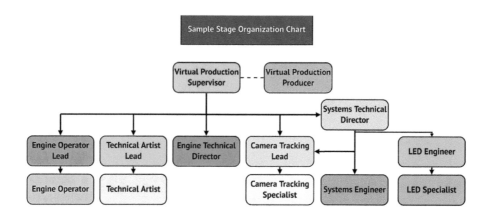

Figure 17.1 Sample stage organization chart – just one of many organizational charts representing on-set labor
Source: (Image courtesy of Lux Machina Consulting)

Virtual Production Supervisor

The VP Supervisor is the most senior member of the Brain Bar team. The position represents the nexus of a vast network of interconnected conversations, in all phases of production, and one must be a skilled manager of the team. The VP Supervisor must be capable of working hand-in-hand with the Production Visual Effects Supervisor, Production Designer, Art Director, First AD, and Producers, to carefully position the needs of production within the capabilities of the virtual production system. They must also be capable of working alongside multiple Virtual Art Departments (VADs), as well as managing the politics, and helping to bridge the realities of on-set production with remote artists who have limited visibility to the creative process.

The VP Supervisor should be able to speak the common vernacular spoken by filmmakers and creatives. They should have prior experience on-set to appropriately prioritize any request of their team and understand what the end goal of the request is. While it is impossible to be the master of all trades, a VP supervisor should have a "beyond proficient" understanding of most of the Brain Bar systems and techniques that are in use on any project and be able to have an informed opinion with their team.

Equally important is a broad understanding of traditional visual effects practices so they can offer up practical solutions in pre-production conversations for all parties, as well as foresee potential post-production problems that others may not expect.

Alongside traditional visual effects practices, which are closely tied to the role, knowledge of traditional production practices is important. Lighting skills, camera skills, producing skills, rigging knowledge, etc., are key knowledge bases to help facilitate a successful shoot within a virtual production environment. As virtual production touches almost every department on set, it is important to understand how to best capitalize on any opportunities presented and what impact they might have.

Importantly, the VP Supervisor should also be a shield or umbrella from negative attitudes and anger toward the Brain Bar crew. The most successful VP supervisors ensure that when problems arise on set, any particularly pointed opinions are expressed directly to them – their role is where ultimate responsibility stops within the Brain Bar.

In both permanent and temporary Brain Bar crews, a VP supervisor should also have excellent managerial skills. A VP supervisor should know what the hopes and aspirations of their crew are and help them be the best possible version of themselves. Situations on set require de-escalation skills, and VP supervisors without prior experience leading teams in stressful situations may not be appropriate for certain large-scale projects.

Virtual Production Producers

The Virtual Production Producer is the right-hand partner of the Virtual Production Supervisor and takes the lead on many critical tasks. Slightly divorced from the pressure cooker of on-set shooting, the VP Producer can help engage with the various other heads of department (HOD) to help direct the flow of information and responsibility – on set and within a company.

A VP Producer is, above all else, ultimately responsible for the budget of the virtual production Brain Bar crew and, potentially, portions of the facilities and project budget. Questions and negotiations of contracts, overtime, forced turnarounds, expenses, etc., are well within their purview. Most VP producers also play a key role in helping keep track of the morale of the team on long shoots.

A VP Producer must have a keen eye for detail and follow-through. They should be able to implement systems and procedures that can help track and prioritize tasks and expenses. They also are involved in the scheduling and scope of a VP shoot.

Engine Operators

The Engine Operator's role is as close to being the "driver" of the process as is possible. The engine operator role is ultimately responsible for facilitating the hundreds of requests that can flow in during on-set shooting. They must be deeply proficient in the specific virtual production engine being used and the technique at hand.

Engine operator roles require personality types that do not crack under pressure. For long periods of time on set, they may be asked to make complex changes to an already complex environment within the blink of an eye to satisfy a request from any number of people. Communication and prioritization of any request to a Brain Bar crew member should go through the Virtual Production Supervisor, but in the end, it is up to the operator to facilitate those requests.

It is important to note that communications on-set are happening in many places simultaneously, and engine operators may receive requests directly from production department heads who have not yet spoken to the Virtual Production Supervisor. It is the responsibility of the Engine Operator to understand when a request to change something about the virtual set is innocuous enough to be enacted immediately and when a request needs to be brought to the

attention of the VP Supervisor before being enacted. Regardless of the answer, all requests should eventually be brought up to the VP Supervisor to keep the team leader aware of what is happening on set.

Requests of an engine operator may be as simple as creating a light card or as difficult as attempting to change a complex animation that is a critical component to the shot – within minutes. Often the number of requests coming to the Engine Operators may begin to stack up as different departments express their needs to bend the virtual world to their will – especially when first looks are happening onset. In conjunction with the VP Supervisor, an engine operator must be swift enough to respond, but also wise enough to inform a requestor that their needs may potentially be put into the back of an existing queue due to higher priorities being at hand.

Engine operators will be requested to alter virtual materials, virtual set layouts, virtual lighting, animation data, blueprints, etc., and as such, CG generalists often excel in this role.

They should have a keen eye for blending digital worlds with virtual worlds when looking through the camera to help achieve a believable composited onset image. They must also be knowledgeable enough to know that fast changes to color and assets on set need to be communicated to the original VAD teams and the appropriate post-production team to make sure that those changes will be understood and tracked.

Engine Technical Directors

The distinction between an engine operator and an engine TD can at times be thin, but it is always distinct. Unlike an engine operator, engine TDs should be versed in aspects of software development and tool building. If a plug-in needs to be incorporated into the code base of a project, a script needs to be made to help automate a workflow, or a visual scripting logic flow needs to be drafted, the Engine TD should be the first point of contact.

An engine TD can often be closely related to a software developer, with a key distinction being their role is on set vs. in the office. The Engine TD can be a lifesaver on set to help solve complex requests quickly without requiring the time penalty of calling on a pipeline TD or software developer at the home office. The Engine TD is aware of the context of a request or problem because they are present when the problem or request arises – a challenging communication problem when trying to phone back to a satellite team.

Engine TDs are often supported by a variety of other team members in the back office who can be considered a safety valve for complex requests that are not able to be efficiently answered on set. If a task requires more than the individual efforts of the Engine TD or is an all-consuming task for multiple days, a conversation with the Supervisor over priorities is needed and other offset resources consumed if possible.

Engine TDs often work hand-in-hand with engine operators when there are fewer code-oriented or complex systems pipeline tasks at hand and can end up becoming integral to the day-to-day operation of the volume.

Technical Artists

Onset technical artists are generally representatives of the VAD team that created the assets being used on the day. They are not responsible for operating the equipment or engine within a virtual production environment but are ambassadors of the artists who created the digital environment.

It is the responsibility of the Technical Artist to help guide the Engine Operator where changes can be made and liaise the onset conversation back to the office-based, or distributed VAD team. They may also be able to take complex artistic requests off the plate of the Engine Operator outside of the live on-set environment and allow for concurrent change efforts to begin within the Brain Bar.

Systems Technical Directors

The Systems Technical Director is primarily responsible for the physical components that might make up a virtual production system. This can be everything from render or editor computing nodes, networking switches, video distribution equipment, scopes, cameras, carts, etc. They are often the original designers of the system in use and are generally very technical engineering-oriented individuals.

As the leader of the systems team, the Systems TD should (much like the VP Supervisor) have a broad understanding of as much of the equipment they are responsible for as possible. They are key members in the creation of disaster recovery plans, maintenance schedules, wiring diagrams, cable routes, and the day-to-day functionality of a system.

They are also often responsible for balancing the needs of corporate IT departments, production IT departments, and Brain Bar IT departments.

When a production first comes onto the stage, the systems team and their crew are responsible for getting signals and cables patched correctly and distributed to those on set. They consistently engage video assist/video village teams to receive signals from the camera and are responsible for distributing timecode and genlock to anyone who may need it.

As the leader of the systems team in permanent virtual production volume, a systems TD should have managerial skills to draw from and, along with the Virtual Production Supervisor, ensure their department is running effectively.

Like engine operators, systems TDs are often requested to be in multiple places at once, solving complex challenges at the beginning of the day, and they should be supported by additional systems engineers whenever possible.

Systems Engineers

Systems Engineers report to the Systems Technical Director and are often skilled in many of the same areas, but with potentially less experience. The right hand of the Systems Technical Director, systems engineers are crucial to helping create and act upon the myriad of technical components to be operated in a virtual production system. While it is possible for either a systems TD or systems engineer to operate independently when working together, their cumulative knowledge

bases and ability to troubleshoot both ends of a cable simultaneously create an extremely powerful and dedicated team that is solely focused on the health of the system that represents (potentially) the environment that is going to be shot on set. It cannot be overstated how great an impact a quality systems engineering team can have.

LED Engineers

While a virtual production crew may be operating any number of technologies, LED panels are a common one. As there are sometimes thousands of LED panels on a set, powered by numerous LED processors and electrical components, it is essential to have crew members dedicated to the proper maintenance and health of those panels.

LED Engineers are responsible for the installation and disassembly of the LED wall. They control the LED processor settings and are often responsible for additional physical rigging and structural components.

Once an LED structure is completed, the LED Engineers often join forces with the Systems Engineering team to accomplish day-to-day tasks and maintenance. While ongoing maintenance of LED walls is required (cleaning, repairing bad pixels, swapping failed components, etc.), the LED Engineering team can benefit from the potential relative calm of their position by being immensely helpful to the other departments on a set. Their skill sets often include networking, rigging, video engineering, etc., and they are excellent partners to work alongside.

Motion Capture / Camera Tracking Supervisors

Motion capture is an industry unto itself and predates many components of virtual production. The Motion Capture Supervisor may therefore oversee many various aspects of different workflows occurring during a production.

The Motion Capture Supervisor is responsible for the maintenance, operation, alignment, and operation of the motion capture cameras, or various other tracking systems, on an LED volume or otherwise. Whether those systems are designed to capture the position of a camera for an LED ICVFX shot or for capturing animation data to drive a real-time creature on set or for replacement in post depends on the project.

Motion Capture Supervisors lead the motion capture team that is comprised of a myriad of specific skill sets: Camera tracking, facial capture, VCam operators (potentially), and others. Like the VP Supervisor and Systems Technical Director, they should have a strong skill set in people management to help build a cohesive and effective team.

Motion Capture Supervisors are highly technical and talented individuals who must operate complex software and engage with complex visual effects pipelines on set. They typically have strong competency in general visual effects workflows, animation pipelines, and systems designs. They are often supported by on-set systems engineering teams that may be helping with production networking and integration.

The Motion Capture Supervisor is often the Camera Tracking Supervisor on a virtual production LED volume set. In this case, they are also responsible for working with the camera department and helping to integrate the tracking technology with the cinema camera. As a motion capture supervisor in the Camera Tracking Supervisor role, they should know how to mount outside-in, and inside-out tracking systems on a camera, capture lens distortion information, and potentially liaise with the camera team about genlock and timecode settings on the camera.

Because the camera tracking role requires close proximity to the main unit camera, a strong understanding of camera technology and crew etiquette is extremely helpful. The camera department structure on a film set is very particular, and the best Motion Capture/Camera Tracking Supervisors integrate, not alienate them. They work as partners.

Motion Capture / Camera Tracking Technicians
The Motion Capture Technician is the support agent within the motion capture/camera tracking department. He/She is responsible for helping calibrate the motion capture system, working hand-in-hand during the alignment of cameras, and working with actors and on-set departments to integrate technology as needed.

Rendering and Control Computers
Amy Gile and Hardie Tankersley – Silverdraft
Sarote Tabcum Jr. – VFX Technologies

Volume Control – Brain Bar
The function known as Volume Control, a.k.a., the Brain Bar, is responsible for managing all the technology for delivering the pixels to the LED wall or surfaces. It includes the computers that power the graphics displayed on the volume displays, as well as other control systems that may be synchronized with, or driven from, the virtual set content such as dynamic lighting sources. Volume Control typically includes workstations for the operators of the virtual set, motion tracking systems, and dynamic lighting controls. Some roles in the Volume Control workflow may be remote via a live connection (bandwidth permitting).

The computing architecture stack, working backward from the display, involves some number of render "nodes," or computers, that send the image to the LED processors. The number of render nodes is determined by the performance required to render the scene to the wall at the full frame rate, which is in turn, driven by the combination of the number of pixels and the scene complexity. These render nodes are driven by a single "control" node computer which is responsible for synchronizing all the render nodes feeding them the camera position data and is the main user console for operation of the system.

The technologies that support this workflow are constantly evolving. But as of this writing, a typical workflow is for a virtual art department (VAD) to design the virtual set, then hand off those assets to a game engine development team, who will implement the code to render the scene, enable any controls the director or production team might need to be able to change properties of the scene during shooting, and performance test and load the assets into the equipment on the volume.

Each virtual set is loaded on the render systems one at a time. And this process typically takes a few minutes. Any changes to the scene (such as moving a light source) may require a step called "light-baking," in which the system recalculates light and shadows, pre-"baking" them in to enable better performance on playback.

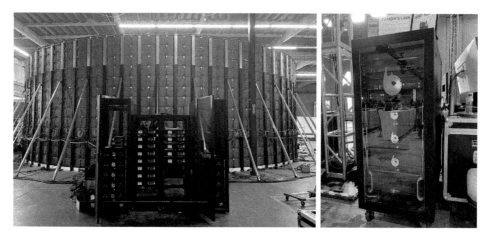

Figure 17.2 Left side is a Big Volume Control Technology Stack. Right side is a Small Volume Control Stack
Source: (Image courtesy of Silverdraft)

Optimization and Trade-Offs

To obtain the best performance and support the most natural production workflow, it is essential that the render system can deliver the correct frame rate to the LED wall without dropping frames or suffering lag. Crucial factors in the system design are selection of high-performance components such as CPUs, GPUs, storage, and networking. Other important factors are power and cooling. Unreal Engine and Unity game engines, as well as media playback software such as Disguise or Pixera, are highly demanding of GPU resources in particular. If the architecture is not properly designed or implemented, or the scene graphics are too complex, or the network pipelines are not sufficient, then artifacts can appear on the wall displays such as stuttering, jittering, or freezing of the graphics. The bigger the wall displays, the more pixels required, the higher the camera shutter speed, and the faster the camera moves, will all drive the need for more computing performance to keep up. This is true for both 3D virtual sets as well as high-resolution video plates – even without tracking. It is important to test all content and shots on the system before live production begins. Performance may be optimized by having specialist artists/engineers re-work scene geometry or textures, lighting, or materials. Each virtual set is unique, and best practices are for production time to be allocated to scene performance testing and optimization.

What Is Best for Real-Time Rendering?

Introduction

LED volume solutions require high-performance real-time rendering. The image on the wall must appear fully realistic in the camera as it moves. So, the image must be able to display each frame to the camera for each "revolution" of the camera shutter. The image rendered by the computers to the LED wall must match the position and orientation of the camera, usually at (or around) 30 or 60 fps. This means "real-time" rendering because the rendering system only learns the camera position from the motion capture system as the camera moves freely around the set. This allows simulation of the same ability to frame shots and move the camera as in a real set.

Typical render systems Real-Time Rendering for Virtual Production considerations:

- What workstation hardware specifications are required by Unreal Engine or Unity to get sufficient performance with the virtual set complexity and resolution required?
- What goes into a high-performance workstation that will allow real-time rendering for a VP workflow?
- Which components matter most and why?
- How to determine the ideal workstation placement, power, and cooling requirements?
- Does the stage or facility already have a rendering system capable to deliver the performance needed for the shoot? Or does a more powerful or custom system or configuration need to be brought in?

Ultimately, the specifications and architecture of the system required will be driven by the specific details of the shots desired, considering all the details of frame rates, focal lengths, lenses, framing, camera movement, visual effects needs, virtual scene geometry, motion capture, and more.

Specific Hardware Needed for the Brain Bar's Individual Roles

Most staff in the Volume Control will have remote KVM access to rack-mounted computer systems located off-stage in a climate-controlled data center.

Other considerations in the system architecture:

- Rendering and control systems architecture – GPU, CPU, memory, storage, networking
- Software stack – game engine (Unreal Engine, Unity), display mapping (nDisplay, Pixera), source code control, and media asset control (Perforce, 5th Kind)
- Video pipeline – latency, video processing, frame remapping, SMPTE 2110 digital pipelines
- Sync/Genlock – sync sources, render sync cards, connectivity, camera system
- Hardware infrastructure – power, cooling, rack space, redundancy, power conditioning
- Connectivity – external, fiber, cabling, networks, latency considerations and trade-offs
- Control and management – Brain Bar configuration, remote access
- Testing and certification – standards, measurement, reliability

18

Software for Virtual Production

Virtual Production Software
Philip Galler – Lux Machina

Virtual production is represented on set in a vast variety of ways, demonstrated by techniques intended to ease the burden of visual effects and digital production. Applications such as Simul-cam, 2D or 3D in-camera visual effects require robust software and creative content creation approaches. All the tools listed here are publicly available.

Unreal Engine
Unreal Engine is a real-time render engine and has a suite of tools for virtual production. One of these tools is NDisplay, which is a fundamental tool for natively displaying Unreal Engine environments on an LED or projection display and is typically rendered on a cluster of computers running Unreal Engine.

Additionally, there is a compositing tool called Composure, that is intended to work when using blue screen or green screen on-set. Composure is a keyer which also enables workflows around foreground composites of real-time digital assets. Unreal Engine offers a variety of extensible solutions for virtual production and is a great overall tool.

Unreal is one of the premiere creation tools for previs artists, virtual art departments (VADS), and others in the virtual production industry who are creating virtual environments for film, as well as being a leading animation tool. There are a number of third-party plug-ins and applications leveraging Unreal Engine to offer virtual production solutions, such as StypeLand, Zero Density, Pixotope, and Aximetry.

DOI: 10.4324/9781003366515-19

Unity

Unity is a real-time render engine that is developing its suite of virtual production tools and can be used for the creation of virtual art, previsualization, and animation content. Unity has some limited capability to be used on LED walls and projection displays, with a native solution being developed soon (as of this writing). There are existing third party solutions, such as Middle VR, which offer cluster rendering and external display support, a solution similar to Unreal Engine's NDisplay.

Touch Designer

Touch Designer is a rendering engine and visual scripting program that has been present as a production tool for over a decade. Used for everything from interactive lighting effects, real-time environments, and compositing. Best known as a node-based visual programming language enabling the creation of immersive and interactive content, Touch Designer offers a completely extendable solution that can be packaged into finished or evolving products. This tool was used on *Rogue One: A Star Wars Story* (2016) and *Solo: A Star Wars Story* (2018) to provide interactive lighting effects and plate playback for driving sequences. In more recent applications, it is used for delivering high-quality, stitched plates for playback in 2D and 2.5D applications on set.

Notch

Notch is the premiere software for real-time playback integration with media servers on set. Notch is specifically designed for the live production environment in the content creation ecosystem. It must be used in conjunction with a media server to deliver its content to a display. Notch works by encapsulating a scene and its parameters into a file that can be loaded into a media server and mapped, via traditional techniques, onto a display. Notch is built for flexibility, speed, and efficiency but lacks many of the game-centric features of a traditional game engine. It is a great tool for when one wants to deploy something interactive and responsive quickly. It also finds extensive use in broadcast productions.

Types of Content for On-Set Virtual Production
Philip Galler – Lux Machina

Virtual Production can consist of a variety of content types. Whether it is a real-time environment for in-camera visual effects, or procedurally created content for use as back plates and driving work, there is a large variety of ways in which content can be deployed on-set. Because they have different applications, these content types are often mixed and matched on a single production.

Real-Time Environment Content

The use of real-time content is one of the primary advantages of virtual production. This is essentially an environment that is rendered in real-time at a minimum of 24 frames per second. These environments are often authored by a virtual art department in an application such as Unreal Engine. These environments afford the production abilities such as endless sunlight, controllable cloud environments, and composable digital assets – which can all be changed interactively on-set as the needs of production change. These environments often take a long time to create and properly blend with physical sets, but when done correctly, they appear photo realistic.

One limitation of real-time environments is often scene performance, which is a cross-section of the number of complex objects, textures, and other scene variables. This often demands that time is spent on optimization to get the best quality and on-set performance – particularly when striving for photorealism. However, real-time environments and animation are great tools for on-set previs content and may not always appear, or need to be, photo realistic.

Real-time environments are one of the fastest-growing techniques for modern filmmakers and visual effects teams because there are so many applications for it.

Generative Content

Generative content is a reference to a piece of real-time content that is created procedurally, that is, based on some number of user inputs and parameters, interpreted by a computer graphics engine without explicit direction. Unlike a crafted real-time environment, generative content can be unpredictable and create very dynamic but sometimes uncontrollable results. This type of content is great for particle effects, such as explosions, fireworks, and dynamic effects that are best created with some randomness. It is also great for dynamic weather effects, such as rain, lightning storms, fires, etc. There are a number of tools for creating this type of content, with Notch and Touch Designer being two of the more prominent options.

Pre-Rendered Content

Pre-rendered content is one of the older forms of content in use on sets today. Often represented as back plates for use in Simulcam, or on LED walls for vehicle driving simulation. There are several tools for deploying this type of content, the most common being a media server of some kind. Pre-rendered content takes the form of video files that are explicitly delivered by editorial, visual effects, or an outside vendor for playback on-set. This found its modern use on *Oblivion* (2013), which used an array of projectors and a large front projection screen to playback cloud environments around a highly reflective set. The content for this was captured via a camera rig in Hawaii and delivered by visual effects for on-set manipulation and playback. Pixera, disguise, and Touch Designer are the most common tools for playing back high-quality, high-resolution pre-rendered video files.

On-Set Applications
Philip Galler – Lux Machina

What follows is an exploration of how this content and software is used on-set and what type of results are expected. These categories cover everything from creating simulated police siren lighting, hybrid 3D solutions, and Simulcam, among others.

Interactive Lighting Effects

Interactive lighting refers to the use of LED or lighting fixtures that are used to create dynamic lighting on a subject. This includes things like police lights on an actor's face or a crack of lightning highlighting a set piece. This is one of the most basic ways of using content on set and is often used to add realism to on-set environments. This category also covers the use of LED panels out of frame for creating reflections on set pieces and actors – a good way to cut down on expensive visual effects and digital painting costs. When executed properly, interactive lighting can add dynamic effect lighting and high-quality reflections and create an immersive and responsive environment for actors.

2D

2D workflows usually refer to the use of pre-rendered content, on LED walls or projection screens, for use outside windows of vehicles or set pieces. This solution does not include any camera tracking technology and has little to no real-time features. Therefore, it does not create a sense of perspective or parallax. Usually this content is environmental, and at a distance that would not give away the lack of parallax. It is most akin to traditional softdrops or trans lights. This technique has been used effectively in dozens of driving scenes, recreating the process trailer experience, but without the hassle of being out in traffic chasing the sunlight. One of the key benefits to this application is usually the cost, compared to real-time environment techniques. Real-time environment techniques require more staff, more equipment, and more time for setup and operation. 2D environments can be as simple as a static HDRI environment or as complex as elaborate stunt sequences rendered out to timecode.

2D content is usually displayed on projectors or LED screens on the set.

2.5D

2.5D, or a "hybrid" workflow, sits at the sweet spot between 2D and 3D solutions. Content for this workflow is usually created by layering pre-rendered 2D content in the background with midground and foreground simple 3D assets. An example of this would be a skyline HDRI backdrop with a few buildings in full 3D composited into the foreground. The benefit of this solution is a reduction in operation, setup, and content creation time, but at the expense of flexibility and control. This requires camera tracking for the limited sense of perspective that is created in the mid and foreground objects. This is often an affordable solution when there is a need for parallax or more immersion on-set, without taking on the full complexity of 3D.

Much like a 2D solution, 2.5D workflows are usually presented on a projector or LED display.

3D

A 3D workflow refers to a fully created real-time environment for use on set, often used in an LED Volume. This workflow requires robust camera tracking, a qualified and competent staff, and a team of artists capable of creating high-quality real-time environments. This solution provides a large amount of perspective and parallax, as well as the ability for control over the composition of the scene lighting and environmental effects, such as fog and haze. This is an excellent solution for capturing complex shots in-camera, but it comes at the cost of time for the content creation, setup, and accommodations made on-set for time to make changes and adjustments at the requests of the various department heads. However, by taking the proper upfront precautions, preparing correctly, and collaborating across all departments, this solution can provide efficiency, opportunities to shoot in multiple locations a day, surreal or imagined environments, and many other benefits that can only be imparted using real-time content and a 3D on-set workflow.

Much like 2D and 2.5D, a 3D solution is often displayed on an LED or projection display but requires significant calibration to match the content to the screen shape and size.

Simulcam

Simulcam is a workflow for providing front and back plate compositing on-set. This usually means the use of a real-time keyer, for replacing blue screen and green screen, as well as overlaying graphics on top of a camera feed. This solution can be used on-set with or without camera tracking. It can also be used with 2D, 2.5D, or 3D content, discreetly on each layer – for example, a 3D asset could be composited on top of a live-action scene, while a blue screen is keyed out and replaced with a static image. Simulcam is good for providing actors and creatives with a visual to respond to on set. For example, it could be used to superimpose a monster over a live feed for an actor to view on a nearby monitor. Unlike 2D, 2.5D, or 3D solutions, Simulcam is on monitors to be used as visual reference, so that everyone can clearly communicate about the composition of a scene, especially with regard to what might be planned for in post or visual effects after the live-action shoot ends.

Media Servers for Filmmaking
Philip Galler – Lux Machina

Media servers are a combination of software and hardware tools that are used for both the playback of 2D content and sometimes the display of 3D real-time environments. They come in many shapes and sizes and are set apart from previous tools in this document because they are not truly intended for virtual production. They have a history in live entertainment and have recently been adapted for use in virtual production with varying degrees of success and capability.

Pixera

Pixera is a software media server with optional hardware platforms. Pixera recently incorporated OCIO (Open Color IO) color framework, and this makes it a powerful choice for virtual production, particularly for plate playback. As more features come online related to LED volume, Pixera will offer more advanced virtual production solutions. This solution is often seen on productions that may be providing their own hardware, has Notch support for working with generative content creation, and a lightweight real-time environment deployment.

disguise

disguise, with its roots in rock-and-roll and live broadcast, has been an active media server provider for many years. disguise servers are particularly good at dealing with projection mapping and the calibration of LED volumes and XR stages. It has incorporated an interesting plug-in called "RenderStream" that allows many real-time software applications, such as Unreal Engine and Unity, to stream their camera views into disguise to be mapped onto LED walls creating the similar parallax effect required for proper virtual production in a volume. In addition to RenderStream for Unreal and Unity, Notch files can also be hosted by disguise.

VyV Photon

Photon, a media server created by VyV, has a powerful set of features enabling robust virtual production workflows. This includes camera calibration, color management, composition tools, and media playback. It can also be used to host Unreal Engine and Unity environments for use on-set. VyV is a lesser-known media server vendor but has been around for a decade or more. They are known for uncompressed 2D video playback at very high resolution, enabling extremely crisp, accurate projection, and LED display solutions.

Cameras for Virtual Production

Characteristics of Cameras for Virtual Production

Scott Dale – PRG

Virtual production is a continuously evolving landscape of innovation in terms of talent, creativity, and technology. The industry has already seen huge leaps in the creative application and exploration between the real and the virtual worlds. Future technology will transform the way one approaches all aspects of production and artistic intent. This section explores the integration of cameras and lenses into this new milieu.

Design

Global Shutter vs. Rolling Shutter

The camera shutter is a standard component of the motion picture or broadcast camera. In motion picture film cameras, a mechanical shutter is used to block film exposure while the film is advancing to prevent streaking or blurring before the next frame is registered in place and exposed. With electronic shutters, the camera sensor is exposed to light, frame by frame, primarily via two different methods: A global shutter or a rolling shutter. With a global shutter, all pixels are read out simultaneously, while with a rolling shutter the sensor reads the signal of the pixels one line at a time, typically from top to bottom. The rolling shutter can introduce unwanted artifacts due to the vertical, or rolling, of the exposure of horizontal lines from top to bottom, one line at a time. One example of a rolling shutter artifact would be that objects can have their shape altered or appear skewed or slanted as they move horizontally through the frame or as the camera pans quickly. Another rolling shutter artifact example is a potential for a partial exposure, where the top portion of a frame might be exposed to a flash of light, while the bottom portion did not have enough time

DOI: 10.4324/9781003366515-20

to be exposed to that same flash of light. For example, the top three-quarters of the frame may be exposed properly, but the bottom one-quarter of the frame may be under-exposed or unexposed.

For use in virtual production, different LED panel displays have various methods of refreshing from one image, or level change in content, to the next. If using a camera with a rolling shutter, and if the project shooting on the LED volume includes any unusually fast movement by talent or practical objects, or with the intent to include rapid camera movements, then testing is always recommended to eliminate any surprising artifacts.

Camera Testing on LED Volumes
LED display panel manufacturers often use differing technology in the design of their product. These differences are sometimes subtle but can result in various potential issues for the camera, which may need to be considered before shooting begins. Some of these issues include color cast, artifacting, banding, flicker, and visible seams between panels, and can also appear more prominently when running LEDs at lower brightness levels, which is common for camera work.

Testing LED panels for off-angle color casts and brightness reduction due to emitter layout design and pixel shaders may be important for certain productions depending on where the camera might be to capture specific shots. Some panels look fine at a 90° viewing angle but may appear to cast an overall magenta, green, red, blue, or other colors cast from a more extreme angle. Other panels may have a greater illumination fall-off when viewed from a more extreme angle. Pre-testing is recommended to discover if any of these deviations might be an issue for the camera angle parameters of a particular production.

Ideally, any production-specific camera and display test should be done using the same model camera, lens, and LED panel systems, which will be used on the day of production. Even the most prepared production should expect that all may not be perfect even after thoroughly testing for any of these issues in a simulated environment. Compromises and solutions may yet be required, leading to exploration and further innovation.

Circle of Confusion / Depth of Field
When a lens focuses on a distant spot (a point of light, for example), that point is imaged as a point on the image plane in the camera. Since a lens can only focus at one distance at a time, physical points closer and more distant than that focus point will be out of focus and appear as a circle on the image plane of the camera. These circles are called circles of confusion (CoC). The size of each circle will vary on how out of focus they are. The widest diameter circle is the farthest out of focus, and there is a threshold where the eye can no longer detect it as a point of focus. The "confusion" is when these circles are small enough to confuse the eye into thinking that they are in focus. This concept explains how objects with depth can appear entirely in focus to the camera, though the focus is on one single point within the depth of the object.

There is a range of object distances from the focal point where these circles on the image plane can appear sharp. This range is called "depth of field." Parameters contributing to this range include the lens focal length, aperture size, the distance to the focal (focus) point, the size of the image circle the lens is projecting onto the image plane, and the size of the target area on the image plane of the camera. All these parameters affect depth of field. There are charts to help determine depth of field, as well as focus assist measuring tools for the Camera Assistant/Focus Puller crew member.

Taking the above into consideration, to help to avoid moiré, it is important to keep the lens focused on the people, props, or practical set pieces, in front of an LED panel array instead of focusing on the LED panels or within the current depth of field. To help to keep depth of field to a minimum, try using longer focal length lenses, larger apertures, and focal points closer to camera and farther away from the LED panels in the background. (See sections Sensor Size, Resolution, Moiré.)

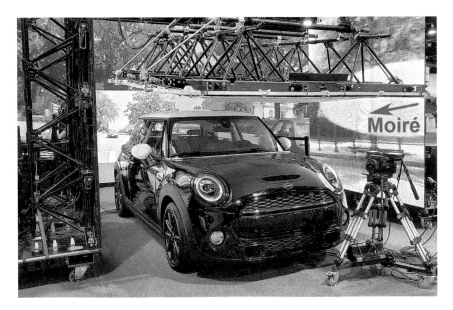

Figure 19.1 Example of Moiré Effect. In this example, the LED panel array on the right of the image was designed to provide interactive lighting only and is a lower pixel pitch compared to the higher resolution LED panel array behind the vehicle – which the camera will be seeing, though focusing on the driver or passenger.
Source: (Image courtesy of Scott Dale)

Moiré

A moiré pattern is an unwanted effect when shooting LED panel arrays with digital cameras. Moiré is an interference pattern that can occur when one pattern with gaps is overlaid on another similar pattern. Moiré can occur when the two patterns are not completely identical but instead have a slightly different pitch, are rotated, or are displaced. In this case, the grid pattern in the camera sensor can interfere with a similar grid pattern from the individual LED diode size and layout (i.e., pixel pitch) on the LED wall. When these two grid patterns do not match each other, one might see wave or line patterns appear – sometimes as colored lines. This is what is called a moiré pattern, which will reveal the plate content not being real, thereby destroying the illusion.

Pixel pitch, variances in focal length, focus point, lens aperture, distance to subject, and distance to the LED array, behind the focus point, all contribute to whether one will observe moiré at any given time. The moiré effect is also a common problem when LED screens are too close to the camera or in too sharp focus, requiring careful lens and depth of field choices.

(See sections on Sensor Size, Resolution, Lens Kit, and Aperture.)

Sensor Size

There appears to be no standard when it comes to camera sensor dimensions, especially when labeled "super 35."[1] Different digital camera manufacturers can use slightly different widths and heights. Also, many camera sensors "window" or extract a smaller section of the sensor, to achieve lower resolutions. For example, a 2K resolution capture may be half the size of a 4K resolution capture on some sensors, utilizing a smaller portion of the lens' image circle and field of view. When considering a camera selection, some of the other sensor size categories one might also consider could be IMAX or 65mm vs. Large Format vs. S35 vs. APS-C vs. 2/3" sensor and smaller. The larger the sensor size, the less depth of field for a given field of view and aperture. The less depth of field, the lower the potential for producing an unwanted moiré pattern.

For virtual production on an LED volume, the most applicable consideration of sensor size may be to help fight moiré: The larger the sensor, the better chance of being able to reduce the depth of field, thereby having a greater opportunity to put the LED panels out of focus. As mentioned above, the appearance of moiré can also be affected by the lens' focal length, lens aperture, and distance of the focus point in front of any given LED volume wall, floor, or ceiling. (See sections on Moiré, Resolution, Lens Kit, and Aperture.)

Sensor Sensitivity

Many of today's digital camera sensors are extremely sensitive to light input, allowing the ability to shoot in lower light levels – which is a good thing. In virtual production, there are many cases where one does not need the high nit value or brightness of some LED display products, particularly if the camera is looking directly at them. In some situations, where an LED display product is being used to light the scene or create reflections on glass or surfaces, then a higher nit value product may be advantageous. On most LED panels, the brightness can be dialed down to a very low percentage of the maximum light level value and then dialed back up as needed.

Lens Kit

Larger format lenses and larger sensor sizes can allow less depth of field when desired, especially when shooting with a wide-open aperture. Prime lenses generally have faster aperture choices available. These faster lenses can help by reducing the visible moiré by decreasing the depth of field, thereby ensuring that the LED panels in the background remain out of focus.

When utilizing camera tracking in virtual production, keep in mind that tracking systems require lens calibration on the camera being used and may need additional calibration time if switching between prime lenses. Zoom lenses can be helpful in this respect as they require no additional calibration if any change in focal length is made for a given shot or setup.

Anamorphic lenses are an acceptable choice when shooting on an LED volume. They offer a more limited depth of field and therefore can help keep the LED background out of focus. It is also

possible to achieve the often-desired oval bokeh from points of light in the content as well. When considering anamorphic lenses, one must also consider the size of the LED volume, or walls, in relationship to the focal lengths desired so that the camera does not see off the LED walls when de-squeezed.

Resolution

Because there is a greater density grid pattern on higher resolution cameras, the chances of avoiding a moiré pattern are better. However, some moiré may be unavoidable at certain focal lengths, apertures, and focus points, both in front of or at the screen, for any camera. Therefore, testing the camera/lens combination of choice ahead of time will always be helpful.

In recent years, some sensor manufacturers have increased the size of their sensors to achieve higher resolution. This means that larger sensor sizes, like Full Frame, 65mm, 70mm, and IMAX, have a smaller depth of field.

Pixel pitch, which is the distance between each pixel and is how one measures the resolution of LED panels, will only get better and tighter as time goes on. However, when evaluating panels for camera, one should consider how much black there is in between the individual LED light emitters to ensure there is enough black to create a deep black in the overall. Some panels use a gray between the emitters that can photograph as black. Also, lower-resolution LED panels may be preferred when utilizing panels to provide any interactive lighting in a scene. This is because the individual LED emitters are usually larger and therefore brighter.

Genlock

It can be valuable, and sometimes necessary, to utilize genlock if the camera being used can genlock, or sync, with the display system and the content-providing system on the stage. Genlock is a broadcast-centric feature and usually requires some fine-tuning between systems to get perfect. Genlock uses a pulse to synchronize the many devices within the entire system to assure that all units generate or capture the start of frames at exactly the same time. Genlocking as many sync-able components in the system can be helpful to minimize any sync artifacting. Genlock is important when working with a camera tracking system and is a critical component for performance capture, especially when shooting off speed.

Some game engines also may offer a genlock feature, though might require the help of an external device. Some camera systems do not offer genlock. One should inquire about these features before shooting.

Timecode

Timecode is a numeric clocking system used for the tracking of individual frames and files. It is implemented as metadata and can be important for pre-production, production, and post-production. The use of timecode and timecode notes can be very useful when wishing to cue up different plates on the day of production. Not all playback systems have timecode capability, however.

Some game engines providing content also may offer a timecode feature, though it might require the help of an external device to implement. One should inquire about these features before shooting.

Frame Rates

To avoid any motion artifacting, it is important to match the frame rate on all devices in the system and plate footage. The frame rate on the original plate content, media server or playback device, and the processors feeding the LED panels should match the shooting camera's frame rate for final pixel on the day of production. The same technique should apply when over or under-cranking the camera. It may be possible to have some components be at a different frame rate, or frequency, such as a media server or LED processor system, especially if the frame rate is a multiple of the desired frame rate. Testing is always, always recommended.

LED Colorimetry

LED display color spectrum technology is constantly being improved and developed to better mimic real-world colors to provide a color gamut as sophisticated as today's high-end digital motion cameras can capture. But it is not there yet. That said, today's LED color spectrum is fine for on-stage vehicle process work with flashes of light and interactive movement of plate lighting on the vehicles' interiors and exteriors. Current LED display panels are not yet a perfect match for the color spectrum provided by advanced professional lighting – particularly for lighting human faces in less dynamic scenes.

LED RGB (red, green, blue) vs. RGBW (red, green, blue, + white) displays vs. new/future advancing LED technology are in the process of being developed to fill in missing portions of the color spectrum that traditional LEDs have yet to achieve.

Camera Frustum

The Camera Frustum (specifically the "Inner" or "View" Frustum) is the shape of the taking camera/lens' field of view on the LED volume wall, ceiling, or floor. A frustum is a geometry term used in 3D computer graphics. In the case of the camera's relationship to an immersive LED volume in virtual production, a plane parallel to the camera sensor is sliced off of a virtual pyramid (or cone of vision) created by the lens' field of view. On the LED volume wall, a shape is created to cover the field of view of the lens and camera capture to only cover what one needs to see.

One can think of the camera frustum on an LED wall like a projector beaming a rectangle onto a screen. The interior of the frustum is all that needs to be at the higher resolution. It is also the portion of the virtual world where the talent and any practical props or physical set pieces can be live composited into a virtual world. This interior frustum also allows the camera tracking systems to correct for the parallax of the moving camera and to provide set extensions if desired.

It is important to understand that the frustum can have its own independent exposure level. Therefore, the surrounding area in the volume can do more of the lighting work to compensate.

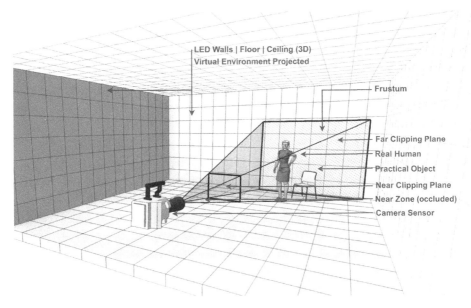

Figure 19.2 The camera viewing Frustum as used in virtual production
Source: (Image courtesy of Scott Dale)

LED Processing for Camera – Frame Remapping for ICVFX
Daniel Warner – Brompton Technology

What Is Frame Remapping?

Frame Remapping is a technique for multiple cameras to view different content displayed concurrently on the same LED screen. This technique offers an array of possibilities for virtual production.

How Frame Remapping Works

By operating the LED wall at multiples of the project frame rate, one can interleave frames of different pieces of content and display them at the same time on the LED panels. For example, on a 24fps cinema project, the LED system could run at 48Hz, or 96Hz, etc., and for a 60fps video project, the LED could run at 120Hz or 240Hz. Each camera system is then sent a unique phase delay from a common genlock signal. This sequence of frames is then interleaved to be displayed on the LED panel(s) and captured independently by different cameras. The shutter of each camera is synchronized to capture only one of the interleaved video signals displayed on the LED wall. This technique is used for a wide variety of applications: Multicam frustum overlap within a shared area of LED, XR cues that appear for talent and crew through persistence of vision but not the camera, markers for tracking systems can appear directly on the LED saving the need of installing reflective dots on location, colored mattes can be used to create a green or blue screen on the LED. For broadcast television, a presenter can appear in several regionally targeted environments simultaneously, or multiple advertisements may stream out to different global markets at a live event.

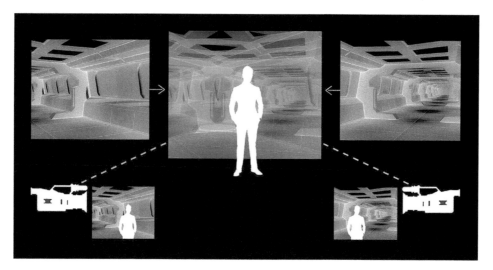

Figure 19.3 Example of Frame Remapping
Source: (Image courtesy of Brompton Technology)

Creative and Technical Considerations

When interleaving different images at a multiple of the project's frame rate, some visible strobing might be perceived for the slower refresh rates below 96Hz. This appears to the eye but not on camera.

CAMERA SHUTTER

When using rolling shutter for frame remapping, a faster exposure time or a smaller shutter angle is required to accommodate the sensor readout time, in addition to the advertised exposure period. Since a large amount of content is produced at a 180-degree shutter angle, the capture from the camera would capture multiple frames on the LED wall, not allowing space for the readout time of rolling shutter cameras. In this case, global shutter cameras with instant full sensor readout will prevent temporal image artifacts.

Advantages of Brompton LED Processing Technology

Tracking Markers

Frame remapping can be utilized to display tracking markers for an inside-out type tracking system.[2] In this setup, the tracking markers are displayed on the LED ceiling and are synchronized to be out of phase from the camera capture.

Low Brightness Performance

In LED systems incorporating cameras, capturing the full dynamic range while maintaining HDR content detail is crucial. Various tools are available to reduce banding and display content accurately to address the challenge of low brightness:

Spatial and Temporal Dithering Technique (Dark Magic)
Maximizing Dynamic Range (Extended Bit Depth)
Batch-Specific Linearity Correction (PureTone)

Spatial and Temporal Dithering Technique (Dark Magic)

Dithering is employed in the LED processor to subdue banding artifacts noticeable in shadow areas. It improves the quality of gradients and detail in this area of the image. The amount of dither depends on the bit depth available inside the LED driver for the signal.

Extended Bit Depth and Maximizing Dynamic Range

With some advanced LED processing techniques, it is possible to effectively increase the bit depth, or dynamic range, of existing LED panels by up to a factor of ten. The improvement is most notable in the deep shadow areas near black.

LED Non-Linearity Correction (PureTone)

LEDs and their driver chips do not behave in a linear fashion, and when asked to produce a particular brightness, they may not accurately achieve it. This is due to the different colored LEDs (within an LED device) dimming in slightly different ways, often producing an unsightly color cast on content, particularly at low and ultra-low levels of brightness. Additionally, the driver chips and LEDs in different batches of the same LED panel will have slightly different responses, making matching different batches very tricky. These problems can be ameliorated by using a special calibration process called PureTone. PureTone requires one panel of each batch to create a special calibration profile that can be applied to each LED batch, which greatly improves these commonplace problems.

Pixel Level Dynamic Calibration Technique (Hydra and DynaCal)

In a unique approach to calibration, it is possible that every pixel's colors are physically reproduced with the best possible accuracy. This allows for unrestricted peak brightness and the maximum physically achievable color gamut of the LEDs in comparison to legacy LED calibration techniques. The color space mapping, white point, and maximum brightness can be precisely adjusted dynamically without compromises, along with thermal compensation unique to every LED panel design. Dynamic Calibration is required for precise color workflows, particularly those involving HDR.

Camera Sensor Readout Timing Compensation (ShutterSync®)

If dark or bright horizontal lines appear on camera, they are most likely related to the difference in frequency between the LED lights and the camera's shutter speed. This artifact might manifest only during a vertical tilt move, especially with rolling shutter cameras, as both the LED and camera are scanning vertically. To prevent this timing misalignment, the processing system must be aware of the camera's sensor readout timing, to make necessary compensations inside the LED panel's electronics.

279

LED Processing for Camera – GhostFrame

Jeremy Hochman – Megapixel VR

Explanation and Definition of GhostFrame

GhostFrame is a software toolset within Megapixel's HELIOS LED processing platform that is used to create on-set, real-time in-camera visual effects (ICVFX) workflows.

GhostFrame is made possible by the fact that the refresh capabilities of LEDs are far greater than a camera's capture duration. This means that alternative imagery can be displayed on an LED screen while a camera shutter is closed, resulting in content visible to human eyes but not the camera. The GhostFrame user interface within HELIOS allows for the control of this alternative imagery – choosing what to display and for what portion of the frame time.

What Effects Can Be Achieved

There are several useful effects that can be deployed with this additional imagery, such as the following:

- Cue markers and content for actor sightlines
- Camera tracking markers
- Chroma key mattes
- Multiple overlapping camera frustums each with their own rendered perspective (up to four)
- Multiple single-camera exposures with different ambient lighting effects for extended HDR workflows

The image below shows a volume deploying two simultaneous camera frustums. For the purposes of easily identifying the different perspectives, Camera A captures a green matte and Camera B captures a purple matte. While the studio-view camera captures white where the frustums overlap (because the shutter angle is 360 degrees). In practice it is possible to "hide" either the A or B camera view so that the in-person experience gives talent and crew only a single environment to experience. Meanwhile, the A and B cameras are only exposed to their respective individual colors (or assuming the use of a render engine, their respective rendered perspectives).

The image below shows each camera's "view" of the LED volume during simultaneous capture. Notice how neither camera perceives the overlapped combination of color.

While these images are greatly simplified to communicate the possibility of two simultaneous captures of different rendered content, there are countless creative applications for multiple sources to be displayed in the LED volume at the same time. For example, rather than using the GhostFrame toolset for two cameras, it can instead be used for a single camera with a different in-person experience: Imagine the addition of wireframe visual effects elements into the LED wall for talent to react to, yet not capturing the wireframes in camera

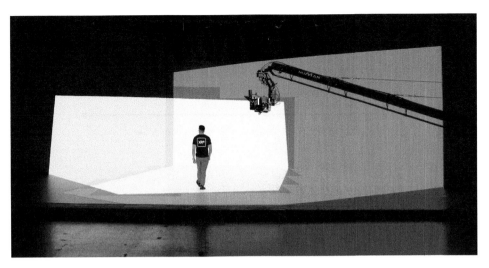

Figure 19.4 Two overlapping camera frustums
Source: (Image courtesy of XR Studios)

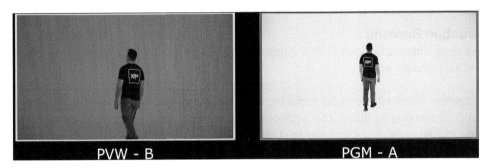

Figure 19.5 Footage as seen from each camera
Source: (Image courtesy of XR Studios)

so that the recorded footage is clean for post-production visual effects to insert elements into. Or imagine a situation where talent cannot remember their lines: Text and cue markers can be added to the LED wall for guidance, yet these elements can be completely invisible to the camera.

How to Plan

To make efficient use of GhostFrame, special considerations need to be accounted for, including genlock, camera shutter angle, and in-person experience. While this chapter will not cover the differences between sensor technologies (rolling vs. global shutter[3]) or specific camera models, these are the two most important factors that can determine how far the GhostFrame toolset can be pushed.

To better understand how to make use of a camera's closed-shutter duration, it is helpful to think about the camera sensor's behavior on a timeline assuming 24fps and 180° shutter angle.

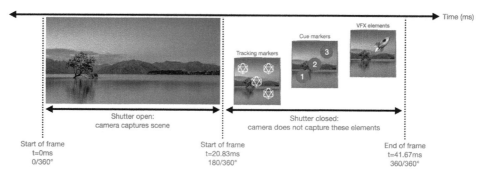

Figure 19.6 Timing diagram of camera shutter
Source: (Image courtesy of Megapixel VR)

While the open shutter duration will result in a recorded image, there is a significant amount of "extra" frame time when the shutter is closed. This closed shutter time is where GhostFrame can add a variety of sub-frames for additional content or for cancellation sub-frames[4] to hide content from in-person viewing.

Production Benefits

GhostFrame offers advanced ICVFX capabilities while potentially reducing on-site production time in the following ways:

- Complex visual effects shots requiring substantial post-production work can be confusing and disorienting for talent. The addition of cue markers and content for actor sightlines can reduce the number of takes required by ensuring talent hit their marks and remember their lines, even when a physical set is sparse.
- In-camera tracking markers can self-align in real-time as long as the camera sees a portion of the LED screen – this means no more loss of tracking if a boom mic crosses above the camera requiring a reshoot.
- Capture chroma key matte and imagery simultaneously in a single take.
- Capture multiple camera perspectives in a single take (up to four).
- Capture multiple lighting conditions simultaneously, such as day and night scenes.

What to Expect in the Future

Virtual production is in its infancy. Camera manufacturers continue to offer faster and larger sensors, while LED display manufacturers constantly strive to improve the refresh capabilities of their tiles. As these manufacturers collaborate and learn from each other – both in terms of benefits and limitations of their respective technologies – the interoperability will become more automatic and feature-capable. One can image the simultaneous capture of not simply two or four camera perspectives, but one hundred or more so that consumers with VR and AR headsets can navigate through cinematic footage of a scene – or offer a director the ability to do so in a final edit, or dozens of lighting conditions could be captured simultaneously so that a director can later decide if a scene should have taken place during the day, at dusk, or at night. Toolsets like GhostFrame do require a significant amount of planning and operator training as of this writing; however, in the near future, much of the specialty setup knowledge will "automagically" take place when all of the equipment is connected.

Calibration and Lens Metadata
Kevin Cushing – Epic Games

For visual effects post-production, it has always been an important process to calibrate the cameras and lens parameters that are to be used on a production. This data is used in the compositing process to integrate visual effects with the recorded footage. This will ensure the CG effects match the characteristics of the lens and appear to be a part of the original footage.

With the growth of virtual production, these calibrated camera parameters can be used on set and not just in post, for what has become known as In-Camera Visual Effects (ICVFX). In this case, it may be required that calibrated camera extrinsics and intrinsics and other camera metadata is used to update CG elements that are added and viewed through the camera in real-time. Camera and lens metadata may include some of the following: Lens distortion, timecode, aperture, focus distance, focal length, shutter speed, white balance, and more.

Sync (genlock) is a necessity as well when hardware and software systems need to record or draw elements at the same time. For example, a production camera shooting an LED wall as a background element requires the camera shutter to be in sync with the LED processors drawing the content on the LED wall, to avoid flicker or other artifacts.

For the successful use of camera footage combined with CG elements, synchronization of all systems on set is required using a common timecode. In an ICVFX scenario where compositing is added, the camera tracking may be delayed to match the video feed from the camera that arrives later, along with the system creating the CG elements. This synchronization is made through the alignment of the common timecode being used.

Camera Parameters

For a CG element to be composited correctly within a scene being recorded by the camera on stage, it needs to be projected by a model of the camera that accurately matches the parameters of the real camera.

CG elements to be seen in front of the camera can be defined by 3D points within a world coordinate system. These points are viewed from the camera's coordinates in translation and rotation relative to these world coordinates and recorded to the 2D plane of the camera sensor. Camera parameters impact where the 3D points of an object being viewed are drawn on the 2D plane of the sensor.

Camera Extrinsics – The camera's coordinate system in translation and rotation relative to a 3D world coordinate system. The center of the camera coordinate system is considered the optical center of the lens on the camera. An example is where a defined location on the stage is set as the origin of the world coordinates. If x and z represent the horizontal axis and y represents the vertical, the origin of the world x, y, and z equal 0,0,0. The location of the camera on stage based on its optical center is given as a translation value that is relative to this world zero. The camera also has a direction it is aiming, which is defined as a rotation value relative to the world.

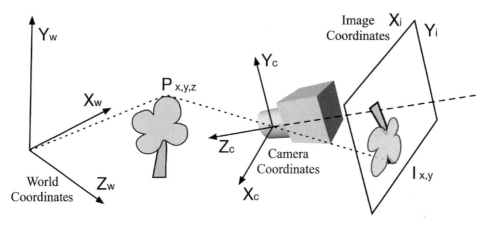

Figure 19.7 Image of world and camera coordinate system
Source: (Image courtesy of Epic Games)

Camera Intrinsics – Includes the optical center of the lens on a camera as well as properties of the lens such as distortion and the location of the sensor. The intrinsics further inform where the 3D points in front of the camera are to be drawn on the 2D sensor of the camera.

Optical Center – The center axis of the lens where light rays pass through it without any deviation. On large complex lenses, this could be far away from what is considered the geometric center of the lens. The camera coordinate system originates at the optical center.

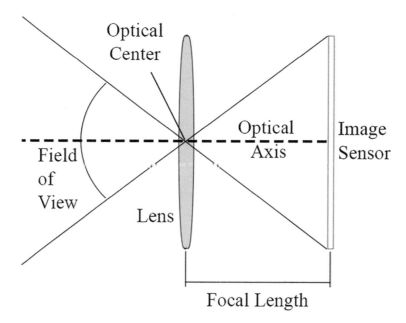

Figure 19.8 Image of lens optical center
Source: (Image courtesy of Epic Games)

Distortion Coefficients – In an ideal world, straight lines that are recorded by a camera would appear straight on the 2D sensor. This is a rectilinear projection of the world on a 2D surface. However, lenses are complex elements of curved glass. Distortion caused by the curvature of the glass is the deviation from its rectilinear projection and appears in different forms. The further away from the center of the lens, one tends to see more distortion projected on the image. The shape of this distortion can appear to be described as barrel shaped where straight lines bend outward or pincushion where straight lines bend inward.

There is also tangential distortion, which occurs when the sensor and lens are not parallel. In this case lines can appear to converge in one axis top to bottom, left to right, or on the diagonal.

Lens Calibration

Lenses may include fixed focal length or zoom lenses. Fixed focal lengths have a singular magnification of the image on the sensor. Focus distance affects distortion. Calibration of lens distortion should be made at different focus distances. With a zoom lens the focal length will change, and the distortion of the image will change as well. Zoom lenses should be calibrated at different focal

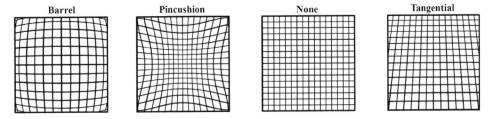

Figure 19.9 Image comparing barrel, pincushion, none, and tangential distortion
Source: (Image courtesy of Epic Games)

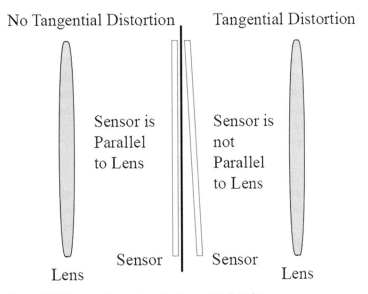

Figure 19.10 Sensor alignment causing tangential distortion
Source: (Image courtesy of Epic Games)

lengths, as well as focus distances at differing focal lengths. Zoom lenses make for a much more involved calibration process due to the ability to change the focal length.

Anamorphic lenses add to the complexity of calibrating lens. Because of the squeeze factor that is created by the lens, the horizontal focal length is different to the vertical one.

There are a variety of methods for gathering lens data for calibrating a lens. Most calibration processes involve filming a physical object with a checkerboard or other pattern. This calibration object has accurately defined measurements of the patterns displayed. There are also different software packages that can be used to process the images gathered from the camera. The premise of using these images is to compare points on the calibration object's pattern as if it was projected in a rectilinear format on the sensor without distortion to where these points are recorded after projection through the lens. From these measured differences across the entire field of view of the lens, a 2D map of the lens is created. Some lens manufacturers are starting to include distortion profiles with their lenses after manufacturing.

Lens calibration can be used in a post–visual effects pipeline to undistort footage to composite CG effects and then re-distort for final delivery. It is easier to apply the CG elements on the undistorted image. In an ICVFX scenario the video image with real-time compositing may need to have the distortion applied only to the CG elements that are not seen in camera such as AR elements and set extensions. When shooting an LED wall or video projection with CG elements being displayed on them, the lens of the camera is already distorting what is in view.

Camera Movement and Parallax

The camera's extrinsics are modified when the camera moves on set. With a camera and lens that have been calibrated to find the optical center, the parallax of any objects in view of the camera will perform as expected when the camera is tracked, and the position and orientation are updated. Parallax is the way objects close to the camera appear to move relative to objects far away when the camera translates. For ICVFX where parallax is required to be seen on an LED wall or projection screen, the camera will need to be tracked during shooting. The model that represents the projection of the camera view on the LED wall uses the optical center of the lens as the projection point of the image. By doing this, the parallax shift that occurs between objects both real and CG will be accurately displayed. CG compositing for Simulcam or broadcast are other scenarios where the camera movement will also need to be tracked while operating

Camera Tracking

Outside-in tracking is where tracking hardware is mounted outside of the production camera in some way. This exterior hardware is actively tracking a sensor of some type mounted to the camera. A form of this is optical tracking, where an array of motion capture cameras is mounted on stage and used to track an optical sensor mounted to the production camera. Software is used that reconstructs in real-time the location and orientation of the production camera.

Inside-out tracking is where a sensor or camera is placed onto the production camera that detects features outside or around it to determine the location and orientation of the production camera.

Some systems use visible 3D features of the set and stage. Other systems may require supplemental reflective markers or patterned fiducials to track.

No matter what type of camera tracking systems, there are two things that need to be accounted for. The first is aligning the tracking system to the world coordinates. Camera tracking systems can either move their coordinate system to match the world coordinates of the software rendering CG elements, or the rendering software itself can move the camera tracking to the required world coordinates.

The second is calculating the offset between the elements used to track the camera and the optical center of the lens on the camera. The tracking system is not aware of the optical center (nodal point) of the lens being used. The axis of the tracking system needs to be updated to match the lens optical center. If not, the CG will appear to slide relative to the camera view being recorded as the camera moves.

One method to calculate this offset is similar to the one used to calibrate lens distortion. A calibrator of known size can be placed in front of the camera. Using the tracked position of the calibrator, software can be used to calculate the difference from where the camera is currently being tracked and the optical center of the lens. The tracking data is then updated using the optical center as the camera coordinates as expected.

Lens Metadata

Lens parameters that will change on a camera include focus, iris (aperture), and zoom (focal length). This metadata is commonly referred to as the FIZ data.

These parameters can be either recorded and used for post–visual effects or used to update composited CG elements in real-time. Each of these impacts visually how the image captured in camera is resolved. Aperture will change the amount of depth of field that is perceived. Focus distance will change where depth of field will begin. Focus distance will also change the distortion that is created by the lens. Focal length changes the magnification of the image and is valuable when using a zoom lens that changes focal length during a take.

It is important to note that what is viewed through the physical lens of the camera already has these qualities of depth of field, distortion, and magnification applied. It is the CG elements that are composited that will need to be updated by these parameters to fully integrate them with elements recorded by the production camera.

Streaming of focus, iris and zoom (FIZ) data in real-time, to software responsible for rendering the CG elements can be done in a number of ways. It can be streamed from some camera manufacturers over the output video from the camera itself. When this is not possible, hardware attached to a camera can be used to evaluate changes in camera parameters and passed on to software or hardware that records and updates the calibrated camera parameters.

Often a geared lens encoder system of some type allows the control of FIZ either manually or via a remote unit operated by the first camera assistant. As the FIZ is changed on the lens, the

encoders move. In turn, hardware that can read the changes made sends it to be used by the software responsible for rendering the final CG elements.

Smart lenses are an option. These lenses have a port on them where FIZ and lens distortion can be output directly from the lens. The FIZ data can be converted by other hardware and then streamed to the CG rendering software system to read these updates directly without encoders.

Notes

1 For more information on why this is a true statement, please see: www.tinyurl.com/cinelenses.
2 Inside-out refers to a motion tracking system that is physically mounted on the camera looking out to markers placed in the real world environment (examples include Mo-Sys Startracker, NCam, stYpe). Outside-in tracking systems (such as OptiTrack and Vicon) typically consist of camera arrays along the ceiling and combine their perspectives to generate positional data of objects such as a camera.
3 **Rolling shutter** is a method of image capture in which each frame of a video is captured not by taking a snapshot of the entire scene at a single instant in time but rather by scanning across the scene rapidly, usually vertically from top to bottom.
4 **Cancellation sub-frames** are negative images of the incoming video content that are self-generated in the LED tiles themselves. By displaying video content and a negative image of the content, the content is not visible to the human eye.

20

Camera Tracking for Virtual Production

Overview of Inside-Out and Outside-In Tracking Systems

Mike Grieve – Mo-Sys Engineering Ltd.

The foundation of all virtual production that uses rendered virtual scenes or elements is the ability to match the virtual camera to the physical camera so that the virtual graphics stay locked in 3D space, and the blend between virtual and physical elements appears seamless.

The glue that matches the virtual and physical cameras together is a real-time camera and lens tracking system, of which there are two main technologies, optical based and encoder based. The optical based variety can be further split into two types: "inside-out" systems and "outside-in" systems.

Inside-Out Tracking Systems

What Constitutes Inside-Out Tracking?

An "inside-out" camera tracking system is one where a secondary witness camera is mounted to the main camera, and the witness camera references an external map comprising one of the following:

- A map of fixed physical markers (retro-reflective or fiducial) attached to a studio ceiling, studio floor, or studio wall.
- A point cloud created by detecting natural salient points in the physical scene in front of the witness camera, or in front of the main camera.
- A map of digital markers displayed on an LED wall or ceiling, flashed out of the shutter angle of the main camera but within the shutter angle of the tracking system camera.

DOI: 10.4324/9781003366515-21

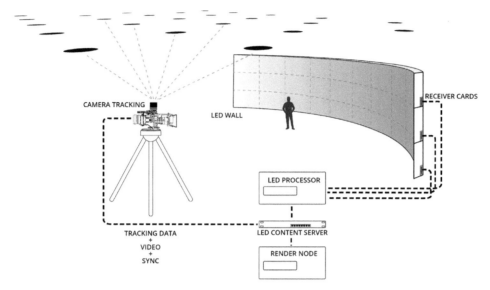

Figure 20.1 Schematic diagram showing an "inside-out" marker-based camera and lens tracking system, as part of an LED virtual production stage.
Source: (© 2023 Mo-Sys Engineering Ltd.)

As the camera moves the image of the markers captured by the tracking sensor changes, and from mathematical calculation, the 3D movement of the camera can be derived.

In addition to tracking the 3D movement of the camera, most inside-out camera tracking systems also provide real-time lens encoding, which is required so that the virtual scene more accurately matches with the content captured through the camera.

Real-time lens tracking data is derived either from high resolution mechanical encoders on the focus and zoom wheels of the lens or from a digital output port on the lens. The lens tracking data is used in conjunction with a pre-built lens file for each particular lens, to distort the virtual graphics to match the distortion of the lens on the camera so that the component parts of the camera output image are seamless.

Tracking system vendors create their own library of master lens files using highly accurate measurement techniques, and this is the most common approach to implementing lens distortion today. These master lens files provide a highly accurate generic lens file for each model of lens, but for greater accuracy, tracking vendors also provide user software to further "tweak" each individual lens for a particular camera body, as each lens and camera combination will have minor variations to the CAD models used for manufacturing.

Each lens file contains typically measured parameters across the entire focal length and zoom range of the lens, and the real-time focus and zoom tracking data determine (in much the same way as a look up table works) which parameters are used from the lens file to drive the distortion of the virtual scene at that particular point in time.

The typical lens parameters measured for the lens file are as follows:

Fx – focal length (or field of view) in the horizontal plane
Fy – focal length (or field of view) in the vertical plane
Cx – horizontal offset between center of the lens and center of the camera sensor
Cy – vertical offset between center of the lens and center of the camera sensor
FD – focal distance
K1 – first spherical distortion term
K2 – second spherical distortion term
K3 – third spherical distortion term
P1 – first tangential distortion term
P2 – second tangential distortion term

In recent years, lens manufacturers have begun adding data ports to their lenses to directly output the lens distortion data set above. However, one complication is that most lens manufacturers do not output the Cx and Cy values because they are dependent on the exact mounting of the lens on the camera body.

Originally output lens data was based on the CAD model of each lens used for manufacturing and did not take account of individual lens variations of the same model, reducing the accuracy of the distortion. However, lens manufacturers are starting to use lens files based on measuring each individual lens, meaning that the accuracy would increase accordingly.

Inside-out camera tracking systems can be classified as relative or absolute. Relative systems on power up need to re-learn the environment they are in before they can derive the 3D position of the camera. Absolute systems power up already knowing the environment they are in and only need to establish the 3D position of the camera within the environment.

What Constitutes a Tracking Data Set?

A complete tracking data set consists of eight parameters, six describe the 3D positional movement of the camera, two describe the rotation of the lens barrel:

* Camera Pan, Tilt, Roll, X (left-right), Y (forwards-backwards) H (up-down movement)
* F (focus) Z (focal length, or zoom)

Camera and lens data is checked at the same or higher video frame rate that the camera is set to. This ensures both that the smallest and the largest movements of the camera and lens are accurately captured per video frame.

Tracking data generated by the inside-out tracking unit is passed to the computer, rendering the virtual graphics. This could be a virtual studio or augmented reality compositing system or an LED content server.

The six-axis of camera data (P, T, R, X, Y, H) determine the perspective view of the virtual graphics, whilst the focus and zoom data drive the lens distortion of the virtual graphics, ensuring it matches the real lens distortion.

There is a choice of where the lens distortion is calculated; it can be done by the camera tracking system or by the virtual graphics system. Wherever it is calculated, it is the same process of using the focus and zoom tracking data from the lens, in conjunction with a previously generated master lens file for that lens (where the lens has been mapped across its focal range), to create an accurate distortion of the virtual graphics to match the virtual and physical image elements together.

Test Packages for Visual Effects Artists

Not every visual effects shot captured in a real-time ICVFX shoot can be used as captured. Many of these shots will still need to be finished in a post-production compositing suite.

In this scenario the virtual studio software package, in conjunction with the camera tracking system, must capture and then output the complete tracking data set for each shot, along with the captured camera shot and the virtual scene. With these components, visual effects artists can re-assemble the composite scene in their preferred DCC system and either re-render the virtual background scene or add elements to the composite, or both.

For visual effects artists to practice with exported ICVFX shots, most camera/lens tracking manufacturers provide a visual effects test package. This typically contains a sample virtual scene, the captured camera content, the camera/lens tracking data, and a sample of one or more DCC package scenes or scripts.

An exported shot package from the real-time virtual production suite for post-production compositing will comprise of the following elements:

- FBX file – contains the virtual scene and the six-axis camera tracking data.
- Sidecar text file (e.g.,. TXT) – contains metadata about the scene and camera providing compositors with additional data. The sidecar file will have the same file name and timecode as the FBX file it refers to.
- Video file – containing the green screen, blue screen, or green frustum take.
- Reference video file – containing, for example, the on-set real-time previs.

Marker-Based Camera Tracking

The majority of inside-out camera tracking systems use physical markers attached to the studio ceiling, studio wall, or studio floor to reference positional changes in the 3D movement of the camera. These markers can either be fiducial or randomly spaced markers; however, the majority of inside-out tracking systems today use randomly spaced markers made of retro-reflective material.

Marker-based camera tracking systems are the most accurate for studio use. They do not drift over time, they do not require daily 3D positional calibration, and they are impervious to lighting changes.

Examples of inside-out tracking systems that use retro-reflective markers include the following:

- Mo-Sys StarTracker
- Stype Redspy

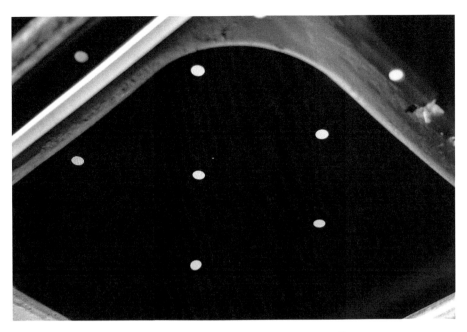

Figure 20.2 Tracking markers positioned in a random pattern on a studio ceiling.
Source: (© 2023 Mo-Sys Engineering Ltd.)

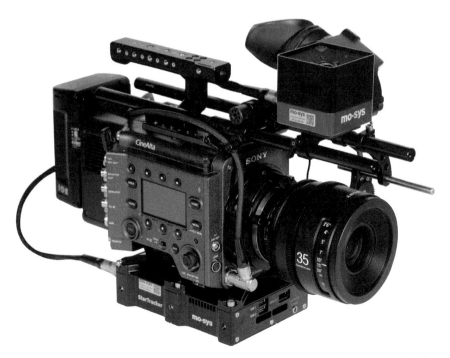

Figure 20.3 Marker-based "inside-out" camera tracking system mounted to a camera rig. The sensor is on the top of the camera, and the processor is under the camera.
Source: (© 2023 Mo-Sys Engineering Ltd.)

293

- Trackman VioTrack S
- Ncam Reality/MK2 camera bar

Marker-Less Camera Tracking

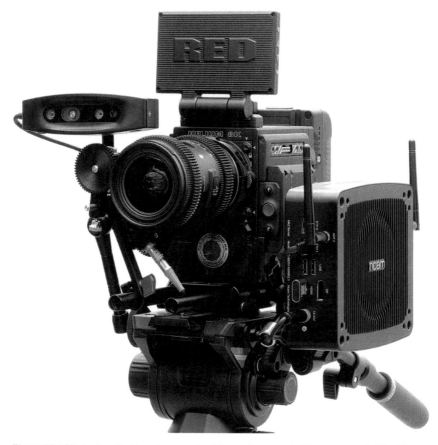

Figure 20.4 Marker-less inside-out camera tracking system mounted to a camera rig. The binocular sensor is on the left-hand side, and the processor is on the right-hand side.
Source: (© 2023 Ncam Technologies Ltd.)

Another approach to generating a reference map from which to derive 3D camera movement is to extract high-contrast features from the live video image that the tracked camera is pointing at, store these contrast points as a 3D map (also called a point cloud), and track changes in their position. This approach uses computer vision techniques such as visual simultaneous localization and mapping (vSLAM), and this can be implemented in one of two ways:

- Using a binocular tracking sensor mounted on the camera that looks either at the same image as the main camera or, if inside a studio, at an image of the studio ceiling.
- Using the same image, the camera is capturing, called "through the lens" (TTL).

One advantage of marker-less inside-out tracking systems is that they are highly suitable for tracking outside of a studio. Marker based and encoder based inside-out tracking systems can be utilized for outside use in certain situations, but marker-less tracking systems offer complete freedom of movement of the camera. However, marker-less systems do not operate well in an encapsulated LED volume as the features required for tracking necessarily change as the camera moves and a new perspective is rendered.

Examples of marker-less inside-out tracking systems include the following:

* Trackmen VioTrack R+
* Ncam Reality/MK2 camera bar
* Trackmen VioTrack TTL

Digital Markers

LED-based virtual studios are becoming common, and those that have an LED ceiling can sometimes present a problem for marker-based camera tracking systems. If the LED ceiling is too deep, it prevents the sensor of the marker-based tracking system from seeing sufficient markers on the studio ceiling.

If the pixel pitch of the LED ceiling tiles is in the region of 2.5mm – 5mm, perforated markers can be added to the LED ceiling tiles, such that the LED elements are not covered, and sufficient retro-reflective material is viewable by the tracking sensor.

However, these markers can show up in the reflection from the LED ceiling on a shiny object in the studio, for example, a car. A solution to this problem is to generate "digital stars" that are flashed on the LED ceiling or wall but outside the shutter angle of the main camera. This ensures that the digital markers are not seen by the main camera, but they are seen by the tracking sensor, ensuring that it can still reference a map from which to calculate 3D camera movement. An example of this solution is the Brompton Digital Stars system.

Outside-In Tracking Systems
Neil Abrew – OptiTrack

Camera Placement and Calibration

Tracking Accuracy and Precision

What Constitutes Outside-In Tracking?

Outside-in tracking is defined as sensors secured on the perimeter of a room, or "setup area," to track groups of markers within the space to determine their positions and orientation. The "capture area" is the volume within the setup area that is sufficiently covered by the field of view

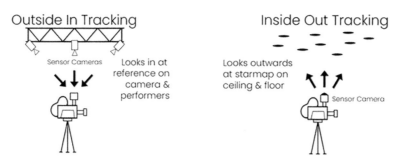

Chapter 20

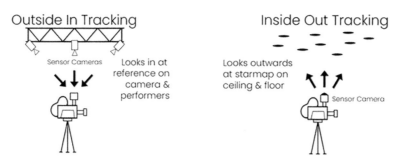

Figure 20.5 Left side: Diagram of outside-in system. Right side: Diagram of inside-out system.
Source: (Image courtesy of Mike Grieve/Bendac)

of at least three cameras, allowing for triangulation of each marker position. Adding additional cameras, or using cameras with wider field-of-view lenses, will help to maximize the volume of the capture area and overcome occlusion from lights, set pieces, etc.

Camera Placement and Calibration

The following is a generalized, step-by-step process of building an optical motion capture stage. To prepare the capture area, start by clearing out unnecessary objects in the space and blocking out any sunlight. It is good practice to limit highly reflective surfaces as they can add noise to the data. One can optimize a space by covering the floor with non-reflective rubber mats that are completely black in infrared light.

Next, mount cameras on tripods, or clamped to a truss surrounding the volume. The latter is preferable when possible because the cameras are less likely to be bumped or moved after calibration. In most virtual production installations, cameras should be placed up high, around the edge of the capture volume at varying heights, and with unobstructed views to the cinema camera.

After mounting each of the cameras, connect ethernet cables to the back of a power-over-ethernet (PoE) enabled network switch, then to the back of each camera. Lastly, connect the switch to a computer that has the requisite motion capture software installed. For larger systems requiring multiple PoE switches, use an aggregator switch before connecting to the computer. There are also USB camera models from some motion capture camera companies that use a single USB cable for power and data transmission. For these, the cameras would be plugged into a USB hub rather than a PoE switch.

Each camera should be aimed towards the middle of the intended capture volume. Placing a few markers in the central location as reference points to help aim and focus the cameras. Using the motion capture software provided with the system, place the camera into its calibration mode and (if applicable) manually focus the camera lens, in and out, until the marker appears as small as possible. For some cameras with larger lenses, adjust the lens' aperture and the exposure setting in software to optimize the lighting in the space. The end goal is to produce images with bright markers and dark backgrounds.

With the physical setup complete, the system is ready to be calibrated. First, apply masks over existing bright spots seen in the camera views. This tells the software to ignore any shiny objects

that remain in the volume. Second, "wand" the volume by slowly waving the included calibration wand, while walking around the volume. This allows each camera to capture enough samples covering most of its field of view.

The motion capture software will indicate when the cameras have enough samples to provide an accurate calibration. When that occurs, head back to the PC and click calculate. The software uses these calibration figures to determine where each camera is relative to one another. Check the result, and make sure it is satisfactory.

The final step is setting the ground plane to define the global origin. Simply place the included calibration square in the middle of the volume on the floor and select "Set Ground Plane" in the software. Completing this last task makes the motion capture system calibrated and ready to use.

Next is creating some assets to track. Setting up rigid bodies is simple: Attach either passive or active markers to any object that needs to be to be tracked. In most cases for virtual production, this would be to the cinema camera itself (or on an object firmly attached to it). To attach passive markers, one typically uses marker posts and adhesives and/or hook and loop fasteners. Allow some space between neighboring markers for optimal tracking.

Tracking Accuracy and Precision

In a peer-reviewed paper from University of Delaware,[1] it was shown that the three main motion capture companies (Vicon, OptiTrack, and Qualisys) all are basically in the same sub-millimeter accuracy and precision range – regardless of camera resolution. Typically, camera models are chosen to match the size of the desired tracking space along with other factors, such as frame rate and price.

Marker Types

Passive Markers – Classical optical motion capture emits light from infrared LEDs on the front of the motion-capture cameras into retro-reflective spheres, hemispheres, or flat discs, then back into the camera to illuminate, and ultimately track, the markers. For those unfamiliar with what retro-reflective is, think of the shiny material used on running shoes; it bounces incoming light back to the sender. These markers can be used to track a variety of types of objects or people.

Powered LEDs – Instead of bouncing light off an object the object itself can emit the light. This involves a small device with LEDs and a battery to emit light back into the cameras. One can either have the LEDs on continuously (not good for brightness or battery life) or turn them all on only when the motion capture cameras expose.

Active Identification in LEDs – This method takes powered LEDs a step further by blinking the LEDs in repeating patterns. This repeating blinking patterns can be used to uniquely identify each marker in the scene. Having unique marker IDs allows one to reliably track a single marker even after its occluded, can create and track multiple objects with identical shapes and marker arrangements, and several other useful things.

Inertial Measurement Unit (IMU) – Trackable objects that include industrial grade IMUs alongside actively identified LEDs are quickly becoming standard for in-camera virtual effects

and virtual production (at the time of this writing). The IMU is sensor fused[2] with the optical data to produce a tracking result better than the sum of its parts, resulting in smooth tracking – even with significant occlusion. With unique marker IDs, this can be used to track objects with one marker on it and with full, six degrees of freedom (typically one needs a minimum of three).

Physical Tracker – Inertial / Optical / Hybrid / Encoder Based Solutions
Mike Grieve – Mo-Sys Engineering Ltd.

Encoder Based

Electronic encoders are used to capture both rotational and linear movement. As the shaft of the encoder is rotated, the encoder outputs pulses or discreet values that can be used to derive changes in rotational or linear position. There are two types:

An **incremental encoder** is a linear or rotary electromechanical device that outputs pulses when the unit is moved, providing directional movement data. An incremental encoder cannot indicate its absolute position, only changes in position from a reference point.

An **absolute encoder** is also a linear or rotary electromechanical device containing an internal shaft with a disc comprising unique code patterns. Depending on the resolution of the encoder, each code pattern creates a unique reference that is determined by each revolution of the code disc. Absolute encoders measure actual position by generating a stream of unique digital codes that represent the encoder's actual position.

One of the simplest uses of encoders in virtual production (an incremental encoder in this case) is for capturing changes in zoom and focus settings on a lens, as part of delivering the full eight parameter tracking data set. The encoders are mounted to the camera rig, and the toothed wheel on each encoder is engaged with the focus and zoom toothed lens rings. The focus and zoom lens rings are calibrated by turning each one from its minimum to its maximum setting to capture the range of encoder movement. The system is then ready for use.

A more complex use of encoders is one where a crane with a remote head is being deployed for a virtual production shoot. In this scenario, multiple encoders are required, plus an inside-out tracking system, to capture nine axes of movement and eleven parameters in total:

- Remote head – pan, tilt, roll (3x encoders) plus focus and zoom (2x encoders)
- Crane arm – elevation, swing, extension (3x encoders)
- Crane position and yoke height – forwards/backwards, left/right, yoke up/down (3x axes – tracked using an inside-out camera tracking system positioned on the yoke)

Figure 20.6 Close-up shot of incremental encoders mounted to a virtual production camera/lens rig.
Source: (© 2023 Mo-Sys Engineering Ltd.)

In this example multiple encoder outputs are "fused" with the output of the inside-out tracking system. This enables the 3D position and off-axis movement of the virtual camera generating the virtual scene to match the physical camera.

One characteristic to be aware of when using tracked cameras on extended arms during a virtual production shoot is unencoded movement. This can occur if the arm flexes at the camera/remote head end on a pan or tilt move. Visually this appears as the virtual scene/element not moving when the physical camera image is still moving. This issue occurs because from an encoder perspective, the arm has stopped moving at the axis end, so no encoder value changes are output. If unencoded movement is likely, switching to a marker-based or marker-less inside-out tracking system would make more sense.

Encoders are used on the following equipment to provide tracked data outputs:

- Remote heads, e.g., Mo-Sys L40
- Motion control robots, e.g., MRMC Bolt. Motorized Precision Kira
- Lens focus and zoom outputs
- Jibs and Cranes, e.g., Stype Kit, Jimmy Jib, ServiceVision Scorpio

Laser Time of Flight (ToF)
Where larger linear changes in position need to be accurately tracked and rotational encoders may not be suitable due to drifting, laser measurement can be used.

An example could be tracking the extension of a telescopic crane. In this scenario a laser Time of Flight system can be used, where the laser emitter/receiver unit is placed on the crane close to the

yoke, and a large retro-reflective marker on a rigid bar is placed in the path of the laser beam at the tip of the crane. As the crane is extended or retracted, the laser light pulses emitted take more or less time to return back to the receiver, and from this the extension position can be calculated.

Inertia Based

In addition to tracking a star map (marker-based) or a point cloud (marker-less), most inside-out camera tracking systems will also have an inertial measurement unit (IMU) onboard. These are the same integrated circuits commonly found in mobile phones. An IMU contains one or more accelerometers to measure linear acceleration, one or more gyroscopes to measure rotational rate, and one or more magnetometers to measure direction. Typically, IMUs have one of each sensor type on each of the pitch (tilt), roll, and yaw (pan) axes.

The IMU is used as a continuity back up to the main tracking system, should it temporarily fail to see sufficient markers or points, enabling tracking performance to be maintained. However, IMUs suffer from accumulated errors which over time create "drift," a scenario where the sensor thinks it is in a location which differs to the actual location.

Notes

1 https://pubmed.ncbi.nlm.nih.gov/32517978/.
2 Sensor fusion is the intelligent coordination of two separate tracking sensors, in this case between the inertial positioning of the IMU and the optical motion capture system. When there is a lack of optical tracking data (say, if an object is occluded from the view of the cameras), the inertial sensor can continue to track the device.

Introduction to Color Management for LED Walls

Rod Bogart – Epic Games

The Definition for Matching

It is important for the color to be correct on the LED wall. But what is meant by that phrase, and what must be changed or calibrated for the colors to match? This chapter will cover best practices for the common pipeline using the Unreal Engine as the source of the pixel values and will call out when other pipelines may be similar or different.

The color pipeline for shooting on the LED wall has three major segments. The first is "Generation of the Virtual Scene Pixels." The second is "Display the Pixels on the LED Wall." The third is "Photograph with the Production Camera." Each of these segments has color management concerns that must be considered for the results to be proper for the next segment in the pipeline.

During the first segment (generation of the virtual scene pixels), a virtual scene is rendered in real-time to produce pixel values that represent linear light in that scene. This means that an object that is twice as bright as another will have pixel values double those of the other. Those pixel values are sent to the next segment (display the pixels on the LED wall) by converting to a signal for input to the LED processor. The LED processor will display the pixel values on the LED wall, maintaining the linear relationship calculated during rendering. Finally, the wall is captured during the third segment (photograph with the production camera), producing raw footage. When the entire pipeline works properly, the linearized footage will match the original linear values in the virtual scene. This end-to-end behavior enables many additional desirable features during production – including preview viewing in engine of the final result, natural scene changes such as exposure, and similar lighting for real and virtual objects.

In the following sections, each of those segments will be further explained to clarify how the linear scene can be maintained all the way to the linearized footage.

DOI: 10.4324/9781003366515-22

Rendering a Virtual Scene to Produce Linear Light

The Unreal Engine is a real-time graphics engine that performs accurate lighting for complex geometry to produce photo-real images at high frame rates. Other engines serve a similar purpose and have much in common in terms of lighting controls. It should also be noted that image playback servers are used to drive LED walls, which typically do not perform 3D rendering, but instead playback 2D image media.

The real-time graphics engine calculates the lighting and shading in a scene by using linear values to describe the light, textures, and materials. Internally to the renderer, linear values are maintained as floating point values. The range of these numbers can be quite small for very dark values or quite high for bright values. This is called High Dynamic Range (HDR) because both the bright and dark values are well represented. When the renderer calculates the lighting on surfaces, it does so in a fully HDR scene. In Unreal Engine, it is preferred to consider the brightness values to have specific units related to the real world. When the scene is sent to the LED wall, the measurable real-world units of the wall should have a known relationship with the units used in the virtual scene. For example, a scene luminance of 5.3 could represent 530 candelas per meter squared (cd/m^2, or nits). In this case, the relationship is a multiplication of one hundred to produce the desired output units.

During the rendering process, the lighting and shading results in a buffer of information that is called "Scene Color." That buffer is sent to an important rendering pass called "Post Processing" to finalize the pixels. The post processing pass performs a sequence of operations including anti-aliasing, depth of field, motion blur, translucency, etc. The final step of post processing is the Tonemapper Pass, which might be better referred to as the "Camera Emulation Pass." Since Unreal Engine is a game engine (as all other engines are), it normally needs to produce images that appear to have been produced with a camera. However, in ICVFX, there is no need for camera emulation because a real camera will be used to capture the scene off the LED wall. Therefore, it is important to disable the camera emulation features in the Tonemapper Pass, including "Bloom," "Vignette," "White Balance," and "Auto Exposure." Additionally, it is important to ensure that the pixel values remain linear, so all operations associated with applying a tone curve should also be disabled.

It is important to recall that the LED wall is intended as a light source; it is supposed to produce light similar to the real world. The LED wall is not a large movie screen. The content displayed should not have any non-linear curves such as film emulation or other looks applied. If any of those looks were applied to the content on the wall, there would be "double LUTing" because there would also be a look applied to the output of the camera.

Creating a Signal From Linear Light

At the end of the post processing pass, there is a final conversion of the linear pixels to an output signal. Typical signal bit depths are 10- or 12-bits per color channel (RGB). Since the output signal

uses less bits per pixel than a full floating-point value, some conversion must be done. Unreal Engine uses OpenColorIO (OCIO) to do this conversion in a standard way. The conversion has two parts: The source color definition and the destination color definition. The source is chosen to match the working color space of the rendering, and the destination is chosen to match the signal that is expected by the LED processor. It is important that the engine produces the type of signal that the LED processor expects, otherwise the processor would misinterpret the signal, resulting in an unintended conversion.

The signal for the LED processor can have a few different encodings, where the main two are PQ and gamma. The PQ (Perceptual Quantizer) encoding is defined by SMPTE in ST-2084 and converts between HDR linear values and a quantized 10- or 12-bit value that can be passed across an HDMI or SDI wire from the graphics workstation to the LED processor. The details for the conversion can be found online, but the important property to note about the conversion is that it accepts values with known luminance units and converts them to an encoded value. For example, an intended output brightness of 1000.0 nits would be encoded into a normalized value of 0.751827, which would round off to a 10-bit value of 769 (out of 1023).

As an alternative, some users choose a gamma encoding on the signal to LED processor. A popular default value for this gamma is 2.35, but the specific value can vary as long as the value used by the engine to encode the signal is the same as the value used by the processor to decode the value. The important difference between gamma and PQ is that gamma is not an absolute value with known units. Instead, the values in a gamma signal represent percentages of the overall peak brightness of the wall. If this method is chosen, it is important to find an appropriate conversion from the HDR linear scene values to the conceptually zero-to-one range of the gamma conversion. This is best done with an overall exposure compensation to bring the scene down so that most of the values fall within the capabilities of the wall. It should be noted that values that are too bright will be clipped to the peak brightness of the wall. This is true for either the PQ or gamma methods, so it is important to confirm the range of virtual scene values and to set the exposure compensation factors to produce the desired results.

Many of the LED processor vendors refer to the PQ method as HDR and to the gamma method as SDR (Standard Dynamic Range). Strictly speaking, the LED wall does not have more dynamic range if the PQ method is used. The brightest value will be the same in either case. The key is to match the engine's signal conversion to the input settings of the LED processor.

LED Processor Conversions

There are various vendors of LED processors and the associated hardware and software needed to interface with LED panels. The few at the highest level provide the service and features needed to guarantee proper linear behavior of the values represented in the signal to light produced by the LEDs. At the lowest levels, however, the LED processor can be little more than a conversion from an input signal to an exceptionally large television. It is important to confirm that the calibration services and user interface controls meet the needs of ICVFX before settling on an option.

The exact steps used in the color pipeline that displays values on the panels vary by vendor. The overall process may happen in the LED processor itself, or portions of it may occur in the hardware of each LED panel. The essential conversions that occur are as follows: Linearize input signal, convert to native color space, and send linear values to LEDs.

The LED processor accepts an encoded signal that must be linearized for display on the panels. The LED processor will interpret the input signal based on information provided by the user in an interface tab labeled "Input" or "Source" (or similar). If no information is provided as specific overrides, the processor may try to use values in the signal to influence the conversion. There are commonly three aspects of the signal available to be overridden by the user. One is the "Color Encoding," which corresponds to the PQ and gamma options described earlier. The second is the "Color Space," which is used to do the proper conversion to the LED panel color space. And the third is whether the signal is "Full Range" or "Video Range" (also called "Studio Range," "Limited Range," or "Legal Range"). This third option is the most common mistake on LED wall stages.

It is important to match the "range" of the workstation output to the range of the input to the LED processor. When using RGB signals, the most common method is to set the workstation to be full range. However, there are often many pieces of video hardware between the workstation and the LED processor. It is possible that one or more of them alter the signal, but this is not common. The more common issue is that one or more of those devices label the signal as video range. If the downstream LED processor has an automatic setting for interpreting the input range (which is the default setting), it will assume the data is video range when it is not. The visual result is that the lowest values of the full range signal are lost (i.e., 0 to 64 in a 10-bit signal). Colors will look more saturated than expected because the subtle dark values have been pulled down and clamped to zero. It is best to explicitly override the range option for the input to ensure that it matches the setting on the workstation.

In addition to the input range and the color encoding, it is important to properly set the color space of the input signal. The LED processor usually has options to choose various known color spaces from a list. That list probably includes Rec709, Rec2020, DCI-P3, and others. It also will have an option that sets the color space to match the native color space of the panels. This might be called "Widest," "Achievable," "Native," or "Panel Space," depending on the LED processor vendor. For the native color space, the intent is that the processor does not do any color space conversions when it transforms from the given RGB to the values sent to the LED panels. When one of the predefined color spaces is used, the processor performs a transformation from that color space to the native space. Mathematically, this operation is a matrix multiply. It is determined from the given input color space, which has a specific definition for the colors red, green, blue, and white. That definition is combined with the definition of the native color space of the panels to produce the conversion matrix.

The last conversion in a typical pipeline is from a floating-point linear value to a specific integer value that can be sent to the LED driver. Again, this varies greatly by vendor, but the common method of driving LEDs involves "Pulse Width Modulation" (PWM). To create different brightness amounts, the LED will blink a certain number of times within a certain period of time. By changing the width of the pulse (the time while the LED is on), the amount of light that is produced

changes. This is a linear operation. If, for example, the driver accepts a 14-bit value, then the maximum pulse width would be 16383, which would correspond to the brightest value the LED can produce because it is on the entire time. To produce a brightness that is one stop down, the value would be 8192. This value would tell the LED to be on for half of the time, resulting in half the peak brightness. Notice that for each reduction by a single stop, the number of integer values that can be used to drive the panel will be reduced by half. For very dark regions of the content, this could mean that only a few different values can be used to drive the panel. For example, for the case of a panel with a 14-bit drive that has a peak brightness of 1500 nits, values below one nit would occur with driver values of 11, 10, 9, 8, etc. (out of a possible 16383). The visual artifact that results from this quantization is banding in the very dark content. Some LED processor vendors provide methods to use temporal updates to the value being sent to the panel drive to give the impression of values in between the steps in those bands. For those devices, the driver values may still only be 14-bit, but the value could flicker at various rates between, for example, 8- and 9-bit to produce a range of apparent brightness values between the two bands produced by 8- and 9-bit.

It should be mentioned that there are many subtleties to the technology of LED panels that are being glossed over with generalities here. For more specifics, it is important to speak to the manufacturers about the features of the specific processors and panels that are in use.

Photography of LED Panels

With proper settings in the engine and the LED processor, the light from the LED panels should represent the linear values of the virtual scene. This light can then be captured by the production camera. In general, the camera will be under the control of the Director of Photography and the camera assistants, which means that creative choices will influence the camera's settings. Color pipeline changes within the camera include exposure, white balance, and any creative look that is applied to make the content look like a movie. For the exposure and white balance, there may be considerations that occur during the rendering of the virtual scene.

The overall exposure of the virtual scene can be adjusted in Unreal Engine using "Exposure Compensation" in a post process volume. Additionally, the color temperature of the virtual scene can be set to a specific value. By default, the LED processor is usually set up to produce a "white" color that targets the D65 illuminant (although other targets may be chosen by the user on the processor). When the pixel values of R, G, and B are equal, the pixel will be neutral and will have the color of D65. If the physical scene has been lit with additional light sources (and it should be to help fill in the spectral response of the LEDs alone), it is possible that the overall scene may have a different color temperature than the default temperature of the wall. In this case, the "Color Temperature" control in Unreal Engine can shift the neutrals of the virtual scene toward a particular target that has been set with the physical lights. Then, if the camera has a particular white balance setting, the entire scene will be balanced all together by the camera.

When all the settings are correct for output from the engine and input to the LED processor, an exposure change in the virtual scene will produce that exposure change to the light from the panels. Having this predictable behavior is crucial to the color control operations that occur on set. Therefore, the entire pipeline is built around the idea of linear values that represent light.

The captured digital camera footage is often looked at in two ways: First is with a "look" applied via a camera LUT, and the second is the "log" signal from the camera. When a digital imaging technician (DIT) is present, they usually receive the camera log signal directly. All monitoring of the camera output is then distributed from the DIT station, where the DP and DIT have the option to make overall adjustments to the look that is being applied. With or without a DIT, the displays of the look signal are where the bulk of creative decisions are made.

To determine if the content matches end-to-end, the log footage will be used. This footage needs to be linearized to be compared back to the original linear content of the virtual scene. For the common digital cameras (ARRI, Sony, Red), there are published methods to linearize footage and convert to a target color space. Most involve a log-to-linear function that is specific to the encoding that the camera uses. Then, a 3×3 matrix converts from the camera encoding color space to a particular target color space for comparison. For the example situation involving Unreal Engine as the virtual scene renderer, the working color space of the rendering is the target color space to use for comparison. If all settings are correct according to the preceding descriptions, the footage will have much in common with the original virtual scene. Objects which are a stop brighter than another will also have that property in the resulting linearized footage.

However, the match will not be entirely accurate. This is because the digital camera sensors interpret the narrow spectra of the LEDs in a way that is unique to each camera manufacturer. To adjust for this difference, the content sent to the LED wall should be calibrated to the camera. The process for this calculation is described in detail in Unreal Engine documentation under the heading "In-Camera VFX Camera Color Calibration." In the end, the calculation produces a single 3×3 matrix that should be applied to the output of the renderer, preferably during the conversion from linear to signal encoding that occurs in OCIO. At the time of this writing, there are open-source tools that implement this calculation to assist with the calibration. Note that calibration for the camera is preferred but is not required. The matrices that result from this calculation usually have very little effect on the neutral colors, with the main adjustment being a slight change to the specific colors of red, green, and blue.

Preview of Camera Look in Real-Time Engine

The look applied to the camera signal can also be applied to the virtual scene. Since the matching criteria is to ensure that the linearized footage matches the linear values in the virtual scene, any look that is applied to both should produce similarly matching results.

The mechanism to apply a look in Unreal Engine is similar to other digital content creation tools; Unreal Engine uses the OCIO library to apply color transformations for viewing. If, for example, a camera LUT is intended to be applied in Unreal Engine, the OCIO transforms that enable that conversion would simply be a conversion to the camera encoding and color space from the linear working color space of the engine, followed by the application of the camera LUT (which is usually embodied as a 3D cube file). In OCIO, this would be implemented as a sequence of FileTransforms that perform each of the steps of the overall conversion. Alternatively, users might consider evaluating their footage using the Academy Color Encoding System (ACES) and using the standard OCIO config files for ACES in the real-time engine. Note: It is important to distinguish between the OCIO conversion that is used for viewing versus the conversion that is used for creating the output signal that is sent to the LED processor. The first is to see the virtual scene as it will appear in the final show. The second is to present the linear virtual scene on the LED panels.

Summary of conversions for ICVFX Matching

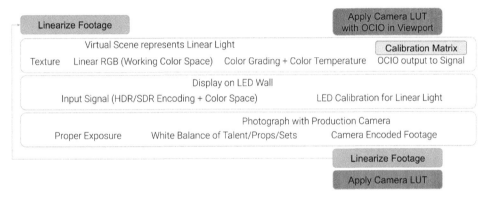

Figure 21.1 Summarizes the various color conversions that are described in the sections above
Source: (Image courtesy of Epic Games)

Limitations of LED Wall Panels

The color pipelines described above do not make specific assumptions about the capabilities of the LED processors and LED panels. However, there are criteria that should be considered to ensure the best possible results in the final footage. The overall peak brightness of the panels is typically in the range 1,500 to 2,000 nits. This is sufficient to portray the brightness range associated with magic hour skies, for example. However, the brightness values of midday sunlight objects can be slightly above that, and the brightness of the sun itself or the highlight from shiny objects is well beyond the capabilities of the panels. Additionally, LED panels are basically

diffuse sources; they do not focus their illumination in a particular direction. Because of this, it is beneficial to utilize additional lighting instruments to illuminate sets, props, costumes, and characters.

At the dark end of the content, there are two concerns, portions of which have been mentioned previously. The LEDs themselves do not have subtle luminance values near their darkest limits. Also, the black surface of the panels can reflect more light than expected from nearby panels and additional light sources. Both these issues can give the impression that content is insufficiently contrasty. To mitigate this, care should be taken with opaque flags to reduce stray illumination on the panels. And creative color controls in the real-time engine can be used to increase the contrast when needed. In the extreme, this would affect the overall end-to-end linearity of the pipeline, but in small amounts, these adjustments can help reduce visual artifacts.

In the end, final decisions are made with the view from the camera in the presence of the show's look. The color pipeline described here is to create an environment where adjustments to the scene and the photography behave in a manner that is familiar and similar to the methods used in the rest of production.

Art Department Integration in the Digital and Physical World

Getting the Environment Ready for the Cinematographer and Lighting in the Volume

Felix Jorge – Narwhal Studios

Before the environment can be displayed on the LED volume, the virtual set must be prepared by the virtual art department. Virtual pre-lights are the process of preparing the sets to be displayed on the volume with the Cinematographer. During this process, the VAD Gaffer prepares two versions of the set:

- A baked lighting version – This version is typically used during virtual location scouting. Baked lighting runs faster than dynamic lighting, reducing the chance of making creatives disoriented in the virtual reality headset. The lighting is embedded in the 3D assets for the scene. Though it does not allow for lights in motion, it provides the most realistic quality.
- A dynamically lit version – This process is used during reviews and screen share sessions but rarely in virtual reality. This version utilizes lights that have no bounce calculations and is meant to be an approximation of the light. It is a great tool to use for live modifications.

The environments that are prepared for the LED volume can also be developed the same way as a pre-light in virtual reality. Evaluating whether the virtual set is digital or physical, and the best lighting techniques to use. This often happens in pre-production and is replicated at a later date.

DOI: 10.4324/9781003366515-23

Preparing a Virtual Set for In-Camera Visual Effects With the Cinematographer

While designing the sets in pre-production, the Cinematographer will start to flag call-outs – requests to prepare for the day of the shoot. These requests can range from set decoration exchanges (from scene to scene), to creating lights that replicate barn doors and other real-life fixtures. Because of these requests, the real-time engine scenes need to be highly organized. Several on-site run-throughs need to be conducted, and a plan for what to expect should be created so that the in-camera visual effects team, running the LED volume, can act quickly while the shoot is happening.

File organization may vary from studio to studio, and even though the decision-makers will not need to be aware of this structure, the in-camera visual effects LED volume team will need to understand that system based on the needs of the Cinematographer. Within the Unreal Engine scene file having quick selections or groups that are clearly labeled and easily accessible are essential to not slow down production while on a shoot.

On-site run-throughs with the Cinematographer and the stage team should be held often, even if the entire setup is not fully functional. This enables the team to understand and iterate the needs of the Cinematographer.

During the design phase, the VAD creates initial thorough documentation of the virtual set plans, callouts for vendors, and in-camera visual effects teams. It is highly advised to update the documentation with any new callouts or set changes. The documentation for the plan is meant to be referenced for data verification, ensuring all parties understand ahead of time the procedures for the day of the shoot.

What Is a Virtual Pre-Light, How Does It Translate to the Final Shoot?

A pre-light is a process that is typically done on a film set to ensure the lighting is correctly set up before the filming begins. This is executed by the Cinematographer and team, who work closely with the Gaffer, or VAD Gaffer, to plan out the lighting for each shot. Pre-lights help ensures that the lights are placed in the correct position, there is enough coverage, and that the desired effect will be achieved when filming begins. With the advent of virtual production, pre-lights can now be done entirely in real-time software. Virtual pre-lights are the way a cinematographer can more reliably explore lighting setups prior to touching any physical objects. At the beginning of a project, the virtual art department will sit with the Cinematographer to discuss mood and aesthetic. References will be sent back and forth and reviewed after each light bake. Virtual pre-lights allow for an added layer of experimentation and flexibility, providing a digital lighting process that can be updated on the fly.

Virtual pre-lights are becoming increasingly popular in the world of cinematography. Virtual pre-lights can be done entirely remotely, without having to travel to the film set. Some benefits from virtual pre-lights include allowing for more collaboration between creatives and the ability to save and reuse data for future projects. Ultimately, virtual pre-lights provide a more efficient and effective way to plan and execute a shoot.

Things to Note When Lighting for In-Camera Visual Effects

When lighting for in-camera visual effects, it is advantageous to check the virtual sets on the LED volume through the lens of a camera. This is best reviewed with a live actor in frame and, if possible, during a work in progress. There will be things that pop up that are not noticeable from the virtual art department. This is especially needed to plan out the shooting methods, discover how much of the background is in or out of focus, what areas of the virtual set need more construction, what physical lighting is needed to complement the LED lighting, etc.

When pre-lighting the set, display the image on a color-calibrated monitor for the most accurate representation of the end result. While modern monitors generally have a high color range and contrast ratio, having a color-calibrated monitor for viewing provides an added layer of security. The Cinematographer might provide a tried and trusted monitor, which is the best scenario as the Cinematographer will know how to react when viewing scenes.

Buy-off from all key creatives (decision-makers) throughout the lifespan of the set is highly important in that there are no surprises when the set lands on the LED volume. The Director(s) often only joins in the larger-group virtual location scouts to focus the group on what execution is critical for the scene, the intent, the story beats, and cameras to lay out.

When lighting for in-camera visual effects, it is good to think about real-life limitations, to light in terms of what is physically possible, and consider how the cinematography team will light on the day of the shoot. Often in a CG visual effects construct, a floating invisible light is placed in mid-air to lift the shadows of a dark corner. But in physical reality that light would be seen in the frame. With in-camera visual effects, the virtual set needs to match as closely as possible to how the lighting team would set up lights for a physical shoot. This includes full C-stands, light fixtures, flags, etc., installed just outside of the frame. The purpose of this is to make sure the lighting in the virtual set is not breaking the reality.

Blending the Physical and Digital World

Philip Lanyon – csc

Initial Planning Prep Preparing to Blend

Script Breakdown, Lighting Motivation, and Influence

A successful and convincing blend of the physical and digital world starts with a good amount of prep and communication between many departments. A DP breaking down the script or ideas, knowing the beats, and having a rough idea of blocking and the mood to convey, and communicating those ideas helps inform set design from a story and lighting point of view. Since each set requires a different and

unique approach to lighting and blending, one must consider how all elements will interact early in the prep phase. This will ensure that everyone will be moving in the right direction.

Testing, Choosing a Camera and Lens

Choosing the right camera and lens combination on any production should start with the script. The look of the camera and lens combination should serve the story in a narrative situation, and/or serve the technical requirements of the network, speed, or budget of the production, hopefully all three. There are certain camera and lens combinations that work best with virtual production. The main consideration is having some control of depth of focus and the distance from the LED wall. LED panels consist of very fine rows of LED lights, and the camera sensor consists of very fine rows of pixels. When the two converge in a resolved image, the result can be moiré or other color artifacts and inconsistencies. Distance and focal length can also produce a moiré effect. At the time of this writing, most panels will moiré if the camera focuses directly on them. Subsequently, it is wise to choose a camera lens system with a large sensor and a lens with a large aperture. This will maximize the ability to throw the wall out of focus, if even slightly, to control moiré. Testing the camera package on the wall production will use and adjusting for distance and subject distance will go a long way to limiting problems on shoot days.

In addition to controlling the depth of focus, the visual production studio may want to sync the image on the wall to the shutter of the camera. This will help avoid any banding and sync issues, especially when shooting off-speed or with a nonstandard shutter angle. Only some camera systems have a built-in gen lock connection, so it is a good question to ask when choosing a camera for virtual production.

Conversations With the Art Department

Once an idea of where the script is going and what sets will be needed, early discussions should be had with the Production Designer and Director about look. From there, the art department may create, or work with concept artists to create drawings or films-capes for discussion. At this time the DP can look at early renders of the virtual set. The renders from the concept art should provide a good idea of the sources of light planned for the scene, allowing configuration to work best for blocking and to sell the effect of one cohesive world. One should also be thinking of physical limitations within the stage itself and what lighting instruments may be able to augment the world being created. For example, the concept art may depict a large amount of hard sunlight. Does the stage allow the distance for a hard source to be back far enough to fall off in a believable way?

Another example would be a magic hour. Will the wall panels themselves be enough to light the actors' faces in a believable way? Or will soft boxes need to be hung, or use shapes on the wall to augment? Knowing which tools the DP and lighting department have and how they are planned to be used may dictate what the art department builds – so getting these ideas into the plans early is crucial for a successful blend.

Conversations With Production, Time, and Budget Considerations

Letting production know well in advance which time and resources will be needed to prep goes a long way in helping the blend go seamlessly. Assuming a virtual asset is already built before

getting into the stage itself, leave enough time to install and pre-light the physical set and fully test how the virtual and physical sets react to one another. This can take days or weeks to prepare depending on the complexity of the builds and scene requirements. Production will also want to know the costs and budget of any off-camera lighting and rigging beforehand, so having and communicating a plan early to both the crew and production will align expectations on both sides.

Pre-Lighting in 3D Space

Set Design
The set design will have a large influence on how to light the practical set. Whether interior or exterior, day or night, all will have a different approach. What does the virtual set offer for lighting motivation? How will this bank of wall panels with an image on it affect the physical world? Will it affect the set evenly, or will different areas need different treatment? Advance thinking about where brighter and darker parts of the set will be on the wall, which directions light is coming from, and how that will affect the subjects in the place they will be in the blocking will yield huge benefits. Is it one source, or are there many? Will there be practical lighting built into the physical set or none? Maybe the virtual set has dark walls, and the set may need to be lit from the ceiling or the floor, off camera. Thinking generally and giving input about lighting in the concept stages of a set's design will help to create a more cohesive environment that shoots efficiently and looks great.

Lighting With the Virtual Art Department
Once a set is laid out in 3D space, the process of lighting with the visual effects artists, or virtual art department for larger projects, can begin. This might entail looking at a set together on a computer, over zoom, or more preferably, an early version on the actual wall that will be used in shooting. This might mean looking at a file or screen grabs of an environment or an in-person meeting with the Director, Art Director, or studio heads. Giving notes and feedback into how and why a set might be lit will get everyone thinking about any lighting challenges and how to solve them. At this stage, basic control of brightness and color, lighting movement, object placement, and set placement should be available. Often the virtual art department will need time to implement and update any changes and notes, so be sure to give them plenty of time to make them in advance.

Studio Pre-Lighting in the Physical Space

Virtual Production Studio Design, How the Shape of the Stage Effects Blending
The layout of the studio setup will have a large influence on the approach to blending the physical and virtual worlds. There are many types of virtual production studios: Different sizes, configurations and arrangements, some straight wall, some curved, and different heights and widths are possible. Some virtual studios will have a video ceiling, some will not. Some will have the ability to hang film lights, and some will not. Whatever the studio's design, it is important to understand the basic concepts of lighting – how light acts in the real (or made up) world, and what the story requires or inspires for lighting design. Having a flat single wall with no ceiling will throw light in only one direction. So, unless the scene is in silhouette, some combination of front, side, top, under, or backlight will

need to be utilized. Using a studio with multiple sides, a curve or ceiling, will give more background to look at but will also begin to fill in light (wanted or unwanted) from different directions.

The floor design of the stage itself will also have an effect on blending. Is there a gap between the floor and panels? If so, a riser will give the sense of an infinity edge and allow the camera to go up and down.

Using Off-Camera Lighting Fixtures

Though LED and other display panels give off light themselves, the quality of light may be different than that demanded by a scene. Display panels give off a fairly soft light, which falls off quickly. The actors in the middle of a volume may be quite dark compared to their backgrounds. Yes, certain off-camera portions of the walls could be dialed up, but turning up sections of the wall light can decrease contrast on the opposite side of the volume. Using parts of the wall to light with can also limit the ability to see the entire wall in a single shot or a camera move that covers the whole wall. Augmenting with off-camera fixtures can help certain areas to bring in light with a bit more directionality and throw. Classic and modern film and video lighting fixtures can be hung, or placed on stands, off camera to help craft and shape the lighting within the volume.

Using Practical Fixtures

A great way to bring light into a volume where the light is falling off in the center is through the use of practical or "on camera sources." This might be anything from a candle to a desk lamp or architectural lighting within the set design. Using practical lighting in camera can create a very realistic effect because the light is motivated and believable to an audience, especially if replicated as sources in the virtual world. Keep in mind that practical sources can light the wall panels themselves, so keeping some distance from the walls or being able to control the backside of the practical through dimming or housing the light, can be helpful.

Pre-Lighting/ Blending, Tech Rehearsal Days

Once all the planning is complete, it is now time to light, blend, and tech rehearse. These three important processes all relate to one another and should be done looking through a camera lens and calibrated video system along with any looks or LUTs that will be used.

The pro light involves fine tuning any off camera lighting and rigging. It is also the time which the asset is up and running, and general brightness and contrast is set. This is where some of the virtual elements and lighting can be moved around in the asset. Keep in mind the asset may not be running at full frame rate at this point. A set built in a game engine, just like any video game, is limited to the processing power of the video cards and CPUs of the given system. Through the pre-light process, objects and lighting that are dynamic or movable can be optimized to take up less processing power, meaning one could be asked after the pre-light to lock certain elements that cannot be moved on the shoot day. This will ensure systems tracking and movement will run smoothly.

Once physical and virtual lighting and objects are in place, the blending of the floor can be begun. Blending is done mostly through the use of color adjustments to the virtual floor and the

adjustment of off-camera lighting. There is a relationship between the LED panels and the physical set, so changes to the floor blending in virtual space may affect the physical floor, resulting in the need to re-adjust the lighting levels to compensate, and vice versa. This may require some back and forth until the sweet spot looks real.

Once lighting and blending are in a believable place, it is a good time to do a tech rehearsal. This is a time where the camera is placed in all the positions planned to shoot in order to make sure that the blended surfaces look right from all angles. Because there can be differences in reflectivity of practical and virtual surfaces, looking at surfaces from different angles can reveal a seam. Placing and moving the camera during a tech rehearsal also tests the tracking system for any blind spots, so adjustments can be made before the shoot day.

Pre-Light Considerations
Below is a list of pre-light considerations:

- Rigging of any-off camera lighting, materials, set pieces or fabrics.
- Changing the shape of the panels or wall itself, adding or taking away panels.
- Working with and around art department as they install the physical set.
- Power requirements and hiding cable within the physical set.
- Off-camera tech area for monitors, lighting, and wall control.
- Off-camera gear storage for different departments.
- Rough in and test lighting.

To fine-tune virtual set and lighting elements, choose which elements can be optimized and which elements need to be adjustable on the day of shooting.

Tech Rehearsal Considerations
- Tracking tests
- Camera movement tests (processing speed, frame rate, shutter angle)
- Wall tests (banding and color)
- Asset tests (stuttering)
- Fine-tune overall lighting

Studio Pre-Lighting in the Virtual Space

Setting the Exposure, Dynamic Range of the Wall
The area between a camera sensor's brightest and darkest sensitivity is typically referred to as the camera's "dynamic range." Similarly, a wall display panel in a virtual production studio has a minimum and maximum brightness it can display. Suppose a camera has a range from one to ten at which it can read information, one being the darkest and ten the brightest. Now suppose a video wall has the same range. Perfection, right? But what if shooting in candlelight is required and the background is too bright for the candle to appear to be lighting the subject? Turning the wall brightness down is not a solution because a wall pixel does not get any darker than "off"

(plus whatever ambient light is hitting it); turning down an image on a wall will only decrease the bright areas. Now, the wall might only display a range from one to six, the blacks can begin to look muddy, and the highlights look flat. Not optimal.

Using the full brightness range of the wall can give a more realistic and engaging image that can take advantage of the dynamic range of a camera sensor, but it can also out-power practical and off-camera lighting sources.

Moving Objects in 3D Space

One large advantage of virtual production using a game engine is the ability to move objects in virtual space. Having the ability to craft the backgrounds and compositions on a shot-by-shot basis in real-time is a very powerful tool. Literally having the ability to move mountains without moving any physical objects saves an incredible amount of time and resources compared to moving a real mountain. However, there are a few complications to consider. For example, moving virtual objects may break the lighting on the objects themselves or surrounding virtual objects, or leftover shadows or light might stay where an object was and not update to where the object now is. As game engine software evolves, the calculations on object and light interaction are increasing. But as of this writing, if an object is moved fairly quickly, it may take more time to fix the lighting that did – or did not – move alongside it.

CCR Color Correction Regions

Think of color correction regions (CCRs) as an adjustable area or window in the virtual asset where basic color, brightness, and contrast can be manipulated in an adjustable size or region. Typically, these are used as the final touches once the general colors of real and unreal objects have been matched. CCRs are very useful for floor blending, as different angles on the camera will show variations in reflectivity, and therefore variations in color and brightness, on or around the point where the physical floor meets the digital floor. Since CCRs are fast to work with and do not use much processing power, many can be used at once.

Ground Blending Between the Digital and Physical Sets

PLACING THE CAMERA IN DIFFERENT POSITIONS TO AVERAGE THE BLEND

The edge of the set (where physical meets virtual) is the blend point. Using lighting, set shape, and layering objects to create a foreground, mid-ground, and background all work as a starting place to draw the eye from the blend point. The Unreal artist will take care of the final step of color matching the floors, but this should be the final 10 percent of the puzzle. Careful planning to create a set that is not the same shape as the stage, using leading lines to draw the eye away from the blend point, hiding the line in shadows, using objects to hide and break up obvious places where the floor meets the wall all work together to create the illusion of a seamless world.

The design of the floor – both inside and outside the wall – is also very important to blending. Although the tools in Unreal Engine are very good at making small color adjustments near

the practical floor, the eye can spot the differences. This is especially true when using brighter, smooth surfaces without much detail. It is a good idea to use a floor with texture and some sort of break-up such as rocks, dirt, or sand, and to use set pieces to "break the line" of where the practical floor meets the virtual wall. Dark floors can also help hide the line in the darkness.

Workflow of Shooting on LED Wall
Philip Lanyon – csc

Shooting

Frustum Considerations and Shooting With Multiple Cameras

When a camera is tracked and lens info is given to the volume's software, a full resolution image of the digital asset can be created on the display panels that includes and extends outside the frame of the camera. This "window," or frustum, moves with the camera as it pans and tilts. As it does, the information within the window adjusts its perspective according to where the camera is in space. Generally, a frustum is used to focus processing power and resolution only to the area one is shooting, while the area outside the frame can be of lower resolution and still provide realistic reflections and lighting.

The frustum can also be used as a key color, such as green or blue, while the rest of the wall still provides realistic lighting and reflection on the subject. When shooting multiple cameras, multiple frustums can be created depending on the processing power of the system being used. When shooting with two or more cameras, crossing of two frustums can be prioritized with one on top of the other. That said, the two frustums cannot share the same part of the screen since perspective will differ from two different camera positions and the image inside the frustum will be incorrect for one of them. Please be aware that there may be systems available now, or in the future, that will allow two frustums to occupy the same part of the screen, so one may wish to check with the studio team for the most up-to-date info. Alternatively, one can use "global projection," where the whole wall displays a tracked image without a frustum. This configuration is typically used for wide shots where a camera's distance from the wall allows the system to spread its maximum resolution over all panels.

Moving the Camera

Because virtual sets are typically built in a 3D environment, objects and backgrounds in a virtual asset contain information in the dimensions of width and height, along with information in the third dimension: Depth. When moving the camera, 3D depth information allows one to see objects moving at different speeds, depending on how close they are to the camera, giving the brain the same depth cues it uses in the real world. This is due to the effect of parallax, in which objects that are closer to a viewer appear to move across screen at different speeds, compared to those farther away. As a way of thinking about this, imagine driving down a desert road. The telephone poles

317

will appear to move very rapidly across the field of view compared to the mountains in the background, which appear to move very slowly. Everything in between the poles and the mountains will move faster or slower accordingly, depending on the object's distance away. In virtual production, this phenomenon can be used to advantage, by placing objects in foreground, midground, and background, and then moving the camera will help make the set feel like one space.

Tracking Systems and Considerations

Depending on the tracking system used, one may need to fit tracking hardware on the camera. This will affect the size and shape of the camera and may have an influence over the use of three axis heads, gimbals, or a steadicam. Placing objects around the tracking system could result in an image on the wall that moves, or glitches suddenly, ruining the take. Tracking systems may also need calibrating from time to time since any slight movement of the tracking cameras over the day can cause false information about the camera's position.

Turning Around and Set Mirroring

Depending on the virtual production studio setup, one may not have a full 360° wall to use as a background. This may be fine if only shooting in one direction. What happens if one needs to shoot in directions not covered by the wall? It is very easy to "rotate" the virtual world over the LED panels to display another direction – but what about the practical set pieces and lighting? Solutions to this may include building the stage on a turntable or building a practical set in a symmetrical fashion. A symmetrical set, like a tunnel, bridge, or mirrored set, might include a rock at one end with a similar rock at the opposite end for example. Now, when one changes directions on the LED wall image, the practical set maintains a sense of continuity and direction. The same applies to the lighting setup where symmetrical, or mirrored, lighting on either side of the set can help save time when moving the lighting around to look in a different direction.

Lighting

The light sources built in the virtual world influence practical sources one needs to put in the practical world. Together, these will influence what off-camera lighting may be needed to light the actors. The relationship between all three sources of virtual, practical, and off-camera lighting will affect how the two worlds marry, completing the illusion of one seamless world. Once all the appropriate set up has been done and the virtual, practical, and off-camera lighting has been installed, the volume should feel like shooting at a real location with considerably more control and consistency. Although some environments do, in fact, light themselves, many do not. In those cases, one will need to supplement light from the display panels with practical light or traditional off-camera fixtures. Keep in mind that wall display panels are not only an image but a lighting source. This means that while an image on a wall gives the illusion of depth, the wall itself is bound by the same physics as any light source. Light source images do not act like they do in the real world. Rather, the light falls off faster, meaning that objects closer to the wall will be very bright and fall off quickly in the first few feet, then fall off more gradually towards the center of the volume. Practically, this means that the illumination in the center of the volume may not equal that at the edges. In this case one may need to add off-camera sources to balance the scene. An example to highlight this idea would be that of the sun. Because the sun is so far away, falloff here on earth

has decreased to an imperceptible amount. In fact, the falloff is practically the same anywhere on earth (assuming a clear sky at high noon), whereas a sun on an LED wall would be much brighter at the wall itself, than say, 20 feet away.

Using Cards, 2D Shapes for Lighting or Negative Fill

One of the more powerful tools available to the DP is the use of digital cards. These are patches of light on the LED wall and can be anything from basic shapes of color, white light, or dark area to still images or video. Digital cards can be placed on a virtual production wall over top of the virtual asset or set and outside of the camera frame. These cards can be used to shape and sculpt light or create reflections within the virtual production stage. For example, if one were shooting a day exterior on a location, a large black fabric might be placed on one side of a subject's face to create dimension and shape. This is known as "negative fill." In the volume, a large black square on the display panel could be used to create the same effect without any setup of physical equipment. Similarly, a bright digital card on the wall may be used to light a subject or parts of the set. Keep in mind, lighting from the wall is a very general light source. Wall lighting is usually very soft, not very directional, and can inadvertently light more than what was intended, including the black levels in the wall itself. The lighting crew may end up using stands and fabric to control the light as one would a physical fixture.

Using Off-Camera Lighting Fixtures

One of the biggest misconceptions of virtual production on a LED stage is that traditional physical fixtures are not used or needed. While this may be true in certain cases, the benefits of having physical tools and brushes on-hand to allow one to paint with light apply to both real and virtual worlds. Some advantages of using traditional physical film and video lighting fixtures include the following:

- Better color accuracy.
- Ability to use a dimmer board and use DMX control.
- More accurate control of light falloff.
- The ability to use hard light sources.
- To bring in light where there is no wall, if a virtual production stage is only one flat wall, 180°, or has no video ceiling for example.

In the case of a volume of more than 270 degrees, or a video panel ceiling, one may find that a subject in the center of the space appears much darker than the wall panels themselves. This is because the light from the wall falls off quickly. One may therefore need to light the subject with physical lighting fixtures in order to keep the light on the center area without lighting the wall panels themselves.

Using DMX Control

Virtual production software offers the ability to assign DMX channels to control lighting within the virtual world. This is accomplished using a lighting programming board that uses the DMX protocol, allowing a board operator, or lighting programmer, to take control of certain lighting and effects within the virtual space. This can be helpful with lighting cues that need to sync with either practical or off-camera lighting fixtures.

Image Control

Camera and Lens Settings, Focusing on the Wall, and Moiré

When looking through a camera, off-speed frame rates and shutter settings other than 180° can introduce scan lines, strobing, and unwanted artifacts on the display panels that may not be detectable by the naked eye. If camera movement is introduced, the problems can be even further amplified. Best practices suggest that one always tests camera movement beyond what is intended to be done in the actual shoot. Additionally, putting sharp focus on the wall may introduce moiré in panels with a high pixel pitch, especially in bright areas. Using a shallow aperture with a larger sensor can help throw the background out of focus and give a more effective physical set to shoot in.

Using Atmospherics and Flares

Using smoke, fog, flames, sparks, particulate, and lens flares add another dimension of realism and work well on a virtual production stage. Atmosphere can soften the digital image on the display panels and add parallax to give the brain another depth cue. Lens flares, which have traditionally been problematic for any color keying, affect subjects and backgrounds as naturally as they do in the real world but may not be part of the aesthetic of the project. Using particles, such as snow, rain, or organic matters like leaves or flower petals, can go a long way into breaking up the transition between physical and virtual. Just be sure to add these practical special effects into the virtual set for the most seamless result. Keep in mind that some infrared light tracking systems may experience interference from the use of fire or atmospheric effects.

Setting the Look With the DIT

A DIT (digital imaging technician) traditionally works on set with a DP to set up looks for a particular shot or scene. They can generally affect an image globally, rather than waiting for selective color correction in post-production. Because of this, using a DIT to set a look on a virtual production set can be thought of in the same way as on a traditional set. The DIT will have mathematical information about colors and brightness levels hitting the sensor and can point out what light or colors are out of the range of the camera sensors. The virtual team can work with the DP and/or the DIT to adjust these colors, in 3D space, to bring them into a range the camera can see.

Real-Time Compositing Between Physical and Digital World

Charmaine Chan – ILM

Real-time compositing in virtual production encompasses a variety of processes and techniques, from color correction to blending to real-time lighting. It is key to incorporate a color/lighting operator with the DP, Gaffer, and camera crew from the start. With a dialed-in real-time compositing lead, the chances of in-camera finals increase and thus helps reduce the need for additional post-production work.

Art Department Integration in the Digital and Physical World

Before one begins the process of real-time compositing, the content displayed on the LED walls must first be created. It is vital that lead team members, of both the content team and operating team, work together in optimizing the scenes to create maximum flexibility for on-the-day adjustments.

There are many ways to set up a scene, but generally they fall into three categories: 2D, 2.5D, and 3D. All exist within a 3D generated scene, but each have their own pros and cons.

Setups in 2D generally imply images projected onto flat cards facing the camera. It is used like a layer-based system, where one composes the images from back to front. Each layer is given individual control to grade and transform. This is the lightest type of load – meaning the performance should be smooth, fast, and does not require heavy processing. A good use of this setup is when looking out a window from a vehicle or building.

Setups in 2.5D are a combination of 2D card-based layers in addition to some 3D geometry. An example of this is a cityscape. The background and midground city can be projected onto 2D cards, while foreground buildings might be actual 3D geometry. This allows for more specific controls of objects but also allows for a better sense of depth via parallax. However, with the introduction of 3D geometry, the scene becomes a medium load, as there are more polygons to process.

Setups in 3D on the other hand are fully geometry based. These are best used when there is a need to extend practically built sets. For example, a scene of a village containing many huts, and three huts on set are practical builds and the rest are the digital content used to extend even more huts in the distance. These are more likely to be heavier loads.

Within these categories one may also utilize baked renders, real-time renders, or a hybrid of both. When the term *baked* is used, it is to imply the lighting is in fact "baked" into the renders and therefore cannot be changed. Basic grading can be applied to baked renders, but there are limitations before the illusion breaks. When the scene is rendered in real-time, both lighting and color adjustments can be made live. This method has the most flexibility. Sometimes a combination of both can be used as well to help balance the performance of a particular load.

As mentioned earlier with 3D setups, extensions can be done to the practical sets. To ensure the most accurate replication of a practical set, that set can be scanned and photographed to be replicated digitally. Additionally, props and set dressing elements can also be scanned, photographed, and digitally recreated to further decorate the digital set. Each one of these objects can be transformed and graded for even more variation and detail.

One must consider the on-set factors when combining digital with practical. The content that was created on a computer monitor may not look exactly the same as what is displayed on the LED walls.

The type of LEDs used will affect things like luminosity. If a bright blue sky environment is used, the set which was lit practically suddenly has a lot more light than originally planned. In addition to the luminosity, that blue saturation will also affect the physical set, where yellow-brown huts now look more green.

Additionally, any practical lights used on set will in turn affect the LEDs. If practical lights are aimed at or near the LED walls, the wall may become flashed and black levels lifted in those areas. There is a fine balance between adjusting the practical and digital to work together.

Chapter 22

One usually might have a few minutes in between takes to make all these adjustments. Being able to do so quickly and accurately is very important. This is a skill set visual effects compositors are very familiar with, being at the end of the process with very little time to finalize an image. A competent compositor can take renders in, no matter what state, and get them integrated to look photoreal. This is no different in the world of virtual production. The artist operator is expected to throw up digital lights and flags, blend a digital set with a practical set, and fine-tune every detail in the scene so the camera sees no distinction.

Working in partnership with the DP and their team is extremely important. They are there to compose the image and define the lighting, and virtual production is their toolset to accomplish that. The digital lights and flags work no differently than practical lights and flags. If one is composing a back-and-forth conversational close-up, any real estate on the LED wall not seen by the camera can be used to light the actors. For example, one can place a digital light (called a light card) on the LED wall opposite the actor. With that digital light one can increase or decrease the luminosity, its shape or size, its color temperature, and even whether it has a hard edge or a gradual falloff, very quickly to create the mood of the shot. The opposite can be applied as well. If one has a high noon bright environment that it is too hot for the baked-in digital sun, a digital flag, with ranging opacity, can be put up to black out or bring down the intensity.

In addition to the digital lights and flags, the DP will also investigate adjusting the content on the walls. For example, imagine a scene in a bar where the actors are having a conversation. The digital extended bar can be rotated and modified very quickly to help the DP frame the shot. There may be digital candles on tabletops behind the bar to help create interesting bokehs in the shot, and each one of those can be graded and resized. Or perhaps there is nothing interesting behind the actor in certain angles, individual objects can be placed exactly like traditional set dressing.

Occasionally one may run into a scenario where the actor may have a CG element or character pass between themselves and the LED wall, something that will be a post-production visual effects task. Typically, a green screen would be advised, but due to the dynamic nature of the LED wall, one can create a smaller digital green screen that could be tracked with the actor's movements. This not only limits the green spill on the actor and set but it also makes it easier to extract the actor.

Another scenario is using pre-shot material on the LED walls. Examples of this would be capturing footage of a view outside a moving car, train, or plane. One can queue to or rewind specific sections but still have all the full grading and exposure controls. Not only can the footage be used in camera, the interactivity and reflections from the footage increases the realism.

Learning the skill sets of real-time compositing can unlock significant opportunities for the television, advertising, and filmmaking production process. By fostering a strong collaboration between teams and departments, the real-time compositing process can reduce the need for green screens and increase the number of in-camera finals. If one can master the range of available techniques and prioritize flexibility on the day of the shoot, the final results can often achieve exactly what the creatives had in their mind's eye.

23

Lighting Types for Virtual Production (LED Volume)

DPs on Lighting for an LED Volume
Greig Fraser – ASC

Collaboration

In a certain sense, the Director of Photography (DP) is the key individual who controls the flow of any set. It is up to that individual, in collaboration with the Director and the First AD, to determine what is shot, how it is shot, when it is shot, and most importantly, what the final product will look like. The VFX Supervisor plays a key role in many of these decisions and the final product as well.

With the advent of virtual production, new horizons have opened, and the need for collaboration has grown to include the design and layout of any LED stage/virtual production volume, the writers, the production designer, the VAD, the visual effects department, previs, techvis, and so many more – BEFORE anything is even built. As an example, the loads for *The Mandalorian* (2019) and for *The Batman* (2022) were successful because the material was written and designed to play to the strength of the volume. Scenes that helped disguise the deficiencies of shooting in a smaller than normal environment were chosen based on lighting and blocking.

The most successful loads on *The Mandalorian* on *The Batman* were done in very close collaboration with the Production Designer and the VFX Supervisor. The Production Designer and the VAD team under him/her design the world that the film sits in. It becomes a collaborative effort between the Production Designer, VAD, the VFX Supervisor, and the company that is creating the assets. They all will have very strong opinions and points of view. This creative process, as a collaborative affair, yields results that are much greater than the sum of its parts – in other words, a synergy is created.

DOI: 10.4324/9781003366515-24

Creativity of Lighting

What the lens sees displayed on the LED screen is a small part of what is actually creating the illumination on an actor. Most of a DP's creativity is in how to light within the time and money budget. LED volumes are good for soft light but not for anything that involves hard, direct light. Certain limitations come into play when trying to achieve that look, such as spill and lighting angle issues.

Consider how DPs light an actor on location. Do they just shoot the actor where he/she stands without modifying the light landing on them to both tell the story better and make the actor look appropriate? Rarely. DPs have to either funnel more light in and/or, at the same time, take light away. Sometimes the light needs to be softened, and sometimes it needs to be harder – depending on what the story tells the DP is needed. In a LED volume, one must do the same thing. The issue becomes one of either reflections and/or light spill, washing out the background, or a host of other undesirable effects.

Remember that volume designs and volume science is evolving. There are no "one design fits all" situations. For example, *The Mandalorian* volume was *designed* for an actor wearing a highly reflective chrome helmet. So, the volume was built with a specific shape and ceiling piece to allow for proper reflections on that helmet. It was also designed with curved walls to be able to pan the actor across the stage without any off-axis light falloff or color shift.

The creativity of how to light in a volume is what one needs to learn, understand, and focus on. In short, the labor force needs to be trained to light the volume properly.

What Is the Holy Grail?

Some people believe that pixel pitch is the holy grail. But pixel pitch is not the only holy grail – it is a combination of things:

a) The color and quality of the light must be good to render skin tone well.
b) The light from the LED wall and the practical light falling on an actor's face should match in color tone and be in balanced with one another.
c) The load must be properly designed with the lighting in mind.

Every DP will have a different opinion on how to light a volume. Therefore, every volume that is built must be built for the specifications of the project that is to be filmed based on the collaborative input and effort of the Heads of Departments (HODs).

Atmospheric Elements

How much atmospheric elements can be added to the LED panels is an important consideration as well. For example, a 1.5mm pixel pitch panel is very fragile and sensitive, so one cannot put much wind, atmospheric smoke, or rain on that LED stage – therefore, one is limited on what atmospheric effects can be used.

Depth of Field

When shooting in the real physical world, say, on a location in Monument Valley, using a shallow depth of field will defocus the monuments depending on the distance from the lens. Each of the monuments would appear out of focus differently from one another as they recede away from the lens. An object that is 10 feet away will not defocus at the same rate as an object 1,000 feet away. But unless care is taken, that is not the case on an LED screen. All monuments, in this instance, regardless of distance from the lens, will have the same amount of defocus and the final image look phony.

If the VAD and Brain Bar have powerful enough equipment, and if the VFX and VP Supervisors are knowledgeable, then they will program the asset to be broken apart properly (for the lens being used), allowing the correct depth of field per the camera aperture and the amount of light. If done correctly, the image will be indistinguishable from reality (of course proper atmosphere and color would also have to be programmed in).

Final Word

There is an opportunity to design volumes better to address the problems, limitations, and needs of a project. Stages must be driven by the creative needs of a project – which argues for having a volume that can easily be re-configured per those needs, or even utilizing multiple stages. Again, there is no "one solution fits all."

When projects come out a volume that do not look as good as they should, or could, it diminishes the idea of using the volume – it gives the volume a negative connotation. It takes away a director's, or producer's, confidence in utilizing the volume. If it is not done properly, or done well, the LED volume building boon may result in hundreds of stages worldwide being under-utilized because the people who control the look, workflow, and money may not want to risk the time and expense of using them. It is for this reason that it is important that the DP, Producer, Director, and VFX Supervisor understand what their needs are, what their look is, and if a specific LED volume can deliver that in a time and cost-efficient manner.

Lighting for the Outer Frustum
Chuck Edwards – NBCUniversal

Lighting Continuity

Lighting on virtual production stages provides an opportunity to visually integrate the actors and props in the foreground with the virtual environment being rendered in frustum on the LED wall. The human eye is very sensitive to lighting continuity – if the lighting of the foreground and the

lighting of the background do not match in color temperature, structure, and motivation, it creates a visual discontinuity. The resulting experience of the viewer is that the actors are standing in front of a projection and not "there" in the scene. The opposite is also true. If a lighting condition, source, or event in the background is clearly impacting the actors in the foreground, it sells the environment as continuous. Therefore, a key factor in scene planning for virtual production should be selecting locations and lighting conditions that can be reproduced on stage from the light coming from the LED wall combined with additional stage lighting.

LED walls are inherently soft sources and do not project hard shadows or beams of light. The lighting they provide on stage is exclusively diffuse and unstructured. If a hard source like headlights, streetlights, or the sun is depicted on the LED wall, the image can look convincing – but the light coming from the LED wall will have no beam structure and will not reproduce the structured hard light on the foreground stage. A simple example would be a car at night drives by in the virtual background. A synchronized hard light, off camera, is needed to mimic the headlight beams on stage, visually linking the actor(s) to the virtual car in the background.

Many VP stage layouts are "U" shaped, so the LED wall lighting on those stages comes predominantly from the back and sides, but not from the front. Therefore, recreating the front lighting environment depicted in the VP scene, and any light sources or lighting events indicated in the virtual background, needs to be accomplished by traditional stage lighting. This means in addition to fill and key lighting of talent, hard lights will be needed to reproduce any structured beams in the foreground, including direct sunlight, streetlights, vehicle lights, and flashing signs, just to name a few.

The first recommendation is to avoid composing VP scenes with direct sunlight covering the foreground whenever possible. It is exceptionally difficult to reproduce. The technical reasons why result from how unique midday direct sunlight is as a light source (see Figure 23.1). An effect called Raleigh scattering separates sunlight into two light sources. About 10 percent of sunlight is unstructured bluish light coming omnidirectionally from the sky, scattered by molecules in the atmosphere. Raleigh scattering is preferentially blue, making the sky blue and its indirect light component a cooler color temperature. This is the primary light that fills the shadows.

The 90 percent direct sunlight is extraordinarily hard with an equivalent beam angle of just $0.5°$ – 30 times more focused than a traditional $15°$ HMI or Daylight LED. Figure 23.1 shows measurements taken under three different conditions for the same location, demonstrating the shift from extremely hard direct sunlight to predominantly diffuse light. For these technical reasons, lighting a VP scene shot with direct sunlight in the foreground is a challenge. The LED wall itself emits significant amounts of diffuse light that will compete with any hard lights on stage used to create hard sun-like shadows. Additional stage lighting also needs to avoid over-lighting the LED wall itself as that can be visible on camera and decreases contrast on the LED wall. Today's leading VP productions have embraced the diffuse nature of LED walls as a light source and carefully select scenes that are consistent with the strengths of this tool.

VP productions that have created very successful outdoor scenes, *Oblivion* (2013), *The Mandalorian* (2019), *House of the Dragon* (2022), and *1899* (2022), share a common thread: They

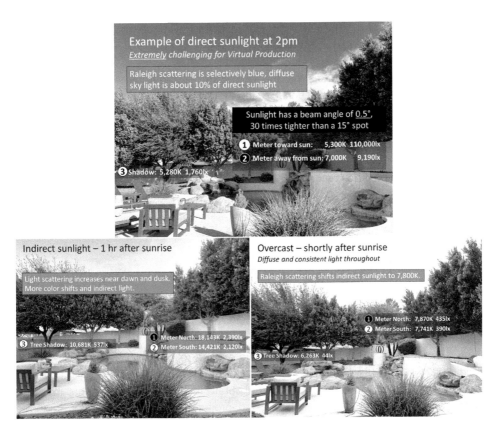

Figure 23.1 VP scene selection for lighting
Source: (Image courtesy of NBCUniversal)

create a motivation for why the foreground lighting is diffuse rather than hard direct sunlight. Time of day is a straightforward way to accomplish this. There is a time, around both sunrise and sunset, when the prevalent lighting is diffuse rather than direct. In Figure 23.1, shifting to early morning changed the scene to diffuse lighting, as did overcast skies. At the times around dawn and dusk, sunlight passes through more atmosphere at an oblique angle, resulting in lower intensity light that is diffused and often with the added benefit of dramatic color shifts that change depending on weather. Placing scenes at these times enables VP filmmakers to recreate outdoor lighting conditions more easily on the LED wall. Scenes set in diffuse light will find the LED walls provide a significant amount of the stage lighting as well, leaving the additional stage lights for fill and key lighting of talent, enhancing color, and reproducing specific light sources indicated in the scene.

Other outdoor scene options that avoid direct hard sunlight in the foreground are the following: Nighttime scenes, overcast clouds, fog or atmosphere, urban scenes where buildings' shadows block direct sunlight, awnings or other shade structures, and forest cover. Generally, interior scenes are great candidates for VP. Daylight windows in the VP background can present a challenge that should be planned for. If a beam of sunlight is expected to pass through the window into the foreground, then an out-of-frustum hard light will be needed on the VP stage to reproduce

that beam. Many VP productions have removed individual LED panels out of the LED wall, or LED ceiling, to provide the proper location for this type of hard lighting.

Intentionally designing light sources into the VP background that the viewer expects to impact the foreground is an excellent way to enhance the VP illusion. In one production the red color of a virtual flashing overhead neon sign was reproduced with an out-of-frustum color LED stage light. Hangar lights, cop car, streetlights have all been placed in VP backgrounds then reproduced with stage lights to enhance the connection between the virtual background, the real foreground, and the talent being filmed in frustum. Creating lighting continuity through careful scene planning and stage lighting design provides an excellent opportunity to enhance VP imagery.

Using the LED Wall as a Direct Reflection Lighting Tool
Jeremy Hochman – Megapixel VR and Chuck Edwards – NBCUniversal

One of the first and most dramatic set designs to explore reflections with virtual production was *Oblivion* (2013). A futuristic apartment was surrounded by walls of glass revealing a panoramic apocalyptic world. Most impressive was the deliberate reflective nature of furnishings, flooring, and construction materials. Accomplished using projection screens, this groundbreaking film showed how reflections carefully leveraged in VP can amplify the dramatic impact and immersion of the audience into the environment on screen.

Careful consideration needs to be given to reflections during set design and shot planning; what props, materials, and other elements of the stage will be reflective, and where will they be positioned in the shot?

There are two types of reflections to be considered:

- Low detail reflections – these are materials that have a semi-gloss finish (wet pavement, semi-gloss metallic surfaces, or paints), where it is accepted that the amount of visual detail in the reflections will be very low.
- High gloss, detailed reflections – gloss vehicles, windshields, silverware, polished floors, window glass, etc. The viewer expects a clear image within these reflective surfaces potentially revealing more about the environment.

The source location of the reflected image is also key. The existing LED wall image in frustum may provide the proper source location. Horizontal glass tables and glossy floors are two obvious examples of reflections that will be captured in-camera from the LED wall in the background. More challenging situations are sets that feature glossy curved shapes like vehicles or other vertical and/or complex curved reflective surfaces. In most cases, the reflections on these will need to come from LED panels that are outside of the frustum. Careful shot planning is needed to provide sources for these reflections and avoid unintentionally capturing the camera and crew on these surfaces.

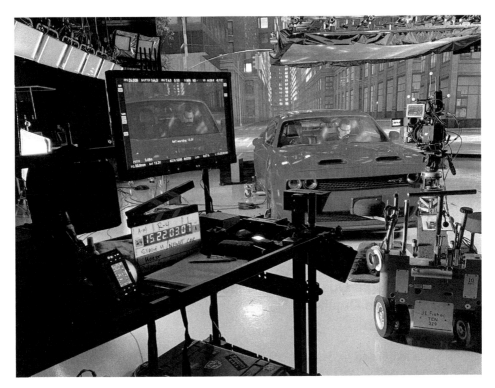

Figure 23.2 Car process using LED wall and flying LED panels
Source: (Image courtesy of NBCUniversal)

The largest volumes for high-budget productions may have a full 360° LED wall surround and full LED ceiling. This ensures reflections from any angle will show LED panel background content. However, on most VP productions using smaller volumes, a more selective approach is used. A common VP scene is a car process shot. After the camera location is selected and the vehicle and LED wall are positioned to accommodate the frustum, an additional flying LED panel is frequently rigged so it can be hung over the car and positioned at the correct location and angle to create the additional reflections needed. Unlike a simple LED ceiling, these will generally NOT be in a horizontal orientation. These flying LED panels may need to be quite large (10 to 15 feet or more) to provide coverage of the vehicle's full length to create a complete reflection. Another benefit of flying LED panels is the content and position of the reflections on the vehicle can be adjusted for the camera by repositioning of the panels.

The optical impact of curved reflective surfaces also needs to be considered. Convex or concave reflective surfaces can act as unintentional optics, in some cases magnifying the reflected image and making the pixels of the LED panels visible in camera. This can create a moiré effect in the captured image. Car windshields are a common convex reflection that can create this problem. A proven technique to solve this is the placement of a thin diffuser a few inches in front of the flying LED Panel. This diffuses the LED panel image, eliminating the detail of individual pixels, and giving the impression the image is slightly out of focus due to the depth of field. Adding diffusion in front of the panels also enables the use of lower resolution LED panels with larger pixel spacing without the concern of moiré effects.

For low-detail reflections, consider if a stage light(s) may be a better alternative. A simple example is a cop car effect on wet pavement or the side of a building. LED panels do not have the same intensity and do not have a beam structure. A stage light off-camera may do a better job of creating this effect. Creating the reflections of an off-camera overhead sodium vapor streetlight is another example. Several LED light fixtures now feature zonal color as well. This allows these fixtures to make low-resolution chases and other color patterns. For low-detail situations in VP, these may be better choices than using additional LED panels that may not be able to reproduce the light intensities, or beam structure, needed for the effect. In many cases, a stage light, or series of stage lights, can provide a better approximation. Another example was a production using LED walls for a car process shot and stage lights directed to light the talent inside the vehicle. The background plate on the LED wall also created direct reflections on the car hood, while the stage lights were used to vary the lighting of the passengers inside the vehicle to reproduce the illusion of changing lighting conditions caused by passing trees, buildings, overpasses, and other shadows the vehicle passed through.

Metamerism and Light Quality – The Impact of LED Wall Spectrums on Image Quality

Metamerism

Metamerism is a term used to describe the perceived matching of color when, in fact, the different sources can be made of drastically different visible light wavelengths or spectral power distributions.

Why Is Metamerism Important for Cameras and Lighting Quality?

The result of metamerism can be two light sources that are perceived to be the same color to the human eye while looking completely different on camera. Or the inverse, in which two light sources look different in person, yet they look the same on camera. This metameric effect is important to understand when using LEDs to illuminate talent and scenery for camera capture.

How LED Exacerbates the Effect

LEDs are narrow-band emitters. This means that the wavelength of light emitted by an LED is an extremely small distribution – it is what helps LEDs achieve their amazing power efficiency. However, this same attribute is also very different than most traditional light sources, such as the sun or an incandescent light bulb.

The image below is a single-camera capture of two LED tiles displaying a diagonal gray/white pattern. On the left-hand side, the LED tile is made of RGB and white phosphor LEDs. The right-hand side is a tile made of only RGB LEDs. While the camera perceives that these two tiles look completely different, they both look identical in person to the human eye, and they also both measure D65 with a spectroradiometer. Imagine if these LED tiles were illuminating talent – the right-hand tile would make a person appear pink in camera, thus requiring significant color correction that would possibly conflict with other elements in the scene.

Figure 23.3 Two LED tiles pictured, RGB + phosphor white on the left, RGB on the right
Source: (Image courtesy of Megapixel VR)

In another pictorial example, NASA footage can be seen on two LED tiles of the same pixel pitch and the same RGB wavelengths. The left-most picture is an original photograph and was used as the source content for the LED tiles. The middle image below is an RGB + phosphor LED tile, and the right-most image is the RGB LED tile. Notice how the RGB tile appears far more saturated and too magenta. The RGB + D65 phosphor creates a much more natural representation of the source material. While both captures can be color corrected to match the appearance of the original, the RGB + D65 phosphor adds a level of accuracy to the untouched capture and thus requires less editing.

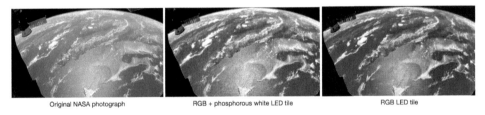

Original NASA photograph RGB + phosphorous white LED tile RGB LED tile

Figure 23.4 Original NASA photograph next to RGB + D65 phosphor and RGB LED tiles, all images are as captured and not re-touched or color corrected
Source: (Photo and LED tile samples courtesy of Megapixel VR)

Existing Technology and How to Work With the Equipment at Hand

While LED tiles today mostly utilize the three color primaries of red/green/blue, it is possible to simultaneously create two different color corrections when combined with camera frustum tracking. The level of accuracy to the original content required in-camera versus out-of-camera can be quite different, especially for highly saturated simulated lighting effects, such as Las Vegas neon signs illuminating talent in a car process shot.

Typical content in a volume contains an in-frustum view pre-warped based on the camera lens data and an outer frustum area used for general lighting effects. These two sets of imagery, usually the same or substantially similar content, can be adjusted separately in a game engine or media server to offer the desired in-camera color and lighting color temperatures.

What to Expect in the Future

Most of today's LED volumes have deployed RGB LED tiles both for in-camera capture and general illumination. For in-camera use, these tiles can usually be set to a known color gamut matching the content and be adjusted to look accurate through the camera lens. Lighting becomes a more critical issue as the narrow band red/green/blue LEDs are not sufficient to properly illuminate skin or simulate broad-spectrum daylight scenes. In this case, fixtures that deploy white phosphor or RGB + white phosphor are preferred. Given the amount of research put into color and narrow band versus broad spectrum lighting by studios and visual effects creators, the industry will start to see a number of more sophisticated LED tiles in the coming years, starting with key/fill lighting, then LED tiles for ceilings, and eventually for in-camera high-resolution tiles as well.

External Lighting on Stage vs. LED Wall Lighting

Tim S. Kang – Quasar Science

What Is LED Wall Lighting vs. "External" Lighting?

Virtual production volumes typically employ an array of display tiles arranged in a geometric solid enclosing a physical set and subject. In addition to providing a visible, rear-projected environment, the array's light creates a lighting "volume" that has become seen as an environmental lighting source for the set and subject. Eventually, LED volumes will no longer consist of display tiles alone but will become a fully synchronized amalgam of highly resolute displays and light fixtures of different types and form factors.

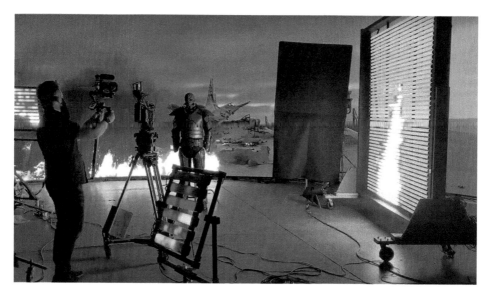

Figure 23.5 Image of LED Volume array
Source: (Image courtesy of Quasar Science, LLC)

Lighting Types for Virtual Production (LED Volume)

"External" lighting, then, defines lighting sources *in addition* to the volume array, used by the Cinematographer and lighting technicians, to augment or supplant the volume environment's light. Successfully marrying these two distinct lighting sources together requires familiarity with a host of technological concepts new to prior motion picture industry experience.

Terminology Concepts

The technical curiosities behind the issue of volume lighting start with understanding fundamental color science concepts. Physical motion picture imaging entails color reproduction – a craft built upon the science of color defined by the field of *psychophysics*. In color science, physical light energy illuminates real-life objects that, in turn, modify this energy that humans perceive and mentally interpret as "color." Breaking this process down entails understanding radiometry, the science of light measurement, and colorimetry, the science of human color perception.

Radiometry describes light as electromagnetic energy of different types. For any given light, the total collective signature of these different types of energy is called a spectral power distribution (SPD) and, therefore, forms the fundamental definition of a given light source. The standard SPDs for white light can generally be approximated by the TM-30 color metric's reference illuminant – blackbody radiation SPD until 4000K, CIE Daylight SPD above 5000K, and a proportional blend of both SPDs that transitions between 4000K and 5000K. The only metric able to evaluate the quality of a light source's SPD makeup compared to the desired SPD target is the Academy of Motion Pictures and Sciences *Spectral Similarity Index* (SSI).[1]

The term "*quality of light*," commonly used by cinematographers and gaffers, can confuse visual effects artists since it can refer to different radiometric parameters:

- A light source's SPD
- Its light-emitting element's surface size relative to a subject
- The distribution of light intensity across its emitting surface; the shape of the light's beam projecting through space
- The light's beam distance, position, and orientation angle in 3D space

When illuminating a subject, *objects* on a physical set all *modify* this energy by the combination of *transmission*, *reflection*, and *fluorescence*. This modified light energy then travels to an *observer* that perceives and converts this energy into information – that is, a person or camera.

Colorimetry then describes detection and interpretation of directly transmitted, or object-modified, light energy by human observers. The International Commission on Illumination (CIE) defined a model of the average human observers called the *CIE 1931 2° Color Matching Functions* (CMFs). This "camera" essentially creates a clearly defined numerical response to all light SPDs. Camera sensors and film stocks use a different set of filters and therefore are their own CMFs that manufacturers try to calibrate to match the CIE 1931 2° CMFs "camera" translation of all light SPDs.

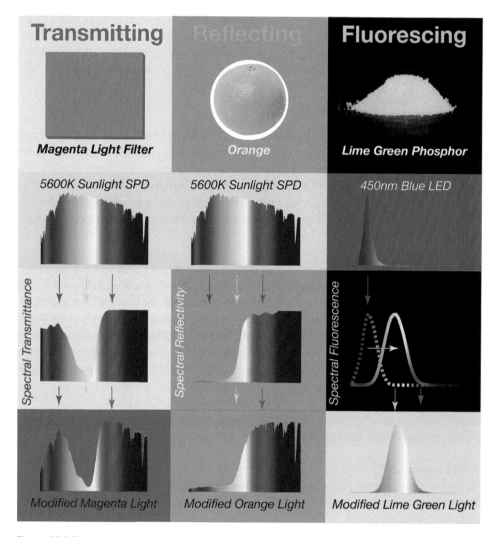

Figure 23.6 Objects modify light
Source: (Image courtesy of Quasar Science, LLC)

Photometry, the measurement of photometric output, essentially is a directly translated readout of the CIE 1931 2° y_bar filter. This output measurement, therefore, does NOT match a light's total radiometric output; the commonly understood brightness value of "nit" is a photometric value.

Defining "white" light, as mentioned previously, starts with understanding *TM-30 reference illuminant* SPDs and the CIE 1931 interpretation of these SPDs. Different spectral values correlate to the temperature of a theoretical energy radiation source, so the white point's Correlated Color Temperature (CCT) is the primary color definition of white light and falls along an orange to blue color axis. Deviation from this axis for a given CCT appears green or magenta and is called the "duv value."

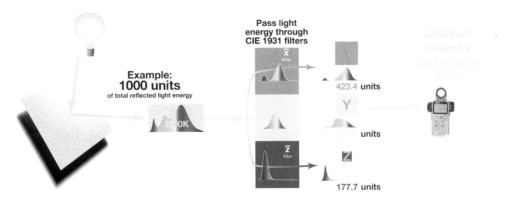

Figure 23.7 Nits as "filtered" photometric value defined by CIE 1931 2° y_bar filter
Source: (Image courtesy of Quasar Science, LLC)

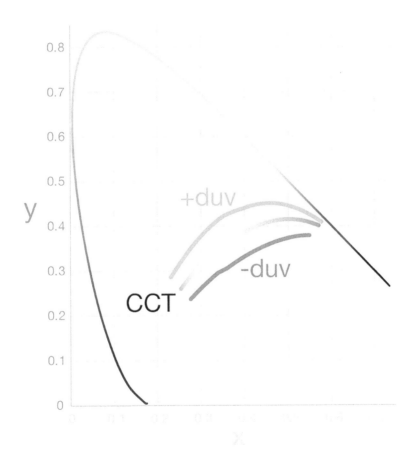

Figure 23.8 CCT and duv as CIE 1931 color coordinates
Source: (Image courtesy of Quasar Science, LLC)

Color rendition, a light's communication of a scene it illuminates, fundamentally is a psychophysical process of Light + Object + Observer. As mentioned, different psychophysical models describing this process exist, and the most relevant metric to gauge the colorimetric capabilities of a light for human vision is called *TM-30*. The metric reports color fidelity value R_f, and color saturation value R_g, and presents typical object hue and saturation shifts in a convenient TM-30 *Color Vector Graphic* (TM-30 CVG).

An LED volume array's radiometry and colorimetry are extremely critical characteristics to understand for a successful volume shoot. Currently, display LED volumes consist of only narrow SPD red, green, and blue light channels that function adequately for direct CIE 1931 viewing but, unfortunately, exploit the differences between motion picture camera sensor CMFs and CIE 1931 CMFs. Direct photographic lighting from LED volume RGB tiles suffers from poor colorimetric rendering capabilities due to SPDs that do not spectrally match white light standards used to calibrate camera sensors – skin tones and orange objects generally suffer the most in color shifts. Furthermore, LED display and fixture colorimetry must be understood distinctly as having a directly viewed light color rendition separate from object color rendition.

In addition, volume arrays based on display tiles cannot alter their display outputs' emitted beam or direction. Lighting fixtures compatible with video signals greatly improve upon radiometric qualities and therefore their colorimetric and beam performance. Multi-primary LED Systems using additional diode colors and broader SPD output beyond RGB currently exist in lighting fixtures, so they can currently render superior imagery of sets and subjects. Furthermore, lighting fixtures can vary in beam shape, intensity, and uniformity and therefore must be chosen to light a scene more appropriately.

Volume arrays will continue to integrate *formerly* external lighting tools into their array to generate a more convincing light environment. Light fixture types include point sources or sources with light-emitting surface areas relatively very small to the subject; linear sources, that is, one-dimensional emitting patterns; area sources in two or three-dimensional space; and "movers" that change beam shape, size, and orientation. The following figure shows different examples of each source.

Point Source	Linear Source	2D & 3D Area Sources	"Mover" Source

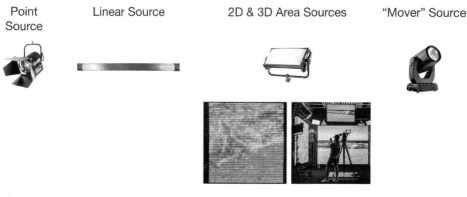

Figure 23.9 Different types of light sources
Source: (Image courtesy of Quasar Science, LLC)

On-Set Image-Based Lighting (OS IBL) / Lights With Special Integration for Virtual Production
Tim S. Kang and Ben Dynice – Quasar Science

Review: On Set Image-Based Lighting

On-Set Image-Based Lighting (OS IBL) describes the real-world manifestation and live application of Image-Based Lighting (IBL), the computer graphics lighting, and reflection mapping technique that maps a High Dynamic Range Image (HDRI) onto a photosphere enveloped around a subject to serve as its primary lighting data source for the render engine.

High Dynamic Range Image (HDRI) photosphere

Mapped onto surrounding emissive surface

**Image Based Lighting
of virtual objects**

**On Set Image Based Lighting
of practical set**

Figure 23.10 Traditional Image-Based Lighting vs. On-Set IBL Setup
Source: (HDRI & Rendered image courtesy of Erik Winquist and Thomas Mansencal, WETA VFX; LED volume photo courtesy of Paul Debevec, Netflix)

OS IBL, IBLs real-world counterpart, consists of a physical array of lighting fixtures that uses video imagery as the control signal to project a light environment onto a subject. It could, but not necessarily, completely envelope the subject in a sphere or other solid geometric form that transmits a volume of light onto the subject and motion picture set using its inner surface. As a subset of *interactive lighting*, a generalized method of using animated lighting sequences from fixtures to light a subject, OS IBL represents a leap forward in realistic lighting methods for physical motion picture production.

Chapter 23

Essential Concepts

OS IBL can employ both displays and lighting fixtures of any type to output lighting environments from video signals. Video signals are defined by colorimetry models based upon CIE 1931 2° CMF based definitions and models of color.[2] A video color space, the range of possible colors in a video signal, consists of the following:

- A set of Red, Green, and Blue (RGB) primary colors
- A White Point (WP) defining the unity of these three values
- The entire possible range of RGB values in between the primaries and White Point

RGB primary colors and WP point to specific locations in the CIE 1931 x, y Chromaticity coordinate space, and the linear combinations of R, G, and B values mathematically translate into CIE 1931 X, Y, Z colorimetric intensity values. The CIE 1931 Y value defines the absolute luminosity, or perceived brightness, of a specified color value, and can be measured in lux/m^2 units – or nits.

Due to both computational efficiency and a need to model human vision response to light intensity, linear changes of a scene's light intensity (scene linear light) can be mathematically converted to a non-linear change of values, to be stored or transmitted. This light intensity "dimming curve," as lighting technicians commonly understand this concept, needs the inverse mathematical operation to drive a display's or lighting fixture's linear output intensity. This operation, called an Electro-Optical Transfer Function (EOTF), "transfers" light intensity behavior in the electrical signal into optical light intensity behavior.

EOTFs, therefore, represent "light encodings" as follows:

- A *Linear* EOTF, i.e., Output = Gain*Input + Lift, represents a directly linear relationship to arithmetic changes in light intensity. Gain represents the slope of the relationship, and Lift represents the minimum value of this relationship.
- A *Gamma* EOTF uses the Greek letter 1 to represent an exponential relationship: Output = Gain*Input[1] + Lift.
- A *Logarithmic* EOTF applies a logarithm of any *base*, usually 10 or 2, to the input: Output = Gain*log$_{base}$(Input) + Lift.

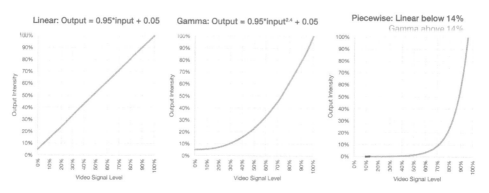

Figure 23.11 EOTF type
Source: (Image courtesy of Quasar Science, LLC)

- Many common video EOTFs employ "piecewise" functions that use different mathematical equations for different ranges of inputs: sRGB, the common computer display video EOTF, has a linear relationship at its lower values and a gamma relationship in the rest of its values; camera log encodings, such as Cineon, Arri Log C, Canon Log 2, Red Log3G10, and Sony s-Log 3; and High Dynamic Range (HDR) EOTFs like ST2084/Dolby PQ or Hybrid Log Gamma (HLG).

The colorimetric definitions for video color spaces driving OS IBL volumes do not specify spectral behavior of the array's component lighting devices. The spectral output of any display or lighting fixture in any OS IBL scenario essentially "burns in" the scene's relative reflectance color values within a camera signal, so filmmakers must take great care to know or specify the spectral definition of the video color space's white point and RGB primaries.

OS IBL arrays use, as a digital control language, video RGB signals either directly in a display or translated into DMX (directly or via ethernet transport wrappers) by a media server, lighting console, or 3D rendering environment.

OS IBL Light Fixture arrays need software and hardware mechanisms to properly "pixel map," that is, map video pixels, into their light engines arranged in a real space. Common systems to pixel map generally employ a virtual representation of these arrays and may rely upon physical motion trackers to synchronize the virtual position of these fixtures with their physical counterparts.

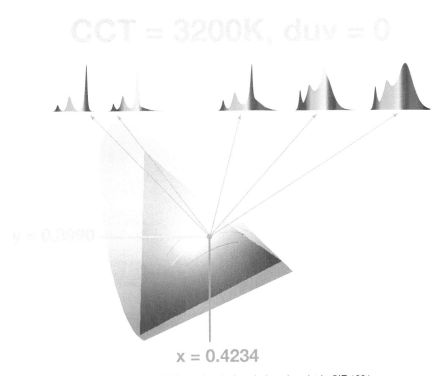

Figure 23.12 Multiple spectrum definitions of a single colorimetric point in CIE 1931
Source: (Image courtesy of Quasar Science, LLC)

OS IBL array source materials can include live 3D rendered environments, live camera feed video plates, and preproduced video plates.

OS IBL Workflow: What System Elements Would an OS IBL Setup Require?

An OS IBL array requires the following system elements to function: A 3D render engine (Unreal, Unity, Stagecraft, etc.) for live generated 3D environments; media server software that organizes all video content sources and converts the content to all OS IBL array devices' necessary data protocols; and media server hardware that transmits the video data to the OS IBL array. Within this entire workflow of data, a virtual production stage team must clearly know which system components encode and decode video data, and they must decide the correct components in the entire system to adjust and transparently transmit the OS IBL video data.

Hog4 Lighting Console Pixel Mapping Interface **Unreal Engine Pixel Mapping Interface**

Figure 23.13 Pixel ap interfaces
Source: (Images courtesy of High-End Systems, Epic Games, & Quasar Science, LLC)

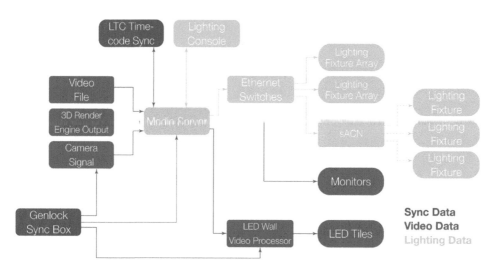

Figure 23.14 OS IBL Workflow Block Diagram
Source: (Image Courtesy of Quasar Science, LLC)

All OS IBL displays, lighting fixtures, and lighting control devices in a full OS IBL setup need to support internal device calibration, or internally need to be able to have clearly defined device behavior.

What Challenges Exist for Any OS IBL Setup?

At the time of this writing, any OS IBL setup team must examine and calibrate the entire array's performance in the following:

- Color stability
- Color accuracy
- OS IBL vs. external lighting spectral accuracy or definition
- OS IBL vs. rear projection playback timing synchronization
- OS IBL array component device patching
- OS IBL array networking and data throughput

Lighting Control Systems, Pixel Mapping, and Protocols With Virtual Production

Ben Dynice – Quasar Science

Traditional Lighting Control Integrating With Virtual Production Lighting

Virtual production has brought an increased need for precise lighting control to create dynamic, interactive lighting that helps bring the virtual environment to life. This allows for greater flexibility and time-saving capabilities, ensuring that the lighting matches the surrounding environment and enhances the realism of the performance.

The **Lighting Programmer** is the member of the lighting team responsible for this control. The Lighting Programmer programs the lights to change or move in specific ways using a lighting console or similar computer-controlled system. Their duties include programming and operating sequences from a lighting control desk, as well as communicating with the Chief Lighting Technician and the LED volume control team members. This role requires strong technical skills, attention to detail, and the ability to work effectively in a team environment.

In a virtual production, the LED wall can be controlled by a 3D system such as Unreal, Unity, disguise, Stagecraft, or Pixera. The lighting console can work alongside the 3D system to create dynamic and interactive lighting effects. The media from the 3D system can be exported as 2D video files and loaded into the system to control the lights, or the lights can be controlled directly from the 3D system. When planning the lighting network, it is important to consider how the general lighting system will need to interact with the wall. This may involve the transfer of DMX

data streams between the 3D system and the lighting console, to coordinate the lighting effects with the visuals on the wall. By making these decisions ahead of time, it is possible to create a seamless and integrated lighting system that enhances the realism and immersion of the virtual environment.

Lighting console systems are used to control various aspects of a lighting setup, including media servers and 3D engines. Media servers are specialized computer systems that are used to process video files for pixel mapping, allowing them to be displayed on LED walls or other multi-pixel lighting fixtures. By using a lighting console to control the media server, it is possible to synchronize the lighting effects with the visuals on the wall, creating dynamic and interactive lighting that enhances the realism and immersion of the virtual environment. The lighting console can also be used to trigger events happening within the 3D engine, allowing the lighting to respond to changes in the virtual environment in real-time. Overall, the lighting console plays a crucial role in coordinating and controlling the various elements of a virtual production.

Filmmakers working in the LED volumes utilize interactive lighting to create immersive believable imagery on the actors from the environment they are in. This can be achieved by pixel mapping video onto multi-pixel lighting fixtures. This video can be streamed in from the 3D environment or can be video files or static images used to create a sense of the world around the actors.

The major lighting consoles used in film and television production are grandMA by MA Lighting, EOS by ETC, and Hog4 by High-End Systems/ETC. These lighting consoles are all part of different ecosystems, and each one has its own unique features and specifications. All three systems are capable of achieving the same results and are commonly used on sets to control the lighting for a production.

Pixel Mapping to Create Interactive Lighting in Virtual Production

Pixel Mapping is the process by which a video or image source is mapped to the pixels of a light. This is the process for creating image-based lighting. Pixel mapping can be achieved in a lighting console, a media server, or even in a 3D engine.

The process typically involves three steps:

1. **Patching the fixtures –** involves assigning the multi-pixel lighting fixtures to the lighting console or system using the appropriate DMX profile. This step ensures that the console or system can control the fixtures and access their full range of capabilities.
2. **Building the array** – involves creating the grouping, or arrangement, of fixtures that will be used to display the video or image. This step allows the user to control how the video or image is mapped across the fixtures and can include features such as orientation, intensity, and color metrics.
3. **Playing the video or image** – involves selecting the video or image file and adjusting the playback settings to achieve the desired visual effect. This step allows the user to control the timing and sequence of the video or image, as well as any interactive or dynamic elements.

This process will take the RGB Video data that the video source overlays on the array, create a real-time RGB value in 8-bit or 16-bit, and relay that data out at 44 hertz to each pixel.

When pixel mapping, the value of light created when the red, green, and blue channels are all set to their maximum value (255) is white. However, the color temperature of this white light can vary depending on the light fixture. In virtual production lighting, it is important to match the white point of the LED lights with the white point of the LED wall, to achieve accurate and consistent color reproduction.

Color space is another important factor when pixel mapping. The color space of a video file or video source refers to the range of colors that it can represent. Unreal is native sRGB. Rec709 is another widely used color space for high-definition video. LED lights may be calibrated in their own manufacturer color space, which may differ from the color space of the video file or video source. It is important to ensure that the color spaces match to achieve accurate and consistent color reproduction. For example, if the LED light fixture is set to 100 percent red, it should match the color produced by the wall at full red.

Figure 23.15 Example of a photo and a pixel-mapped version of the photo
Source: (Image courtesy of Quasar Science, LLC)

Media Server

A more specific type of computer-controlled lighting system is called a media server. This is a specific computer-controlled lighting system that can output video or still images onto large arrays of lights. A media server can be controlled from a lighting console or can stand alone.

Some of the media servers used in film/TV lighting sets are PRG Mbox, GreenHippo, Madrix, and MadMapper.

Lighting Control Data in Virtual Production

There are three primary **protocols** used in lighting control:

DMX – a one-way communication protocol used to send data to lighting fixtures. It is an 8-bit protocol comprised of 512 channels that each have a value of 0–255. A collection of 512 channels is called a DMX Universe. One 5-pin DMX cable is used for each DMX universe.

Art-Net – a network-based protocol for transmitting and receiving DMX512 data over ethernet networks developed by Artistic License. It uses UDP to send network packets of DMX 512 over TCP/IP. Traveling over standard ethernet cables and switches, Art-Net carries multiple universes along one network cable.

sACN (Streaming ACN) – a network-based protocol for transmitting and receiving DMX512 data over Ethernet networks developed by ESTA. sACN utilizes multicasting, which allows for very little configuration. It is much more scalable and flexible than DMX and requires less bandwidth than Art-Net. It also carries multiple universes along one network cable.

Both Art-Net and sACN can be used in unicast mode, which requires the manual entry of each light's IP address on both the light and the console. This can be time-consuming and error-prone and is not ideal for large or complex lighting setups.

Where sACN shines is in its ability to use multicast mode, which eliminates the need for manual configuration of IP addresses. With sACN multicast, one needs simply to set the DMX universe on the lights and the console, and the lights will automatically subscribe to the correct data stream. This makes it much easier to set up and manage large lighting installations and allows for more flexibility and scalability than unicast mode. Overall, sACN multicast is a powerful and efficient way to control lighting fixtures in virtual production.

sACN Priority is a specification of sACN that allows manual assignment of a priority level to the packet of data that is sent to the lights. This enables a technician to change the priority of the packet, allowing an individual to determine which device or console is in control of the light at any given time. This is a useful tool in virtual production as it allows seamless switching between controlling the lights from the 3D system and the lighting console.

In virtual production, these protocols are used to control lighting and other devices in real-time, allowing filmmakers to create the desired lighting and visual effects for a scene. This can help improve the realism and immersion of the final product and make the production process more efficient and flexible.

Notes

1 Full Information on AMPAS SSI can be found in this dedicated landing page: www.oscars.org/science-technology/projects/spectral-similarity-index-ssi.

2 Please see section "External Lighting on Stage vs. LED Wall Lighting" for a more detailed discussion of the CIE 1931 2º.

24

Epic Training (Unreal Engine)

Training In-Camera Visual Effects (ICVFX) for Virtual Production

Brian Pohl – Epic Games

Virtual production as an interdisciplinary technical practice is the logical evolutionary advancement of existing traditional computer graphics and filmmaking fields. ICVFX is the resulting marriage of these two fields and requires a training program that places the new discipline under the umbrella of virtual production and within the greater context of filmmaking. An ICVFX program must hybridize a massive number of technical skills while also providing access to the more elusive knowledge base of understanding the filmmaker's creative and cinematography processes.

An ICVFX technical artist will likely begin their career with a knowledge base of one of the older fields. From the computer graphics side of the profession, understanding the standard visual effects and animation production pipelines is critical. In industry speak, it is likely advantageous for the artist to be a strongly proficient generalist so they can be exposed to a wider number of computer graphic disciplines such as modeling, materials, layout, lighting, animation, and previsualization. Within the film industry, previsualization is one of the early technical forerunners that spearheaded several of the workflows used within ICVFX from a computer graphics perspective. Likewise, those working in classical art and CG modeling departments will likely favor potential professions in the Virtual Art Department (VAD) and is directly essential to the successful operations of a ICVFX LED volume. The greatest issue is translating the highly nuanced profession of computer graphics into something more physically tangible, like the conditions found within a stage environment. (Members of the art department already have their feet in both worlds.)

DOI: 10.4324/9781003366515-25

From the principal photography and stage production side of the profession, directors, cinematographers, VFX Supervisors, camera operators, DITs, gaffers, production designers, and members of the art department will likely show the most aptitude towards ICVFX. Individuals within these disciplines have a real-world understanding of production and its specific culture, vocabulary, and intricacies. The ICVFX stage offers a relatable gateway from their familiar production world to the computer graphics world. Game engine developers, through the advent of ICVFX technologies, have created a set of tools that better accommodate traditional production job roles, integrate existing filmmaking techniques, and promote exploration. Any expressed interest in ICVFX by production personnel should be strongly encouraged, and great care must be made to provide training that is relatable, particularly in terminology and procedures.

The potential ICVFX prospect will face a larger common hurdle which entails the engineering aspects of the actual stage itself, regardless of which side of the divide they started. An ICVFX stage will require a command of common technologies typically found in broadcast and cinematography production circles. While the larger studio-based ICVFX technical artist will not be required to build the stage themselves, smaller more indie productions may require additional engineering and cinematography skill sets, such as understanding signal flow, extensive camera operations, lens knowledge, timecode and genlock setups, LED processor and wall configuration training, DMX lighting, color science, mocap setup, and network engineering.

Working in an ICVFX professional environment requires a large amount of information. Training materials that are significant to ICVFX are still difficult to come by, and their relevance is rapidly compromised by an ever-evolving toolset, application UI, and new workflows. Training materials must be properly vetted to ensure their relevance while also granting the trainee access to a properly assembled ICVFX stage. While stage configurations are also rapidly changing, they should be able to meet certain production guidelines surrounding wall trussing, sufficient energy and cooling requirements, safety standards, adequate computational hardware, house engineering requirements, soundstage building height, roof and floor strength concerns, and a robust networking infrastructure. Additionally, the instructor staff should also be vetted to ensure they have prior ICVFX stage and real-time computer graphics industry experience. (Working industry professionals cycling in and out of the educational circuit are likely better candidates to be trainers due to their stronger familiarity with current production practices and educational backgrounds.)

Currently, existing schools and institutions are attempting to meet the training demand through classical educational approaches. This usually amounts to semester-based training, which is tied into existing curriculum like the school's film, computer graphics, or broadcasting programs. These types of programs usually do not concentrate instruction for rapid learning. While they will likely prove sufficient over time for newcomers to the profession, they will likely fall short for working professionals trying to upskill their knowledge in shorter time frames.

At Epic Games, the Unreal Fellowship program was designed to take a more community and mentored-style approach to training these technologies. By using dedicated mentors and teams in the training environment, students feel more comfortable knowing someone is helping them better understand the various course requirements. The program is structured to deliver multiple

two-hour live classes, via Zoom, with a corresponding course lab immediately following each class. By leveraging existing assets, via Epic's Marketplace, Quixel Megascans, and Sketchfab, students can lower the overhead of constructing new worlds for their ICVFX needs and the program's challenging projects. The goal is to quickly infuse the students with immediate information, get them working within the engine, and move to the ICVFX stage itself as soon as possible. These classes are supplemented throughout the program by working industry guest speakers and a concentrated, hands-on portion of the class, where all demonstrated content during the virtual live lectures is reinforced on stage through a round robin approach of exercises.

If the program is combined with a central challenge project, like a short film, it will likely be necessary to add the concept of conducting scrums[1] to track the progress of students' work, align their priorities, and offer small group creative reviews amongst their teammates. This can be combined with additional "Live Labs" that provide more access to program instructors and TAs for technical question resolution. Weeklies are also another industry practice that can be deployed to review works in progress for the entire student body to benefit from – so there is a healthy balance between small and large group dynamics when it comes to completing their challenge project. It also replicates similar conditions found at more traditional animation and visual effects studios.

After the course, and its challenge project is completed, it is important to continue the student's learning experience by placing them into an active alumni program. Due to the relatively small size of the ICVFX community, maintaining any sort of continuing education is paramount. This can be accomplished by keeping students enrolled in an alumni Slack workspace or set of dedicated Discord channels, while also promoting various job opportunity discussions, guest speaker events, and access to any new recordings and class materials generated by future programs.

Note

1 In work cycles, scrums are typically short but productive meetings that rapidly assess the situation and make modifications nearly every week, as opposed to waterfall approaches, that wait considerably longer.

Unity Software – Overview / Aspects of Virtual Production

Introduction

Habib Zargarpour and Ron Martin – Unity Technologies

The real-time 3D (RT3D) tools in Unity can be used for visualization, animated shorts, features, and full-blown final pixel visual effect shots for film production. "Virtual Production" is any use of real-time technology to augment and impact traditional filmmaking techniques. In this chapter, an overview and links to documentation are provided for users to navigate virtual production workflows using the Unity Engine.

While the definition of virtual production is relatively new and has become the cumulation of several combinations of steps and processes, the idea of visualizing a shoot in CG prior to starting any physical build or practical photography goes back to the early days of previs. For example, in previs, a director wants to create a low-fidelity version of what will ultimately be shot. With the Virtual Camera (VCam), one can easily simulate what final filming might look like with tools that mimic what a DP will be using on set. Real-time feedback is key for artists to work and iterate, just as they would in the physical world.

This creative process can begin with a multitude of options for CG artists and designers collaborating in Unity's Real-Time Engine Editor.[1] The Game view[2] simulates what the final rendered shot will look like through the Scene Cameras. The Scene view allows one to visually navigate and edit the contents of the Scene. The Scene view can display a 3D or 2D perspective, depending on the type of project one is working on.

Unity has physical cameras whose properties simulate real-world camera formats. This is useful for importing camera information from 3D modeling applications that also mimic real-world cameras.

DOI: 10.4324/9781003366515-26

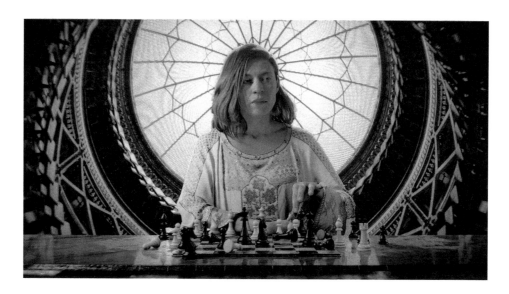

Figure 25.1 Unity short film *Enemies* (2022)
Source: (Image Courtesy of Unity Technologies)

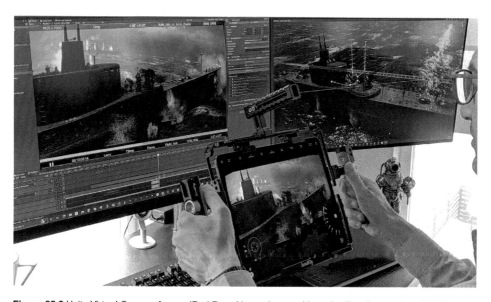

Figure 25.2 Unity Virtual Camera App on iPad Pro with previs scene from the film *Comandante* (2023)
Source: (Image Courtesy of Unity Technologies and O'Groove Productions)

Unity provides several post-processing and full-screen effects that can greatly improve the appearance of the scene with little setup time.

Cameras in Unity for virtual production come in two different forms: Cinemachine and Live Capture App VCam.

Cinemachine is a suite of modules for operating the Unity camera. Cinemachine is a procedural tool that solves the mathematics and logic of tracking targets, composing, blending, and cutting between shots. It is designed to reduce the number of time-consuming manual manipulations and script revisions during development.

The main tasks that the Cinemachine Virtual Camera does for the user are as follows:

- Position the camera in the scene.
- Aim the camera at something.
- Add procedural noise to the Unity camera. Noise simulates things like handheld effects or vehicle shakes.
- The "Follow" target specifies a node or asset for the camera to move with.
- The "Look At" target specifies the node or asset to aim at.

Cinemachine includes a variety of procedural algorithms to control movement and aiming. Each algorithm solves a specific problem and has properties to customize the algorithm for specific needs.

Live Capture is a solution for Unity users to interface with mocap hardware, manage performance takes, and connect to powerful companion apps. It handles how data from external sources is streamed, previewed, and recorded in the Unity Editor. It has three core feature areas:

1. Hub: To preview and capture streamed data as animation clips.
2. Live Link: To manage connections and data streams between the Editor and external data sources, such as the Unity companion apps and third-party solutions like Faceware, Vicon, Xsens, OptiTrack, Ncam, etc.

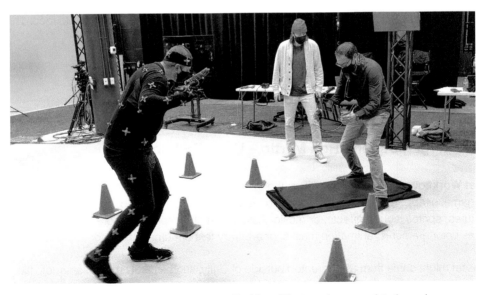

Figure 25.3 Operating the Unity Virtual Camera on iPad Pro while streaming mocap into the engine
Source: (Image Courtesy of Unity Technologies)

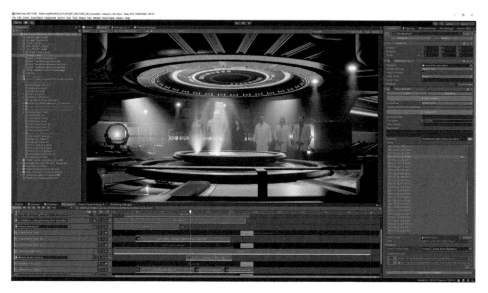

Figure 25.4 World building for the feature film *Dark Asset* (2023) using Simulcam
Source: (Image Courtesy of Unity Technologies and City of Crows, LLC)

3. Take system: Use this to integrate the capture workflow with Timeline to manage versions of live performance data.

Live Capture[3] is released alongside two cinematic companion apps:

- Virtual Camera, which allows the user to drive an in-scene camera from a mobile device and perform camera moves.
- Face Capture, which leverages the power of mobile device facial recognition to record human face performances and bring them into Unity.

World Building in Unity
Habib Zargarpour and Ron Martin – Unity Technologies

Asset Workflow – An asset is any item that is used in a Unity project to create a scene, project, game, or app. Assets represent visual or audio elements in a project, such as 3D models, textures, sprites, sound effects, or music. Assets can also represent more abstract items, such as color gradients, animation masks, or arbitrary text or numeric data for any use.

An asset might come from a file created outside of Unity, such as a 3D model, an audio file, or an image. One can also create some types of assets in the Unity Editor, such as a ProBuilder Mesh, an Animator Controller, an Audio Mixer, or a Render Texture.[4] Importing storyboards, 2D plans, or concept art onto the Cinemachine timeline as assets enables the user to start to design the

environments using the ProBuilder package to access the scene's content in the Editor. ProBuilder enables the creative team to build, edit, and texture custom geometry. Use ProBuilder for in-scene design, prototyping, and collision meshes – all with on-the-fly iteration and simulation. Advanced features include UV editing, vertex colors, parametric shapes, and texture blending. Start gray-boxing with ProBuilder, then export Assets to FBX until they can be replaced with the final assets.

The FBX Exporter package provides round-trip workflows between Unity and 3D modeling software. Use this workflow to import or export geometry, lights, cameras, and animation from Unity to Autodesk® Maya®, Autodesk® Maya LT™, Autodesk® 3ds Max®, Unreal Engine, Blender, or any other software that can import the FBX format, and back again, with minimal effort. The 3D modeling software remembers where the files go and what objects to export back to Unity.[5]

Use the Alembic package to import and export Alembic files into the project's scenes, where one can playback and record animation directly. The Alembic format bakes animation data into a file so the animation can be streamed directly from the file. The Alembic package brings in vertex cache data from 3D modeling software, such as facial animation (skinning) and cloth simulation (dynamics). When played back inside Unity, it looks the same as it did in the 3D modeling software.

Import and export Alembic files (.abc), record and stream animations in the Alembic format directly in Unity.[6]

Asset Store and UDAM

Assets can be created by artists or designers through applications such as DCC tools, Maya, and Blender, or acquired through the Unity Asset Store. The Asset Store is accessible directly inside the Unity editor or an internet browser where there are over 11,000 high-quality 3D models as part of over four million assets, including environments, terrain design, modular buildings, weather systems, UX designs, and helper tools for creating AI and character control.

- The new UDAM Platform will simplify the complexities of 3D digital asset discovery, management, and transformation with a creator-first approach. By building a storage-agnostic, easy-to-use digital asset management platform from plug-and-play components, creators can be used to upload, manage, transform, and share their 3D assets.

Users and Studios Can

- Search assets easily using filters, tags, and metadata.
- Browse private and pro art assets (Speedtree, Weta, Twinbru).
- View assets with clearly laid out information and thumbnail previews of the content in a responsive UI.

BIM/CAD and PiXYZ. PiXYZ is a collection of software for converting BIM/CAD data used by a prop or scenic designers to bring plans or drawings into the Unity engine as a 3D asset with original metadata. PiXYZ can also import LiDAR scans of film sets or assets into Unity to reduce the number of points required to make a more feasible real-time asset. It includes standalone software and plug-ins below:

353

PiXYZ Studio: For conversion of multiple BIM/CAD data formats without loss of metadata, also enables 3D asset optimization for game engines or other DCC software like Maya/Max. The PiXYZ plug-in for Unity can import e57, RCP, pts, and ptx Point Clouds for importing any other model format to retopologize and use in any real-time engine, app, or immersive experience.

Unity Terrain Tools and SpeedTree

SpeedTree is the industry-standard vegetation modeling toolkit that works as a standalone application or a real-time engine plug-in for Unity. The SpeedTree Modeler features procedural generators and a cutting-edge photogrammetry workflow that converts real scans to customizable models, match concept art with freehand art tools, grow assets around any obstacle, and animate growth sequences.

- Intuitive editing allows creators to make fast manual edits with the artist-centered Freehand Mode. Sculpt, paint, draw, and fine-tune vertices.
- Build high-performance models with all the realism of photogrammetry scans. Use the new Mesh Converter to capture textures, convert trunks to procedural models, and extend scans with SpeedTree geometry.
- Manage complex wind, growth animations, and multiple resolutions.
- Living Assets in the Unity Asset Store add access to the SpeedTree Library, enabling unlimited downloads of expertly researched dynamic models. Each model is fully equipped with infinite randomization, seasonal changes, and wind animations.
- There are thousands of trees and vegetation textured and modeled available on the Speed-Tree Store to expedite the production creation workflow.[7]

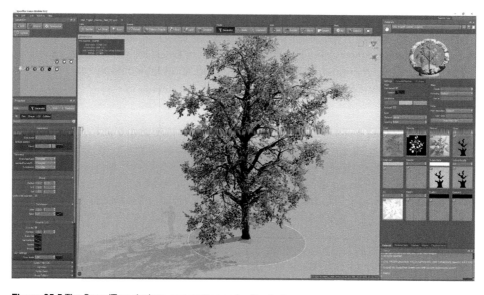

Figure 25.5 The SpeedTree desktop app creates and edits plants
Source: (Image Courtesy of Unity Technologies)

The SpeedTree plug-in is real-time engine agnostic and works with both Unity and Unreal Engine from Epic Games.

Unity Terrain Tools – The Unity Editor includes a built-in set of terrain features that allow one to create landscapes or 3D matte paintings. In the Editor, one can create multiple terrain tiles, adjust the height or appearance of the landscape, and add trees or grass. The Terrain Toolbox allows one to create new terrain from preset settings or imported heightmaps, batch change terrain settings on multiple terrain tiles, and import/export splatmaps and heightmaps.

Terrain Tools has added 14 new tools to the Paint Terrain drop-down menu, which include several Sculpting, Erosion, and Transform tools, Mesh Stamping, and upgraded Texture Painting and Terrain Stamping experiences.

High-Definition Render Pipeline

A render pipeline performs a series of operations that take the contents of a scene and displays them on a screen. In Unity, one can choose between different render pipelines. Unity provides three prebuilt render pipelines with different capabilities and performance characteristics, or one may create their own. For cinematic, realistic lighting and the flexibility to take assets and build real-time final pixels starting with the HDRP or cinematic template is a good way to begin working in Unity for visual effects or film workflows.

Cinematic Lighting

Lighting in Unity works by approximating how light behaves in the real world. Unity uses detailed models of how light works for a more realistic result, or simplified models for a more stylized result.

A global illumination is a group of techniques that model both direct and indirect lighting to provide realistic lighting results. Unity has two global illumination systems, which combine direct and indirect lighting. The Baked Global Illumination system consists of lightmappers, Light Probes, and Reflection Probes. There are two options for baking: The Progressive Lightmapper (CPU or GPU) and Enlighten Baked Global Illumination. The real-time global illumination system is Enlighten Realtime Global Illumination. Light Probes are used to provide high-quality lighting on

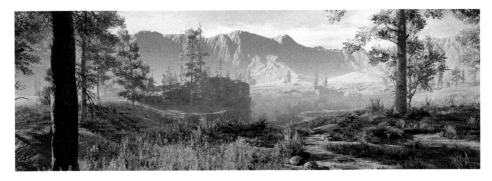

Figure 25.6 Unity Terrain Tool uses brushes to edit the surface and add/remove plants
Source: (Image Courtesy of Unity Technologies)

Figure 25.7 Unity *Enemies* (2022) scene lit with HDRP using Probe Volumes and Screen Space GI with ray traced reflections
Source: (Image Courtesy of Unity Technologies)

Figure 25.8 HDRP Probe Volumes lighting a scene from the feature film *Dark Asset* (2023)
Source: (Image Courtesy of Unity Technologies and City of Crows, LLC)

moving objects in the scene. Light Probes can create baked lighting – such as emissive materials and area lights to illuminate moving objects passing through the area.

Create a Probe Volume by right clicking on the Hierarchy Window and selecting Light > Probe Volume, then create Reflection Probes via Light > Reflection Probe[8] and place them at key locations where light would gather. The Probe Volume probes are automatically distributed at a given density and tap into the light from the reflection probes and affect static and moving objects.

Visual Effects Graph

The Visual Effects Graph (VFX Graph) is a node-based editor for creating stunning real-time visual effects in Unity Pro. Harnessing the power of the graphical processing unit (GPU) and compute Shaders, VFX Graph can author effects consisting of several million particles simultaneously.[9]

Camera Tracking in Unity

Habib Zargarpour – Unity Technologies

Camera Tracking Options

There are many options for tracking a physical or virtual camera. Below are a few of the options for tracking real-world cameras to combine real and virtual content. The Unity Virtual Camera iOS app is used for virtual camera movement but, in some cases, could be attached to physical cameras to track basic movement.

- **Mo-Sys**:

Mo-Sys is a precise camera tracking system for real-world cameras using reflector markers on the ceiling. There is a plug-in and package available for Mo-Sys that includes camera tracking, lens, and focal depth as well as lens distortion (Figure 25.9). The Virtual Camera position and lens will be driven directly by the data from the Mo-Sys tracker. The calibrated system will supply pixel-accurate tracking where characters filmed on a green screen can be composited into a virtual environment without any sliding.

- **Vicon**:

Vicon is an industry-wide motion capture system that typically uses 50 to 100-plus tracking cameras on a stage. The camera can be tracked via reflector markers and its position streamed into Unity via the Vicon motion capture system.

Overview of the Unity Virtual Camera (VCAM)

The Unity Virtual Camera consists of a package called Live Capture and an app in the iOS App Store called Unity Virtual Camera. Together these allow the user to use an iPhone or iPad as a virtual camera with advanced controls on the screen. The images, of the real-time rendering out of Unity, are physically sent back to the device so that one can freely compose and shoot without having to look at the computer monitor or a TV. The Live Capture package also comes with a Face Capture component that allows one to drive a face in Unity from an iPhone/iPad and record that onto a rig in Unity.[10]

The VCAM app works as a companion application to Unity Pro acting as a physical camera operating the functions of the editor's scene camera for creating handheld shots. VCam can create virtual "takes" and use the take management system to review or preview entire edits.

Figure 25.9 Example of lens distortion used on the Previs for the film *Comandante* (2023)
Source: (Image Courtesy of Unity Technologies, distortion data from Cooke Lenses)

Other Unity packages that help filmmakers using Unity in virtual production: Timecode support to stay in sync with cameras and virtual stages, Alembic streaming, Python scripting for pipeline integration, and Sequences for animation and shot structures that help organize the Timeline. The Recorder allows complex rendering and AOV output. All these tools along with OpenTimelineIO support allow for metadata and scene/take management to tailor how each studio likes to work. There are many controls on the iOS device screen to offset the camera. One can raise and lower it and change the lens, T-stop, and focal distance (see Figures 25.10 and 25.11). The camera tracking can work with Unity in editor mode or in play mode. The difference is that in editor mode, whatever one changes in the scene can be saved. The system revolves around the Take Recorder node in the editor, which determines the shot name and take numbers, as well as any other nodes that need to be recorded with the take, such as the dolly rig position. Once a take is recorded, the user can switch to playback mode to view the results. The tracking of the device is turned off because it is simply playing back the results of the recording. A master timeline is required with a Take Recorder track, and a slate clip, for the system to function. Each take, in the Take Recorder list in playback mode, can be seen from the start and end of the frame number at which each take was recorded.

Other features are as follows:

- Control focal length, focus distance, and aperture with configurable damping for a smoother feel.
- Reticle Auto Focus mode to automatically set the focus distance based on a screen reticle.
- Tracking Auto Focus mode to have focus distance dynamically match a scene object's distance to the camera.
- Axis locking to prevent motion in any combination of 6° of movement.
- Temporarily halt tracking and reposition around the physical space.
- Camera motion damping can be adjusted for smoother moves.

Figure 25.10 Unity Virtual Camera App on iPad showing some of the on-screen controls; Screenshot from the Previs for the film *Comandante* (2023)
Source: (Image Courtesy of Unity Technologies and O'Groove Productions)

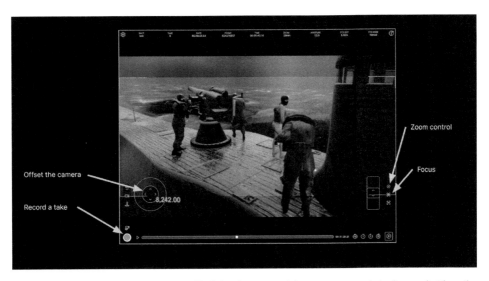

Figure 25.11 Unity Virtual Camera App on iPad showing some of the on-screen controls; Screenshot from the Previs for the film *Comandante* (2023)
Source: (Image Courtesy of Unity Technologies)

- Motion scaling to multiply physical motion, for example, one foot of motion can become five feet of motion in the scene.
- Non-destructive and iterative workflow – camera settings like damping and focal length can be changed after a capture session via iteration takes.
- Snapshots system to save an image along with the camera's position and metadata, like lens information, that can be loaded to pick up where one left off.

There are two nodes that control the virtual camera. One is the virtual camera device, under the Take Recorder node, and the other one is the virtual camera actor. The virtual camera device is where the film back, aspect ratio, select lenses and lens types, are set as well as the T-stop and other lens details. The virtual camera actor is the actual camera that is used to render the scene and takes all the above values from the virtual camera device. The virtual camera has display options for masking the gate center, crosshairs crop marks, and other display options. By selecting a different aspect ratio than the film back and then turning up the opacity of the masking, the user can see the masked area as a semi-transparent overlay. This action will show the crop.

There are two companion packages available from Unity Solutions that can help speed up the process of using the virtual camera as well as adding additional options, such as simulating physical camera rigs. They are the Previs and the Previs Rigs Packages. The Previs Package will help install a heads-up display on the scene as well as setting up the entire virtual camera system and nodes necessary to start shooting, and a batch renderer. The Rigs Package allows the creation of virtual rigs such as dollies, rails, drone rigs, tripods, and a basic flight rig to control the virtual camera position. This is done through an Xbox controller that drives the underlying physics of the rigs, allowing the user to perform a dolly move or fly a drone using the analog controls on the controller.

The rigs can be controlled in Unity editor mode as well as play mode. The user can create multiple rigs and parent them to various objects if desired, to follow them in the shot. The Xbox controller is connected to the PC or desktop computer to control the rigs. Options include connecting an Xbox controller, or generic game controller, to the iOS device to use analog input for its camera controls replacing the on-screen joystick, elevation, and lens controls. Both can be connected at the same time, and multiple controllers can be used with the physical rigs to split tasks such as dollying, zooming, and focusing with several operators simultaneously. It is also possible to layer the different performances of the physical rigs and the camera and lens functions as iteration takes.

On the iOS device, there are controls and options for the Camera T-Stop and focal distance, as shown in Figure 25.13.

A director or DP can use the virtual camera to location scout and take snapshots of places they would like to shoot. After animation is brought in, or live mocap, they can film those shots while looking at fully lit scenes in HDRP (High-Definition Render Pipeline). Add post-processing features such as Screen Space Reflections, Screen Space GI, Depth of Field, Bloom, and Film Grain by clicking on the Add Override > Post-processing of a Volume node. The stories come together with design, lighting, composition, and animation – while the parameters are tunable in real-time. There is a Path Tracing option that can be added in the post-process via Add Override > Ray Tracing > Path Tracing. This option is not in real-time but is used to render out high-fidelity frames. In

Figure 25.12 Previs Rigs Dolly seen here in a shot for *Comandante* (2023)
Source: (Image Courtesy of Unity Technologies and O'Groove Productions)

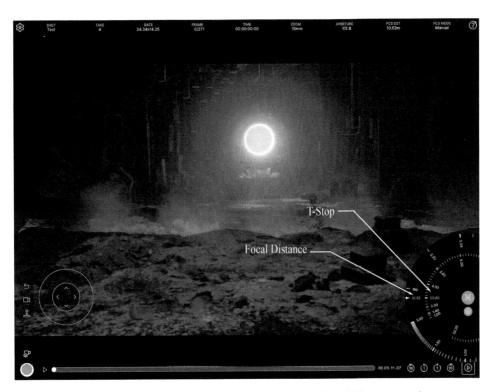

Figure 25.13 Unity Virtual Camera app on iPad showing the T-Stop and Focal Distance controls
Source: (Image Courtesy of Unity Technologies)

most cases, editing can happen directly in Timeline and remain live, or rendered for offline DCC editing for the following:

- Shot blocking
- Virtual location scouting
- Animatics and previs
- Discuss metadata and support within Unity Engine and timeline
- Advantages and features for emulating IRL equipment

Simulcam With GS Shooting – Live Set Compositing

Habib Zargarpour and Ron Martin – Unity Technologies

The Virtual Camera functionality allows one to shoot virtual shots quickly and easily, iterating takes and rig movements through performance. The VCam motion can be scaled up or down depending on the scope of the shot. In the case of Simulcam, the camera movement is scaled accurately according to the real-world scales using one of the methods mentioned in Camera Tracking in Unity above on Page 359. The takes recorded with the Take Recorder will indicate the start and end positions on the Timeline Take Recorder Track.

The Blackmagic Video package helps leverage video capture cards from Blackmagic Design to input and output pro-grade video and audio in the Unity Editor and runtime builds.

This allows for users working in film, virtual production, live events, and broadcast to have time-code synchronized frame-accurate control. The package allows one to capture and output SDI video from and to the Unity Editor from a Blackmagic capture card. The Blackmagic Video package supports the following features:

- Automatic detection of the available DeckLink cards and driver versions.
- Ability to modify connector mappings directly from the Unity interface.
- Interlaced and progressive standard HD, Full HD, and UHD (4K) video.
- Multiple simultaneous inputs and outputs.
- HDR and Audio input and output.
- Compatibility with standard color spaces: BT601, BT709, and BT2020 (HDR, HLG, and PQ).
- Compatibility with GPUDirect technology.
- Works with all of Unity's render pipelines (Legacy, URP, and HDRP).
- Works in the Editor, Play mode, and in Standalone builds.
- Internal and external fill-and-key.
- Pass-through and Low latency mode.
- Single/Dual/Quad Link for output devices.
- Timecode integration for input and output devices.
- Public API in C# (C Sharp) programming language.

Overview of Recorder

The Recorder[11] enables the exporting of rendered frames, movie files, FBX, and USD formats as well as AOV layer output.

Use the Recorder to do the following:

- Export video: H.264, WebM, ProRes.
- Export frames: PNG, JPEG, EXR.
- Support for accumulation motion blur: High-Definition Render Pipeline (HDRP) only. Note for Path Tracing, the Accumulation Samples should match what is set in the Post Process Path Tracing for Maximum Samples.
- Export AOVs: For effects and comp work.
- Export animation data: Anim, FBX, Alembic for DCC roundtripping.
- Export WAV audio: For improved audio.

Unity Keyer – The Unity Keyer identifies the green/blue shades in the background and renders the source as an alpha channel.

The Unity Keyer can be used in various manners:

- Multipass Keyer – Keyer allows the user to save a set of pre-configured keyer parameters as an asset in the project. One can then reuse this asset.
- Material Shader Green Screen Keyer.
- Video Texture Shader Green Screen Keyer.
- Graphics Compositor Green Screen Keyer.
- Custom Pass Keyer.

Keyer properties include Despill, Garbage matte, Matte Cropping, Blur Clip, and Blend Cropping Masks.

Ziva Dynamics – Photographic (Realistic) People, Animals, and Creatures

Ron Martin – Unity Technologies

Unity created The Digital Human tech package, initially shared for *The Heretic* (2019), which was refreshed in the spring of 2022 with all the improvements made for *Enemies* (2022). Some of the updates include moving the Skin Attachment system to the GPU, which now allows for high-density meshes (peach fuzz), more realistic eyes with caustics on the iris, and a new skin shader. Ziva has introduced tension technology, which allows for blood flow simulation and wrinkle maps while eliminating the need for a facial rig. This package also includes Ziva integration.

Figure 25.14 Unity *Lion* (Siggraph 2022) scene featuring skin deformations from Ziva
Source: (Image Courtesy of Unity Technologies)

Ziva Dynamics has been used to create lifelike digital humans, fantasy-based creatures, and stylized characters. Ziva gives creators a complete suite of tools to create, simulate, and deploy the most performant characters, creatures, and assets for both real-time and linear content. Character creators can produce models that move, react, and respond in a way that is believable for a chosen design language, much faster than traditional methods. This gives the artist more time to iterate and realize a better final creative. The results are more believable and engaging experiences that cross the "uncanny valley," regardless of design language. These assets can be used in any media project, in any format, on any target platform.

With Ziva's intuitive toolset, artists can replicate the effects of physics and simulate any soft-tissue material, including muscles, fat, and skin to create quality assets with ease. Ziva VFX's toolkit is a plug-in for Maya. The plug-in is real-time engine agnostic and works with both Unity and Unreal Engine from Epic Games.

What makes Ziva VFX special is the physics properties that can be simulated, such as the following:

- Material types simulating muscles, fat, clothes, etc.
- Preserve volume mass for any material for a precise and realistic look.
- Simulate realistic muscles that work with physiology of biomechanics.
- Simulating collision and how the material would react. For example, punching a wall and the ripple effects through the arm.

Ziva uses the embedded FEM (Finite Element Method) to simulate all objects computed with consideration to the embedded surface.

- Muscle Excitation: Using ML the characters' muscles fire automatically when muscle contraction and flexion occur.

- Material Properties: The character artist can assign infinite real-world material layers to a single object to make it behave like its real-world counterpart.
- Collisions: Collide objects utilizing collision detection and response with organic volume conservation eliciting realistic interactions.

Using Ziva's tools to build a character that can be simulated, the underlying simulation acts as a reference library for deformations that can be applied to models with similar traits. The ability to move the simulation behavior to real-time, and harvest that data using machine learning, empowers a PoseSpaceDeformer as an alternative simulation reference input.

This change avoids hand sculpting hundreds of body correctives and, instead, change it once on the hero model, speeding up the character simulation workflow significantly and consistently. If that simulation needs to be updated, it can be made to the base model directly, which then automatically updates the model in every scene it appears in.

ZivaRT

ZivaRT utilizes the work done by Ziva VFX to turn cinematic-quality characters into real-time assets. Machine learning accelerates the training of character models so repeatable biomechanics are baked into the asset. Assets can be deployed to any real-time engine or environment. It allows one to accelerate the training of any model, baking its properties within the asset.

Using ZivaRT, users can create fast and performant models with the precision and lifelike qualities of a fully simulated character running in real-time. By translating and optimizing biomechanics, the real-time character models enhance the end-user immersion. The resulting model will be extremely lightweight and, therefore, without any compromise in real-time use cases.

ZivaRT Player is an embedded API that allows the real-time engine to access the resulting high-performance (sub-millisecond) recall of high-quality shapes. As of this writing, ZivaRT rigs can be deployed to Maya and Unreal Engine but will soon work with players for MotionBuilder and Unity.

Notes

1. Please refer to "Getting started in the Unity Editor" https://docs.unity3d.com/Manual/UnityOverview.html.
2. https://docs.unity3d.com/Manual/GameView.html.
3. Live Capture Package Documentation: https://docs.unity.cn/Packages/com.unity.live-capture@1.0/manual/virtual-camera.html.
4. Unity has a wide variation of built-in Importers found here: https://docs.unity3d.com/Manual/BuiltInImporters.html.
5. Here's a tutorial for working with FBX round-tripping in Unity: https://learn.unity.com/tutorial/working-with-the-fbx-exporter-setup-and-roundtrip-2019.
6. Here's a tutorial for learning more about Alembic: https://learn.unity.com/tutorial/introduction-to-alembic-2019-3.
7. https://store.speedtree.com/speedtree-store/page/28/.
8. Tutorial to learn how to use Light Probes: https://learn.unity.com/tutorial/configuring-light-probes-2019-3#.
9. documentation to get started making FX with the VFX graph: https://docs.unity3d.com/Packages/com.unity.visualeffectgraph@12.1/manual/GettingStarted.html.
10. The documentation page for the details is here: https://docs.unity.cn/Packages/com.unity.live-capture@1.0/manual/virtual-camera.html.
11. Recorder documentation: https://docs.unity3d.com/Packages/com.unity.recorder@2.0/manual/index.html.

26

The Future of Virtual Production

Overview of the Future
Ben Grossmann – Magnopus

Content Creation Accelerants

The expense of virtual production is presently a key challenge in many projects. It may seem that a large LED stage and supporting infrastructure would be the most significant expense, but often the largest budget item is what goes IN the LED wall. Content also represents the most significant labor investment and can be the hardest for a production to estimate.

Because productions have become comfortable with digital content being added AFTER physical production, most schedules begin production as soon as locations can be found, or physical sets can be designed and built (often the longest lead item in the timeline). Virtual Production requires that the digital content be built *before* the shoot, and if the production intends to achieve ICVFX in an LED stage, it must be the highest quality, which takes time. Though practical background plates, or matte-painted "digital translights" may be prepared in two to four weeks, large real-time scenes might require two to four *months* of development with a team of VAD artists. The schedule and budgetary impact can be a challenge for many productions. So, a lot of effort is being put into streamlining the creation of content through Computer Vision and Machine Learning.

For environments that exist in the physical world, there is promising research in the area of developing neural networks that can optimize what was once a labor-intensive process or bypass the need for that labor altogether. Presently, LiDAR scanners are used to generate point clouds that are meshed and optimized into efficient models by hand, then combined with photography that

DOI: 10.4324/9781003366515-27

has been "de-lit," to generate textures. Then manual "material estimation" is performed to determine view-dependent characteristics like reflectivity or metallicity.

Many teams and companies are now working on systems that can use handheld mobile devices or drones with cameras to capture a location through photogrammetry or videogrammetry, and then process that data into optimized models that are ready to load into real-time systems, removing much of the manual labor previously required.

In addition to systems that capture the existing physical world more efficiently, there is exciting research coming to market, and already available commercial tools, that can create deep neural networks of understanding for object and environment capture. These developments will permit users to create optimized images or models for learned objects or, more excitingly, to create novel objects and environments that do not exist. They can offer users highly complex results to simple user requests by comparing natural language descriptions against a taxonomy of words associated with a library of knowledge trained from images or videos. While these developments are generally in their infancy, their impact on visual effects is already being seen through the application of "deep fakes" and the use of deep learning models like DALL-E 2, Stable Diffusion, and Midjourney to create original 2D images.

Similar generative adversarial neural networks, able to create 3D models from this training, can also be used to create meshed data. This will result in the ability to train a system by feeding it a large quality of reference images for a location or object and then giving the system low-fidelity 3D reference for the desired layout or shape. The system can then generate the output models, influenced by other standard descriptive text or prompts. This will have the potential impact of empowering fewer artists to create a higher volume of content faster, reducing the time it takes to get assets into virtual production. Aside from potentially democratizing the ability to create high-quality content for filmmaking teams with lower budgets, innovations like these may relieve pressure from a presently over-worked content creation industry.

Interestingly, meshed and textured models are not the native way that neural networks "understand" objects or environments, and leveraging Neural Radiance Fields (NeRFs) might soon address another challenge in virtual production. Game engines can become overwhelmed with data sizes and computations that task the bandwidth and resources of graphics cards powering display systems. The scalability of these graphics solutions can limit the size and quality of scenes that can be loaded into a virtual production environment. Many productions forgo using 3D assets at runtime in LED volumes, switching to matte-painted 2D cards or lower resolution geometry with re-projected textures and baked lighting, for higher quality and lower impact on rendering hardware. This keeps frame rates up and latency down.

A new technique for rendering viewpoints of objects and environments using machine learning called Neural Radiance Fields may soon change the way loading scenes into virtual production is accomplished. Instead of generating a meshed model of the objects and applying textures and shaders for realism, a NeRF, a neural network trained by studying a large library of reference images of that scene or object, is capable of generating an understanding of what that object should look like, given a particular viewpoint, and output that imagery.

Because this knowledge structure is more efficient to store than models and textures, the file sizes can be significantly smaller and the render times significantly faster. This may eventually make more complex assets much faster to load into an LED wall or into other forms of virtual production at a higher quality and in larger quantities. One can also imagine stacking machine learning techniques, as with deep learning models like DALL-E, to generate original objects and environments and represent them as volumetric data in the form of radiance fields for their use in virtual production.

At the time of writing, many considerations make this technique not yet amenable to virtual production contexts, such as challenges around dynamic or animated content, the speed at which the network can train, and the speed at which the network can generate novel viewpoints. There are additional challenges around the ease of re-lightability, and integration issues, like collision geometry for simulations and direct-ability of rigging and animation. But the speed at which this area of research has evolved over the past few years has taken many of these items from "it takes days" to "it takes seconds," and from "it is not possible" to "sure, that can be done."

To overcome the labor-intensive and technically challenging process of getting content into virtual production, there is significant promise in the continued development of more scalable computing solutions built on computer vision, machine learning, deep learning, and neural networks.

New Opportunities Created by Virtual Production

Inviting the Audience Inside the Screen
To date, most virtual production techniques have been employed primarily to improve the experience of producing film and television content. To the audience, there is no realized benefit in the application of the technique; there is no experience that virtual production can offer audiences that visual effects cannot already provide. The only positive impact passed through to viewers is subtle and translates through the filmmaker's ability to make better content.

But the next generation of filmmakers have come of age in an era where interactive media like games is now a larger industry than film, sports, and music – combined!

For these filmmakers, virtual production offers significant advantages over traditional physical locations and sets. In this methodology, a movie set might not require a stage with a construction team; it may be created asynchronously by artists working from their homes around the world. When the next generation of filmmakers is done crafting their linear stories, they can also invite the audience to step inside the film and become a character of their choice, seeing the world from that viewpoint, not the cinematographer's. The audience can follow the characters or storylines that are most attractive to them, rather than the one that was released in theaters or on a streaming platform.

Physical sets and locations like theme parks can only host a limited number of people at one time. But virtual sets and locations can scale to hundreds of millions of people at once – all having the best experience created for them uniquely. As machine learning advancements in areas like

speech synthesis, style transfer, performance capture, and artificial general intelligence create convincing characters for audiences to engage with, expectations for more immersive and interactive windows into the worlds currently seen in film and television will grow.

In the past decade, many well-reviewed experiments and consumer products have been created with IP that has put audiences into scenes of their favorite films through virtual and augmented reality. The primary challenges of these immersive productions have been the high cost of creation because often the content must be recreated from scratch from the assets of the film. With film or television content being produced using virtual production techniques, more of the production assets of the film are already natively real-time and can travel more naturally into other monetizable experiences – effectively increasing the production value of the investment into world-building. This elevates the quality of both the linear and interactive experience at the same time and allows for a stronger narrative cohesion between them both.

Pushing Film and Television Beyond the Screen

When the cost-benefit analysis of using virtual assets tips past using physical assets, and the monetization opportunities presented in interactive or immersive media meet or exceed those offered by linear media, the emergence of a different philosophy to *telling a story* that becomes more akin to *building a world full of overlapping stories* will emerge. Virtual production techniques will allow creators to focus on world-building where they create multiple environments and characters with overlapping narrative networks and multiple channels of story progression featuring protagonists that more closely represent the diversity of the real world.

From that world-building environment, it becomes easier for filmmakers to create films, or seasons of broadcast shows, from that world via virtual production techniques for audiences who prefer to watch, rather than participate. As seen in games today, communities form in these spaces and might contribute to the developing and emerging narratives of that world. In this context, it might be seen that virtual production becomes a toolset for storytelling similar to the way journalism and documentary films cover events in the physical world.

Another capability enabled by the adaptation of film and television media to real-time can be found in the world around us. There is no need to create a fictitious planet to have a great story. Some of the best movies are filmed in this time, in these cities. Virtual production techniques combined with augmented reality displays can allow these narratives to escape the screens in one's home to populate the canvas one already knows best. People might follow a story that unfolds across the city that they live in, over the course of days or months, rather than the two hours previously spent in a theater. It might be a story with multiple protagonists and narratives, each appropriate to different members of a family, unique to different geographies.

The unification of physical and digital production through the techniques offered by virtual production brings these possibilities within reach of news filmmakers with the passion and determination to explore where no one has been before.

Beyond Flat Screens for On-Set Virtual Production Stages

Jeff Barnes

Light Field Displays Break the 2D Barrier

True light field and holographic displays form focused objects containing wavefronts that allow the viewer to discern depth with just one eye and see behind objects when one moves their head. Parallax and focus are maintained, reflections and refractions behave correctly, and the brain thinks "*real* – not an image."

When looking at current display technologies used in mobile devices, home televisions, or movie screens (as of January 2023) – one instinctively knows that images displayed are 2D representations of a three-dimensional object – not the original object itself. This is because every pixel on the screen has the same appearance regardless of the viewing angle or focus location. If one moves their head from side to side, the image does not change because there is no motion parallax, which allows one to see behind a foreground object. If one focuses their eyes from front to back, the image defocuses because there is no depth of field, which allows one to freely focus in space.

Available 3D display technologies rely on multiple 2D representations to create the *illusion* of depth. Such displays, including stereoscopic, lenticular, augmented reality, and virtual reality, effectively provide two flat images from a particular view of the object – one for each eye. However, there is still no information presented to allow the viewer to freely focus in space. As such, at any moment in time, every pixel radiates the same value independent of angle or focus. Human eyes are in constant motion, even when stationery. Without micro-parallax changes in the scene, the brain thinks "image – *not real*."

2D Barriers in Production

Filmmakers prefer the flexibility that *real* things (virtual and physical) provide. That necessitates all the information associated with objects. Unfortunately, the technical challenge of converting 2D pixels into wavefront samples currently limits filmmakers working on volume stages to what can be accomplished with a 2D representation of the digital environment. This creates several production challenges:

- **Color:** Chromatic aberrations are common when shooting off-axis.
- **Artifacts:** To avoid moiré patterns, the digital environments are often rendered with soft focus, and DPs regularly use blurring filters on the camera lens to blend LED images with the live-action objects.
- **Depth of Field (DOF):** Because the 2D video wall is a single plane in the photographed volume, the DOF is unrealistic and incorrect – without regard to the quality of the rendered content.
- **Single Camera**: Using more than a single camera is difficult, time consuming, and may have an impact on the second camera quality of the image.

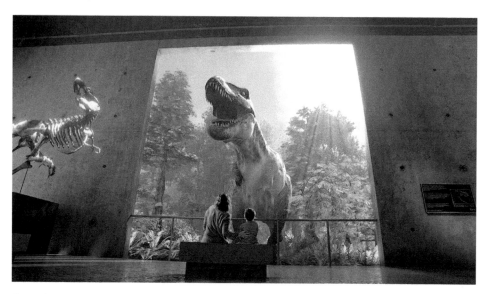

Figure 26.1 Future vision art of large-scale holographic display experience
Source: (Image courtesy Light Field Lab, Inc, © 2022)

Light Field in Production

Recreating the real world is the primary objective of light field and holographic displays. Technologies capable of recreating wavefronts that are indistinguishable from physical objects promise to address many of the challenges associated with volume stages, including the following:

- **Color:** Chromatic aberrations are mitigated through precise color control for the entire field of view, resulting in more accurate on-set environmental illumination.
- **Artifacts:** Moiré may be alleviated by decoupling the regular grid pattern of the camera pixels from the engineered structures within the holographic display – further integrating the real and digital environments without blurring filters.
- **Depth of Field (DOF):** For holographic objects that exist within the projected volume, the photographed DOF is identical between physical and virtual objects.
- **Multi-Camera**: Synchronized and simultaneous multi-camera capture is possible for all objects that exist within the viewing volume.

The Future

Although not yet commercially available to visual effects professionals, there are exciting holographic, light field, volumetric, and multi-view display technologies in rapid development worthy of attention:

- **Holobricks**: Disney and University of Cambridge (holographic)[1]

Disney's Holobricks are a modular course integral holographic display system capable of forming full parallax 3D CGI Fresnel holograms. It has been claimed that prototypes demonstrate the seamless tiling of two full-color 1024 × 768-pixel Holobricks exhibiting a 40° field of view at 24 frames per second.

- **SolidLight**™: Light Field Lab, Inc. (holographic)[2]

Light Field Lab's SolidLight holographic surfaces combine size, resolution and density to project dense converging wavefronts and form objects in mid-air without headgear that accurately move, refract, and reflect in physical space. The hardware features self-emissive bezel-less panels that assemble into modular holographic video walls modulating 10 billion pixels/m^2 at 60 frames per second and over 100° field of view. Real-time interactive experiences are powered by Light Field Lab's proprietary WaveTracing™ software.

- **Optical Trap Display**: BYU (volumetric)[3]

BYU's Optical Trap Display is a volumetric display that works like a high-speed Etch-a-Sketch to create 3D images that appear to float in mid-air. The technology leverages a near-invisible laser

Figure 26.2 Holographic toy train with Disney's Holobrick
Source: (Image courtesy Li, J., Smithwick, Q., & Chu, D.)

Figure 26.3 Light Field Lab's holographic chameleon with SolidLight™
Source: (Image courtesy Light Field Lab, Inc © 2022)

beam to trap a single particle and rapidly move it in space synchronized to a second set of red, green, and blue lasers that project color onto particles that appear as solid lines through persistence of vision. Prototypes have exhibited single particle control up to an effective 1,600 dpi with several millimeters of total volume at ten frames per second.

- **Aktina Vision**: NHK (multi-view display)[4]

NHK's Aktina Vision technology is a full parallax autostereoscopic multi-view display superimposing 350 two-dimensional images. The prototype system features a 19.2 × 10.8-inch screen with 100 million total pixels to reproduce a maximum spatial resolution of approximately VGA within ± 8" depth of field, 35.1° × 4.7° field of view and at 60 frames per second.

Beyond Virtual Production

The evolving world of visual effects is fast-paced, and these are just a few of the leading technologies in development that could change how content is created forever, ultimately transforming all aspects of visual communication. First applications anticipated include high-impact locations like museums, corporate lobbies, theme parks, sporting events, and other location-based entertainment venues. These initial installations will leave 2D displays and flat screens behind in favor of compelling holographic experiences. Content creators will be empowered to bring visual effects' "movie-magic" into everyday life by removing the constraints of the frame for engineers, designers, architects, advertisers, and filmmakers alike.

Alternative Display Technology: Projection Based Volume Using White Cyc
Irfan Nathoo and David Cannava – Create This

Why Projectors?

Projectors have been used to project 2D backdrops and scenes in film and events for decades. Virtual production is a natural evolution of that use. Bounced light offers a softer more filmic look compared to emissive LEDs. It is like vinyl vs. CD. Analog vs. digital. It is an aesthetic choice. It can be scaled to fit the size of any wall, Cyc, or space and is a considerably cheaper solution to the LED alternative. And there is no moiré to worry about.

The Process

The process on a projection volume is identical to any other virtual production pipeline, up until the final output. Instead of outputting to LED panels, a multi-projector front projection system onto an existing Cyc wall is used.

Equipment

One will need between two and four projectors depending on the size and dimensions of the space. The projectors should be a minimum of 12,000 lumens to gain the necessary brightness and have short-throw lenses to minimize shadows.

Any professional film camera can be used, but it is important to select a camera that is good in low light and has genlock. Genlock on the camera will ensure the frame rate is locked throughout the entire system.

Camera tracking is a fundamental piece to the entirety of virtual production. In essence, one is marrying the studio camera to a virtual camera. Wherever the studio camera moves, the virtual camera moves in exactly the same way and re-projects whatever the virtual camera sees onto the projection volume to be captured in real-time by the studio camera.

The complexity of the servers necessary for production can scale. One needs the most powerful servers and graphics cards available to get the best results. A server is needed to control the system and individual servers to render the content for each layer (backplate, set extension, augmented reality). Finally, a server is needed to do the projection mapping and output the image to the wall.

Projection Mapping a Cyc

Projection mapping the Cyc[5] is one of the most challenging aspects of working with virtual production and projectors. The goal of this process is to generate a virtual Cyc that matches the physical Cyc as accurately as possible. Short-throw lenses are ideal for a projection volume because it allows the projectors to be as close to the wall as possible. This maximizes brightness while minimizing shadows. A 12,000-lumen projector with a short throw lens can be about 15 feet away from a wall. Ensure the light of each projector overlays the others, with at least a 15 to 20 percent overlap, to allow for smooth blending.

It is possible to do a manual projection map of the Cyc, but this is painfully tedious and very difficult as Cycs do not have any hard corners or edges – making it one of the most challenging geometries to map. It is more efficient and all around better to do this with software. LiDAR scan the Cyc and make use of various mapping software to create the projection map of the walls. Using carpentry lasers, mark the Cyc with the same measurements that were established on the virtual model. It is critical these measurements are as accurate as possible. The more accurate the measurements, the better the mapping will be.

Defining the "zero point" is critical for virtual production as it establishes the basis for the link between the real world and the virtual world. Mark the zero point at the exact center back of the Cyc. Ensure this point is measured as accurately as possible. Once the mapping is complete, blend the projectors to make the light as smooth as possible. Try to eliminate any hotspots between the images. A blend of 15 to 20 percent should make the Cyc look like one large and beautiful canvas.

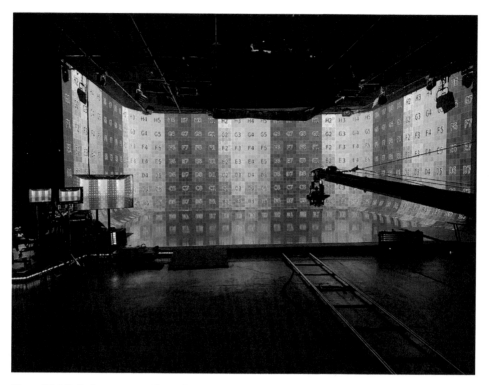

Figure 26.4 Projection map on a Cyc wall
Source: (Image courtesy of Create This)

Software and Hardware Integration

Now that there is an accurate representation of the Cyc in the software, make sure the camera tracking system has meticulously mapped the same zero point measured and established earlier. At this point, when moving the studio camera, the virtual camera should move within the Cyc geometry in the same way. The pipeline is now the same for the projection volume compared to that of an LED volume.

Set Extension

Set extension on a projection volume is a challenge of its own. Take the top edge of the virtual geometry created from the LiDAR scan, and extend that edge much higher in virtual space, as if the real-world Cyc were more than double in height. This allows one to look into the ceiling with the studio camera and see a continuation of the virtual world – all within the final output of the camera in real-time. Once it is working, set extensions are a great asset in the virtual production realm.

Showtime

On a projection volume, light is the enemy. Projections look vibrant and beautiful, but the contrast can easily be lost with too much ambient light. To mitigate this, open the camera lens and bring down the lighting. Match the light levels on the stage in the real world to the brightness of the images on the projection volume. It is surprising what low light levels are needed to get fantastic results. Flag every light to get the least amount of spill away from the projection wall possible.

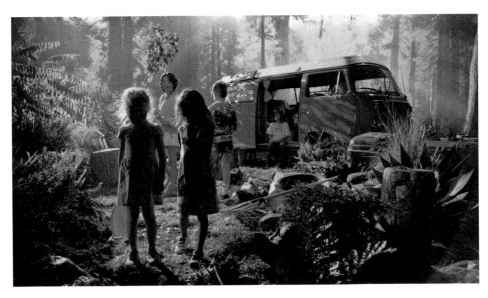

Figure 26.5 Practical set against virtual forest with projection-based XR
Source: (Image courtesy of Create This)

As with any new technology, there are challenges to overcome. Most issues tend to involve synchronization between everything in the system. Lock the camera, the tracking system, the servers, monitors, and projectors all to the same timecode with the genlock for sync. Projection offers a beautiful and filmic alternative to the traditional LED walls in virtual production. The end product can compete with, and exceed, that of an LED wall.

High-Resolution Depth (HD3D)
Dr. Paul Banks – nLIGHT

Real-time in-camera visual effects (ICVFX) have become the mantra for predicting the future of virtual production. However, such views are primarily referring to the background since anything in the foreground or midground still must be handled practically, requiring a traditional visual effects solution. For ICVFX to apply to all aspects of a production, a critical missing link for the future is depth, or the knowledge of the three-dimensional location of everything in the virtual production volume – down to the pixel level, including moving actors and objects.

Capture technologies and 3D cameras are gradually improving, but traditional approaches cannot scale to achieve the performance required by complete ICFVX. However, a new approach from nLIGHT uses HD sensors to create HD depth maps with latencies less than one to three frames. It is then straightforward to treat foreground actors and objects the same as CG objects within a render engine (see Figure 26.6). In the future, arrays of these HD3D cameras can create high-resolution, real-time 3D holograms of actors and sets.

Figure 26.6 (A) Captures of real-time output from render engine using HD3D depth maps (grayscale insets). Day scene with actors behind and in front of CG elements. (B) Screen shows night scene with one actor properly lit by CG candle.
Source: (Image courtesy of nLIGHT)

Traditional Depth Measurement Technologies

There are many techniques and technologies that have been used to capture location information or the depth of objects in a scene. There is often a belief that these technologies will solve all problems. They will not. If things go well, they may solve one without creating more.

Figure 26.7 gives a high-level summary of common technologies and their pros and cons; all have situations where they work well with proper expertise and others where they do not.

New High-Resolution Depth Sensing – HD3D Today

There is a new technology known as optical TOF (oTOF) that promises a unique combination of high resolution, long range, and video speeds. It solves the problem of measuring time very precisely in large arrays (which has proven to be very difficult to scale) by not measuring time. Instead, a specialized filter is placed in front of a normal camera image sensor, coupled with a short laser flash, to record a precise encoded image, which is then quickly turned into a distance measurement for every pixel of the image sensor. It all happens in less than a microsecond. Think of a massively parallel LIDAR that looks and works like a camera at 24 or 30 fps (higher in the future), including genlock and timecode. Standard HD sensors (including UHD or higher) can readily be used to create HD depth cameras (HD3D) that capture HD depth maps in a flash.

Figure 26.8 illustrates some actual results taken with this technology (using 720p and 1080p prototype HD3D cameras): a grayscale depth map to 10 m (33 ft), meshed geometry from video (SLAM), and high-resolution face texture mapped over high-resolution geometry captured from 6 m (20 ft).

HD3D in Virtual Production and Pre-Post-Production

A high-resolution depth map, or a z-buffer, can make many traditional visual effects workflows real-time, or reduce the amount of time and labor required to achieve them. Figure 26.9 illustrates

Photogrammetry	RBGD cameras	LIDAR	iLIDAR
A collection of 2D cameras (or phone)	Commercial depth cameras	Laser scanner for static areas	Apple's phones and tablets
Can work anywhere if conditions are good	Can be quasi-real-time (< 10 frames).	Long range. Very accurate. High point density. Reliable.	Commonplace. Small. Can be good performance. Good software.
Not real-time – a lot of computer power. Can fail at unexpected times.	Low res. Limited working distance. Does not do black. Does not do outdoors.	Not real-time (minutes to hours). Scans do not always work. Static only.	Very low res. Short working distance. Small objects. Does not always work.

Figure 26.7 High-level comparison of common 3D capture techniques
Source: (Image courtesy of nLIGHT)

Figure 26.8 Left image is a HD3D grayscale depth map (3–10 m distance). Right image is a SLAM-based geometry mesh from HD3D video. Bottom image is a Textured HD3D geometry captured from 6 m (20 ft) distance.
Source: (Image courtesy of nLIGHT)

steps of how the depth map allows compositing of CG and physical elements in real-time. Figure 26.9 (a) and (b) show the RGB image from a separate camera and the HD3D depth map, respectively. These two can be mathematically transformed to the same frustum and principal point using the known depth values and displayed in compositing software or a render engine (Figure 26.9 (c)).

Figure 26.9 (a) The scene, (b) depth map
Source: (Images courtesy of nLIGHT)

Figure 26.10 (c) original scene in the render engine, (d) scene in CG environment
Source: (Images courtesy of nLIGHT)

Figure 26.11 (e) scene with background removed using depth, (f) CG hoop added with action in front and behind
Source: (Images courtesy of nLIGHT)

Figure 26.10 (d) illustrates how the real scene can be placed at the right scale in a 3D CG scene. The background objects, such as the walls, can be removed or made transparent based on depth values for those pixels (Figure 26.11 (e)). In this case, a mesh and surface normals were calculated in real-time so that digital shadows and lighting could be applied. CG elements can be added, such as a hoop, with foreground and background physical elements correctly occluding or being occluded by the CG elements (Figure 26.11 (f)) – even for moving objects (the actors and ball). The fidelity of the occlusions and HD3D depth data is illustrated in Figure 26.12 (g) where a complex CG object is inserted between the hands and body of the actor, with fingers handled correctly. Finally, even physical objects can be removed from the scene in real-time, as illustrated in Figure 26.12 (h), where the trash bin is removed, and the CG rabbit inserted. Figure 26.12 (i) shows the live display from the render engine with the real scene and action in the background.

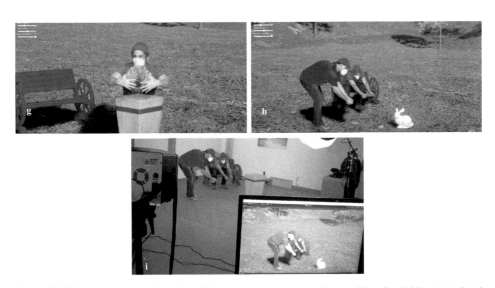

Figure 26.12 (g) zoomed view of precision CG placement seen through fingers, (h) real trash bin removed and CG rabbit added, and (i) live scene with engine display in left corner
Source: (Images courtesy of nLIGHT)

Compositing	Interactions between live and CG
Simulcam+ (with CG behind live)	Applying a digital blur
Witness cameras	Keying based on depth
Color grading	Volumetric video
Other lighting or shadow adjustments	Auto rotoscope
Volumetric effects (e.g., fog)	

Figure 26.13 Possible uses of HD3D depth in real-time production as well as pre- and post-production work
Source: (Image courtesy of nLIGHT)

Depth, or location information, for all pixels in the scene make it possible to achieve many different effects beyond compositing. Figure 26.13 lists other potential uses.

HD3D in Existing Tools and Workflows

HD3D depth can readily be used in any existing visual effects and virtual production workflows and software that make use of depth information or a "z-buffer." For a single depth camera, the depth maps can either be streamed over ethernet to a render engine or saved to disk to be read into the appropriate software later. Plug-ins will be available to make depth data readily accessible in either workflow. Figure 26.14 shows the expected data flow.

Making the data available in software, either in real-time or as an offline workflow, is straightforward with current tools. However, it will likely take some time to change software tools and optimize workflows to fully implement the power offered by HD3D data. At the beginning, it may be best used as an aid to speed up existing workflows (or make it possible to use them in near-real-time).

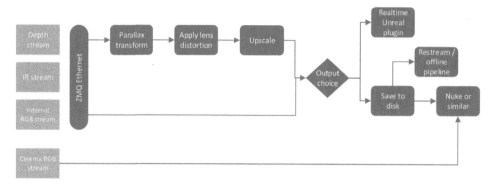

Figure 26.14 HD3D data can be readily integrated into existing real-time, pre- and post-production workflows
Source: (Image courtesy of nLIGHT)

The Future

In essence, HD3D depth cameras can provide depth or 3D location information of everything (object or surface) on set in real-time that can be used for virtual or traditional production workflows. As the technology becomes productized, it will first be available as a small accessory (Figure 26.15) that can be added to any existing camera. Over the long term, the technology can be integrated within the RGB camera, providing depth and color from the same device. The depth map resolution or 3D point density will increase over time, because of the technology's core use of normal CMOS image sensors, to ultimately match even 4K or 8K color from any camera being used on the set.

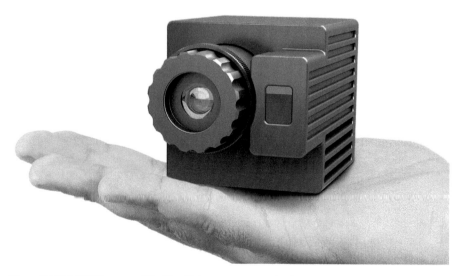

Figure 26.15 A HD3D concept (3" × 3" × 3") for an accessory depth camera that can be attached to any existing camera
Source: (Image courtesy of nLIGHT)

A single camera allows fast keys for the main cinema camera in any environment, and a small array of HD3D cameras (perhaps six to ten for a typical set) will make it possible to have real-time volumetric video or live holograms that can be mixed with CG elements as desired. These holograms and digitized reality can be used during pre-production, shooting, and post-production

as needed. Instead of just having in-camera visual effects, it will become seamless to achieve in-engine reality.

MicroLED – High-End Display and Resolution
Jeremy Hochman – Megapixel VR

Why Moiré Occurs When Filming LED Displays

Moiré is an image artifact appearing when two similar patterns overlap. In the case of displays, this is because the grid array of camera sensor pixels overlaps with the grid array of display pixels. Moiré is not unique to LED displays – it occurs on LCD and OLED displays, and it is even common to see when filming talent wearing patterned clothing, such as a plaid shirt.

What Filmmakers Do to Help Reduce the Moiré Effect

When filming an LED screen, pixel pitch and focal length are critical to consider. It is best practice to specify an LED screen at a resolution sufficient for multiple LED pixels to fill a single camera sensor pixel. For very large displays, a coarse pixel pitch such as 2–3mm can be sufficient because of the distance from the camera to the LED wall. When filming in large volumes, due to the sheer amount of space for scenic pieces and talent, depth of field is also generally shallow enough to blur the LED wall in the background. Smaller displays mean that both cameras and talent are closer to the LED wall, therefore 1.5–1.9mm pixel pitch is typical for these smaller volumes.

Why Color Shift Occurs When Viewing LED Displays at Different Angles

LED pixels have an inherent color shift. Assuming that a pixel is made of red, green, and blue sub-pixels, three elements are lighting up to create the desired color for that pixel. Viewing from off-axis, different colors will be more prominent than others – an apparent color shift. A color shift also occurs due to physical pixel attributes – standard SMD pixels are constructed with the emitters inside of a tiny reflector, and the shape of the reflector physically blocks light from the sub-pixels at different angles.

How Filmmakers Are Handling the Color Shift Issue

There are several ways of working around the color shift, each with its own set of challenges. Some filmmakers choose to keep their shots relatively close up so that the amount of LEDs seen in camera is minimized and thus has less overall shift. It is also possible to utilize camera tracking and LED processor APIs or render engine color correction to alter sections of the LED wall based on the angle of incidence and the camera frustum – this method yields great results but is complicated to execute. Lastly, color shift issues can be fixed in post-production; however, this is not ideal due to time and cost.

383

Differences Between MicroLED and Standard LED Technologies

MicroLED and standard LED tiles utilize different pixel package methodologies. Standard LED tiles, with advanced surface features, can achieve a more uniform matte texture, which is highly desirable; however, this comes at the cost of pixel pitch. The smallest achievable standard LED pixel pitch is approximately 0.9mm (before making significant sacrifices to durability and thermal performance). The SMD LED packages used in these tiles have somewhat narrow and non-uniform light emissions. MicroLED tiles can obtain higher resolutions (as small as 0.4mm pixel) with wider viewing angles, significantly more uniform light emission, and better power consumption.

Surface finishes of SMD pixels are vastly different from MicroLED. Standard LED tiles make use of a "mask" element: a physical layer, typically made of plastic, that can improve the black level in between pixels and in some cases add light-trapping features between the pixels as well. MicroLED tiles have a darker-appearing emitter area with a better black level; however, it is not feasible to add light-trap features between the pixels. The fact that each technology has its pros and cons means that both will remain relevant for the foreseeable future.

The Benefits of MicroLED Display Technology – Preventing Moiré and Color Shift

MicroLED technology has several benefits. It utilizes a chip-on-board (COB) process by which the LED emitters are bonded directly to a display surface rather than being packaged on their own and requiring a multi-step fabrication process. The multi-step fabrication process limits achievable resolution, reliability, and off-axis color performance.

The COB process allows emitters to be fabricated with much higher density. This density, resulting in a higher resolution LED tile, means that many more pixels can be captured by a single camera sensor pixel, resulting in little to no moiré.

This packaging technique also allows for more uniform light distribution from the red, green, and blue sub-pixel emitters. This uniform distribution significantly reduces off-axis color shift requiring minimal or no color correction.

Full Gamut Color – RGBW
Rod Bogart – Epic Games

Full Gamut Color

Spectral Response of LED Wall Pixels

When LED pixels are viewed directly by the production camera, they are intended to represent the illumination that exists in the real world. However, the gamut of all possible colors that can be reproduced by the LEDs is smaller than the full set of colors that can be seen. This difference

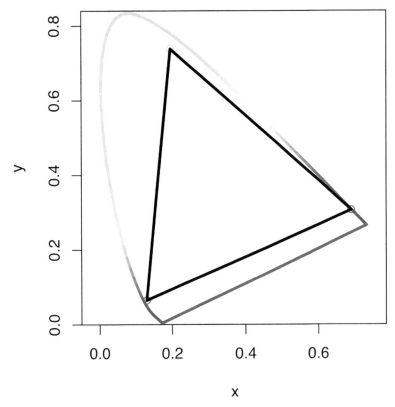

Figure 26.16 Shows an example of an LED panel gamut diagram
Source: (Image courtesy of Epic Games)

is shown in Figure 26.16, where the region within the triangle is the set of all colors that can be produced by a typical RGB LED panel at the time of this writing.

The curved region surrounding the triangle is called the Spectrum Locus, and it is the boundary of all possible colors that can be seen. From this figure it is clear that there exists colors that can be seen in the real world that would only be approximated by the RGB LEDs.

Some LED panel manufacturers are considering additional individual LEDs to expand the gamut beyond the three that are typically used. Candidates for these additional LEDs would be one or more in the cyan range (between green and blue, but with more saturation) or possibly a yellow primary, that would provide additional gamut excursion beyond the green-red line.

If these panels were viewed with the human eye, the appearance could more accurately represent the real world. However, the ICVFX process is based on the spectral sensitivities of the production camera. When future panels arrive that have additional diodes to expand the gamut, they will need to be evaluated in the context of direct viewing by the production camera to see if the distinction of the wider gamut can be perceived by the camera.

It should be noted that there are additional issues added when the panel has more than three primaries. The bulk of ICVFX is produced in real-time engines and playback servers that operate only in RGB. Any additional primaries would need additional channels of data in the output signal from the engines to be useful. Alternatively, those additional channels could be derived from the RGB signal, but that would involve choices of how the additional channels were calculated. To truly maintain artistic intent, the full spectrum would need to be considered during the conversion to the multiple primary panels.

Lighting With RGB Panels

When a colored object is lit by a colored light source, the spectra of each of them is combined. The individual spectral values are multiplied together causing the overall spectral response of the object to be reduced in the regions where the light source has little or no spectral information. For RGB panels, the spectra of the individual LEDs produce very narrow spikes, as shown in Figure 26.17.

If the RGB LEDs are the only illumination for the sets, props, costumes, and characters, there may be unexpected differences relative to how those objects would have appeared under sunlight or other production lighting. This is because the LED spectra shown above has large gaps in its illumination. A broad-spectrum illuminant would better fill the gaps, allowing distinctions in the colors to be perceived by a viewer.

RGBW

Future LED panels may include additional diodes that provide broad-spectrum illumination which would help fill the gaps. The panels are referred to as RGBW because they would have red, green,

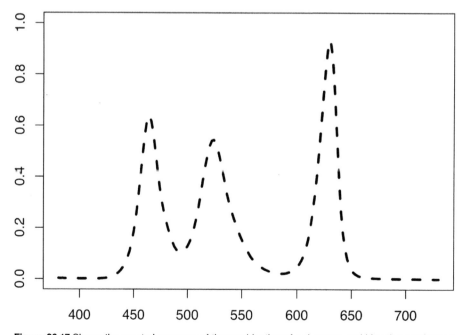

Figure 26.17 Shows the spectral response of the combination of red, green, and blue that produces a "white" color shown on a typical LED panel
Source: (Image courtesy of Epic Games)

and blue diodes, along with an additional diode that produces a "white" color. To go further, a RGBWW panel would provide two different broad-spectrum diodes – each with a different "white" color to have more control of the overall color temperature being produced.

It should be noted that RGBW (or RGBWW) panels are less important if they are directly viewed by the production camera. This is because only the spectra of the panels and spectral responses of the cameras are involved. The benefit of these panels would be in the illumination that they provide to sets, props, costumes, and characters. In that case, the spectra of the panels are combined with the spectra of the objects resulting in a new spectral distribution that is seen by the camera. When the panel spectra are only RGB, the combination is even further reduced by the spectra of the objects. So, the presence of the W component can improve that spectral combination. This benefit comes at a cost. Additional diodes take up more space, so the pixel pitch of these panels is likely not to be as high as the current RGB panels. Of course, these more complicated panels will likely be more expensive as well.

The additional diodes would need to be driven separately from the RGB diodes, so the additional channel of data would need to be provided or derived. However, unlike the expanded gamut of additional primaries, no new colors would be produced by the RGBW panels. Instead, they would produce the same colors, but with better spectral distribution of the light. So, the W channel could be derived from the given RGB data along with a preference for how the additional spectra is filled.

RGBW Panels and RGBW Lighting Instruments

Currently, there are many RGBW (or RGBWW) lighting instruments that are not high-resolution LED panels. These already serve the purpose of lighting typical movie sets independent of whether that set also has a LED wall. These can be driven from the real-time engine or playback device to produce a "pixel-mapped" result where changes in the scene are represented on these instruments. The difference between a pixel-mapped instrument and a RGBW panel is resolution. With a higher resolution panel, the reflections could be better resolved than they would be if the larger scale instruments are used. But both examples help produce higher quality light with a broader spectrum. The effectiveness of RGBW panels will be determined by individual use cases. Even with RGBW panels as part of the lighting options on set, there will still be a need for normal lighting instruments as well. They can provide greater illumination, as well as focused illumination that is not possible with general RGBW panels.

NVIDIA Omniverse and Artificial Intelligence
Rick Champagne – NVIDIA

NVIDIA Technologies for Virtual Production

Virtual production has given studios the opportunity to visualize stories in ways they have never before been able to and iterate on their ideas in real-time. This has fundamentally changed production workflows and, in essence, has transitioned content creation to the next phase of its evolution.

The virtual production workflow can be split into three interconnected parts:

- Development and pre-production
- Production
- Post-production

The departments within each of these stages include story, previs, visual effects, editorial, and post, to name a few.

Unlike traditional methods of production, shots do not move in a linear fashion through the stages, rather they move in parallel and, sometimes, in a circular flow. This creates flexibility for storytellers and is what allows for the expanded iterative capabilities of virtual production.

Another hallmark of the virtual production workflow is its collaborative nature. Because data flows back and forth in parallel, filmmakers and artists in different departments are communicating earlier in the process and can make and test creative decisions from the outset.

NVIDIA Omniverse Enterprise was built for collaboration and real-time photorealistic and stylized, physically accurate simulation. Multi-app and multi-user collaboration are enabled for complex workflows through the platform. Omniverse is based on Pixar's Universal Scene Description (USD), an open and extensible ecosystem for describing, composing, simulating, and collaborating within 3D worlds. USD enables non-destructive workflows and collaboration in scene creation and asset aggregation so teams can iterate collaboratively.

For virtual production, studios can collaborate across any application that supports USD, including Autodesk 3ds Max and Maya, SideFX Houdini, Adobe Substance 3D Painter, or Unreal Engine.

Omniverse DeepSearch[6] uses AI to allow artists to search through large volumes of untagged assets using text or a 2D image. DeepSearch uses AI to categorize and find content more intuitively than keyword searches. On a virtual production stage, DeepSearch can help the virtual art department (VAD) quickly find content using the natural language from the Director or on-set production team.

Omniverse is multi-GPU enabled, which makes it possible for artists to work with complex geometry with high-resolution textures in real-time during the content creation process. Assets can later be optimized for games engines.

Deep Learning Super Sampling (DLSS) uses AI to up-res HD content to 4K or higher. The advantage of this for virtual production is that up to 2× frame-rate boosts can be achieved using DLSS. This gives users the performance of real-time ray tracing at lower resolution while maintaining the visual quality of higher resolutions. DLSS requires a workstation with an RTX GPU and can be enabled in either Unreal Engine or Unity.

NVIDIA RTX professional GPUs[7] have been used by visual effects studios for over a decade for graphics and rendering. More recently major software providers like Adobe, Autodesk,

Blackmagic Design, and Epic Games have adopted AI capabilities that NVIDIA RTX accelerates with the goal of enabling real-time workflows.

NVIDIA RTX 6000 GPUs have been a mainstay for real-time content on LED volumes due to the large GPU memory profile, support for genlock, and display synchronization using NVIDIA Quadro Sync II and Unreal's nDisplay.

For virtual production, advanced IP-based networking is essential for real-time performance. NVIDIA networking reduces network latency for critical tasks, including camera tracking, nDisplay nodes, interactive DMX lighting, and scene loading over the network. NVIDIA Rivermax enables direct data transfers to the GPU and complies with the stringent timing and traffic flow requirement of the SMPTE ST 2110–21 specification.

The latest innovations in artificial intelligence and graphics that will transform virtual production include Neural Radiance Fields, or NeRFs, and Generative AI.

Inverse rendering is known as the process that uses AI to approximate how light behaves in the real world, enabling the reconstruction of a 3D scene from a handful of 2D images taken at different angles. The NVIDIA research team developed an approach that accomplishes this task almost instantly – making it one of the first models of its kind to combine ultra-fast neural network training and rapid rendering.

NVIDIA applied this approach to a popular new technology called neural radiance fields, or NeRF. The result, dubbed Instant NeRF, achieved more than 1,000× speed-ups in some cases. The model requires just seconds to train on a few dozen still photos – plus data on the camera angles they were taken from – and can then render the resulting 3D scene within tens of milliseconds. NeRFs have the potential to be as important to 3D graphics as digital cameras have been to modern photography. With this rapid approach to 3D scene generation, NeRFs will be used for set extensions, humans, props, and other set dressing with photorealistic results in a fraction of the time.

Generative AI can faithfully turn input text prompts into artistic and photorealistic images. Newer techniques provide more control for artists to guide the creative process using additional inputs such as a paintbrush to specifically position generated imagery into the desired locations.

Diffusion-based generative models have led to breakthroughs in text-prompt-engineered high-resolution image synthesis. Starting from random noise, text-to-image diffusion models gradually synthesize images in an iterative fashion while maintaining relevance to the input text prompts. As the images resolve, novel images and ideas fill the canvas to give artists new starting points that can eliminate "blank canvas syndrome." With new, more advanced starting points, artists can quickly iterate to reach a final image much faster.

A highly detailed digital painting of a portal in a mystic forest with many beautiful trees. A person is standing in front of the portal

A highly detailed zoomed-in digital painting of a cat dressed as a witch wearing a wizard hat in a haunted house, artstation

An image of a beautiful landscape of an ocean. There is a huge rock in the middle of the ocean. There is a mountain in the background. Sun is setting.

Figure 26.18 NVIDIA eDiff-I combines generative AI with greater artistic control
Source: (Image courtesy of NVIDIA)

For virtual production, generative AI provides directors and other key creative decision-makers with a set of tools that allow for dynamic changes to concept drawings, digital mattes, 3D textures, audio, or 3D objects and scenes live on a virtual production stage.

It is clear at this time that advanced compute capabilities, real-time technologies such as game engines, and artificial intelligence will pave the way for greater creative options at a much more rapid pace, while reducing repetitive tasks and increasing time spent on high-value creative work.

What Is Next? – Beyond the Volume
Rob Bredow – ILM

The Building Blocks

Virtual production tools for feature film and episodic shows have seen tremendous growth over the past several decades. However, despite all the innovation and changes in these areas, many of the key technical building blocks have been in place for many years: motion capture, camera-tracking, real-time 3D rendering, computer-controlled lighting, projection screens, and LED screens.

The key elements that were first used to provide a preview render of a virtual environment on a TV monitor for Stephen Spielberg on *A.I. Artificial Intelligence* (2001) are still being used today on more recent films like *Thor: Love and Thunder* (2022) and series like *Book of Boba Fett* (2022). The job of the visual effects professional is the same: To be a trusted advisor who can help recommend the best creative and technical workflow given the needs of a particular show.

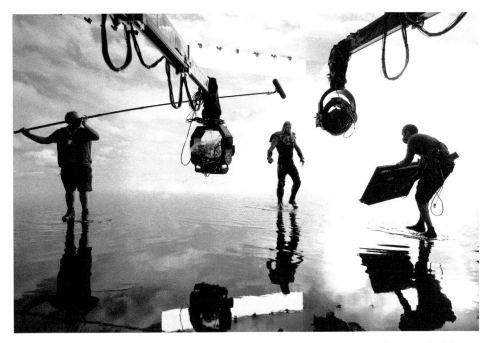

Figure 26.19 Behind the scenes photograph taken on an ILM StageCraft LED volume during principal photography of Marvel Studios' *Thor: Love and Thunder* (2022)
Source: (© 2022 MARVEL)

Opportunities for Continued Innovation

LED's volumes have grown in popularity as a tool for creating in-camera visual effects (ICVFX) often cited for their strengths of creating believable live-extensions of practical sets and other special effects. When used properly, they can help create a seamless illusion on set by integrating the on-set lighting, for both the practical sets and cast, using the virtual backgrounds without having to pull mattes from process screens.

That said, today's tools have limitations that can be addressed in future iterations of the technology. The cost to create an LED volume is high, driven by the cost of the LED panels themselves, along with the complex installation requirements due to the weight of the LED panels. Given the current cost structure, the largest installations tend to be fixed in certain configurations, which may not be ideal for all production use. Sometimes a very large stage is not the best way to achieve a particular scene, so compromises may need to be made, or certain sections of the LED panel can be configured to be "wild" or on motors at an additional cost.

Even in today's fixed installations, there are workarounds. For example, in the Meat Locker scene from *The Book of Boba Fett* (2021), a set wall was built to partition the large LED stage into two smaller spaces. Each side of the physical wall was then blended seamlessly with different room content, creating the illusion of two separate rooms in a single LED.[8]

Today's LED panels can be very bright and are designed primarily for indoor/outdoor advertising and rock concerts. They are optimized to be as spectacular as possible when viewed by eye.

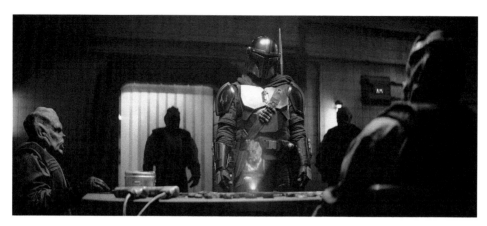

Figure 26.20 Still image from *The Book of Boba Fett* (2021) showing the Meat Locker location with two different rooms on a single LED volume.
Source: COURTESY OF LUCASFILM LTD. *(THE BOOK OF BOBA FETT* TM & © Lucasfilm Ltd. All rights reserved.)

Having a product optimized to be viewed by a digital cinema camera would be preferred. Limitations in brightness, performance in the darker areas of the scenes, color gamut, and resolution, all contribute to the complexity of getting quality results from an LED screen. While there are workarounds for these issues, a future with lighter, more configurable LEDs and broader color gamuts would be a welcome improvement for in-camera visual effects.

As LED panels get brighter, they spill light into the set, and the LED panels reflect that light, turning them from a deep black to a medium gray. Reducing the reflectivity of the panels, through improved material science, can help maintain the black levels of the content and the desired contrast of the final scene. This allows more lighting flexibility for the DP as he/she lights the rest of the actors and set. Typical panels reflect approximately four and a half percent of the light that hits them, and some reflect as much as ten percent. Unless a great deal of care is taken to keep stray light from hitting the panels, this will prevent in-camera backgrounds from attaining a true black appearance, making shadowed areas of the environment appear dark gray instead of black. This will make the shadows seen on the actors inconsistent with the set around them. New materials are in development which will be able to absorb more of the light hitting the panels while still transmitting the light from the LEDs. This should reduce the reflectivity to two percent and, hopefully in the near future, close to zero.[9]

Lastly, there remains large improvement opportunities to be made in the area of live GPU rendering. Although current GPU rendering engines present a spectacular array of tools for the artist, they are still a number of years behind what is possible in slower offline rendering systems (in terms of both scene complexity and the accuracy of the final rendering solution). Today's solutions employ a mixture of techniques, including mixing offline rendering techniques (such as baking certain expensive calculations into textures or other caches) with real-time effects for greater interactivity and improved feedback for the artists. As GPUs continue to improve in speed and ray-tracing abilities, the major software providers will enhance their products, making it easier for artists to achieve highly complex scenes at a higher degree of photorealism. This will mitigate having to resort to inaccurate solutions and/or time-consuming offline rendering.

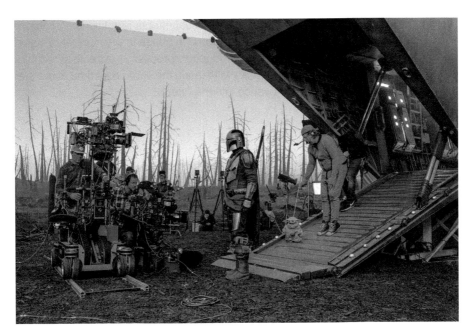

Figure 26.21 Behind the scenes photograph taken on ILM's StageCraft LED volume during principal photography of *The Mandalorian Season 2* (2019) COURTESY OF LUCASFILM LTD.
Source: (*THE MANDALORIAN* TM & © Lucasfilm Ltd. All rights reserved)

Beyond the Volume

While an LED volume is a remarkably useful tool, in-camera visual effects can be achieved with other methods as well.

If a scene does not require an LED screen to provide illumination for the actors and set, a real-time set extension can be rendered and live-composited on set. This shares many of the same advantages of an LED volume without the investment in the panels and construction costs. By providing a high quality live-composite, leaning into traditional practical lighting, the DP and Visual Effects Supervisor can work together to create final shots on set, or on set high quality "confidence previews" that assure the team that the lighting integration works well with the planned digital background extensions.

LED volume work can also be paired with live on-set compositing and Simulcam to create both background extensions *and* foreground object additions – like characters or additional foreground CG sets in the same shot. While this is commonplace today in post-production, it is likely to become a more frequent workflow as teams of artists and technicians get more experience with real-time in-camera visual effects techniques.

Future augmented reality (AR) hardware will allow for the Director, DP, and visual effects Supervisor, each wearing AR headsets, to see the digital extensions and additional character(s) in real-time on set. While it remains to be seen whether this will be useful enough to become a significant part of a creative team's workflow, it is clear that the technical building blocks for this style of working are beginning to be available at the time of this writing.

Chapter 26

Virtual production techniques have been part of the visual effects practitioners' toolbox for several decades. Since 2017, there has been a tremendous increase in the number of visual effects techniques integrated into the entire physical production process – especially techniques like LED volumes. While many of the building blocks will remain the same over time, there are several areas remaining for streamlining and innovation into the future.

Notes

1 www.nature.com/articles/s41377-022-00742-7.
2 www.lightfieldlab.com.
3 www.nature.com/articles/d41586-018-01125-y.
4 www.nature.com/articles/s41598-019-54243-6.
5 Short for Cyclorama – a curved wall or curtain that has no corners and smoothly joins into the floor, commonly placed at the back of a stage and covers at least 2 walls of the shooting area.
6 www.youtube.com/watch?v=IniYx78Bx48.
7 www.nvidia.com/en-us/industries/media-and-entertainment/.
8 Example provided by *The Book of Boba Fett* Senior VFX Supervisor Richard Bluff.
9 Panel reflectivity estimates courtesy of Paul Debevec, Director of Research, Creative Algorithms, and Technology at Netflix.

Acknowledgments

Special Thanks

Philip Galler (Technical Consultant)
Heather McCann
3500 Kelvin Studios
Brompton Technology
Create This
Do Equals Glory
Epic Games
Feeding Wolves
Fonco Studios
Fox Media LLC
Fuse Technical Group
Glassbox
Greig Fraser, ASC
Halon Entertainment
ICVR
ILM
LED Display Technology
Light Field Lab
Lucasfilm Ltd.
Lux Machina
Magnopus
Marvel Studios
Megapixel VR

Acknowledgments

Metastage
Microsoft Corporation
Mo-Sys Engineering
Move AI
MR Factory
Narwhal Studio
NantStudios
NBCUniversal
nLIGHT
NVIDIA
OptiTrack
Orbital Studios
Perforce
Philip Layton, csc
PRG
PROXi Virtual Production
Quasar
Reel FX
Rigney Global Entertainment
Silverdraft
Stargate Studios
The Illusion Cartel
The Third Floor
Unity Technologies
VFX Technologies
Voltaku Studios

Charts and Technical Diagrams

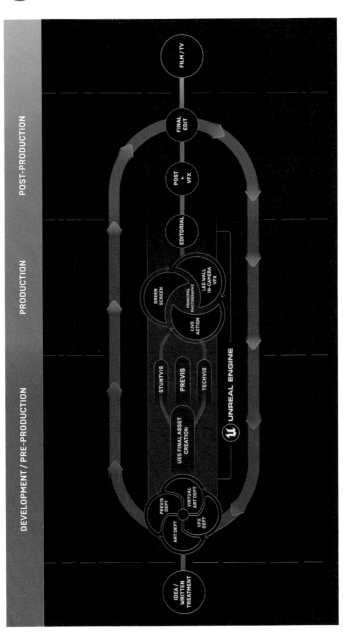

Figure A.1 Epic Games Workflow Chart of Virtual Production

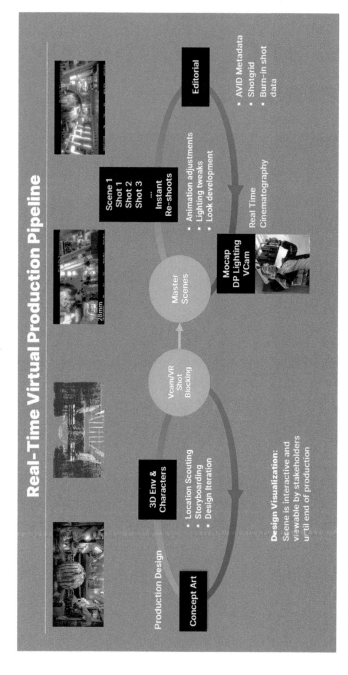

Figure A.2 Real-Time Virtual Production Pipeline for Unity Technologies

Real-Time Animation Story Workflow

Adapted from *Super Giant Robot Brothers!* workflow for 10x22 min episodes

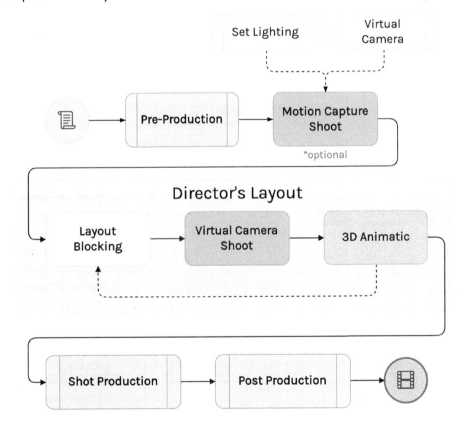

Figure A.3 *Super Giant Robot Brothers!* (2022) Real-Time Animation Story Workflow
Source: (Image courtesy of Reel FX Animation)

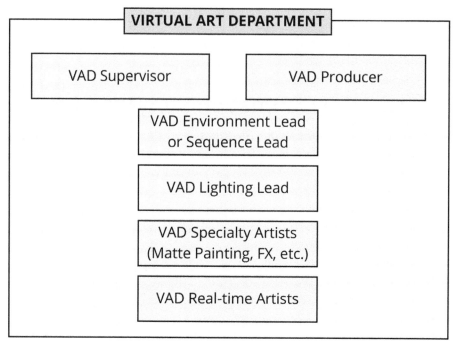

Figure A.4 Virtual Art Department
Source: (Image courtesy of Magnopus)

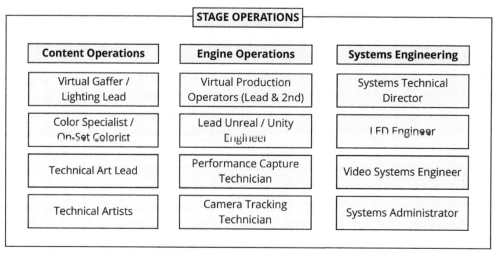

Figure A.5 Stage Operations
Source: (Image courtesy of Magnopus)

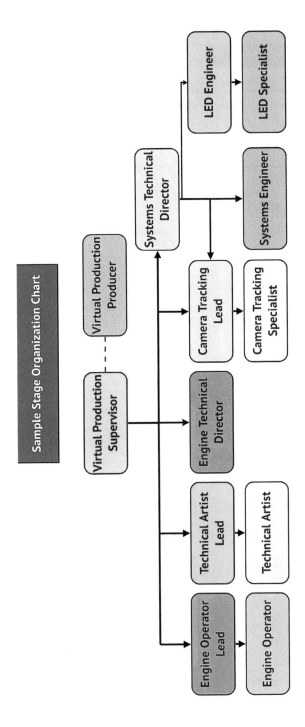

Figure A.6 Sample stage organization chart – just one of many organizational charts representing on-set labor
Source: (Image courtesy of Lux Machina Consulting)

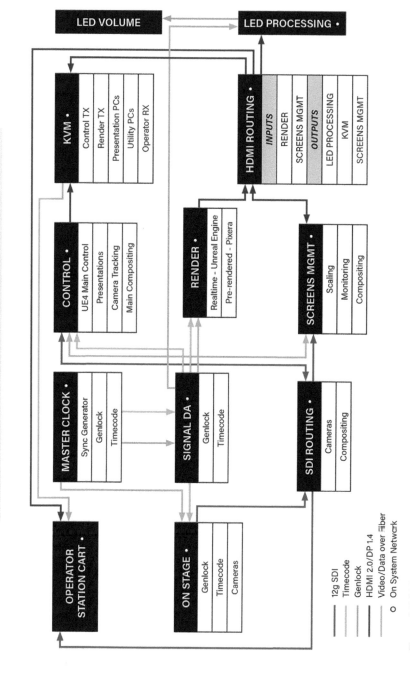

Figure A.7 A high-level system diagram that shows how some of the equipment in an LED volume system may connect
Source: (Image courtesy of Nicole Vos – Lux Machina Consulting)

Appendix B

The Virtual Production Glossary

The Virtual Production Glossary is made possible with generous support and input from the Visual Effects Society, the American Society of Cinematographers, Epic Games, and Netflix.

The initial version of the content was written and edited by Noah Kadner, Addison Bath, Michael Keegan, David Morin, Miles Perkins, Ben Schneider, and Sebastian Sylwan, VES.

A special thanks to the many industry professionals who generously provided their time and input for this glossary, including Ben Grossmann, Casey Schatz, Girish Balakrishnan, Matt Rank, Adam Davis, Brittany Montero, Curtis Clark, ASC, Stephen Rosenbaum, Dane Smith, John Refoua, ACE, Kim Richards, Matt Madden, Michael Goi, ASC, Phil Galler, Rob Legato, ASC, Susan Zwerman, VES, Wyatt Bartel, Fae Corrigan, Vlad Bina, Steve May, Haarm-Pieter Duiker, and Heather McCann.

Appendix B

Term	DESCRIPTION
Acquisition team	The team responsible for capture of real-world locations via photogrammetry, lidar, photography, and other methods. See also building team.
Action design	A form of visualization, typically using live performers. The output is a simulation to plan live-action stunts. Also called stuntvis.
Active marker	A tracking reference that emits light or radio waves, often a strobing LED.
Aperture	The opening of a diaphragm within a lens through which light passes to either a digital sensor or a film negative. Usually referred to as what F-Stop a lens is at, aperture influences the depth of field and the light gathering ability of the lens. See F-Stop and T-Stop.
Aspect ratio	The ratio between the width and the height of an image or screen. Some common film/TV production aspect ratios are 1.85 (spherical), 2.35/2.39 (scope/anamorphic), and 1.77 (a.k.a. 16:9).
Atmospheric	Fog, smoke, fire, and other physically based visual effects rendered by a real-time engine.
Augmented reality (AR)	Technology which integrates virtual elements into a physical environment. See also simulcam.
Avatar	A virtual representation of a real-world user, often operated via performance capture or physical control interfaces; see also digital humans.
Baked lighting	An asset with highlights and shadows baked into its surface texture, which does not directly respond to lighting changes; useful for increasing real-time render performance. See also interactive lighting.
Bi-color	A luminaire with the ability to toggle between daylight and incandescent color temperatures, as opposed to a full-color luminaire, which covers a much broader color spectrum.
Bit-depth	The number of binary digits used to store a value, such as a pixel's color. Higher bit-depths offer greater accuracy. An 8-bit image can display 256 color values for red, green, and blue, equaling ~16.7 million colors. A 16-bit image raises that number to ~4.3 trillion colors. Some common bit-depths in cinematography include 10- and 12-bit.
Bokeh	The aesthetic quality of the blur in out-of-focus areas of an image. Bokeh is often used to make virtual cinematography appear more realistic. See also circle of confusion.
Brain Bar	The team of artists and engineers operating the equipment that drives a smart stage or any space used for virtual production. Areas of responsibility include content distribution, image manipulation, camera tracking, recording, and creative visualization of data. Also known as volume control or mission control.
Building team	The team responsible for taking the data captured by the acquisition team and transforming it into digital assets.
Camera calibration	The process of aligning a real-world camera to its virtual counterpart, essential for integration between live-action and virtual elements.

Term	DESCRIPTION	(continued)
Camera extension	The process of augmenting footage from original live-action or virtual cinematography during post-production. Extensions may involve adding additional frames to existing angles or creating entirely new angles.	
Camera tracking	The solving of a live action camera's position and orientation. In a real-time scenario, these coordinates are sent to the engine, enabling the equivalent virtual camera to move identically. There are a variety of tracking methods such as mocap markers, a SLAM tracking device on the camera, or encoding the crane/camera platform itself. Another use of this term refers to a similar process of deriving of the camera position from footage. This is often done in post but can be done during production with the intent of driving an element shoot.	
Cave	A projection screen array built with a curved screen, sidewalls, and a ceiling for increased immersion and interactive lighting.	
Cinematic	A non-interactive animation sequence in an otherwise interactive experience as referred to in real-time engines. Also called a cutscene.	
Circle of confusion	When light from a lens does not come to a perfect focus, the imaging plane intersects a cone and, hence, forms a spot called a circle of confusion. If by changing the focus (or distance to the subject) the diameter of this circle is small enough to be indistinguishable from a dot, then that part of the image is considered in focus. Aesthetically, large circles of confusion are often desirable in the background so that the eye is drawn to the sharp subject in the foreground.	
Clipping	(1) In image processing, the loss of detail of an image in areas whose intensity falls outside of the minimum or maximum range of the capture device. (2) In rendering, the area of a scene which falls outside of the field of view or near/far clipping plane of the virtual camera. (3) In production design, a method used to create cutaway views of a model.	
Color rendition	The ability of a light source, such as a cinema luminaire or an LED wall, to render the color spectrum accurately; units include CRI, SSI, TLCI, and TM30. Current LED volumes have a reduced color rendition when compared to daylight and to incandescent lights.	
Color science	The field and techniques for measuring, processing, and displaying color accurately.	
Color space	Standards for representing the range of color in an image, based on components such as color bands (i.e., red, green, blue), spectrum, hue, saturation, lightness, value, and other measurements.	
Crossover volumes	Different configurations of the same volume load which encompass overlapping physical areas. See also volume variants.	
Cutscene	A non-interactive animation sequence in an otherwise interactive experience. Also called a cinematic.	
Cycle	A sequence of movements that can be seamlessly looped. Can be used to depict a virtual character's walk or other repeatable actions.	
Data capture	The capture of important details during principal photography such as photographic reference, lighting reference, LIDAR scans, camera metadata, etc.	

Appendix B

Term	DESCRIPTION (continued)
Data wrangler	A crew member who records on-set data, which can include camera telemetry, footage, tracking, real-time scene, metadata, etc.
Decimation	The reduction of geometry and texture to optimize an asset's real-time performance; a key difference between assets created for real-time vs. post-production animation.
Degrees of freedom (DoF)	The number of dimensions an object or headset can move or be tracked in 3D space. A 3 DoF system can track position or orientation, but not both simultaneously, while a 6 DoF system can track position and orientation simultaneously.
Depth compositing	The use of machine vision or other techniques to derive a depth matte which can then be used to accurately occlude cg and live elements for simulcam or other visualization purposes. Can be advantageous when compared to earlier chromakey type compositing techniques.
Depth of field	The distance in front of and behind the focused subject that is still sharp. Determined by the focal length, aperture, and camera-to-subject distance.
Digital asset	Building blocks of digital content creation used in a virtual production. Can range from 2D files (photo, video, graphics) to 3D files (models, rigs, animation, assemblies).
Digital asset manager	(1) A software tool used for the management and tracking of digital assets, including stills, footage, sound, etc. (2) The crew member responsible for the tracking of assets between departments and for organizing the file server's hierarchy. Different departments may each have their own digital asset manager. See Digital Asset
Digital backlot	A collection of virtual assets designed for reuse and repurposing throughout the course of an ongoing series or set of projects.
Digital content creation (DCC)	The category of applications used to create different forms of creative content such as 3D, 2D, video, etc.
Digital human	Photorealistic character rigged for real-time, performance capture driven animation, also referred to as avatars.
Digital production	The phases of production within a project which involve visual effects development, in which many tasks can occur simultaneously. See also physical production and virtual production.
Digital twin	A real-life physical prop or piece of not dressing converted into a digital asset to provide continuity between live-action and virtual elements.
Distributed rendering	Multiple instances of an engine processing the same scene in parallel to achieve a much higher total resolution.
DMX	Digital Multiplex protocol for controlling lighting instruments, used extensively with pixel mapping.
Dolly wall	A section of LED panels built onto a mobile platform for easy repositioning and use as a reflection source and other purposes. Also called roaming panels or roaming walls.
Edge diffraction	A light-interference phenomenon that occurs around high-contrast edges of an object, such as LED screens.

Term	DESCRIPTION (continued)
Encapsulant	The physical support structure for individual LEDs within an LED panel for a volume.
Encoder	A device that records and/or streams rotations. Attached to the moving parts of a crane this would give us a solve of the camera position. Also useful in deriving linear translation in the case of a dolly move or the telescoping portion of a crane arm.
Engine operator	The crew member responsible for maintaining and operating the real-time engine within the volume, and loading and operating assets.
Extended reality (XR)	An umbrella term for virtual reality (VR), augmented reality (AR), and mixed reality (MR), and all future realities such technology might bring.
Eye tracking	The capture of eye movements and gaze, typically part of facial capture.
Eyeline	An object that an actor looks at while shooting a scene and spatially represents a CG element. Can be anything from a tape mark, to a tennis ball, to a motion-controlled screen.
F-stop	The ratio of focal length to aperture size which dictates depth of field and the lens' light gathering ability. For example, a telescope with a 400mm focal length and a 100mm lens would be an F4.
Facial capture	The capture of facial expression using a head mounted camera or other methods; a part of performance capture.
Facial performance replacement (FPR)	A form of facial capture intended to replace an original facial performance while retaining the original body performance.
Feed	The live or nearly live footage coming from cameras, real-time engines, or other live-action sources. Often used for remote collaboration to provide camera feeds remotely to editors and other crew members to assist with rapid feedback.
Fiducial marker	A reference object with a known size and a unique pattern, similar to a QR code, that certain camera tracking systems can recognize and use to calculate their relative position.
Field of view (FOV)	The portion of the world that can be seen at any given moment by a person or camera. For a camera, FOV is measured in degrees and based on the focal length of the lens and the size of the camera's image sensor or film back.
Final pixel	The goal of achieving final image quality live, in-camera, without the need for additional major visual effects work.
Fix it in pre	A philosophical tenet of virtual production referring to the preparation of assets and planning during pre-production; as opposed to the traditional visual effects paradigm of fix it in post.
FIZ (Focus, Iris, Zoom)	A control system which enables the remote control of focus, iris, and zoom settings on a camera lens simultaneously.
Focal length	The measure of the magnification power of a lens, typically given in millimeters; the higher the number, the greater the magnification.

Term	DESCRIPTION	(continued)
Four-dimensional (4D) capture	A recording of a performance from multiple angles over a period of time. Typically using a synchronized array of cameras, lights, and sensors surrounding the subject. See also volumetric capture.	
Frames per second	(1) How many pictures the camera is taking per second. (2) How many images the real-time engine is rendering per second, which should never run below that of the camera. Rendering frame rate is influenced by the complexity of the assets, the processing power of the artist machine, and the output resolution.	
Frustum	The region of the virtual world the camera sees. This is important because anything outside of this view doesn't need to be rendered.	
Frustum culling	The process of removing objects or reducing rendering quality for areas that lie outside the inner frustum since they are not directly visible to the camera.	
Gamut	The portion of the visible spectrum that a display can accurately reproduce or a camera can accurately capture, e.g., Rec.709, DCI-P3, and Rec. 2020.	
Genlock	A technique used to synchronize digital triggers; it ensures frames and subframes stay in sync. Often used in high frame rate systems that work in combination such as performance capture with active markers and multiple cameras.	
Global Illumination	A method of virtual lighting which achieves greater photorealism by simulating the indirect, bounced properties of physical light; a crossover between virtual and physical cinematography.	
Graphics processing unit (GPU)	A specialized type of microprocessor optimized to display graphics and do very specific computational tasks. Modern real-time engines rely heavily on GPUs for performance.	
Hand capture	Capture of 3D hand movements using gloves with sensors, haptics, or visually; a form of performance capture.	
Haptics	Technology that creates forces, vibrations, or temperature changes to simulate real-world sensations such as g-force and impact.	
Hard disk drive (HDD)	A computer storage device, typically using a spinning magnetic disk. See also SSD.	
Head tracking	The method used by a head-mounted display to project the correct image by tracking a user's head movements via gyroscopes, sensors, cameras, etc.	
Head-mounted camera (HMC)	A special camera rig designed to capture an actor's facial performance.	
Head-mounted display (HMD)	A head-worn device used to display CG content for VR, AR, and MR	
Head-up display (HUD)	A transparent overlay which presents data about the virtual world to a viewer without their having to look away from their current perspective. Used in conjunction with virtual camera to approximate the display of a real-world camera during virtual scouting, techvis, etc.	
High Dynamic Range (HDR)	The representation of a greater dynamic range of luminosity than is possible with standard digital imaging techniques. HDR images retain detail in a fuller range of lights and darks than standard images.	

Term	DESCRIPTION	(continued)
High dynamic range imaging (HDRI)	An omnidirectional set of images shot in a bracketed wide range of exposures that captures the real-world illumination values of an environment. An HDRI is often used as an Image Based Light (IBL) to light virtual assets and environments.	
IES Profile	A file format defined by the Illuminating Engineering Society which describes a light's distribution from a light source using real-world measured data.	
Image-based modeling	The process of using two-dimensional images to develop three-dimensional content. See also photogrammetry.	
Immersion	The sensation of feeling present in a digital environment.	
Imperfection	The intentional introduction of subtle real-world flaws and visual artifacts to make virtual footage appear more like real-world live-action footage.	
In-Camera Visual Effects (ICVFX)	The process of capturing visual effects live and in-camera on set, such as within an LED volume.	
Incident lighting	Lighting on a subject which comes directly from a source; as opposed to indirect lighting, which is reflected or bounced before reaching the subject.	
Indirect lighting	Lighting on a subject which is reflected or bounced before reaching the subject; as opposed to incident lighting, which comes directly from a source.	
Inside-out tracking	A method of camera tracking which uses a sensor mounted directly on the camera and searches for trackable features such as markers in the ceiling or a map of the physical set using machine vision techniques. See also outside-in tracking.	
Interactive lighting	When light from virtual objects interacts with real-world objects, such as when the emitted light from an LED volume illuminates a physical object or when movie lights are used to simulate the characteristics of objects on an LED wall.	
Interactive lighting	An asset whose highlights and shadows will respond interactively to lighting within the environment. See also baked lighting.	
Jerk and Jounce	Derivatives of acceleration and sometimes important issues to filter out when doing motion control.	
Judder	Shaking or stuttering between frames. Judder can be experienced inside of a VR headset as well as in video imagery.	
Latency	The delay from when a signal is sent to when it is received/displayed at its destination. Reducing signal latency is a key guideline for success when using virtual production techniques. Modest latency can be managed with prediction, interpolation, and overscan.	
LED engineer	The crew member responsible, as part of a team, for the design, prep, and installation of the LED panels and related LED systems. This person is responsible for tasks such as mapping, LED tile configuration, and LED processor setup and LED tile color calibration.	
LED panel	A modular array of LED lights which display video content. Originally designed for indoor/outdoor advertising, entertainment venues, and broadcast use, LED panels are now used to create and enhance lighting and appropriately scaled environments for motion picture cinematography.	

Term	DESCRIPTION	(continued)
Lens mapping	Calculating the distortion of a lens by shooting a grid. Used in making rendered CG elements distort the same way as the lens on the live-action camera. See also camera calibration and alignment.	
Level of detail (LOD)	The representation of a 3D asset, with a specific image quality and render performance. Multiple levels of detail may be produced for various applications.	
LIDAR (Light imaging, detection, and ranging)	A survey method that illuminates a target with laser and measures the reflected light via infrared sensors to derive a point cloud; useful as part of asset creation and to capture real-world locations.	
Light card	A virtual light placed on the surface of the volume to assist with lighting the subject, can be any shape, hue, intensity, and opacity.	
Light contamination	The presence of unintentional light effects on a given surface, such as the spill from movie lights onto an LED wall.	
Load	An assembly file that includes elements such as virtual sets, characters, and performances prepared for shooting with virtual camera, simulcam, in an LED volume, etc.	
Look up table (LUT)	A mathematical formula or matrix that acts as a color correction, such as transforming between a RAW camera image and the desired display appearance such as an SDR or HDR monitor.	
Loom	The protective bundle wrapped around video and networking cables on a volume to tether between equipment carts and other connection points.	
Luminaire	A discrete, integrated device designed specifically for lighting; LED panels create incident lighting but are not designed as luminaires.	
Machine learning	The development of algorithms which enable a computer to learn and improve without being specifically programmed.	
Machine room	The enclosed room on or near a volume where the main computer networking, video server, render nodes, and other critical infrastructure are housed. Also called server closet.	
Map	"Map" or "Level and Scene" refers to a set environment within a real-time engine.	
Marker	A physical reference for tracking purposes. See also active marker and passive marker.	
Matte	A mask used to isolate areas of an image for use in compositing.	
Media server	A repository for digital assets designed to distribute them over a network; can be directly connected to LED volume nodes for distribution. Also a powerful playback device for video and audio assets with sophisticated media control and synchronization capabilities.	
Methodology	The chosen technical approach to the needs of a specific shot or scene. This may include an LED volume, green screen setup, partial set or location.	
Mission control	The team of artists and engineers operating the equipment that drives a smart stage or any space used for virtual production. Areas of responsibility include content distribution, image manipulation, camera tracking, recording, and creative visualization of data. Also known as the Brain Bar and volume control.	

Term	DESCRIPTION	(continued)
Mixed reality (MR)	The general term for connecting the physical world with the virtual world. Manipulation of a virtual object can affect the physical world, and changes to a physical object can affect the virtual world.	
Moiré	An undesirable interference pattern caused by the mismatch between the sensors on a digital camera and a complex, repetitive pattern. For example, moiré can be caused by focusing a camera directly on an LED screen.	
Motion base	A physical platform used to move an object, typically driven by manual input or motion control with capabilities described in axes of motion, such as a 6-axis motion base.	
Motion capture (Mocap)	A process for recording and solving the position and orientation of humans, props, and cameras in space and time. The most common mocap technique used in virtual production is a camera-based system with passive markers. Other techniques can be based on inertial sensors, active markers, tracking marks, or solely on video. Motion capture is often the basis for techniques including virtual camera, virtual characters, simulcam, and other techniques requiring real-time solving. See also Retargeting.	
Motion capture suit	A special costume with sensors used to capture human performance movement to puppeteer virtual characters. Sensor types include retro-reflective markers for optical tracking and inertial motion sensors.	
Motion capture supervisor	The technical supervisor leading a motion capture team responsible for shoots, technology decisions, and is the on-set point-of-contact. Ensures the capture and delivery of the highest quality across all motion capture data and processing to on-set visualization and VFX teams.	
Motion control (Moco)	A special rig which uses mechanical servos and computer control to create precise, repeatable movements for visual effects shots. Can be applied to camera rigs or to physical elements.	
Motion data	The raw data derived from performance capture for use in visual effects, blocking, visualization, etc.	
Motion match	A process that creates much higher realism by matching animations to desired poses.	
Motion processing	The cleanup of raw motion capture performances to eliminate errors or artifacts from the original capture.	
Motion study	The observation and analysis of the motion of an object or character to aid in reproducing it virtually.	
Nit	A measurement of the light intensity of a display screen. One nit is equal to one candela (one candlepower) per square meter.	
Open Sound Control (OSC)	A protocol for networking sound synthesizers, computers, and other multimedia devices for purposes such as musical performance or show control. OSC's advantages include interoperability, accuracy, flexibility, and enhanced organization and documentation.	
On-set operations	The team responsible for managing any technical difficulties related to the volume during production operations and maintain the key creatives.	
On-Set Virtual Production (OSVP)	Use of virtual production techniques to capture imagery in-camera. See also ICVFX and extended reality.	

Appendix B

Term	DESCRIPTION	(continued)
OpenColorIO (OCIO)	A system that enables color transforms and image display to be handled in a consistent manner across multiple graphics applications.	
Optimization	A stage in the process of asset development where assets are optimized for real-time performance while maintaining high visual quality. See also level of detail and performance.	
Outside-in tracking	A method of camera tracking which uses cameras or sensors mounted on the perimeter of a volume to analyze the position of the camera and other objects. See also inside-out tracking.	
Parallax	The perceptual difference in an object's position when seen from different vantage points.	
Passive marker	A tracking reference object that reflects light, often a sphere covered in retro-reflective material or a printed design for image-based tracking.	
Performance	(1) The performance quality and render rate of the onscreen real-time content, measured in frames per second or in milliseconds, also referred to as perf. Perf must meet or exceed the camera's frame rate for optimum visual appearance with an LED volume. (2) The actions of a character in a scene. Performances can be captured via motion picture camera and various motion capture methods.	
Performance capture	A combination of techniques used to capture an actor's entire performance, including facial expressions, head, hands, and body position.	
Photogrammetry	The automated construction of a 3D model asset triangulated from multiple 2D photographs; can also be combined with point clouds derived from LIDAR scans, a.k.a. sensor fusion. See also image-based modeling.	
Physical production	The phases of production within a project which involve physical and linear work, as opposed to digital production in which many tasks can occur simultaneously. See also digital production and virtual production.	
Physical simulation	The calculation of real-world accurate physical interactions and collision detection within a real-time engine.	
Pitchvis	The visualization of a script or sequence prior to production, used to get investors and studios onboard by demonstrating a concept before it's greenlit.	
Pixel mapping	The process of sampling the pixels of a specified onscreen texture and outputting their hue and intensity as DMX for lighting control and synchronization.	
Pixel pitch	The distance between LEDs on a volume panel. The lower the number, the more dense the pitch. Denser panels have greater visual resolution and are usually more resistant to moiré artifacts although they are also much more expensive and can sometimes be less bright. 2.8mm is considered the minimum standard for LED panels in virtual production, while the optimal panel size is determined by size of the volume, typical distance of camera/subject to wall, brightness demands, etc.	
Plate	Footage intended as an element in a composited visual effects shot. Plates often consist of location or sets for use as backgrounds or other elements as needed.	
Postvis	The process of visualizing and/or reconceptualizing the visual effects of a film, after the live-action elements have been shot.	

Term	DESCRIPTION	(continued)
Pre-cap	A pre-production motion capture session used for motion studies and to help guide previs.	
Pre-light	The process of lighting a scene before the main production unit arrives in order to facilitate complex setups and maximize the full crew's efficiency. Can apply to physical production or to pre-lighting virtual environments as they are developed.	
Pre-production	Any planning, testing, visualization, or design done before principal photography or capture begins.	
Precision time protocol (PTP)	A form of timecode with sub-microsecond timing accuracy. See also timecode.	
Previsualization	A collaborative process that generates preliminary versions of shots or sequences using a virtual environment. It enables filmmakers to visually explore creative ideas, plan technical solutions, and communicate a shared vision for efficient production. Also known as previs.	
Projection mapping	A method for warping and conforming content onto a surface. Projection mapping can be used to map content onto the geometry of an LED volume, especially for complex shapes like curves and multiple surfaces.	
Prop	A physical or virtual item which can be interacted with.	
Proxy	A scaled-down file that is used as a stand-in for a higher resolution original.	
Quality assurance	The process of searching for errors, flaws, and imperfections within an environment or asset, often abbreviated as QA or as quality control (QC).	
Rail rig	A curved virtual dolly rig and includes key points in space as well as camera orientation. Can also be called spline dolly.	
Raster scan lines	Visible distortion which can appear as lines or wave patterns on camera such as when capturing an LED panel without proper genlock or a camera shutter out of phase with the display's timing.	
Ray tracing	A rendering technique that traces rays from the camera and lights in a scene, simulating how the lights and virtual objects' materials interact.	
Real-time composite	Layering the live camera feed with foreground/background digital elements viewed live through a monitor on-set. The digital elements could consist of pre-rendered/captured 2D media or real-time rendered 3D assets playing back on a display surface (LED/Projection), a live broadcast or live-keyed against green/blue screen. The live composite provides a dynamic, interactive view on-set to aid with framing digital elements with practical set/talent and can be used in editorial as a temporary or final in-camera composite.	
Real-time engine	If the physical camera needs to be motion captured to strengthen real-time integration of digital elements, see simulcam.	
Real-time rendering	The translation of a scene into display pixels for instantaneous playback at real-time speeds such as 24, 30, 60, 90 frames per second. In contrast, traditional offline rendering may take minutes or even hours to produce each frame.	
Rear projection (RP)	An in-camera compositing process in which an image (such as a previously photographed or printed background plate or 3D environment) is displayed behind the foreground subject. Often used for driving shots when a fully 3D environment may be unnecessary, although real-time engines can also be used for this effect.	

Appendix B

Term	DESCRIPTION (continued)
Refresh rate	The frequency at which an electronic display is refreshed, usually expressed in hertz (Hz). Higher refresh rates can make motion appear smoother.
Remote collaboration	The use of videoconferencing services to connect a virtual production studio to off-site crew members for purposes of collaboration, footage review, live feeds, content and equipment operation, etc.
Render	The digital process of generating an image or video content based on 2D, 3D, and lighting information.
Render node	A member of a group of computers rendering the same scene in parallel. Multifaceted LED volumes generally require several synchronized render nodes to generate a complete environment.
Retargeting	The application of performance capture data to a CG character's skeleton; can be used to convert motion captured such as from a human to a larger character.
Retiming	The process of converting motion captured at one rate to another; useful for synchronizing mocap captured in different sessions or deriving slow-motion or high-speed frame rate effects for virtual shots.
Room-scale	A 1:1 correspondence between a physical space and a virtual environment.
Safetyvis	On-set visualization of crew positions for COVID safety to ensure everyone can work at a safe distance to minimize exposure.
Scene assembly	The integration of discrete elements such as environment, lighting, animation, motion, etc., into a unified file. See also load and DCC.
Selects	The performance(s) or take(s) chosen for further usage in editorial or visual effects development. Select may include live-action footage and motion capture performances.
Set decoration	Physical objects on the set to help blend with the virtual world; elements may also appear replicated within the virtual environment. Also referred to as set dec.
Set extension	A virtual continuation of a physical set which gives the illusion of a much larger area to the camera.
Global Illumination (GI)	Virtual content determined to be of sufficient visual quality to be suitable for final pixel, in-camera visual effects.
Simulcam	The live compositing of virtual elements with live-action. Used for previewing virtual characters and environments during live-action cinematography. See also augmented reality.
Simultaneous localization and mapping (SLAM)	A method of tracking which analyzes physical features of the real-world to compute position and translation in real-time.
Smart stage	A stage purpose-built for virtual production which might include LED walls, tracking systems, real-time animation, performance capture, and VR capabilities.
Solid state drive (SSD)	A hard drive with no moving parts, which improves performance and reliability; M2 SSD's are faster, enabling optimal virtual production capabilities. See also HDD.

Term	DESCRIPTION (continued)
Spectral response	The portion of the color spectrum a given light source emits. LED panels, due to their use of RGB LED bulbs, have a reduced spectral response compared to full-spectrum cinema lights.
Spectrum management	The process of managing all of the various wireless hardware, including non-visible infrared tracking, etc., on a stage or volume to avoid crosstalk and interference.
Sputnik	Nickname for the tracking object affixed to a motion picture camera for outside-in tracking. Also referred to as the "crown" or "tiara." See outside-in tracking.
Storage	The media in which assets are stored, including magnetic and solid state hard drives. Storage performance is a critical factor for real-time workflows.
Stuntvis	A close collaboration between techvis and stunts to plan live-action stunts. This may include position of wire pick points and the rigs that hold them, where safety padding can go, and optimizing the camera crane position to minimize risk to the actor. Safety is of the utmost importance, and respecting the physical parameters while in the CG software is essential. Also called action design.
Systems administrator	The IT professional overseeing areas including network infrastructure, servers, and spectrum management.
Systems integration	The process of assembling, testing, and validating components from different vendors into a single, integrated solution.
Systems technical director	The crew member with overall responsibility for the operation for all real-time specific hardware on a volume, including but not limited to LED walls, real-time render nodes, tracking systems, DMX lighting control, etc.
Tearing	The visual discrepancy between the output of two render nodes when they are out of sync on a display, such as a monitor or LED wall.
Techvis	The use of 3D assets to perform technical analysis on scenes: determine camera type, lenses, rigging, portions of sets which need to be physically built vs. virtual, stunts, etc.
Telepresence	The feeling of immersion within a virtual environment when using an HMD.
Three-dimensional space	The geometric parameters describing the position and orientation of an object in 3D space, expressed as X-Y-Z coordinates and pitch-roll-yaw.
Timecode	A numeric code sequence used in video production, show control, and other applications to provide temporal coordination between different devices. See also PTP.
Tracking	The process of determining the position and orientation of a camera or other object relative to the scene via various optical/digital methods; used for integration between the virtual and physical worlds.
Transliminal set	A physical set that extends beyond the boundaries of LED volume doors to mitigate the proscenium feeling, which can occur when set builds all feel the same size in relation to the volume.
Truss	The physical mounting hardware and infrastructure used to hold LED panels for volume and related equipment such as tracking, lighting, network hardware, etc.

Term	DESCRIPTION	(continued)
USD (Universal Scene Description)	An open-source 3D scene description and file format for content creation and interchange among different tools.	
Version control	A system for tracking and managing changes to digital assets, highly useful for the art development cycle during pre-production.	
Video engineer	The crew member in charge of maintaining and routing video signals to and from sources and destinations on a volume as well as other a/v operations.	
Video processor	Within an LED volume, this device distributes a video signal to the individual panels which comprise the volume's screens.	
Video routing	The process of routing video signals through devices such as switches and matrices.	
Videogrammetry	The automated construction of a 3D model triangulated from video. See also photogrammetry.	
Virtual art department (VAD)	The department which produces all real-time assets such as characters, props, and environments for traditional previs and virtual production. VAD artists help design and assess which set builds will be practical and which will be digital. They capture physical sets and locations, virtually scout digital locations, and develop preliminary environments that the DP can pre-light.	
Virtual art director	The person responsible for managing the design and development of virtual environments and sets.	
Virtual blocking	The use of previs to set up virtual environments for the filmmakers to block action and plan shots.	
Virtual camera (VCam)	A camera in a real-time engine which behaves the same way a real-world camera would with respect to optics, aspect ratio, etc. A VCam can be manipulated using a tracked device such as a mobile device, tablet, game controller, or a physical object with a tracking reference attached such as a real-world tripod, dolly, crane, drone, etc.	
Virtual camera operator	The physical operator of a virtual camera.	
Virtual character	A humanoid, animal, or other living creature whose animated movements are created in real-time via the input of a human operator via performance capture.	
Virtual cinematography	The process of creating virtual imagery which may incorporate aspects of real world cinematography. Virtual cinematography can be used to build complete virtual worlds from scratch and manipulate them with real-world input. The process includes all of the visualization phases of a virtual production from previs through live-action shooting and into post.	
Virtual green screen	A green screen created directly on an LED volume surface; often constrained around the frustum to preserve the rest of the virtual environment for interactive lighting.	
Virtual lighting	Light created within a real-time engine, often simulated with real-world physical and optical behaviors. Can be used on an LED volume to directly light a scene or act as interactive/reflective lighting. See also light cards.	

Term	DESCRIPTION (continued)
Virtual pre-production	An extended period of prep and asset creation prior to the start of a virtual production which ideally engages the VAD, cinematographer, director, and other key production personnel in non-consecutive contracts. Also referred to as soft prep.
Virtual production	Virtual production uses technology to join the digital world with the physical world in real-time. It enables filmmakers to interact with the digital process in the same ways they interact with live-action production. Some examples of virtual production include world capture (location/set scanning and digitization), visualization (previs, techvis, postvis), performance capture (mocap, volumetric capture), simulcam (on-set visualization), and in-camera visual effects (ICVFX). The key to the successful use of this technique is choosing the right tools to solve production problems and empowering the creators without detracting or distracting the crew from the content creation process.
Virtual production supervisor	The crew member who oversees the use of virtual production techniques to integrate smoothly with production. In the planning phase this includes which techniques to employ, budget, workflow, and team size. During production this person acts as the liaison between the real-time crew, art department, VAD, physical production, visual effects, and post-production.
Virtual rapid prototyping (VRP)	A previs process which leverages virtual production techniques and enables a small crew to plan, shoot, and edit sequences in real-time using actors in mocap suits.
Virtual reality (VR)	An immersive experience using headsets (HMDs) to generate the realistic sounds, stereo images, and other sensations that replicate a real environment or create an imaginary world.
Virtual scouting	The use of tools such as virtual cameras and VR headsets to share and interact with a model of a set for shot planning and production design.
Virtual space	An area which exists within the virtual world and which may correspond either 1:1 or proportionately with a real-world space.
Visual effects supervisor	The crew member responsible for the creative and technical aspects of visual effects. Real-time assets often overlap with post-production visual effects and the virtual production supervisor.
Visual fidelity	The degree to which an asset resembles its real-world counterpart in texture, lighting, properly weighted animation, etc.; another name for quality.
Volume	The physical space in which performance capture is recorded. Also refers to a nearly enclosed LED stage in which a volume of light is emitted, or a display surface for projected content.
Volume control	The team of artists and engineers operating the equipment that drives a smart stage or any space used for virtual production. Areas of responsibility include content distribution, image manipulation, camera tracking, recording, and creative visualization of data. Also known as the Brain Bar and volume operations. Also known as the Brain Bar and mission control.
Volume operator	A crew member from the volume operations team; involved with the operations and content related to the LED volume. Includes Key Volume Operator, Assistant Volume Operator, VIT, etc.

Term	DESCRIPTION	(continued)
Volume variant	A variation of a given volume load and physical set configuration, typically due to a desired change in set appearance or camera position.	
Volumetric capture	A recording of a performance from multiple angles over a period of time. Typically using a synchronized array of cameras, lights, and sensors surrounding the subject. See also 4D capture.	
Waldo	A mechanical input device with encoders attached so that any motion of the device can be read by a computer as locations or rotations in 3D space. Waldos are used to assist in the animation of motion-controlled rigs for virtual environments and to puppet virtual characters.	
Witness camera	Camera(s) placed on set to provide alternate perspectives on a shoot and provide a comprehensive understanding of the action within a scene. Often used to facilitate remote collaboration or to capture additional data for later visual effects work.	
World capture	The use of LIDAR, photography, video and other references to translate real-world spaces into digital assets. Also referred to as reality capture or scene digitization.	
World-building	The process of developing a coherent virtual world for use in a production whose qualities may include history, geography, and ecology.	
Z-space	The distance of a 3D object from the camera, real or virtual. When viewing a 2D image on a monitor, Z-space is the distance away from the camera.	
Zintegrator	A category of markered props used for aligning physical sets/objects to virtual counterparts; can be used to drive static non-markered objects within a volume.	
Zulu set	A physical set or prop designed for actors to interact with and stand in as a proxy for a virtual asset. Sometimes built at different scales to accommodate for major size differences in actor to character. This term was coined and still in use by the *Avatar* team; also referred to as a proxy set.	

Index

Note: Page numbers in *italic* indicate a figure on the corresponding page.

Index

Index

Index

Index

9781032432649